The Low Countries

TLC

2009 The Low Countries

ARTS AND SOCIETY IN FLANDERS AND THE NETHERLANDS

17

**Published by
the Flemish-Netherlands
Association**
Ons Erfdeel vzw

Contents

Chronicle

———

Next page:

Ida van der Lee, *Laundry is Good.*

Vrolikstraat, Amsterdam, September 1999

(see: www.idavanderlee.nl).

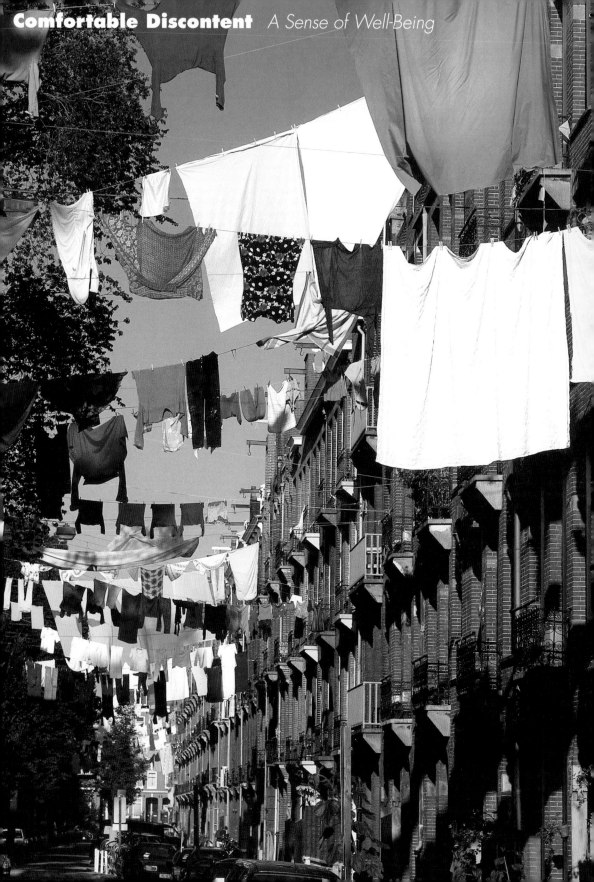

Comfortable Discontent *A Sense of Well-Being*

In September 1999 Amsterdam's Vrolikstraat was draped in washing. Together with the other residents of the street where she lives, the artist Ida van der Lee had created the art project she called *Laundry is Great*. Strictly speaking you're not allowed to hang laundry in public places, let alone right across the street, but this playful infringement of the rules was a clear expression that things were going well again in Vrolikstraat, which had suddenly taken on a Mediterranean look. The 175 clothes-lines strung from one house to the other quite literally connected people of different backgrounds. The laundry project had a huge impact. Residents invited their friends and relations to come and admire their sociable street. People chatted spontaneously to each other. People felt part of the street and the neighbourhood again, and they liked that. Vary the language a bit, and it's called social cohesion.

And that's what the themed section of this yearbook is all about. How good do people feel in the Low Countries, still after all a prosperous delta area? Comfortably discontented, as the poet says? How do they cope with the way of all flesh known as 'ageing', with the welfare-and-happiness supermarket and with their lunatics? And were they unhappy, or just restless and bent on profit, four hundred years ago when they and their ships sailed the seven seas?

For on 4 April 2009 it was four hundred years to the day since Henry Hudson sailed out of Amsterdam harbour at the behest of the VOC – the United East India Company – on a voyage that led to the 'discovery' of Manhattan. On 3 September he reached the mouth of a river which Giovanni da Verrazzano had already discovered in 1524, but which would soon bear his own name. He sailed up that river for nearly two hundred kilometres, almost to the present town of Albany.

When it became apparent that it did not offer a passage to the Pacific, Hudson lost interest in it and turned back. Not until 1624 did the first thirty families, most of them Walloons, settle in New Netherland. A couple of years later, in 1626, Peter Minuit – whose Protestant parents had left Tournai in what is now Belgian Hainault and taken refuge in the North – would go down in history as the man who bought Manhattan from the indigenous people for a handful of trinkets.

Hudson will be honoured in New York for a whole year. But the so-called 'Quadricentennial' of the links between the Netherlands and America has to be more than just a commemorative year. It must also be a festival, at which the tradition of tolerance and diversity native alike to the Netherlands and to New York will be celebrated.

In this yearbook we again aim to display a sample of the diversity of art and culture to be found in that delta region once sneeringly labelled '*that indigested vomit of the sea*' by the seventeenth-century English. Writers, painters, visual artists past and present, culture managers, landscape architects, the Veluwe's cultured nature and naturalised culture, Belgians who speak German, conflict management in Belgium itself as the political consultative model seems to have reached its limits, architects, musicians, film-makers, sociologists and philosophers. They all help to shape this part of Europe.

So are all those people who live in the Low Countries happy or unhappy? Let's just say restless. Always on the move. It could be worse.

11

LUC DEVOLDERE | *Chief Editor*

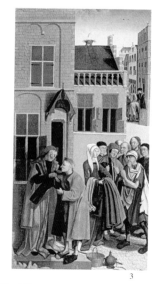

2 3

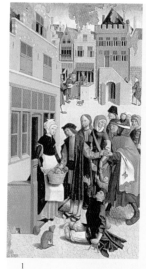

1

Anton Korteweg

In Good Time

Your house is full of treasures, it has class.
A room of your own, a quiet street.
Garden, CD, PC, two piebald cats.
Good job. Brainy children, bright.
Pleasant wife. You could go on like this –
even with your parents
things are still right.

In good time, around your thirty-fifth year,
All false ideals, laid bare, went overboard.
Now ten years on you can report
how comfortably discontent you are.

1. Feeding the hungry
2. Refreshing the thirsty
3. Clothing the naked
4. Burying the dead
5. Lodging the travellers
6. Visiting the sick
7. Comforting the captives

Master of Alkmaar, *The Seven Works of Mercy*, 1504.
Panel, 101 x 54 cm (each panel). Rijksmuseum, Amsterdam.

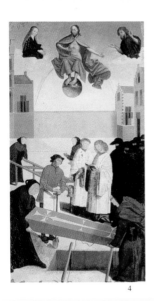

4

5

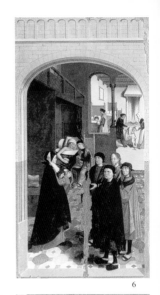

6

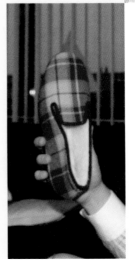

7

Tijdig

Je huis is vol van schatten en op stand.
Een kamer voor jezelf. Rustige straat.
Een tuin. CD. PC. Twee lapjeskatten.
Een mooie baan. Kinderen: goed verstand.
Aardige vrouw. Zo kun je nog wel doorgaan.
Zelfs met je ouders
heb je nog een band.

Tijdig, omstreeks je vijfendertigste,
heb je je valse ideaalstelling herkend.
Nu, tien jaar later, kun je melden dat
je comfortabel ongelukkig bent.

From *State of Affairs* (Stand van zaken.
Amsterdam: Meulenhoff, 1991).
Translated by James Brockway

8. Being comfortably
discontent

The Antidote to Disaffection

Social Cohesion in Flanders

[BART DIRKS]

'Television' gets the blame every time. People don't have time anymore, so it's said, for a club, or for voluntary work, and worst of all: for each other. Because they don't want to miss a single episode of their favourite talk-show or soap. Yet it is precisely 'television' that for years has been rousing randomly chosen Flemish villages from their summer sleep. A few years ago the programme *Fata Morgana*, by the Flemish Radio and Television Network station VRT One, mobilised many hundreds of one village's inhabitants to carry out five fiendishly difficult projects in a single week. There were the same number of stars to be won.

Whereas producers in commercial broadcasting companies know that viewing figures go up in proportion to the number of confrontations and conflicts (between the inhabitants of the *Big Brother* house for instance), or again between the couples being tested in *Temptation Island*), *Fata Morgana* aimed specifically at fraternisation and harmony. Each programme contained two blocks of slow-motion pictures from the relevant location. You would see the inhabitants waving or giving a 'thumbs up': a married couple on a terrace, youngsters on their skateboards, a woman letting her dog out. The message was clear: this is a nice place to live.

The final result, watched by hundreds of thousands of Flemings on Sunday evenings, was to be more than pure entertainment. *'We need 'Fata Morgana' (...). It's good for democracy'*, said presenter Geena Lisa at the beginning of the first season. The Flemish daily *De Standaard* enthusiastically spoke of television with a heart, maybe even a medicine against disaffection.

But did it work? Suddenly it was the turn of Kaprijke, a quiet village in Meetjesland, the rural area between Ghent and Bruges. *'I've been surprised how much enthusiasm and energy the challenge has brought out in us all'*, said Jacky De Wispelaere, a youthful fifty-year-old. He was put in charge of building an aqueduct; the monster was to be fifteen metres high and forty metres long.

The initial terrified reaction of the workman from the firm of Bekaert, in Aalter, quickly turned into enthusiasm – and nights without much sleep. *'It's so easy to think: there's no life in these tiny villages, they're dead. When there was a public meeting to get more volunteers for 'Fata Morgana', it was cold and wet. But the place was packed with people and they were all very keen. You don't really understand it, but it works.'*

Fata Morgana:
'Roman' soldiers in
Kaprijke

In the end VRT viewers could see how Kaprijke had transformed itself into a Roman village. Water was running over Jacky De Wispelaere's aqueduct. Tiny Wauters had press-ganged a Roman army hundreds of soldiers strong. Patricia Coppenolle had found a hundred druids who were handing out a home-made magic potion to thousands of visitors. Under the leadership of Bram De Wulf a Gallic village had been cobbled together. And schoolchildren Marlies Van Hoecke and Ruud Wauters were even lucky enough to go to Rome and be officially told by then Prime Minister Romano Prodi that the words of Julius Caesar still held good: of all the Gauls the Belgians are the best and bravest.

Kaprijke cherished the five stars it had won so gloriously. And afterwards, so Jacky assured us, people in the Den Bolhoed café would regularly reminisce about how, one Monday morning, a TV team, a whole caravan of people, had come and turned everything upside down. 'Television' can alienate people from each other, but it can obviously also bring them together again.[1]

But what has gone so wrong in a country that it takes a TV programme to bring warmth and solidarity to villages and towns? *Fata Morgana* is certainly not the only initiative dreamed up by those on high to strengthen social cohesion in Flanders. Although it is sometime hard to take those initiatives seriously. Like the attempt by Bart De Bondt, a *'bespoke-suited idealist'* working for an insurance company, to persuade Flemings to wear a red badge to let everyone know that they wouldn't mind having a chat.[2] Others launched the slogan *'Pay an unexpected compliment'*, a campaign that was everywhere on radio and TV for a few weeks.

And that was not all. At the Autosalon in Brussels a hundred and fifty thousand outsize 'thumbs' were handed out to motorists who could stick them up as an alternative to their middle finger. Suddenly stickers appeared on buses with the message: *'I'll stop for a compliment'*. And in 2006 thousands of old people received a centrally-dispatched 'comfort letter' on St Valentine's day, clearly meant to compensate for a supposed shortage of love from children and grandchildren.

'It's important to be positive, for yourself and for other people', according to Piet Jaspaert of Boodschap Zonder Naam (Anonymous Message), a *'socially critical'* organisation that works for a society that people can live in. *'Frustration and indifference lead to cynicism and we want to reverse that trend'*.[3] But without being cynical or indifferent, these seem to me to be artificially contrived remedies for decline and individualism. Surely you cannot expect the social fabric of society to improve because of frivolous campaigns and ditto TV programmes?

Sometimes a brief but intense wave of solidarity and unity does engulf the country. As happened when eighteen-year-old Bart Bonroy was stabbed to death in Ostend in February 2007, simply for refusing to give a cigarette to a drunk who accosted him. The then Flemish prime minister, Yves Leterme tried to draw a lesson from this. He asked the Flemings to *'start working towards a caring society'*. Anyone who had a suggestion could email the Christian Democrats. Leterme received nearly 1,500 reactions. There were complaints about the blurring of norms (from 30 percent of the letter-writers), about defective upbringing at home and at school (37 percent), and about criminality (16 percent). 18 percent thought society has become too obsessed with the individual. The remedies proposed followed naturally from this: financial support for non-working parents, more severe punishment for crime, and greater support for the activities of clubs and associations. This last suggestion would have received less support in the Netherlands; although huge numbers of Dutch people also belong to some club or society, there is little awareness there of how important these structures are to society. Just such local initiatives can form the cement of a caring society. Youth clubs and women's associations, for instance, trade unions and sports clubs.

A flourishing social mid-field – sociologists like to speak of *'social capital'* – would be the driving force behind social integration, behind political participation, and it is even a not-to be-underestimated precondition for a country's economic achievements. *'It's precisely by being involved in small-scale associations that people learn to work for common interests, and gain experience in democratic decision-making'*: so says a weighty tome on the role of the mid-field in society in Flanders and the Netherlands.[4]

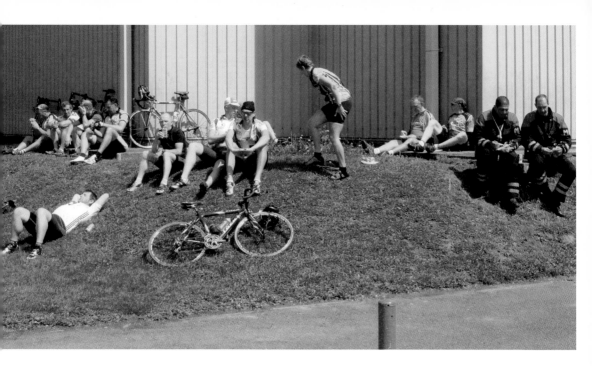

It strikes me that that social capital is referred to much more frequently in Flanders – although naturally the term is seldom mentioned explicitly. Non-profit-making organisations (a term I as a Dutchman then living and working in Belgium quickly got to know) get a lot more attention in the newspapers than they do in the Netherlands. The government in Brussels is much more open-handed in subsidising the social mid-field – the Dutch 'powers that be' in The Hague have resorted to the cheese-slicer and sometimes even the blunt axe. From Third World shops to scouting, in Holland they have all seen their subsidies severely cut back or even disappear entirely.

The importance of social capital receives much greater recognition in Flanders than in the Netherlands. Membership of a club, be it a youth group or the local football team, is seen as effective medicine to promote tolerance. Or as a remedy against disaffection. *'Gaining experience in democratic decision-making'* is code for: we must prevent discontented citizens from dropping out and falling prey to 'anti-politics'.' In short, from going and voting for the far-right Vlaams Belang party.

Let us hope that enough Flemings still belong to a club or association.

Fuel for today's woman

Sadly, though, the membership figures for the KAV (Kristelijke Arbeiders Vrouwen; Christian Workers Women's Movement) lead one to fear the worst. In less than two decades over two hundred thousand women have dropped out, leaving a current membership of one hundred and ten thousand.[5] Campaigns to raise their image have clearly not yet succeeded in reversing the trend. Nor has the song recorded a couple of years ago by a specially formed choir of KAV ladies from Limburg in an effort to promote their movement:

Flemish amateur cyclists on a break.

Once you are all warmed up
and you're for Pure Woman-Fire
you're in the right place here
oxygen for the community
and warmth as well for you
KAV is fuel
for the woman of today!

We make our voices heard,
straightforward and assertive
we fight the fight for women's rights
that's our initiative
for without giving quarter
we break through the glass ceiling
to a new view of the future

(...)

For security and warmth
come sit, enjoy yourself
without any check or limit
every woman here gets credit
your girl-friends you'll find here
a guarantee of pleasure
we'd not do it for less than that

Feminism is right out
and now gender is in
but with women on the move,
that's a new start every time
what if it's still a struggle,
for the women of the world
that gives point to our movement[6]

But does the KAV really still provide *'fuel for the woman of today'*? A tour of the activities of a few of the nine hundred local branches does not immediately give you that contemporary feel. Courses in 'Vegetarian Cookery', 'Fiddling with Jewellery', 'Quick and Trendy Cookery' and 'Colourful Flower Arranging', day trips and cycle rides predominate. These don't strike one as being the skills needed to *'break through the glass ceiling'*. But on the other hand KAV is campaigning for more women in politics, and the organisation has argued for homosexuals and lesbians to be granted the same adoption rights as heterosexuals. It really does look as if this 1920s-style socio-cultural association is afraid of making a choice: it stands with one foot in the past and the other in the present.

 'You're looking at it the wrong way', says Eva Brumagne, director of communications at KAV headquarters in Schaarbeek in Brussels. *'Our twin-track policy isn't ambiguous, on the contrary it's a completely deliberate choice. The cookery courses are low-level, non-threatening activities that still attract a lot of women. If you jump in too quickly with weighty social topics it's counter-productive. But in*

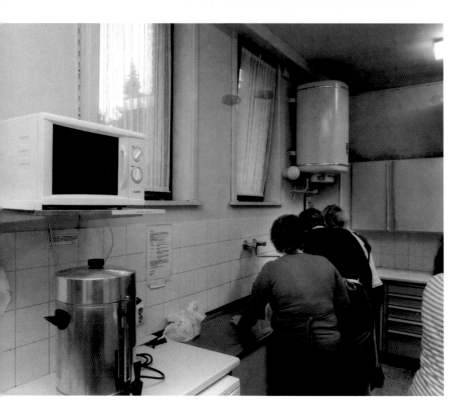

KAV members during
a 'Quick and Trendy
Cookery' course in Essen,
2007.
Photo by Gert Jochems.

*a course on vegetarian cookery you can deal incidentally with the bio-industry
and the fact that the enormous amount of meat we consume contributes to Third
World poverty.'*

Moreover, according to Brumagne, the Christian Workers Women's Movement
is absolutely aware that membership of a socio-cultural association is also
'training in democracy'. That aspect is inherent in many activities without being
explicitly mentioned. And the last thing the KAV wants to do is to force opinions
or attitudes on its members.

*'We stopped doing that at least forty years ago. The KAV's always been good at
encouraging a critical approach. Of course it goes in waves. At the end of the nine-
ties, when it was all about "cocooning", maybe our social involvement wasn't so
much in evidence. But in a group you always learn to work together, to be critical
and express your own views.'*

The association is making every effort to attract new, young target groups.
That is not easy, as the KAV has found. People are no longer so keen on joining
things. *'Becoming a member of a club and feeling involved with it is quite different
from taking out a subscription to a periodical'*, says Brumagne. *'For women, cer-
tainly, it's no longer a matter of course.'*

The reason? – a chronic lack of time. As well as looking after their families, a
lot of young women are also kept very busy with their careers. *'They do need
some relaxation, yes, but it has to be much more informal than before. That's why
we offer flexible involvement. These days you don't actually have to be a full member
to join in KAV activities. This way so-called "shoppers" (mainly young women who've
no desire to become full members, some of whom also have problems with the
KAV's religious affiliation), can pick and choose what appeals to them.'*

'KAV is Networking!'
poster.

As a consequence of this, the association's local voluntary work is also being put on a new footing. More and more local branches are no longer run by a chairwoman and committee who control all activities and publicity from the centre. They are being replaced by teams of varying composition. Anyone who wishes to can take on tasks for a shorter or longer period. *'If someone wants to organise a one-off djembe drum course under the KAV banner, they're welcome'*, says Brumagne. *'In the past something like that mightn't have taken place, because the committee weren't keen on it. We try to respond to the wishes of members and volunteers in what we offer. That really takes a lot of thinking about.'*

The cookery courses are less 'traditional' than one might think. They too have picked up on the modern woman's lack of time. Because Mums who can prepare delicious meals that can be on the table in a jiffy have time left over for other things. *'But do you know what would really provide fuel for the modern woman?'*, I ask Eva Brumagne. *'If it wasn't the women who came along to one of your cookery courses, but their husbands.'*

For the moment that is a step too far for the KAV. *'But we do also publish clearly written cookery books. They can certainly be used by men as well.'*

One for all

There are no cookery books in use today in the playground and huts of the Chiro youth movement's branch at Achter-Olen in the Kempen. This Sunday afternoon there are at least 150 children and teenagers there. As always, this branch of Flanders' largest youth association begins the afternoon with a short game in which everyone plays together.[7] After that the various age-groups each go their own way. The Clubbers (boys and girls of six or seven) make things and play tag, musical chairs, hide-and-seek, or peep-bo. The 'Aspis' (aspirant leaders) aged from sixteen to eighteen go off on a cycle ride, dressed in the official, but not compulsory, shorts or skirt. In their cramped room twenty-two six- and seven-year-old boys are running and shrieking so loud it makes your ears ring. Lode Bellens looks at the exuberant band with amusement. Then he decides that that's enough. He calls them to order:
'One for all...'
'All for one', comes the response from twenty-two throats.
'And what are we then?', Lode asks the children.
'Quiet!!!', they shout back.

But the spell doesn't work. The Chiro Clubbers only quiet down when Lode hands out bottles of cola and lemonade. One of the boys proudly announces a bit later that he has burped three times in a row. Lode laughs. *'Wow, today you're the champion burper!'*

The other two leaders are swotting for exams, so Lode is looking after the group on his own today. They have been playing games with balloons in the field outside, and very soon they going for a romp in the woods. Lode keeps an eye on the children who don't feel like joining in just then and after a squabble he wipes away a tear. *'Matti stamped on me, on purpose!'*.

Olen is not unique in Flanders; every weekend 985 Chiro groups meet in 380 Flemish municipalities. With almost seventy-eight thousand members and a further thirteen thousand leaders Chiro is by far the largest Flemish youth movement. But scouting, with 4 umbrella organisations in Flanders, is also grow-

Chiro youth movement
in Achter-Olen.
Photo by Dierk Hendriks.

ing at a rate of knots. In 2005 the five associations – Chiro, VVKSM (scouts and guides), KSJ-KSA-VKSA, KLJ and FOS (scouts) – had 217,650 members between them. Holland has only two similar organisations, which are much smaller in comparison. *Scouting Nederland* and the originally Catholic *Jong Nederland* have a hundred and twenty thousand and nine thousand members respectively. They look at the Flemish youth movements with envy. Whereas Chiro receives a good 1.3 million euros (39 percent of its budget) annually from the Flemish government, in The Hague financial support for Scouting and Jong Nederland has been reduced to zero since 2006. The Dutch clubs speak of wrecking and feel they are not appreciated; at present all The Hague's money is going into sports clubs.

Unlike in Holland, Flemish scouts, guides and Chiro members do not always hide away in their playgrounds in the woods. No, every weekend you can see groups in the Grand' Place in Brussels, playing games or singing songs – something quite inconceivable on the Dam in Amsterdam. When scouting celebrated its centenary at the end of April 2007 almost a hundred thousand scouts and guides gathered in Brussels. The power to mobilise such numbers is unique in the world; at the World Jamboree in England at the end of July 'only' forty thousand scouts and guides took part – and they came from dozens of countries. To be fair, though, numbers here were constrained by the limited size of the Brownsea Island location.

Innumerable 'famous Flemings' – politicians, actors, singers – are former members of Chiro or of the scouts and guides. In Holland such membership is not automatically seen as a recommendation. On the contrary, people tend to snigger at Premier Balkenende's boy-scout past. In Flanders it is so popular that children sometimes have to join a waiting-list. Although that sometimes proves to be more of a weakness than a strength: there are always children and teenagers who want to become members, but it can be hard to find people in their twenties who are willing to lead the groups.

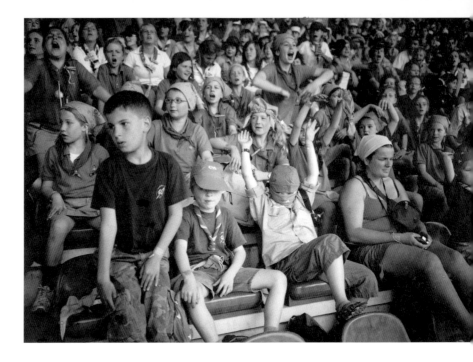

Scouts at JAMbe,
the celebration of
100 years of scouting
in Brussels on 29 April
2007.
Photo by Gert Jochems.

After a decline between 1995 and 2000, membership figures for Chiro and the scouts are now considerably higher again. And so Chiro's director, Hans Bouwen, has an optimistic message for the Christian Workers Women's Movement and the family associations that are likewise losing members. The Flemish youth clubs show that it is possible to defy demographic trends and the supposed spirit of the times. They resoundingly refute the doom scenarios that maintain that sports clubs alone have a bright future and that the age of individualism has set in for good.

'The time of out-and-out individualism is well and truly past', alleges Hans Bouwen. 'Children and adults are again seeing the value of doing things together. The youth movements provide the basis for the socio-cultural spectrum in Flanders.' Therefore, according to him, the revival of the youth movements will work through to adult organisations. 'At the moment you're still seeing numbers falling in the KAV and elsewhere, but I expect the trend to change there too. You'll notice it in the numbers of volunteers for Third World shops and Amnesty International, and in the interest in cookery classes and flower-arranging among women's or-ganisations.'

A bit like Switzerland

However there is also a flip-side to this general support for the local youth movement. To make a joke of it: that's where your typical Flemings are bred. Flemings who often root themselves so firmly in the village where they were born that they prefer never to leave. Who build a house there, and send their own children to the Chiro in their turn. For me, that's really a bit too clingy. Listen to what the Chiro leaders in Olen themselves have to say about it. On Sunday afternoons Leader Marlies Storms is in charge of a group of forty-eight

girls. During the week she also has a number of them in her class. *'In the school where I teach, three-quarters of the pupils belong to Chiro. Children from other schools often drop out. They're welcome, but they still feel rather isolated here.'*

Her friend Nina Van Hirtum has actually given up being a Chiro group leader after five years. For the last six weeks she has been helping out because the other group leaders have exams. *'I miss it terribly, but luckily the Chiro connection lasts a lifetime.'* Lode Bellens, the leader of Olen's six-year-old members, feels the same way. *'Chiro's a kind of social security. I became a member when I turned eight because my parents had also been members. The group leaders from my youth now have children of their own, and I lead them. So the circle's complete.'*

Friendships are forged for life here and of course that can only be a good thing. But at the same time I find the strong social bonding in Flanders suffocating. The ties formed in the socio-cultural associations seem to act as golden chains. The success of the Flemish youth movement partly explains why so many students, even the older ones, still come home every weekend and why so many of them later come back to live in the area where they were born.

'Here you're in the country but close to the big cities. Antwerp's just a thirty-minute drive', says Chiro leader Lode. *'Here you know everyone, in Antwerp you don't know anyone.'* And Chiro's national director, Hans Bouwen, has also continued to live in Olen and commutes to Antwerp to work every day. He wouldn't leave Olen for all the money in the world.

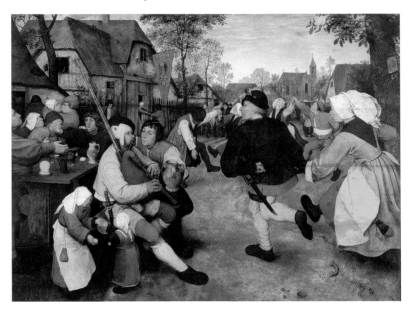

Pieter Bruegel the Elder,
The Peasants' Dance.
16th century.
Panel, 114 x 164 cm.
Kunsthistorisches
Museum, Vienna.

Of course it's not compulsory to go and live somewhere other than where you grew up. But doing so can broaden your horizons enormously. *'The social cohesion in Flanders has considerable advantages, but it also has its limitations'*, admits Marc Hooghe, a political scientist from Leuven University and an expert in this field. *'It can be difficult to integrate in a village where everyone knows everyone else inside out. Flemings maintain the networks they formed in their youth, are loyal to friends they made early in life. The disadvantage is indeed that they are sometimes less open to new networks, to people they meet later in life. They remain tied to their village.'*

Distances in Flanders are small: there is no need to move away and therefore it is far too easy to stay put. *'Here you're never more than sixty kilometres from a university. So the dominant pattern is that you go back'*, says Hooghe. *'Leuven recruits from the provinces of Flemish Brabant and Limburg. That's the flip-side of social cohesion: it also makes for conformity and a lack of innovative spirit.'*

And that pattern is not breaking down; far from it. When the village pastors of West Flanders still had some influence on their parishioners every-day life, they advised schoolchildren to go to Leuven to study because it had a good Catholic university. *'That pressure's gone now'*, says Chancellor Paul Van Cauwenberge of University of Ghent. *'And so the West Flemings are now opting for the nearest university, and that's Ghent. It explains why we're growing at such a terrific rate: it's because of all the students from West Flanders who would once have gone to Leuven.'*

The Belgians are held together by *'age-old tribal bonds'*, writes Rik Vanwalleghem in his lively book *België Absurdistan* (2005). For thousands of years human beings formed part of a group of their own kind of people, made up of a hundred to a hundred and fifty individuals. These structures were shattered by the Enlightenment and the industrial revolution. But as *'one of the last tribes'* the Belgians still live *'according to the rules of the old tribal bond'*. Belgium is a *'network of little networks, and that is what has always given it its charm and significance'*.[8] In *Belgium for Beginners* (België voor Beginnelingen, 2004) Bert Kruismans and Peter Perceval describe it as follows: *'Most of all we like to stay close to Mum, and go round there every Sunday for "pistolekes" (rolls) with the rest of the clan.'*[9] Flanders, says Marc Hooghe, sitting in his study in the University of Leuven, is like Holland without Amsterdam or Germany without Berlin. Brussels, which is mainly French-speaking, does not really count, and that only leaves Antwerp. *'Flanders is a bit like Switzerland'*, muses Hooghe: *'It's fine if that's where you come from and if you like cheese fondue. But if you come from somewhere else, you're handicapped from the start.'*

The wonder of Flanders

But despondency is misplaced. Maybe the wonder of Flanders is above all that so many great socio-cultural associations have survived the ravages of time. At the beginning of the twentieth century they were driven mainly by the efforts of Catholic patronage and the socialist labour movement. These top-level structures have now largely disappeared, but the clubs have remained. The local groups have gained a good deal of autonomy. And that century-old heritage is still cherished in Flanders to this day.

On balance it is far better to live in a country where everyone is a bit conformist and happy to carry on living in his own village than in a society that does not care, where people have all the cohesion of so much dry sand. And for all the tales of doom Flanders is not at all like that. The statistics prove it: Flemish associations are even more flourishing than ten years ago, as figures released in mid-July 2007 clearly showed. In 1998 47.6 percent of Flemings were members of at least one association, in 2006 that figure was 53.1 percent. A respectable increase, then, of 5.5.percent.[10]

This increase is happening in almost every category: youth movements, sports clubs and family associations. Only the women's organisations referred

to above seem to be declining rapidly with a drop of 4.5 percent. That is a pity for clubs such as the Christian Workers Women's Movement and Child and Family (Kind en Gezin), but it does not necessarily mean that social cohesion is in danger, or that the medicine promoting tolerance is losing its effectiveness.

It's true that women (and young people) are more and more often choosing to join a sports club. Despite claims to the contrary, according to Hooghe there is no measurable difference between, say, Chiro or KAV on the one hand and a sports club on the other: *'The criticism often goes: sport's only for fun, while other socio-cultural movements encourage social engagement in their members. But studies have failed to support that distinction. In a sports club you're still part of society, you still choose to get involved, to be tolerant. It's only fitness that doesn't have that effect. That's obviously a purely individual thing.'*

All in all, social cohesion in Flanders is certainly not breaking down as fast as is often feared. Although according to Hooghe Antwerp is an exception. *'Antwerp is more of a metropolis and in terms of communal activities it's become a desert, which means a lot of older people and those with limited skills and education are becoming isolated. There's still a feeling of belonging to a particular district, but it's on a larger scale and that makes it more impersonal. The "Red girdle" of the socialist movements doesn't really exist there anymore.'*

With one's own folk in Bobbejaanland

Saturday 31 March 2007 was a red-letter day for Bobbejaanland attraction park. More than twelve thousand visitors came to the park in Lichtaart in a hundred specially chartered buses or by their own transport. At four o'clock in the afternoon they released ten thousand yellow and black balloons: the colours of Vlaams Belang, who had hired the whole park for a day.

'You don't hear anything but Dutch, and that's really very nice', one enthusiastic lady told the VRT-News camera crew about her political party's family day. An elderly lady added, with a giggle, that she found it so marvellous *'that there aren't any other nationalities'*. A third stressed that at least this event *'hasn't been paid for out of our taxes for once: this is for our own folk.'*

The cliché is becoming reality: Vlaams Belang people do not feel at home anywhere, except among their own kind. But why have they come to feel themselves outsiders? When social cohesion in Flanders was really so strong still? And surely that contributed to a tolerant society? So how can the far-right Vlaams Belang party have advanced so steadily in recent decades?

For Marc Hooghe these are not easy questions to answer: *'You've always had a fairly large group of people that clubs and associations failed to reach. The only difference is that in the past that group had no political identity and no-one to speak for them. That made it easier to act as if it didn't exist. Now that Vlaams Belang is targeting that group specifically, of course they've got an identity and a political voice. But I don't think the group itself has really got any bigger.'*

Moreover, changes in their structure mean that the clubs and associations are reaching a different public from what they used to. The large, old organisations such as the KAV were very good at addressing a relatively uneducated public. *'The new organisations are much less successful at this,'* according to Hooghe. *'You don't find ex-KAV members in a trendy fitness club. And yet those old structures were important.'*

Hooghe refers to a study published a few years ago by Professor Jaak Biliet. *'That showed that older people can be relatively ethnocentric or racist. But membership of Christian organisations still has a "braking effect" on this.'* In other words: among those of equally racist views a KAV member will still always vote Christian Democrat, while someone who does not belong to anything finds it much easier to move to the extreme right.

And there is still one section of the population that at present has little connection with the socio-cultural associations that determine the country's image: the immigrants. The cultural divide appears considerable; the way of life of new Belgians is often very different from that of the indigenous inhabitants. The youth movements appeal mainly to socially committed parents. And despite themselves that makes them somewhat elitist. Immigrant youngsters definitely do not belong to the back seat generation: they are not continually being ferried to tennis lessons, football clubs or youth movements.

Hans Bouwen from Chiro and Eva Brumagne from KAV are aware of that divide. Both clubs, however, are actively working on it. The Chiro, for instance, is making a positive effort on the multicultural side of the borough of Molenbeek in Brussels: Moroccan pupils in Dutch-speaking primary schools are being encouraged to take an interest in Chiro. They do some extra work on Sunday afternoons to learn Dutch. But membership is more loosely defined: no-one ever really knows who is going to turn up at the club premises on a Sunday. And since the mid-nineties KAV has been involved in an intercultural operation with fifteen groups in Brussels under the slogan of *'Vrouwen gaan vreemd'* ('Women and Foreign Affairs'). In 2004 more than two thousand five hundred participants from twenty nationalities were enrolled in some three hundred local activities.[11] *'We're working very hard on it'*, Brumagne assures me. *'It's a question of keeping at it, then we'll get there.'*

A small miracle

In Kaprijke, *Fata Morgana*'s official five-star community in Meetjesland, Mayor Filip Gijssels is still amazed at what the five projects managed to draw out of the population. *'It's a small miracle. Young and old alike joined in. Everyone wanted to look good on telly and win those five stars. People who started as strangers got to know each other. The local caterers did a roaring trade. People were brought together unexpectedly because they had a common mission. The response in the street was like nothing we'd ever known before. Life in the village was more colourful for a while. That's something you can't put a price on.'*

But Kaprijke, which with the borough of Lembeke has six thousand souls, was certainly not at death's door before *Fata Morgana*. And according to the mayor, putting things in perspective, it hasn't really changed since the TV broadcast. *'No, it hasn't brought about any structural changes, we haven't got any new clubs, for instance. We already had at least two hundred associations all told, from sports and youth clubs to card groups. That social life is indeed vitally important. It's good for social well-being and good for preventing isolation and individualism.'* Of course, Gijssels acknowledges, even when you are safe in your own village 'out in the sticks' you have to understand that you are part of a larger whole. *'You don't only live in a village, but also in an area, a province, a country, in the world. It's up to every individual to think about how he or she will deal with that fact.'*

Fata Morgana in Kaprijke.

And there you have the hidden paradox of the changing, but still flourishing life of Flemish clubs and associations: on the one hand it can open people's eyes to the rest of society and to the world, while on the other it inevitably makes the Fleming a bit too much of a homebody. ■

Translated by Sheila M. Dale

NOTES

1. *Fata Morgana*'s invasion of in Kaprijke did not go entirely smoothly. The alderman responsible for public works felt sidelined by the organisation and tendered his resignation. 'Fata Morgana has political repercussions', *Het Nieuwsblad*, 8 August 2006.

2. There was also a (now defunct) website www.derodeknoop.be

3. Represented in the umbrella organisation Boodschap Zonder Naam are, among others, the Farmers' Union, Coca-Cola, Dexia, Electrabel, Fortabel, KBC and the National Lottery.

4. Marc Hooghe (ed.), *Sociaal kapitaal en democratie. Verenigingsleven, sociaal kapitaal en politieke cultuur*. Leuven: Acco, 2000.

5. In 1989 the KAV still had 324,850 members; in 2000 only 176,101 remained. Since then over sixty-five thousand more have dropped out: www¹ be now speaks of a hundred and ten thousand members.

6. Translated by Tanis Guest.

7. Chiro like KAV is a Christian organisation and takes its name from the Greek letters *chi* and *ro*, the first two letters of 'Christos'. Further information can be found at www.chiro.be and on Chiro in Achter Olen at www.chiroachterolen.be.

8. Rik Vanwalleghem, *België Absurdistan. Op zoek naar de bizarre kant van België*. Tielt: Lannoo, 2005, pp. 170-171.

9. Peter Kruismans & Peter Perceval, *België voor beginnelingen*. Leuven: Van Halewyck, 2004, p.128.

10. Statistics from Marc Hooghe & Ellen Quintelier, *Lidmaatschap verenigingen 1998-2006*, commissioned by the Flemish Community, 15 July 2007.

11. See the pamphlet *Vrouwen gaan vreemd, een praktijkgids voor het werken met culturele vrouwengroepen*. Brussels, 2005.

Out of Utopia?

Hans Achterhuis on Welfare and Happiness

The words 'welfare and happiness' set the tone for the book with which the Dutch philosopher, Hans Achterhuis (1942-), would achieve public recognition in 1980. But those words did not stand alone. The title of the book, which gave rise to intense debate about the way in which the state was expected to improve the lives of its less fortunate subjects in particular, was *The Welfare and Happiness Market* (De markt van welzijn en geluk). 'Clients' should be offered assistance that would make them more able to stand up for their rights. Consciousness-raising and empowerment were supposed to transform them from deprived and dependent beings into assertive individuals who were better able to defend their own interests.

In *The Welfare and Happiness Market* Achterhuis demonstrated that this approach had the opposite effect. The 'clients' just became more dependent on their social workers, who for their part profited from this continuing dependence. Social work created its own ever-growing market, concluded Achterhuis, inspired by the Austrian-born but Mexico-based philosopher and theologian Ivan Illich. Achterhuis' analysis greatly influenced Dutch social work and academic training courses for social workers, a number of which would disappear from the scene in the years of economic crisis that followed.

The Welfare and Happiness Market exemplifies the way in which Achterhuis practises philosophy. Without exception his books engage in intensive discussion of the problems and spirit of the time. In his essays he refers with equal ease to eminent thinkers from the history of philosophy and to recent newspaper commentary or news reports. His sceptical mind is usually one step ahead of the prevailing opinion that he is debating. This makes Achterhuis one of the most remarkable of Dutch philosophers and a prominent personality in public debate.

But he has not always been so sceptical. In 1975, in his widely-read volume *Philosophers of the Third World* (Filosofen van de derde wereld) he still aligned himself enthusiastically with such ideological heroes of the time as Frentz Fanon, Mao Tse Tung and, even then, Ivan Illich. And two years before that, in his book *The Postponed Revolution* (De uitgestelde revolutie) he had pinned his hopes on the Third World to force a global revolution in economic relations and especially in lifestyle, with Mao's China and Castro's Cuba as models.

But a lot of philosophising later there is not much of that left. In 1998 Achter-

huis published his voluminous study *The Legacy of Utopia* (De erfenis van de utopie), from which the text that follows this article is taken. Achterhuis starts this insistent plea against the lure of utopia with a confession: *'The fascination of utopias is not strange to me (...) and in the past failure to adequately recognise the dangers thereof has undoubtedly let me down.'* However, he recounts, *'when I was working on the chapter on Mao in "Philosophers of the Third World", I had a nightmare. I dreamed that I personally had landed up in the Chinese Cultural Revolution (...) In retrospect I think I should have paid more attention to this dream. It would have given me more insight into the Cultural Revolution than all the texts I could read about it as an interested outsider'.*

In this book, then, utopia operates as something to be feared rather than as something auspicious for the future. Referring to an impressive number of historical and contemporary utopias (from Thomas More to Ayn Rand and from Campanella to Huxley) Achterhuis shows how they are invariably fuelled by a dream of controllability that cannot help but lead to a totalitarian form of society. Utopia turns into dystopia almost by itself, he discovered with a shock when he read *Ecotopia,* the American author Ernest Callenbach's ecological utopia. *'Why would I never want to live in Ecotopia?'* Achterhuis wondered, after reading the book at one sitting during a journey on an American Greyhound bus. That question became the starting point for his book.

Achterhuis reached his conclusion after a lengthy diversion via books about the ambiguous status of work in the modern world (*Work, a Peculiar Remedy* (Arbeid, een eigenaardig medicijn, 1984)) and the way in which modern economic thinking has begun to focus more and more on the spectre of scarcity (*The Realm of Shortages* (Het rijk van de schaarste, 1988)). Third World thinkers were gradually supplanted by a succession of other authors that Achterhuis discovered: Michel Foucault, René Girard and Hannah Arendt. More and more, too, his work is inspired by Albert Camus, the author he had studied in the 1960s for his doctorate.

In his book on utopia Achterhuis shows extreme reserve regarding any blueprint that claims to be able to establish the ideal society by means of positive measures. He demonstrates how badly that can turn out with reference not only to the implications of the many proposals put forward in the wealth of utopian literature. On a completely different level he also attacked this way of thinking in his pamphlet *The Politics of Good Intentions* (Politiek van goede bedoelingen, 1999), in which he fiercely criticised the Western interventions in Kosovo. Those who allow themselves to be led by humanitarian benevolence alone, without a cool, hard analysis of the political situation, run the risk of causing more casualties than there would otherwise have been, he argued.

In politics, concluded Achterhuis, uncompromising goodness can easily become a road to Hell. In his extensive study of violence (*With Maximum Violence* (Met alle geweld, 2008)) he was forced to draw the equally sober conclusion that a culture or society completely free of violence is an illusion that can easily end up as the opposite of what it is trying to achieve. Even so, as he had already written in his short study *Utopia* (Utopie, 2006), which can be read both as a summary and as a critical revision of his big book on the subject, we cannot manage without images of an ideal society – if only to give direction to the actual steps we take in the long piecemeal engineering that is politics.

Remarkably enough, Achterhuis had already identified the positive side of the future dream in *The Legacy of Utopia* – not in the blueprint of a social ideal

but in the promise of future technology. As a professor at the technologically-oriented University of Twente, Achterhuis started to focus on the philosophy of technology in the 1990s. Gradually the distrust of technology inspired in him by the 1970s shifted to a more positive standpoint in which he not only recognises the merits of technical-scientific progress, but also states that culture and society are not subject willy-nilly to its evolution.

This idea is brought out in the following passage from the book, which has been somewhat abridged for this publication. In it Achterhuis opposes the vision of the American philosopher Martha Nussbaum, who – just like Aldous Huxley in his dystopian novel, *Brave New World* – sees technological development as a danger to humanity. Technology, concludes Achterhuis – with reference to George Orwell – can certainly free humanity from a neediness that for its part might well be called 'inhuman'. As technical promise, utopia has rights which are better denied it as *social* promise. ■

Translated by Lindsay Edwards

Happiness and Suffering in Utopia Achieved

By Hans Achterhuis

'Science does change the world. If part of our humanness is our susceptibility to certain sorts of pain, then the task of curing pain may involve putting an end to humanness.'[1] That is the weighty conclusion that Martha Nussbaum attaches to her own technical utopia, derived from her discussion of Plato's *Protagoras*. Nussbaum starts by describing humanity when it has just received the gift of reverence and justice from Zeus in the myth recounted by Plato.

People now knew these virtues, to be sure, but they still came into conflict over them. If they got into arguments over numbers, weights or measures, they could resort to their technical knowledge to solve them. Questions to do with living together were not so simple. Passions continued to flare, conflicts between different values – piety versus public-spiritedness, love versus justice – continued to trouble them. Some choices seemed always to result in confusion and pain.

People even invented an art form to express that fact: the tragedy. And the greatest wisdom on the subject was, according to Sophocles, that 'it is best for a person not to be born'.

Apollo, the god of sunlight, rational order and numbers, felt sorry for humanity. He sent them a messenger, in the person of Socrates, who taught them the *technè*, in which all values could be reduced to pleasure and pain, so that they could then be weighed rationally against each other and maximised. The deity's gift wrought a wonderful change in the lives of the hitherto so unfortunate creatures. Their whole existence was now governed by an orderly and measurable happiness. Their society, too, took on a new, orderly appearance. Chance, whims and passions were banned. People became 'parts of a single system; not quantitatively special, but indistinguishable'.[2] Thus was humanity saved by Socrates' *technè*.

As Nussbaum describes this salvation in detail, many familiar utopian/dystopian terms recur. Utilitarian calculations of pleasure and pain make moral choices simple, bringing up children along scientific lines is easy. What particularly interests me here is, of course, the theme of utopia achieved. In fact Nussbaum states plainly that this new race could no longer understand the classical tragedies. And even if these new people did read them, the tragedies were about a way of life that was alien to them.

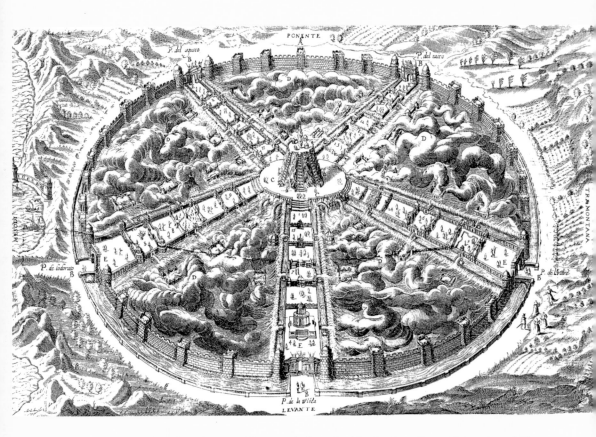

This engraving first appeared in 1609, to illustrate the earlier *Civitas Veri*, or 'City of Truth' by Bartolomeo Del Bene: a utopia with towers, walls, castles, walkways, courtyards, orchards, and so on.

'Here is a character, Haemon, inflamed with what he calls passionate love, killing himself because this one woman, Antigone, whom he loves, has died. This is incomprehensible. Why does he think that she is not precisely replaceable by any other (pleasurable) object in the world?'[3]

Fortunately people like Haemon and Antigone rarely appear any more in the new world that Socrates has formalised. If this does still happen occasionally, if, for example, someone exhibits unique preferences rather than rational desires and admits to various values that cannot be reduced to each other, he must, alas, be 'put to death as a plague on the city'. To celebrate this good fortune the annual 'festival of Socrates' is substituted for the performance of the now incomprehensible tragedies. 'The works of art they present are the clear, reasonable prose dialogues that have taken the place of tragic theatre; they celebrate Socrates' courageous search for the life-saving art.'[4]

Irony drips from these last sentences. However, Nussbaum's conclusion, with which I started this article, is deadly serious. Anyone who is in any way susceptible to anxiety about utopia achieved will recognise its rhetorical force. Nussbaum suggests that if we go wholeheartedly down the road Socrates indi-

cates in the *Protagoras*, our humanness will go by the board. If we take a techni-
cal approach to tackling pain, sorrow and misery, it may well yield the promised
happiness – although Nussbaum's ironic tone makes it clear that she rates it as
pseudo-happiness – but we will lose what we consider to be humanness. And for
her the most important proof of this is that we will no longer be able to under-
stand the tragedies. Tragic choices between equally compelling values, which is
often what is referred to here, do not after all stand up to the all-consuming light
of calculating, technical reason.

How well-founded is Nussbaum's fear that we will lose our humanness if we
set about combating certain types of pain which, according to her, are inherent
to being a human being? The first question that I would like to ask is: what
would have happened if the Athenians and in their wake the whole of subse-
quent Western culture had listened to Nussbaum instead of Socrates. Nussbaum
clearly suggests that that is, in fact, what they did little by little. They set a course
in which the technical approach was given a place alongside the symbolic-lin-
guistic. This school of thought made a definite breakthrough with the scientific
revolution and the utopian-technical thinking of someone like Bacon. Only from
a completely technophobic way of thinking could it be argued that it completely
supplanted the symbolic-linguistic approach. Rather, both approaches were put
on an equal footing; but this is extremely difficult for representatives of the
symbolic-linguistic approach, who throughout history had always had the up-
per hand, to swallow. They can only perceive one big nightmare scenario in
which everything can be expressed in numbers, in other words a technical utopia
achieved, in which there is no longer any room for literature like Shakespeare
or the classical tragedies.

 I have made it clear that this last has turned out better than expected. But that
is not what I am interested in now. My question was: what would have hap-
pened if the Athenians had listened to Nussbaum? I do not want to elaborate
on the thought experiment that could serve as the answer to this. It seems to me to
come down to a certain sort of social stagnation. Anyone who automatically re-
jects fighting against certain types of pain because they just happen to be inherent
to the human condition excludes a scientific-technological approach to reality.
After all, any step in that direction can lead us to the terrible Brave New World of
utopia, in which we have exchanged our humanity for an illusory happiness. Fear
of this imposes limits in advance on every technological undertaking.

 In *Das Prinzip Verantwortung* Hans Jonas introduces the concept of the 'heu-
ristics of fear'. Fear of an erosion of our humanness by the possible, unpredict-
able and irreparable consequences of our technological actions should, accord-
ing to him, be the guiding principle for all future technological development.
Basically this seems to come down to an absolute negative, on his part, to certain
technologies whose consequences for mankind, society and the environment
can, of course, never be accurately calculated. However, that has been true of
all great technological developments ever since the scientific revolution. And

from the very start of that there were warnings that it posed a threat to man's humanness. After all, Mary Shelley's *Frankenstein* dates from 1817. If any notice had been taken back then of those fearful voices, clamouring loudly in the broad groups of society inspired by Romanticism, science and technology would certainly have been called to a halt. Later on, most of the present-day critics of technology who think like Jonas would undoubtedly have argued that this would have been a bit previous. The question we need to answer, however, is why we should follow this kind of heuristic principle nowadays. There seem to be no more compelling reasons now than there were at the start of the nineteenth century. Then, too, the best available knowledge offered absolutely no guarantee that our humanness would not be threatened by the advances in science and technology.

We can go back much further in our thought experiment with Nussbaum. If her advice had been followed, the technical invention of alphabetical script would probably, indeed almost certainly, not have been developed. After all, in the *Phaedrus* and his *Seventh Letter*, Plato offered some good and, in those days, valid-sounding arguments which showed that writing would lead to the disappearance of some of the fundamental characteristics that constituted man's humanness. In retrospect we can easily argue that these characteristics were part of an oral culture, which was indeed doomed to be lost to the rise of the new technology – Plato was right about that. Nussbaum would be unlikely to claim that man's humanness, or culture as such, has been lost along with it. What goes for writing also applies to other technologies. If in the past, for example, mining or the opening of the human body had been subjected to the heuristics of fear, the Industrial Revolution would never have taken place nor modern medicine have developed. Both activities were surrounded by so many cultural taboos and anxieties that it is a wonder – in retrospect again, of course – that they were ever undertaken at all. It was only possible because of the utopian promises of wealth and prosperity, the curing of sickness and deferment of death, which overcame cultural fear. Nussbaum's anxiety about the possible dystopian side of these promises would have made her a bad counsellor in the past, as I assume she herself would admit. But nowhere does she explain why that should not also be the case today.

As the last historical part of my thought experiment I will take Huxley and his time. From his preface to *Brave New World* it is clear that he would not have liked it if science and technology had stagnated in the period in which he situates the Savage. Unlike the character in his novel, Huxley opts for the normality of his own time. He obviously appreciates its technological achievements, but they have gone far enough. Science and technology must once more be subjected to cultural restrictions, otherwise we will hurtle towards the dehumanisation of the Brave New World. But anyone in the 1930s who looked a little further than this scion of the English elite could hardly have subscribed to this opinion. As a counter to Huxley's rather rosy view of society as it was then I would

point to *The Road to Wigan Pier*, by that other great dystopian whose instinct for injustice and social misery was much sharper. In this authoritative report on the living conditions of English miners Orwell described the underside of exactly that society of which Huxley, from his privileged position, was so enamoured. 'For it is brought home to you, at least while you are watching, that it is only because miners sweat their guts out that superior persons can remain superior'.[5] In contrast to the apolitical Huxley, Orwell, who was very much a political animal, understood darned well that changing this inhuman situation was a matter of social justice. At the same time he also knew that scientific and technical progress could contribute to alleviating this very real abject misery, which was at least as bad as the fictitious circumstances of the Savage that Huxley described. Despite his relatively comfortable position as an intellectual, Orwell never entirely shared the dystopian-tinted technophobia of many of his contemporaries. His dystopian anxieties concerned the dangers of a social utopia, dangers to which Huxley remained blind. Undoubtedly this can be partly explained by the fact that the latter remained entangled in the rhetoric of utopia, whilst Orwell, recognising and seeing through its temptations, made a radical break with it.

Undoubtedly this last point deserves further development. At present, with this comparison between Huxley and Orwell I just wanted to stress that the 1930s and '40s again offer hardly any reasons why at that time technology ought once again to be subjected to traditional cultural limits, however much Huxley and a broad group of cultural and technological critics may, for what they considered good reasons, have advocated it. So, it seems to me that the good reasons that have been lacking for some twenty-five centuries already barely exist today either. The structure of the argument for fearing utopia/dystopia achieved has not changed, but the gloomy predictions have never come true.

I do not want to escape from the dilemma with which Huxley, with utopian logic, confronts the reader by opting for some sort of comfortable normality, but by disputing the compelling nature of this logic. In the above I have done that chiefly by showing that the dystopians' fear of utopia achieved can hardly be called well-founded. But the opposite is also true. I would like to put a large question mark beside utopian expectations as well. The promises of future attainable happiness have not been borne out, any more than the fear of dehumanisation. Certainly many, many of the objectives of the technical utopias have been realised, but nowhere have they brought the peaceful and glorious happiness that was supposed to be associated with them.

The radio did not bring us happiness, but neither has it plunged us into ruin as cultural pessimists initially feared. It has undoubtedly enlarged our cultural perspectives, but it would be a gross exaggeration to claim that it has fundamentally changed the human condition with its constant alternation of suffering and happiness. The same applies to television, too, despite the dystopian pronouncements so closely associated with it. However fundamentally it may have

influenced our lifestyle, this technological invention has neither made us happy nor permanently dehumanised us. The same is true of all technological developments of which utopian/dystopian discourse expected, in turn, absolute salvation or total dehumanisation. One by one they have been integrated into modern human existence and new stories, of suffering and grief as well as of pleasure and joy, have been woven around them. So would we want to rid ourselves of radio and television because they have not fulfilled our utopian expectations? That hardly seems to be the case. At least as important as the pursuit of happiness and the struggle against suffering, which are behind scientific and technological developments, is, it seems to me, the desire to understand and control the world. Radio and television are among the wonders that have made this possible. Even if they have not brought lasting happiness, as long as they have not caused the feared dehumanisation prophesied by the Utopia Achieved Syndrome, there seems no reason whatsoever to react with this constant sense of unease.

Is it not this desire to control that is, ultimately, at the core of all this? As well as controlling and manipulating reality, is it not also important to have an attitude of passivity and acceptance? Is it not this which has been completely supplanted by the trend towards control by technical means? And is not this the greatest danger against which the Savage struggles? Is this not the ultimate temptation of the technologically-tinted utopia that we must constantly resist? I do not wish to completely deny the legitimacy of this sort of question, but I do think that the desire for control, just like the pursuit of happiness, is never-ending. Each new technological artefact that it produces raises new – or better, perhaps, age-old – problems for the human condition that can just lead to rebellion against our lot as to acceptance of it. Every form of control produces side effects which cannot be controlled in advance. At present, the fear of dehumanisation through total control seems to be as unfounded as the fear of soulless happiness.

From *The Legacy of Utopia* (De erfenis van de utopie. Amsterdam: Ambo, 1998).
Translated by Lindsay Edwards

NOTES

1. Martha Nussbaum, *The Fragility of Goodness*. Cambridge: Cambridge University Press, 1989, p. 120
2. Ibid.
3. Ibid.
4. Ibid.
5. George Orwell, *The Road to Wigan Pier*. In: *Orwell's England*. London:Penguin, 2001, p. 79

Individual, but not Egoistical

Social Cohesion in the Netherlands

The Schagerkogge crematorium in Schagen, near Alkmaar in North Holland, lies in a vast landscape that simmers in the abnormally warm April sun. Waiting at the entrance to the crematorium is a flock of young people, a whole school in mourning. They're burying Gerd Nan van Wijck, who died on 23 April 2007.

Gerd Nan was the victim of mindless violence – '*zinloos geweld*', as they call it in the Netherlands – a term which has only recently caught on in Flanders. It refers to excessive, motiveless violence for some trivial reason, the explanation for which is sought not only in the perpetrator – his personality, his motivation – but also, and mainly, in society as a whole: an overly liberal educational system, television, computer games, children whose parents no longer set them limits. That's what happened here: Gerd Nan died after having been struck on the head a few times by another boy his age. The fight was a matter of adolescent jealousy, something to do with a girl.

Camera surveillance
in Bagijnestraat,
Leeuwarden.

'A sudden burst of irrational hatred' is what the director of the school called it in his speech at the crematorium. He was using the same words that so many others had used in similar cases. Hatred. Irrational. Senseless. Sudden. It's an echo of No Hate Street, the street-sign campaign that became so popular in Flanders after Hans Van Themsche's murder spree – on 11 May 2006 the 18-year-old Van Themsche shot three people (two of whom died) in the city of Antwerp before the Antwerp police stopped him. It's an echo of the line 'and hatred was not yet a national sport' from the popular Flemish song 'Kvraagetaan' by De Fixkes, a nostalgic meditation on the Eighties. It's an echo of 'against intolerance' from the 0110 concerts in 2006 in Antwerp, Brussels and Ghent. It's an echo of so many attempts to pinpoint a certain cultural uneasiness, the suspicion of social cooling, and to fight it. The website set up in honour of Gerd Nan expresses it this way: 'We also hope that this website will help the people of the Netherlands to be more tolerant and to have more respect for each other, because what happened here is something we wouldn't wish on anyone else!' [1]

Working together on the Netherlands

It's a comment you'll find today on countless sites, in all the newspapers and on every street corner. But in political and intellectual circles people are also convinced that a murder like that of Gerd Nan is not just a tragic incident but the result of something having gone fundamentally wrong. In this respect the Netherlands is no different to other Western European countries; wherever you turn the individualistic, secularised society is in crisis. Everywhere in the West people are convinced that the developments of the last forty years have gone too far, that they have shaken the very foundations of society, and that as a result children are killing other children over some adolescent love affair. Philosopher Ad Verbruggen sees a connection between this kind of violence and the 'myth of the free I', the person who thinks and acts independently and makes his own choices without regard for tradition and authority: 'We see in this tendency a return to a kind of idyllic, Rousseauian view of humanity in which it is believed that corrective constraint by family and society should be kept to a minimum and that real human happiness lies in the full self-development of a person's individual, natural disposition. This idyllic image of humanity is indicative of an utterly naïve and therefore dangerous outlook on life, which fails adequately to recognise that this same disposition also contains evil.' [2]

As the 2007 Dutch Government coalition agreement already noted, 'When traditional ties lose their meaning, people begin searching for new forms of community spirit, security and certainty. The strength and quality of a society is determined by mutual involvement. Not "every man for himself", but "looking out for each other" and "treating each other normally". In a world that's always on the move, community spirit and solidarity give people confidence and the ability to cope.' [3]

Citizens could offer their suggestions on the accompanying website, www.samenwerkenaannederland.nl, and they did. With an unprecedented display of concern comparable to the reaction to the appeal by Yves Leterme, then Flemish Prime Minister, to mail him ideas about how to fight mindless violence in Flanders, proposals and comments about present-day culture in the Netherlands came flooding in: 'No matter how tempting a world without rules

might seem, in the end it actually makes children very uneasy. I think that we as parents should not be afraid to make demands of children.'

'These days children are just plonked down in front of the PC and the TV. You rarely see them doing things with parents any more.' 'Re-institute compulsory military service. At least that makes a man out of you and gives you norms and values for your fellow man.'

'Clubs and societies should be given a good shot in the arm. Not like in my town, where the clubs have been practically strangled by another terrible round of cut-backs.'

'Get marching bands to perform in cities and villages every Saturday. It would increase solidarity and make everybody happy. Foreigners and native-born, young and old, sick and healthy, employed and unemployed, poor and rich: it would cheer everybody up and make them look at the Netherlands in a different way.'

Smile!

In Noordwijk aan Zee, the charming little village that nestles between the beach and the flower fields, people have known for over ten years that the roots of mindless violence are located 'in the very fabric of our society', in the words of Yves Leterme. This is the home of the National Foundation Against Mindless Violence, which was set up in 1997 in response to the first incident to be picked up by the media, the murder of Meindert Tjoelker. 'There was a massive reaction, but after a couple of weeks the interest died down again,' says founder Bart Wisbrun. 'Marches and silent vigils are nice, but you need more than that to turn a culture around.' Today there are over fifty thousand paving stones bearing the ladybird logo scattered all over the Netherlands. It graces Gerd Nan's website, too. 'The logo is widely known.'

'It's like your Prime Minister said, "Violence begins the minute one motorist gives another motorist the finger." That's what we're starting with. We try to make people aware of anti-social behaviour, which carries the seeds of mindless vio-

This ladybug logo of the National Foundation Against Mindless Violence marks the spot were a teacher of the Terra College in The Hague was murdered. Photo by Marcel van den Bergh.

lence. We run campaigns against vandalism, bullying at school, fighting, weapons at school, road rage, minor forms of aggression that poison society and that – at the wrong moment, at the wrong time, with the wrong person – can have fatal consequences. Usually not, but it could happen to you. Today we're working with the police and about a dozen schools on a campaign against carrying weapons at school. Ten percent of Dutch youngsters have taken weapons to school at one time or another, because it's cool or because they don't feel safe. The campaign against road rage will start soon, and the campaigns against bullying at school have been running smoothly for years. Our visiting lecturers are being given update training during this period.'

Scattered all over the office building, which is bursting at the seams, are posters, stickers and pub menus in which the red-and-white dotted ladybird pattern is always clearly visible. The slogans run from 'Make yourself heard at every game' (an appeal to drown out offensive choruses with positive messages during football matches) and 'Snack sensibly, prevent violence' ('there's a clear connection between unhealthy living, poor nutrition and aggression and violence') to a simple 'SMILE!'

When I was still a cynic I would have thought: is this really any different from the 'Swearing has to be learned; don't be a parrot' slogan popularised by the Flemish Bond Zonder Naam ('the Unnamed Society', in existence already since 1938), a time when no-one was afraid of running into a frustrated adolescent with a knife? Now that I know that my cynicism too paves the way for violence, I think: the difference is that the National Foundation Against Mindless Violence has the spirit of the times on its side. And they tackle the problem professionally. The logo is nicely designed, recognisable and ubiquitous. Everything they do includes a promotion to get people on board: the road rage campaign invites everyone to post ideas for preventing aggression and irritation on the roads. There's a GPS device for the ten best tips, and the best one of all gets a Volkswagen Beetle to drive for a year – adorned with the dotted ladybird logo. The Foundation produces lovely anti-violence bags and has succeeded in making the laying of a 'paving stone against violence' a ritual with a certain element of cool: a town doesn't really count unless it's got one. When I compare this with that silly red-button campaign in Flanders, or with Zinloos Geweld (Mindless Violence), the lackadaisical Belgian non-profit-making organisation with their dopey butterfly, I have to stifle a certain amount of jealousy.

But I can't switch off my cynicism entirely. When I was young there were anti-bullying campaigns at school, too. And I was told about the dangers of weapons, and that I was supposed to be courteous in traffic. Aren't schools just doing what they've always done, except that now they've farmed their work out to a separate foundation with a cool logo as part of a 'save our culture' operation?

A swaying sea of Orange

While mindless violence may be one of the most visible causes of the general malaise, the solidarity hype is about more than that. Almost all social problems are attributed to a lack of human contact. Initiatives to promote cohesion are popping up like mushrooms, too. Friction between the native-born and ethnic minorities is tackled by the Social Cohesion Networks, which were set up in a number of cities in April 2007 in order to eliminate cultural misunderstanding

once and for all.[4] And in the realm of politics the hard-liners are being combat-ed by www.tegenhaatzaaien.nl. In 2006 the DOEN! (Do it!) foundation – charged with spending the money from the national lottery on good causes – took on a new sphere of activity: social cohesion. They sponsor a wide range of socio-cultural projects, from the production of a reality soap opera to the vote for the best location for street corner youth to hang out. There are writing contests for 'stories against hate' and group hugs on Amsterdam's Dam Square.[6]

All very nice. Except for one thing: travelling round the Netherlands like this, I'm just not conscious of any lack of solidarity. On the contrary. There's nothing the Dutch would rather do than get together. They seem to be addicted to it.

It's Sunday evening, 29 April 2007, and my driver, whose name is Car ('an ordi-nary Turkish name, but very handy if you've got a cab company'), drives into the car park of the Rotterdam Ahoy. The enormous area in front of the arena is swarming with concertgoers. Every last one of them is wearing orange. And not just a tie or a ribbon, either: from hat to shoes, they're all decked out in the royal colour.

It's Orange Night, the evening before Queen's Day. In several places the fes-tivities marking the national holiday get started the evening before. In Utrecht there's a sing-along event, in Groningen a concert, in The Hague a city festival, and here in Rotterdam a schmaltz song bash – in a concert hall with fifteen thousand seats that was sold out weeks ago.

Inside, the joint is already jumping. It's scarcely eight o'clock, but the place is packed and everywhere there's hopping, dancing, shouting and singing. On the stage: the Deurzakkers. They're all alone, without a group, on that vast expanse in front of the audience. Booming from the amplifiers is an electronic version of a Strauss waltz. The Deurzakkers sing laa-lalala-laaaaaa. Making exaggerated gestures, they urge the audience to do the same. La-lala-la-laaaaa sings the audience, arm in arm, a sea of orange swaying back and forth. Anyone who ever thought the Last Night of the Proms (the exuberant finale of a series of concerts in London, at which an immense variety of popular and clas-sical music is performed) was an infantile, vulgar way to treat classical music should come and take a look at this.

After the Deurzakkers it's the Ko brothers. The same scene repeats itself: accompanied by music on tape, they perform their maritime hits 'Ik heb een toeter op mijn waterscooter' ('I have a hooter on my waterscooter') and 'Ik heb een boot' ('I have a boat'). They make way for Charléne, with 'Boom, boom, boom'. She passes the mike on to Sugar Lee Hooper, who does a house version of Queen's 'Who wants to live forever?' Sugar Lee, a woman of about sixty, is dressed in an orange Big Bird suit.

The spectacle goes on like this for four and a half hours! No fewer than twenty-six artists will perform. With the exception of Lee Towers they all go for the same genre: the Dutch schmaltzy hit/love song, accompanied by a frantic house beat that is devoid of all inspiration. This is a genre that has made no headway in Flanders, but in the Netherlands it's become the new folk music. Take 'Altijd is kortjakje ziek' (the Dutch version of 'Twinkle, twinkle little star') or 'Olleke bolleke knol', put a beat under it, and fifteen thousand Dutch people go berserk. For four and a half hours the audience form conga lines, sing along with all the lyrics and, although literally *every* artist runs onto the stage yelling 'I don't see any hands out there!', the audience submissively stick their hands

up twenty-six times. A confetti machine shoots snippets of orange, white and blue paper into the air. *'We're one of the few countries where the national colours draw people together,'* muses Lee Towers backstage. *'There are people who think it's low-class and trashy... Well. The warmth here, the solidarity, is something you don't find anywhere else.'*

So what's this about a lack of unity?

A good question. Maybe it's silly to use a schmaltz festival as proof of a strong national identity. But even so, that so many thousands of people were willing to come here dressed entirely in Orange shows that they're united by more than a mere love of children's songs set to house music. Add to this the fact that several of the artists addressed the hall as *'Holland'* (*'Are you up for this, Holland?'*) and you understand that this subculture could in large measure be identified with the national culture.

The next morning, on Queen's Day proper, I'm in Den Bosch, where I see the same scenes. The capital of Brabant is packed with people, and they're all – *all* – wearing orange. Before this the only time I had ever seen Orange Mania was at big football matches, but for this kind of dressing-up frenzy to occur on a national holiday – that surprises me. I see inflatable hats, crazy crowns, children *and* adults with their faces painted with the Dutch flag, scenes that you do expect at a football match, or if need be at a schmaltz festival, – but at a visit from the Queen?

'Today the canals of Amsterdam are full of little boats. Hollanders are going bonkers, flashing their muscular torsos, screaming their lungs out, Heineken in hand, "oranje boven". Queen's Day means an outing. Does so much national happiness even exist in Belgium?'[6] muses Dutch writer Oscar van den Boogaard.

Nope, Oscar van den Boogaard, it doesn't. So the Dutch better quit lamenting over their weak national identity and that they're so unsure who they really are and what they stand for. The Dutch are addicted to being Dutch. You heard it from me. Read what *de Volkskrant* writes: one out of every four Dutch families hangs out the Dutch flag on Queen's Day and on the Liberation Days, May 4th and 5th. (One out of four!) In 2007 an estimated one hundred and fifty to two hundred thousand flags were sold. *'We're among the top five biggest flag buyers in the world. Only in Scandinavia and maybe Switzerland are relatively more sold. Belgians, on the other hand, very rarely buy their own flags, which suggests that the Netherlands is one of the most chauvinistic countries in Europe.'*[7] Say no more.

I let myself be swept along by the crowds to the centre of Den Bosch. I'm looking for a spot on the Parade there, where the royal family are going to pass by. As soon as I get there I abandon the illusion that I'm going to be able to see them: the square is jam-packed, and the average Dutchman is bigger by half than I am. So I look around a bit, at every possible kind of orange. I see a street musician with an orange guitar (where do you buy that, an orange guitar? And what do you do with it for the rest of the year?), orange ties, orange pouf skirts, orange wigs, orange inflatable crowns. The Dutch Railway is handing out orange crowns. I see an orange-white-and-blue Mohawk adorning a chauvinistic punk. It's sweltering hot. They don't start on the beer here until the Queen has gone by. I jot down a few thoughts.

Thought One: in Belgium, the national celebration, the day of the dynasty or

Queen's Day in
Den Bosch, 2007.

any other festival to do with Belgium or its royal house, is invariably attended by young children as a school outing and the elderly who feel a sentimental bond with the King. The little kids wave their little flags, the old folks stand politely and timidly, waiting for a wave from the monarch. Here I see families with children, but I also see groups of young people. In Belgium you wouldn't get young people to turn out for the King for all the tea in China. Queen's Day seems more like a city festival, with a flea market, salsa joints and rock performances thrown in. The Free Market in Amsterdam is reminiscent of the Ghent Festival or, say... Mardi Gras madness in New Orleans, and it's wildly popular. It's eleven o'clock and at the Den Bosch railway station they are announcing over the PA system that anyone heading for Amsterdam will not be able to get out at Central Station *due to the crowds*.

Thought Two: I see in the Netherlands what had already struck me in England – a great devotion to the culture of the people, especially a rather vulgar, almost rustic version of it. You can call the Netherlands a middle-class society, but

Orange football craze,
Summer 2006.

the way the Dutch identity is celebrated is decidedly common. Heineken beer flows abundantly, bare chests are visible everywhere, the carnival atmosphere conveyed by all the orange clothing is reinforced by those same sentimental songs set to a frantic beat that reverberate from the cafés. The Queen visits Den Bosch, but her subjects wear Heineken crowns.

Thought Three: when Dutch people do something as a group they fall back on football codes, whether the gathering actually has anything to do with football or not. It was already apparent at Pim Fortuyn's funeral in 2002. It may have been the Netherlands' first political assassination since that of William of Orange, but people mourned as if the Cup were at stake. *'Pimmie, thank you, Pimmie, thank you, Pimmie Pimmie Pimmie, thank you'*, they chanted in chorus

before launching into the football song *'You'll never walk alone'*.[8] The same thing happened at the memorial to Dutch popular singer André Hazes, which took place in the Amsterdam Arena in 2004. And you see it today as well. The vast majority are wearing football shirts. People greet the Head of State with shirt slogans like *'World Cup Experience'*, *'Hup Holland Hup'*, *'Johan Cruijff, el salvador'* and a whole range of player's numbers. There are probably practical reasons for this – they just don't make that many ordinary garments in orange – but it's still a little nutty. Whether you're going to see the Queen or to watch Edgar Davids score some goals, it makes no difference.

Happy Birthday, Afsluitdijk

This hot Queen's Day will eventually attract sixty thousand people to Den Bosch. Half a million went to the Free Market in Amsterdam. And another million and a half watched the live broadcast of the royal visit on by the NOS, the Netherlands broadcasting network, with an additional million watching the repeats. *'Slightly fewer than last year, but considering the marvellous weather and the absence of princess Màxima (who had recently given birth), it's very good indeed,'* said a satisfied Peter Kloosterhuis, head of the NOS Events Service.

Set up in 2007, this service is new. And it has a special purpose: *'In addition to the pure news and sporting events, this year the NOS will also broadcast a number of other events to promote "social cohesion" in the Netherlands'*[9], says NOS director Gerard Dielessen.

'Oh, come on,' responds Kloosterhuis, to put it in perspective. *'The NOS has always broadcast things with a national character – elections, Liberation Day celebrations, Queen's Day – and they have always appealed to a shared experience. They're part of "nation building", great moments in a country's history. With this new department we want to take this even further. Soon it will be seventy-five years since the completion of the Afsluitdijk . Of course the Afsluitdijk is part of our cultural-historical heritage, but it's also a symbol of our struggle against the water. There's historical footage of a woman holding up her skirts and walking across the dike, the first person to do so. On her grave it says, "Her life was the Afsluitdijk". That's a wonderful story to build a programme around, isn't it? And then you can also say something about global warming, our next struggle with the water... But we're going to do something with NPS on the Rotterdam summer carnival, or even the commemoration of the Hungarian uprising – three hundred thousand Hungarians came here, and that makes it possible to say something about that event, about how well they integrated.'*

It's not only the topics that foster national solidarity, it's also the way they're presented. *'I think the way people watch television is slowly changing. The news, series, documentaries – the process is slower than many people think, but it will happen – eventually viewers will watch them when they feel like it and not when they happen to be broadcast. At the same time, I think, there will be more demand for programmes that make the viewer feel as if he were sitting in the front row at an event. A football match, an important political debate, a visit from the Queen – two days later you don't watch them any more. So the shared experience is important. A few hundred thousand people watched the press conference with the lawyer Bram Moszkowicz because they were there at that particular moment. So live television is going to become even more important.'*

A quite different kind of cohesion

Bear it in mind: according to the NOS, television can reinforce social cohesion if you do live broadcasts of major events – those whose content teaches us about the history of the country – so that people have the feeling that they were all present at the same time. So social cohesion has to do with the consciousness of a shared past, expressed in a shared experience.

It's a valid position. But look at the way the popular family channel TROS defends its approach in a report to the Commission for the Media: '*Under the heading of "social service broadcasting" TROS has a range of programmes which are made with the viewer's interests in mind. In TROS's view, consumer programmes like Radar and Opgelicht contribute to social cohesion. TROS also has many programmes in the entertainment category . Examples are the series Lingo, Dit was het Nieuws, Postcodeloterij, 1 tegen 100, Miljoenenjacht, Love Letters and the TV Show. According to TROS, these programmes reflect popular culture and social cohesion. And when it comes to music, TROS has a preference for Dutch artists. Even the music programmes focus on popular culture and social cohesion.*'[10]

Now bear this in mind: a programme fosters social cohesion if a lot of people watch it. That's quite a different definition, isn't it?

And take other television programmes that have been brought together under the motto 'social cohesion' in recent years. Go ahead, include the Flemish ones while you're at it. *Allemaal SAM*, for example. That was about promoting volunteer work and paying tribute to people who took 'positive initiatives' to bring people together. Or *Fata Morgana*, which was shown in the Netherlands under the title *De Uitdaging* (The Challenge). That show had people from a single village combining to face several major challenges and dealing with them successfully. These people are doing something together, it's true, but there is no trace of any sense of a common past to be seen, or of making an effort to ensure a more sustainable society. There, cohesion means little more than ten people working together for a few days to reach a goal that has absolutely no social impact. Getting five hundred dwarves dressed as Romans to build a human bridge over the Dender, for example. Anyone who can tell me what's the use of that gets a Volkswagen Beetle painted like a ladybird.

Who belongs, and who doesn't?

The confusion doesn't stop there. All the previous examples were about mass spectacles: there is social cohesion if as many people as possible do the same thing or look at the same thing. But you can just as easily read analyses that link cohesion with things on a *small* scale – the feeling you can get in a neighbourhood or village.

As I drive over the almost seventy-five-year-old Afsluitdijk, I am thinking about the writer Geert Mak (of *In Europe* fame). I'm on my way to Jorwerd, the little Frisian village – hardly more than three hundred souls – whose history is the subject of one of Mak's books. He places a special emphasis on solidarity: '*For villages, that tradition of solidarity – the kind that once existed in the working-class districts of the big cities as well – is above all a tried and tested means of collective survival. In many places there used to be pieces of common land,*

gifts were exchanged on a grand scale on important occasions, they combined into teams for harvesting and other activities, seasonal workers usually moved around with others from their village, and sometimes people even emigrated as a group from the village to the city. In short, the village was often a direct extension of the family.'[11]

As described here, this is a much more durable form of social cohesion than that of the orange Big Bird singing 'Who wants to live forever?', or the participant in the television challenge. People take care of each other, and of each other's animals, when times are hard. The cohesion in Jorwerd, as Mak tells it, seems to have what it takes to prevent mindless violence.

At the same time, clear-cut limits are implicit in this kind of solidarity . Not everyone can be part of the village community. On the contrary: 'Who belonged, and who didn't? The young people used a complicated set of codes: there were the natives, and there were the imports, and then there was the difference between Frisian imports and non-Frisian imports, and besides that there was the difference between active and non-active imports. (...) The elders had stricter norms. When Eef in the café got into a discussion about who was a real Jorwerter and who wasn't, Folkert and his friends responded with absolute certainty. Although Eef had lived in the village since she was twenty and had run the village's only café for thirty years, the opinion of the men was unanimous and irrevocable: "You're not a real Jorwerter because you were born in Baard.'"[11]

And to me that, too, seems logical. Each group connects and differentiates at the same time. The larger the community, the easier it is to belong to it, but also the more superficial and temporary the connection. And the millions of Dutch people who in some way or other take part in Queen's Day, whether physically dressed in orange or sitting in front of their television – being all together may have made them feel united, but that doesn't mean that they know and respect each other as equal human beings. They know and respect one small aspect of each other: the colour of the hat. But as soon as it goes any deeper than that, it also gets more sinister. The 'us-them' thinking, which every right-minded

Buses carrying supporters of the 'Young Orange' football team on the Afsluitdijk.

View of Jorwerd.

philosopher of cohesion fights tooth and nail, is inherently part of an otherwise tightly-knit community where people would never murder each other for a cigarette.

And isn't that logical? Isn't that how societies function, and have always functioned, despite the concept of the individual who is disconnected and cut loose from every society, who accepts no authority but his own? Wherever people live together there is solidarity and division. At the same time. The more intimately connected you feel, the smaller the group that gives you that feeling. The larger the group, the more superficial the contact. People switch roles every minute of every day – neighbourhood resident, Dutch citizen, car driver, Frisian, Jorwerter, student, Christian... Every role brings with it solidarity with the one and estrangement from the other. Of course it can't hurt to prod people into paying more attention to the things that bind them, but if there are so many different ways of doing that, and if they're all so successful, doesn't that mean that cohesion in the Netherlands is actually doing well? And that what we need to learn is to accept the fact that the different forms of solidarity sometimes conflict with each other, and that when they do things can go wrong?

Stand-by solidarity

That's what Joep de Hart thinks. He's a researcher with the Social and Cultural Planning Office. De Hart studied the massive public reactions to the deaths of Pim Fortuyn and André Hazes. He begins his study with a wide range of remarks made on internet forums that mention the *'great unity'* of the Dutch. *'If only that we had that unity all the time!!!!!'* *'The positive thing that this shows is that there's SOLIDARITY among the people of the Netherlands.'* *'Yes, the sadness you felt and saw was about more than André Hazes... maybe it was sadness for this country?'*[13]

'That feeling being expressed there is quite remarkable', says De Hart. *'As far back as the Seventies you see a strange contrast emerging from questionnaires.*

If you ask the Dutch how their society is doing, the overwhelming response is al-ways that it's getting more and more egotistical and amoral. The norms and values change so quickly that you no longer know where you stand; there are so many identities that you no longer know where you belong. That's what they say if you ask them about society. But if you ask, "How are you doing?" they're very positive. Then they don't think there's any confusion at all, or any lack of norms and values. The percentage of people who say that they personally are satisfied with their lives is just as large today as it was twenty years ago.'

'So there's a gulf between society itself and how people experience it. You can quote dozens of statistics proving that criminality hasn't risen and morals haven't really deteriorated, but it doesn't help. Here at SCP we also regularly conduct sur-veys about the future in which we try to gauge the expectations of the average Dutch person. Once again, it turns out that people attach a terrific amount of importance to unity and solidarity, and that they're scared stiff that in twenty, thirty years they won't exist any more. People are afraid that the dominance of the assertive citizen will only increase.'

'They say that, even though the Netherlands is really a very social country. We're at the top internationally when it comes to volunteer work. When you look at which organisations have grown since the Eighties, it's environmental societies, human rights societies and NGOs, and organisations concerned with moral problems: euthanasia, abortion, things like that. These are perfect examples of subjects of general social importance; joining one of these groups gives you no personal ad-vantage. If society really is becoming more egotistical, then wouldn't those organi-sations be the ones to suffer?'

De Hart doesn't know why this should be so. Like many people he points to the 'ontzuiling' – the breakdown of traditional religious and socio-political barri-ers and affiliations – which has resulted in each person having to learn to steer his own course, leading to greater insecurity. But in the end we're managing pretty well.

'A different kind of solidarity has developed', he says. 'The spontaneous, almost rustic solidarity of the past has been replaced by a more ad hoc form. Stand-by solidarity, is what I like to call it. A month ago there were some serious problems with the trains and travellers had to camp out in the stations. Then suddenly you'd see Dutch people popping up all over, offering the travellers a place to stay, cooking soup for them. It was like Siberia! But as soon as the trains were running again the group disintegrated: they had come together for a purpose, and once that purpose was achieved each one went his own way. But that solidarity is available virtually on demand. If a tsunami happens , the Dutch are there. So don't underestimate it: we are an individualised society, but that is not to say that we're egotistical. We just in-terpret solidarity in a different way. It's more geared to the needs of the time. Maybe people are no longer willing to turn out every Wednesday from eight to ten and sell Limburg fruit pies for our son's football club, but we will pay more to keep the club going. We give more to organisations like Amnesty and Greenpeace, but we're also more critical about them: we expect good service, otherwise we're out the door. That's different to how it used to be. People are more assertive, they choose for themselves more, but that doesn't mean that they only choose for themselves.'

And those big emotions? You can't always attribute them to social uneasi-ness. 'We've simply become a much more dramatic, emotional people than we used to be. That has to do with the democratisation of public emotions. In the past it was seen as improper to cry in public. Now it's almost compulsory. Compare this

with romanticism, when it was very fashionable among the 'jeunesse dorée' to peddle sentiments and emotions far and wide. In that respect the culture has really changed: we get an itch for the dramatic sharing of emotion on a grand scale, just as you saw in the silent marches. But you also see it on popular TV shows: what don't they cry about! If they win some little quiz show they start blubbering.'

De Hart likes to compare it with the pietistic school of Protestantism, in which you proclaim your faith by showing your emotions as explicitly as possible. *'The Dutch were always regarded as introverts, but there's certainly been a breakthrough in that respect. When you look at things now you almost get homesick for that strict Calvinism!'*

And since those old Calvinists wouldn't have been seen dead wearing orange wigs on their Reformed noggins and ripping into another round of 'Olleke bolleke knol', I see exactly what he means. ■

Translated by Nancy Forest-Flier

NOTES

1. Message on www.hetlevenvangerdnan.nl

2. Ad Verbruggen, *Tijd van onbehagen. Filosofische essays over een cultuur op drift*. Nijmegen: SUN, 2004, p. 24. Quoted in: Wouter Beke, *De mythe van het vrije ik. Pleidooi voor een menselijke vrijheid*. Averbode: Uitgeverij Averbode, 2007, p. 31.

3. Coalition agreement between the governing parties of the Lower House of Parliament – CDA, PVDA and ChristenUnie – 7 February 2007, p. 8.

4. See www.socialecohesie.nl.

5. The number of academic studies on this subject, whether or not designed as advice to the government, is nothing to sneeze at either. '*In the Social Cohesion race in the Netherlands, the central question is: in a society in which there are significant differences between groups of citizens in terms of lifestyle, views about norms and values, and identity, how can trust, cooperation, solidarity, mutual care and responsibility develop*,' writes the Netherlands Organisation for Academic Research, which has now produced no fewer than fifty-three studies on the subject.

6. Oscar van den Boogaard, 'Koninginnedag'. In: *De Standaard*, 30 April 2007, p. 17.

7. Peter de Waard, 'Nederlanders hangen weer vaker de vlag uit'. In: *de Volkskrant*, 28 April 2007, p. 2.

8. Enjoy seeing this again on the DVD *Ik kom eraan. Het laatste hoofdstuk van zijn leven* by Hugo van Rhijn (Speakers Academy Multimedia, 2003).

9. ANP, 'NOS gaat extra evenementen uitzenden', 19 February 2007, read on www.nrc.nl.

10. Report of the Commission for the Media, 3 September 2004; download via www.cvdm.nl/documents/2004004801.pdf.

11. Geert Mak, *Hoe God verdween uit Jorwerd*. Amsterdam: Atlas, 1996, p. 180.

12. Ibid., p. 30.

13. Joep de Hart, *Voorbeelden en nabeelden. Historische vergelijkingen naar aanleiding van de dood van Fortuyn en Hazes*. The Hague: Sociaal en Cultureel Planbureau, 2005, p. 9.

A Question of Caring?

Population Ageing in Flanders and the Netherlands

[MARIA BOUVERNE-DE BIE]

The issue of population ageing is receiving a great deal of attention internationally. In 2002 the United Nations produced an action plan with three key priorities: first, concern for the elderly and the development of this, embracing themes such as employment, urbanisation, solidarity between generations and combating poverty; second, the promotion of health and welfare in later life; third, guaranteeing a stimulating and supportive environment for older people in areas such as housing, education, volunteer services and mobility. In common with other countries, Flanders and the Netherlands have developed specific policies aimed at addressing the consequences of population ageing.

Population ageing, dejuvenation and active integration

The term 'population ageing' refers to the increasing proportion of older people in the population. In Flanders, approximately 18% of the population are currently aged over 65; the figure for the Netherlands is 15%. These percentages are expected to continue to rise sharply in the years ahead, which causes considerable financial headaches as well. As early as in 2001 Belgium set up the so-called Silver Fund, with the object of setting aside money to meet the future

costs of population ageing. Initially the Fund was financed out of non-fiscal and one-off revenue (e.g. the sale of buildings). Later it was agreed that the Fund's financing should be changed so that it received the annual budget surplus; in 2007 and 2008, however, there were ominous reports that the Fund was close to running dry.

Photo by Stephan Vanfleteren.

There are several factors driving population ageing, the main ones being increased life expectancy, the declining birth rate and external and internal migration. Consequently, the number of older people in the population can vary widely depending on where they live: for example, the large cities attract a high

proportion of young people and immigrants, so that there the ageing trend is weaker. Population ageing thus refers not only to the growing number of older people in society, but above all to a change in the relative size of the different age groups within a given context. In societies like Flanders and the Netherlands, which are based heavily on participation in the labour market, population ageing leads to an increase in the 'dependency ratio' – the ratio between the economically inactive and economically active population. This increase puts pressure on the established care arrangements, and this in turn impacts on the way in which ageing affects the lives of the population. Increasing the proportion of the older population in employment, as well as adapting the health-care system and supporting and democratising old age pensions, are key focus areas here. All this suggests that population ageing in Flanders and the Nether-lands cannot be seen in isolation from another trend, namely 'dejuvenation': the accelerating decline in the number of young people in society that parallels the growing number of elderly people. Government policy on the elderly has a number of things in common with the policy on youth – for example, promoting independence and the means of achieving it form the central plank of government policy for both age groups. Where government policy for young people is aimed mainly at entry to the labour market, however, the policy on the elderly is the mirror image of this, being focused mainly on the exit side. On both sides of the equation the primary focus of the policy is on activating the responsibility of individuals for their own and others' well-being. Core concepts in the active integration policy are prevention, participation (including in the labour market) and responsible citizenship. The government seeks to realise these through a 'demand-driven' policy. Historically, social provisions for young and old in both Flanders and the Netherlands have developed out of the care and educational practices originally provided by private initiatives, which later gradually came to be recognised and funded by the government. In recent decades this supply-driven development has been shifting increasingly towards an attempt to tailor the policy to the situation of the citizen as a consumer (and thus a customer) of the services available. This 'commercialisation' is reflected in the introduction of new concepts within government policy, such as social infrastructure and social quality. The reasoning is that social policy should take responsibility for the social quality of society, and that a good social infrastructure is a precondition for achieving that. The social infrastructure embraces both the public infrastructure and the personal networks and social competences of individual citizens. A demand-driven approach means that provisions are not viewed in isolation, but are regarded as part of a joined-up network of coordinated provisions and services. In this approach social quality is understood as the ability of individuals and groups to be look after themselves and accept social responsibility, i.e. the willingness to care for each other, be self-reliant and participate in society. In this respect population ageing also means a different perception and experience of old age, starting with a 'dynamic policy on the elderly'.

Perceptions of the elderly

Describing demographic shifts in terms of population ageing and dejuvenation is in line with the abstract idea of an age-based structuring of life through youth, adulthood and old age, in which young people prepare for the labour market

and the elderly take a well-earned rest from their labours. According to this view, greater chronological age is accompanied by social ageing: while youth is associated with increasing development opportunities, old age is characterised by a decline in possibilities. In Western society youth has become the cultural ideal: the message is 'stay young as long as possible'. This has led to growing older being regarded as a problem for the individual concerned, and increasingly – as a result of population ageing – for society: old age as a cause for concern. The present active integration policy to some extent questions this problematisation. In addition to the traditional, uniformly passive image of the older population, other images are now being put forward, ranging from a shift towards a homogeneous 'active image' to approaches which put the main emphasis on continuity of life. These latter approaches assume that older people either have more opportunity (and time) to participate in society in areas other than employment, or are able to remain active, and continuing to work, because they compensate for their declining capabilities with, for example, greater experience. However they may differ, these social perceptions of 'old' versus 'young' have one feature in common: they all imply a different positioning of the young and the elderly with regard to the labour market. In the present climate, however, both entry to and exit from the labour market are increasingly unpredictable, and both carry an increasing risk of exclusion. For older people this leads to the paradoxical situation that, with their life expectancy increasing and the growing pressure to remain young for as long as possible, there is at the

same time the strong possibility that, measured by participation in the labour market, they will be classed as 'elderly' at an ever younger age.

Older people – like the young – are a diverse group; the age limits used to define them vary depending on the policy area concerned and, as the example of paid employment shows, even within one and the same policy area. There are also wide differences within age groups, for example as regards gender (population ageing goes hand-in-hand with an increase in the proportion of women), economic activity, relationship with a partner, philosophical persuasion, relations with children and friends, income level, health, interests and scope for participation. This diversity means that population ageing has to be approached as a factual process which impacts differently on particular individual situations, and on the way in which people experience those situations. A study carried out in 2004 on how the Dutch perceive population ageing showed that roughly half regard it as a problem; interestingly, there was no difference between younger and older people in their views on this. Population ageing is generally seen as a problem by people who regard material or social advancement as important; those who are more conservative or more concerned with enjoying life find it less of a problem. These differences in value patterns partly reflect differences in education: the more highly educated are more likely to regard ageing as a problem than people with a lower level of education. The list of anticipated problems includes deficiencies in care provision, increased health costs, a shortage of help from the voluntary sector, unemployment, economic decline and a lack of fellow-feeling between young and old. Attitudes to the active integration policy also vary depending on the policy area: for example, trying to force people into employment is more controversial than encouraging them to live independently for as long as possible. In Flanders data from a number of needs surveys have been brought together in a 'monitor of local policy on the elderly'. The data were collected using a system of peer research, i.e. by people in the same age group as the respondents. The survey itself used a standardised questionnaire in which respondents were presented with a number of statements. A large majority of respondents aged over 60 agreed with the statement that older people should have a bigger say in matters affecting the elderly; the statements that 'older people no longer count' and 'older people are disadvantaged compared with other groups' received less support.

Participation as a quality label

The active integration policy is aimed at enabling older people to play a bigger part in the life of society in all policy areas. Responsibility for implementing the policy on participation by older people lies mainly at local level. Awareness of the huge diversity of the older age-group is key here: where one section of the elderly population regards being of 'non-working age' as offering the pleasant prospect of a life of leisure, others find themselves trying to make ends meet on a small or even quite inadequate pension. These differences are exacerbated by factors such as illness, but also by the 'Mattheus effects' inherent in social policy – the phenomenon whereby the benefits of social policy tend to accrue disproportionately more to the higher than the lower social classes. Poverty is today still mainly a problem of the young (especially those from single-parent

families) and the elderly; this applies particularly to older people on a pension, women and those who live alone. At the same time, the fact that poverty problems are concentrated within certain districts and neighbourhoods tends to exacerbate the problem. The differences in demographic profile between cities and smaller municipalities mean that the imperatives driving social policy also vary. When devising a social policy, therefore, it is important to achieve a rap-

port between supra-local and local administrative levels, and when implementing the policy to balance solidarity between income groups and between generations.

Developing a policy with the participation of those concerned is seen as something of a 'mark of quality' for good social policy, not least at local level. Such participation in policy-making is important: where policy is formulated by people other than those directly affected by it, there is a considerable risk that the latter group's interests will receive only limited attention and/or be a secondary rather than a central focus of the policy. In this regard, too, the situation of the elderly is a mirror image of that of the young. An over-specified approach, in which the interests of the elderly are set against those of children and young people, can have a negative effect on the social relationship between different age groups. This being so, it is essential not to restrict the idea of participation to active involvement in the policy-making process; a passive presence in that process is also important, i.e. policy must specifically set out

to promote each individual's scope for development, based on a radical principle of non-discrimination. This approach also reveals that the concerns of different age groups are often similar: a healthy living environment; good, affordable housing; adequate services; mobility; opportunities for voluntary work; culture, sport and recreation – all of these are important elements in policy both for the elderly and the young. At the same time, similar 'Mattheus effects' are to be found in both policy areas.

The organisation of care for the elderly

Care forms an essential part of the policy on the elderly. In both Flanders and the Netherlands care for the elderly is organised at different administrative levels, with a clear trend towards a greater emphasis on the local level. Since the passing of a decree on local social policy in 2004 local authorities in Flanders have been required to draw up a local social policy plan, in which they must ensure the maximum accessibility of social services. In the Netherlands, since the introduction of the Social Support Act (WMO) in 2007 local authorities have been given explicit responsibility for developing a policy to make it easier for vulnerable citizens (including the elderly) to take part in society. A key principle behind the organisation of care in both Flanders and the Netherlands is cooperation between the different services and coordination of these diverse and specialised provisions to create a 'continuum of care'. In practice this means that the target groups are less likely to be defined primarily by age when devising care policy. This trend is more marked in Flanders than the Netherlands. Most provisions in Flanders are aimed at all age categories, though a number of them are used more intensively by specific age groups. Services taken up mainly by older people include accommodation, home care and home care support. Accommodation provisions include sheltered housing, residential homes and combined residential and nursing homes. The difference between them is that in sheltered housing and residential homes the emphasis is on the residential function, while combined residential and nursing homes are explicitly intended for older people with long-term medical conditions who need a high level of care. These combined homes are aimed mainly at the very elderly; on average, residents are almost 80 years old on admission, and the majority of them are women. A residential home is a form of collective living; sheltered housing is an intermediate form between living by oneself at home and collective living. A day-care centre, short-stay and/or night-care facilities may be attached to a residential home. Home care includes various forms of assistance and services designed to support people in their own homes, such as assistance with personal care, domestic help and support within the home. This covers a wide range of services such as preparing meals, shopping, personal alarm systems or help with mobility. Home nursing means nursing care provided in the patient's home by a trained nurse. Logistical help and supplementary home care includes help with cleaning, doing odd jobs, providing company and monitoring the individual's condition. The latter two can also be provided by charitable organisations, which are mainly staffed by volunteers. Home care support services, as their name suggests, are designed to support the provision of home care; among other things they provide recreation, education and information as well as, for example, meals.

This lavish array of care provisions and services presents a picture of an older generation which is well cared for. In reality, however, this picture does not hold true; for many older people the cost of care is so high that they are forced to apply for social security benefit, while the accessibility of social provisions and the wide range of help and services available often comes at the price of long waiting lists.

A question of caring

Studies and policy documents often start from the question whether population ageing should be seen as a problem or an opportunity. Approaching population ageing as a factual process shows that its impact varies depending on the specific situation of the older people concerned and the attention that policy-makers can and/or do devote to it. Existing social dividing lines – between old and young, between rich and poor, between the well-educated and poorly educated – are reflected and reinforced in the debate on population ageing. This observation suggests that any policy on population ageing must take account of the ultimate aim of the social policy and the choices made regarding solidarity. Population ageing raises questions about care and care provisions, but first and foremost it is also a matter of ensuring there is a good social policy. ■

Translated by Julian Ross

BIBLIOGRAPHY

J. Baars, *Het nieuwe ouder worden. Paradoxen en perspectieven van leven in de tijd*. Utrecht: SWP, 2007.

M. Bouverne-De Bie & H. Van Ewijk (eds.), *Sociaal werk in Vlaanderen en Nederland. Een begrippenkader*. Mechelen/Brussels: Kluwer/Commissie Cultureel Verdrag Vlaanderen-Nederland, 2008.

M. Capelle & L.Van Lindt (eds.)., *Vitaal ouderenbeleid. Bouwstenen voor een nieuwe legislatuur*. Brussels: VVSG, 2006.

J. Mostinckx & F. Deven (eds.), *Welzijn en zorg in Vlaanderen. Wegwijzer voor de sociale sector*. Mechelen: Wolters Kluwer, 2008.

E. Pelfrene, *Ontgroening en vergrijzing in Vlaanderen 1990-2050. Verkenningen op basis van de NIS-bevolkingsvooruitzichten*. Brussels: Ministry of the Flemish Community, 2005.

D. Verté, N. De Witte & L. De Donder, *Schaakmat of aan zet? Monitor voor lokaal ouderenbeleid in Vlaanderen*. Bruges: Vanden Broele, 2007.

D. Verzijden & J. Fransen, *Vergrijzing in Nederland*. Amsterdam: Veldkamp, 2004.

Good Taste and Domestic Bliss

Art, Home and Well-Being around 1900

[MIEKE VAN DER WAL]

Long tailbacks on roads full of furniture shops, traffic at a standstill on motorway exits leading to furniture superstores, a wide range of interior design magazines and umpteen television programmes devoted to 'home and garden': these are the visible proof that at the start of the twenty-first century a great many people are extremely interested in their home environment and want to feel truly 'at home' there. Of course, the increased prosperity of the second half of last century has been an important factor in expanding this interest to its present scale. But something today's consumer will not be aware of is that the very first impulse towards concern among the general public for a good home environment actually dates from the nineteenth century. Developments that took place at that time in many fields radically changed the appearance of society. The rise of industrialisation in Europe played a very important part in this: on the one hand, it enabled products to be manufactured on a larger scale, while on the other workers were needed in the factories. The poor conditions in which they often had to work had repercussions for society and politics.

William Morris versus 'wonderful ugliness': the Arts & Crafts movement

The first time an extensive range of machine-made industrial products from all over the world was brought together was at 'The Great Exhibition of the Industry of All Nations' in London in 1851. This world exhibition was held in the Crystal Palace, designed by Joseph Paxton and constructed of iron and glass. The objects exhibited were in most cases lavishly decorated in various historical styles, as can be seen in the profusely illustrated catalogue.

With about six million visitors the exhibition was a great success, but at least one of them was not charmed: William Morris (1834-1896). This is apparent from the recollections of the publisher F.S. Ellis: *'I remember him [Morris] speaking many a time of the Exhibition of 1851, at which all the world was struck with unbounded admiration, and telling how, as a youth of 17, he declined to see anything more wonderful in it than that it was "wonderfully ugly", and, sitting himself down on a seat, steadily refused to go over the building with the rest of his family.'*

Morris' visit to the Great Exhibition may well have sown the seeds for his later struggle against what he considered to be the poor industrial products of his time. His criticism was directed both at their appearance, smothered in ornamentation, and at the way they were produced. In his view the factory worker had become a 'slave' of the machine, and could no longer derive any satisfaction from his work. For this reason Morris argued for a return to traditional means of production, so that the employee would once again be responsible for the product he created, as had been customary in the Middle Ages. When it came to design, too, there should be a return to that time of simple forms and the honest use of materials.

In 1861, with a number of like-minded people, he established his company, Morris & Co., to put his ideas into practice and produce, among other things, furniture, upholstery and curtain fabrics and wall-coverings. Morris' initiative was soon imitated elsewhere in England and this led to the birth of the Arts & Crafts Movement. The influence of this movement was also felt on the continent; the Belgian architect Gustave Serrurier-Bovy (1858-1910) is generally regarded as the person who, after spending time in England in the early 1880s, introduced the Arts & Crafts style of furniture-making to the continent.

IKEA store in Groningen, the Netherlands.

Sjoerd de Roos,
frontispiece and title page
of *Kunst en maatschappij*:
lectures by William Morris
about 'arts and society',
translated by
M. Hugenholtz-Zeeven,
with a short biographical
sketch by Henri Polak.
Amsterdam: A. B. Soep,
1903.

The palace as a house: changes in Belgium

The 1890s were a turbulent period in Belgium. Industrialisation took off earlier there than in the Netherlands. This had its positive side, including the creation of a large middle class, but it also had its negative side. In the early 1870s and the mid-1880s economic recession gave rise to social unrest, and in 1885 this led to several elements of the labour movement joining forces to form the *Parti Ouvrier Belge*. The POB gained much support and in the first parliamentary elections in which it was allowed to take part, in 1894, it even won 28 of the 152 seats. Following this success it built a new head office in Brussels to a design by Victor Horta (1861-1947). This *'Maison du Peuple'*, built in glass, iron and steel and one of the earliest examples of Belgian Art Nouveau architecture, opened in 1899. The architect described his design as a *'palace that was not meant to be a palace, but a house, where light and air would be the luxuries that the workers have for so long had to do without in their slums'*.

As well as economic improvements, another of the POB's main aims was the intellectual and cultural development of the workers. In 1891, with this in mind, it set up its *'Section d'Art'*, which would offer talks and courses. It also organised visits to exhibitions, including those by *Les Vingts*, an association of progressive artists founded in Brussels in 1883.

In artistic circles as elsewhere, the 1880s were a time of change and challenge to the established order. To give one example, the magazine *L'Art moderne*, established in 1881, repeatedly emphasised the social role of the artist and stated that in order to exercise real influence artists needed to apply themselves to practical matters, such as designing buildings, furniture, utility objects and even clothes. In the 1890s several artists from this progressive cultural circle became actively involved in the activities of the *'Section d'Art'*, the best known among them being Henry Van de Velde (1863-1957).

A new art for a new world: Henry Van de Velde

Although Van de Velde trained as a painter, he owes his considerable fame to his work as an architect and designer of interiors and objects of practical use. His decision, taken in 1893, to concentrate entirely on this was inspired not so much by artistic motives as by social commitment. He also expressed this commitment in the form of courses, lectures and a range of publications, and from 1890 to 1894 he was editor of *L'Art moderne*. One of the ideas this magazine put forward in the early 1890s was that when the working-class struggle for a new society had ended in victory, a new art would emerge. It would not only produce more luxury goods, but also focus on the design of utility objects.

The growing interest in applied art could also be seen in the exhibitions by *'Les Vingt'*, which from 1891 included not only paintings and drawings but also increasing amounts of applied and decorative art. Looking back on this, Van de Velde wrote: *'The artistic craftsman had won his place and status among the fine arts. The exhibitions no longer made any distinction between fine and applied art'*.

When Van de Velde met Maria Sèthe in early 1893 (they married a year later) it undoubtedly had a significant effect on the direction his career took. She too was extremely interested in the revival of artistic handwork and in William Morris' ideas; she even visited Morris in London in 1893. After her marriage

Chairs designed by Henry Van de Velde, from the '*Bloemenwerf*' house, c.1898. Gemeentemuseum, The Hague.

Bench designed by Johan Thorn Prikker (made by Arts and Crafts), 1898. Drents Museum, Assen (on long-term loan from ICN).

to Van de Velde she became closely involved in the execution of his plans and she designed ladies' clothes and other items jointly with him. In 1895-96 they had a house built in Ukkel (a suburb of Brussels) in which Van de Velde put all his ideas into practice. He designed not only the house but also the entire interior, including the furniture, wallpaper, fabrics and so on. This house, called '*Bloemenwerf*', became not only a sort of 'showroom' for potential clients, but also a meeting place for kindred spirits. One of these was the Dutch painter Johan Thorn Prikker (1868-1932), who was influenced by these contacts to turn his talents to applied art.

Van de Velde's interior design activities soon caught the attention of Samuel Bing, the well-known Paris art dealer. In 1895, in the first exhibition he organised after refurbishing his 'Salon de L'Art Nouveau', he showed three room set-

tings by the Belgian designer. Exhibiting complete interiors in which all the objects were designed to harmonise with each other was a fairly new idea, but in the years that followed it became a regular feature at exhibitions and in art dealers' showrooms. Another firm that did the same was 'Arts and Crafts' in The Hague, which opened in 1898. It took its inspiration very much from Bing, with whom its founder, Johan Uiterwijk (1872-1958), was personally acquainted. Uiterwijk was also a friend of Thorn Prikker, who was in charge of artistic policy. On Thorn Prikker's advice, they made contact with Van de Velde and this led to the inclusion in the opening exhibition of a dining room and bedroom designed by him. Also on display was work by a range of other artists and companies, from both the Netherlands and elsewhere.

The style of much of the applied art exhibited was the curvilinear variant of Art Nouveau popular in France and Belgium. Not everyone in the Netherlands was so keen on this elegant style, however. A critical review in the magazine *De Kroniek* included the following: *'Artists like Van de Velde apparently started out from ornamental drawing, and only later moved into making furniture and architecture. The already rather flamboyant lines of their ornamentation were then automatically applied to the constructional elements of furniture, joinery and architecture and then, if both knowledge and thought are lacking, things are created that simply ignore all the demands of construction and material, i.e. style.'*

This critic was Hendrik Petrus Berlage (1856-1934), who was to become one of the most important Dutch architects of the twentieth century. He too did not restrict himself to designing buildings, but also regularly took on interiors and designed furniture, objects of practical use and textiles. In marked contrast to Van de Velde's designs, his were typified by a rigid, austere form and a restrained use of decoration.

The Exchange as a community centre: H.P. Berlage

Like Van de Velde, Berlage was also involved in the socialist movement, which first appeared in the Netherlands in the mid-1890s. 1894, for example, saw the foundation of both the Socialist Democratic Workers Party, which would soon become the most important socialist party, and the General Dutch Diamond Workers Union (ANDB), the first well-organised trade union. The ANDB soon decided to build its own head office in Amsterdam, and Berlage was approached to design it. The union's administrators considered that the building *'should be as close as possible to the ideal house and should accommodate the workers in beautiful surroundings that in this capitalist society they cannot enjoy in their homes'*. The building opened in 1900 and was not restricted to meetings and political gatherings. All sorts of other activities were also provided for the members, many of them cultural in nature, and there was an extensive lending library.

At roughly the same time as the ANDB building, between 1898 and 1903, a new commodity exchange was also being built in Amsterdam, this too designed by Berlage. The basic principles for its decoration were formulated by Berlage's friend and kindred spirit, the poet Albert Verwey. One of the themes he came up with was the classless society in which money no longer played any part. At first sight, a rather odd motif for an Exchange. However, Berlage hoped that in the course of the twentieth century a new (socialist) society would arise in which there would no longer be any need for an Exchange. The building

Desk designed by
Hendrik Petrus Berlage
(made by ''t Binnenhuis'),
c. 1905. Drents Museum,
Assen.

could then be used as a 'huge community centre'. This utopian vision actually contained a greater element of reality in it than Berlage or anyone else around 1900 could have imagined: since 1987 his Exchange has been used as a cultural centre for exhibitions and concerts.

It was not only in major building projects that Berlage sought to realise his ideals. In 1900 he was also involved in establishing a new cooperative home furnishing company in Amsterdam, called ''t Binnenhuis'. Harm Ellens (1871-1939), one of the artists involved, recalled that it was intended as a counterbalance

Berlage's Exchange
in Amsterdam, 1889-1903.

to 'Arts and Crafts': *'When "Arts and Crafts" opened in The Hague, many people feared that the health of our young movement would be damaged by this firm with its dubious and non-Dutch approach. We put our heads together and a company was set up with the aim of creating a place where Dutch applied artists could show and sell their work'*. That the enterprise was established for idealistic reasons is clear from the following, written by Jac. van den Bosch (1878-1948), a furniture designer and friend of Berlage, who managed the business. In 1907 he wrote that the purpose of the enterprise was *'... to achieve a communal art, a form of*

Jac. van den Bosch,
Cover of a ''t Binnenhuis'
catalogue.

Interior of ''t Binnenhuis'.

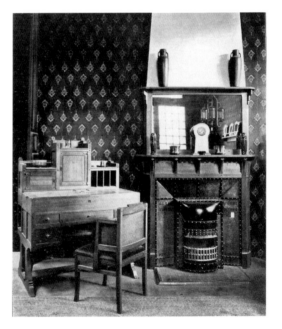

art that would fill the objects we use with all-embracing beauty and put them within everyone's reach'. The furniture, which was characterised by simple lines and a minimum of decoration, was made in the company's own workshops. The limited use of machines for the coarser work was not totally ruled out, but Van den Bosch did make the following comment: *'But what I do want, to encourage the blossoming of every craft, is that the use of machines be developed in such a way that all the work needed to implement a design, and which steals too much of a man's time, and can be done just as well, or perhaps even better, by machine, should be done in this way, but that the finishing, which is what makes the object a work of the mind, a living work of art, should absolutely be done by the artist himself. Only in this way is it possible to achieve a work of art that radiates vitality.'*

Despite the partial use of machines, the retail prices of the products worked out so expensive that they turned out to be beyond the means of the general public. It was precisely the traditional manufacture of the furniture that made it so expensive that it remained out of reach of the workers, the target group such businesses as "t Binnenhuis' actually had in mind. As a result, in practice the company's clientele was to be found largely among the well-off and the intellectuals. As long as many artists maintained their aversion to switching to industrial mass production, the aim of making these products affordable to everyone could not be achieved.

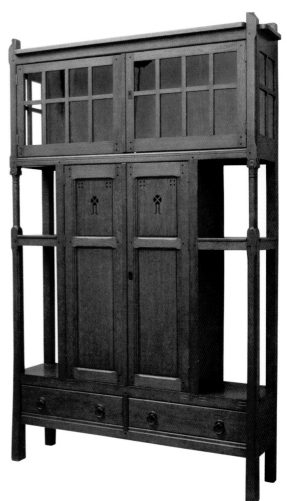

Cupboard designed by
Jac. van den Bosch, 1903.
Drents Museum, Assen.

To educate the general public

Whereas in Belgium the development of the applied arts movement seemed to lose impetus at the end of the nineteenth century (as is also apparent from the diminishing attention paid to it in magazines and exhibitions), in the Netherlands of the early twentieth century the initiatives necessary to support the applied arts were actually taken. A variety of mostly small firms were established to make 'sound' products and shops selling well-designed furniture and applied arts products appeared in several towns. In 1904, a number of artists work-ing in the applied arts founded their own association, the Dutch Association of Crafts and Applied Arts (VANK; Nederlandsche Vereeniging van Ambachts- en

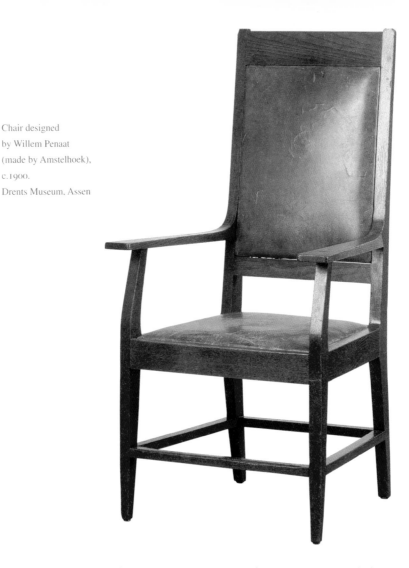

Chair designed
by Willem Penaat
(made by Amstelhoek),
c.1900.
Drents Museum, Assen

NijverheidsKunstenaars), one of whose aims was to 'restore the proper relation-
ship between the artist and society'.

One of the founders of VANK, the furniture designer Willem Penaat (1875-
1957), was also involved in setting up 'Art for the People' in 1903. This was one of
the associations established in the early years of the twentieth century with the
aim of offering cultural education to a broad public, and specifically the (skilled)
working population. In 1905 'Art for the People' organised the 'Furniture and
Household Goods' exhibition in Amsterdam; it was also known as 'Against
Ugliness', and Penaat wrote the articles for the accompanying catalogue. The
intention was to develop the visitors' sense of good taste by showing well-made
and crudely produced machine products alongside one another. The exhibi-
tion included a 'good' and a 'bad' interior of a worker's home, the first being
furnished in a simple and austere style and the second in a more opulently
decorated, vaguely historical style. A questionnaire showed that most visitors
preferred the 'bad' interior, showing just how difficult it was to instil better taste
in people.

Detail of 'Silex' furniture
by Gustave Serrurier-Bovy,
c. 1905.

Same aim, different approach

Nowadays the public is no longer subjected to this sort of patronising attitude . However, the notion of a clear link between a 'good' domestic environment and well-being is still universally endorsed. Amid all the attention paid to interior design in magazines and television programmes, one still finds the idea that some interiors are 'better' and 'more proper' than others.

Since the aversion to industrial mass production was vanquished in the course of the twentieth century, sound design by good designers has become much more widely available. It is partly to this that furnishing stores such as IKEA owe their huge success. Another element of this successful formula also originates from the early twentieth century: it was back in 1905 that Serrurier-Bovy designed his 'Silex' furniture, which was made of standardised components and was thus the forerunner of IKEA's flat-pack furniture. ■

Translated by Gregory Ball

From Squalor to 'Beauty'

The Dutch Approach to Deprived Areas

[MARIEKE VAN ROOY]

When the new Dutch cabinet took office in 2006, tackling the problem of deprived areas was high on its agenda. This was in response to the electorate's evident demand for positive solutions to crime and the general sense of insecurity. During the hundred days that the government spent travelling around the country to take the pulse of the Dutch public, it was decided that forty districts would be eligible for a special offensive. The areas selected, which were chosen on the basis of figures relating to income, population transience and unemployment, were designated 'krachtwijken' (places of power) or 'prachtwijken' (places of beauty). Ironically enough, the names do not refer to the actual situation in these areas but to the hoped-for future. At present these areas are burdened with socio-economic deprivation, with unemployment, low educational levels, school dropout rates, vandalism, a sense of insecurity and crime all rubbing shoulders.

The 'places of beauty' are mainly concentrated in the big cities of the Randstad conurbation and include both run-down nineteenth-century districts in the city centres as well as modernistic post-war reconstruction on the outskirts. These areas have a high concentration of social housing, much of which is made up of small dwellings with foreign, non-European residents. The basic idea is to upgrade the neighbourhoods through the joint efforts and combined financial resources of the national government, the municipalities and the housing corporations. This means developing plans for social welfare and sports on the one hand and dealing with the housing stock on the other. In other words, a challenge which combines a welfare initiative with a physical undertaking. The plans for the 'places of power' are highly diverse, ranging from the construction of Johan Cruyf football fields, language lessons for foreign residents, schools and related educational institutions and micro-credit for small businesses to refurbishing dilapidated homes and shopping streets.

The policy comes under the new ministry that combines Housing, Neighbourhoods and Integration, with Ella Vogelaar at its head. The newly created ministry demonstrates that for the cabinet, and the Labour Party (PVDA) in particular, the minister's 'places of power' policy is one of the key initiatives in which the government does not shrink from interfering in the lives of its citizens. As Aukje Roessel put it in *De Groene Amsterdammer*, *'For Vogelaar's PVDA*

it's a question of prestige. If it's a success, then the watered-down classical social-democratic idea of social improvement will gain in expressive power and electoral credibility.[1] By visiting one problem area a week Vogelaar literally tied her fate to this policy. In November 2008, however, the minister was forced to step down. Even though her resignation was not directly related to the 'places of power' policy but was the result of a string of incidents, it can still be argued that it dealt a sharp blow to this dynamic policy. Now it is under even greater pressure to succeed, an outcome that from the very beginning has been widely disputed by residents and professionals alike.

Social work and social housing in the Netherlands in the twentieth century

The core of the 'place of beauty' policy, in which social programmes are coupled with improvements in living conditions in order to relieve social misery, has a long tradition in the Netherlands. The first steps towards civilising the working classes were taken by the middle class in the mid-nineteenth century. The principal motivation was self-interest: by educating the 'maladapted' in the mores of the middle class, there would be less threat to the elite. The sociologist Léon Deben writes that in some cases draconian measures were taken: *'In a village in Zeeland, two families were placed in one room by a Board of Guardians of the Poor. A table and box bed were placed in each half of the room. A sheet formed the "partition"! These measures were all quite deliberate. The Board of Guardians had no lack of resources, nor was there a great influx of poor people. The idea was that the families would have to demonstrate as soon as possible that they could behave themselves and were suitable for an ordinary dwelling.'*[2]

When the Housing Act was passed in 1901, it became clear that good housing for the working class was no longer a concern for philanthropists alone but was also a matter of national interest on which liberals and social democrats were both agreed. In Amsterdam the new Act produced a number of architectural gems. The apartment blocks designed by Michiel de Klerk, such as 'Het Schip' and the various blocks around P.L. Takstraat in Amsterdam Zuid, are now famous. The housing built on Hoofdweg and Mercatorplein in the Baarsjes district, designed by Wijdeveld and others, still feature on the international architectural tourist trail. This new housing policy was not confined solely to residential construction; a great deal of attention was also paid to urban development, as well as to providing central facilities such as public baths and libraries. These facilities were designed with great care and built in central locations so that they could take over the function formerly fulfilled by the church.

This housing was meant for labourers who already subscribed to the same norms and values as the middle class, such as an orderly domestic life and physical hygiene. Yet there was another group that was excluded from this housing programme. Special educational complexes, also known as 'woonscholen', or residential schools, were established for them in the big cities. Unlike the residential schools built after the Second World War, these were isolated, almost prison-like institutions. Supervisory matrons were appointed and these, following the example of the British Octavia Hill, a pioneer in this area, were responsible for educating the residents. As Deben puts it, *'The intention was to stimulate behavioural changes that exceeded the demands made by the buildings*

inspection authorities. The object was to change the personalities of the individuals involved through strict supervision and discipline. Among the main activities of the supervisory staff were monitoring domestic behaviour, household management, cleanliness checks (inspecting mattresses) and encouraging the use of the bath-house and wash-houses, concern for relations with the neighbours (preventing and settling neighbours' quarrels), collecting rent at regular intervals (weekly rent collection) and caring for the children. They also mediated on behalf of the authorities in the field of social work.'[3] The isolated complexes were controversial, and so this approach died out after the Second World War.

Michiel de Klerk's
'Het Schip' apartment block
in Amsterdam (1920).

In the late Fifties, however, the idea of residential training underwent a revival. Residential schools reappeared, but the architecture of the new housing complexes was more like that of the regular Housing Act dwellings. Now, however, the focus was no longer specifically on re-education but on social work, supported by trained professional staff. This approach stayed in fashion until the early Sixties. When the new spirit of the times demanded an approach that gave the resident more scope for self-development and so more a say in his own life, the whole thing fell apart. Social workers were seen as know-alls and were given the boot.

During the Eighties there was a noticeable slump in social housing construction, and in the early Nineties the privatisation of housing corporations began to gather pace under pressure from a globalising neo-liberalism. Just when the

Housing Act was about to celebrate its centenary, its bankruptcy was announced – very quietly – in the Netherlands. This was a major reversal in Dutch policy, because it meant that for the first time welfare factors were disconnected from environmental planning. The privatised housing corporations shifted their goalposts and became more like commercial developers, making them less responsible for the social component. When the 'places of power' policy was introduced, the corporations were for the first time again called to account by the government regarding their social role.

Kanaleneiland, Utrecht.

Schilderswijk,
The Hague.

In practice

The 'places of power' policy didn't appear out of nowhere, however. As early as 1994 the government had launched its Big Cities Policy, something of a forerunner of the present policy. This, too, involved eradicating the social and economic deprivation that typified various areas. This modernisation consisted mainly of reducing the proportion of social housing, which was then replaced by owner-occupied property. In plain English, the original inhabitants were forced out and without anything really being done to improve their situation – an approach which came in for a great deal of criticism. It also failed to improve neighbourhood social cohesion, because the new, wealthier residents felt very little affinity with their environment. It became abundantly clear to the govern-

Bijlmer, Amsterdam.

ment that the one-sided physical component of this approach was attracting a great deal of criticism. Consequently, the focus of the 'places of power' policy is very much on an integrated approach in which the various parties are to work together to counter socio-economic deprivation. When Wouter Bos (PVDA and currently Vice Prime Minister and Finance Minister) stepped onto the political stage, housing corporations were once again reminded of their responsibilities, despite their officially detached relationship to the government. In short, it was the old liberal and social democrat ideal of elevating the individual citizen.

The 'power neighbourhood' policy began with the drawing up of an agreement between the government, the municipalities and the housing corporations which included arrangements for its financing. This immediately ran into trouble, to everyone's surprise, and for a moment it seemed as if the project and Vogelaar's appointment would never get off the ground. The housing corpora-

Bijlmer, Amsterdam.

Tussendijken, Rotterdam.

tions' umbrella organisation, Aedes, had promised financial support in princi-
ple. The corporations would contribute 2.5 billion euros to the plans; the money
was to be found over a ten-year period, with the corporations collectively depos-
iting one-tenth of this sum in a fund each year. But the housing corporations
proved unwilling to go along with the agreement that Aedes had drawn up. At
the same time Finance Minister Wouter Bos came up with a plan requiring the
housing corporations to pay corporation tax as of 2008. The timing couldn't have
been worse, and the housing corporations were up in arms. Under enormous
pressure from the government, for whom this was ultimately a question of
prestige, the housing corporations were finally brought on board. However, that
meant calling on already existing plans to finance the policy. In practice, just
shifting money around. The municipalities too were not entirely enthusiastic. In
their view, the time constraints meant that there was not enough time to come

Vreewijk, Rotterdam.

up with properly thought-out plans. So the ideas proposed were often elements of projects that were already under way, or ideas that had been sitting on the shelf for a while. Consequently, one major criticism is that renewal is nowhere to be seen, with most projects still hampered by compartmentalisation and the various agencies all too often working at cross purposes.

Another major criticism that won't go away is whether we're actually talking here about dealing with problem areas or with demolition pure and simple, with the less well-off being forced out of their neighbourhoods because of the reduced availability of social housing. This argument is one often used by former residents in particular. In that respect this policy can hardly be distinguished from the Big Cities Policy. The one-sided emphasis on demolition in the 'places of power' policy has already attracted attention in academic circles. A report by the NICIS (research institute for urban renewal at the University of Utrecht) that appeared in July of last year expressed misgivings about the excessive focus on demolition and the consequences of that. It argued that far too much attention is being paid to environmental interventions which only make the problem worse. The residents who are forced to move out end up in neighbouring districts that are not on the 'places of power' list but are already on the verge of becoming problem areas. These new, less well-off residents create a new concentration of people of limited means. Consequently, those residents who can afford it move out of the neighbourhood, and so the new 'place of beauty' is born. This is what is known as the 'waterbed effect'.

The ministry defended itself by arguing that the problem lies in the combination of a number of factors, and that it is wrong for the NICIS to focus so much on the environmental side. In a speech during a demonstration in Amsterdam organised by SASH ('Stop afbraak sociale huisvesting' – 'Stop the demolition of social housing') in February of last year André Thomsen, Professor of Housing Improvement and Housing Management at Delft Technical University, said that Vogelaar knows very well that it's not all about bricks. According to Thomsen, 'The corruption in Mrs Vogelaar's forty neighbourhoods is the work of man. She's well aware of that, and that's why she wants another policy that's oriented more

towards giving people opportunities and less towards real estate. I am convinced that if it were up to her there would be far less demolition. The tragedy is that it's not really up to her, and that the focus shifted long ago.'[4] He indicated that it's all a question of who holds the purse strings. According to Thomsen, the government's tough line with the housing corporations has led to the corporations digging in their heels. Since they have to hand over so much money to the government, they sell more social housing and build less. The small amount of housing that remains is really for those on the minimum wage, and thus social housing takes on the stigma of poor relief – just as it does in the United States, for instance, which is exactly what the Netherlands has always been on its guard against. If Thomsen's prediction comes true it means that the 'places of power' policy is nothing but a palliative, and that all it does for the socially disadvantaged areas and the people who live there is to help them out of the frying pan and into the fire. ▪

Translated by Nancy Forest-Flier

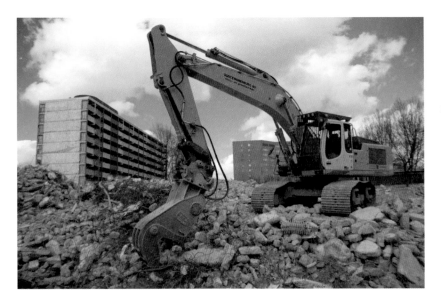

Bijlmer, Amsterdam.

NOTES

1. Aukje Roessel, 'De wijkaanpak kan beginnen'. In: *De Groene Amsterdammer*, 31 October 2008, pp.16-17.

2. Léon Deben, *Van onderkomen tot woning; een studie over woonbeschaving in Nederland 1850-1969*. 1988, p. 95.

3. Ibid., p. 172.

4. www.samenwest.nl/index.php?option=com_content&task=view&id=352&Itemid=85

Urban Health: A Tale of Two Cities

New York Became what Amsterdam once Was

[W. TUINEBREIJER, C. CUNNINGHAM AND N. SOHLER]

NYC.
Photo by
Annaleen Louwes.

The Dutch, or more precisely a mission from Amsterdam in search of a short route to their eastern colonies, established a settlement on an island in the mouth of a river; they are now called the Hudson River and Manhattan, New York. This article describes one aspect of the long relationship between these two cities, i.e. the issue of urban health.

In the early sixteen hundreds Amsterdam was a major European city. International trade, a harbour where ships arrived laden with goods from the colonies, and a golden age in art and architecture together with religious and political freedom made the city wealthy and dynamic. In the seventeenth century about half of the population originated from elsewhere. Immigrants were interested in the opportunities the city had to offer, and in their turn they were vitally important in enabling Amsterdam to maintain its international position. The comings and goings of foreigners in Amsterdam led to a unique development: freedom of religion and a concept we now call tolerance.[1]

'New Amsterdam' started as a trading settlement for beaver fur. The city of New York as we know it today began to flourish in the nineteenth century, long after the Dutch had left. By then Amsterdam was already in decline and had lost its international position. Now it was New York that became the city where people came to try their luck. Europeans weary of Europe's limited horizons and religious wars moved to this city of promise where the Dutch once had managed to establish a viable settlement on Manhattan Island. In the early twentieth century many African Americans from the south of the US settled in the district called Harlem. New York had become a world centre. It is still a leading city in global economics and still a centre of the arts, culture and education. Like Amsterdam in the seventeenth century, New York succeeded in integrating the various groups of newcomers. Amsterdam is now a small metropolis, but it still has the characteristics of a big city. It appears that the ingredients which determine the importance of cities have not changed much since the seventeenth century: factors like migration, international trade and a leading role in the world of education, arts and culture, to name just a few.

By 1940 New York had become the first urban area in the world to have more than 10 million inhabitants – a trend followed by many other cities in the twentieth century. As of 2008 more than half the world's population lives in a urban environment. This urban setting naturally has an enormous impact on people's behaviour, emotions, and health. Cities have become concentrations of deviant behaviour as well as of scholarship and power. We have long been familiar with the images of poverty, violence, homelessness, and the drug-addicted or mentally ill wandering the streets of urban areas. In fact, cities continue to offer two extremes: possibilities of exploiting one's talents for those with the resources and strong social networks, and the impossibility of survival for those without those advantages. Even back in the nineteenth century governments realised that these extremes had an enormous impact on the health of their urban populations, and so they founded institutions like the Department of Health and Mental Hygiene in New York City and the GGD (Medical and Mental Service) in Amsterdam. Their mission was, and still is, to promote, protect and enhance the health of their citizens. In both cities, these institutes are still active in promoting public health policies, providing health care, organising preventive programmes and conducting scientific research. An important element in their work promoting physical and mental health is the need to reflect social norms and values in the societies they serve. Many contemporary views on mental health practice, however, are not new but reflect long-standing values developed in the 1960s. In the sixties Folta and Schatzman[2] already published an article stating that good public (mental) healthcare should meet the following conditions: care should be urban based and orientated. It should be easily accessible, and outreaching, and be a part of the social structures in the neighbourhood. And it should be care for the vulnerable citizens of the city. These conditions still apply. In this article we will compare urban mental health and substance abuse care in New York and in Amsterdam. In doing so, we recognise that globalisation and its effects on mental health are crucial. However, it is impossible to give a complete picture, because public mental health is a complicated combination of medical, scientific, social, and political factors. Nonetheless, this will be a tentative sketch describing how to deal with these issues.

Urban mental health: the city as a monster?

Cities not only provide numerous opportunities, they are also home to many groups of severely marginalised people.[3] Every city has neighbourhoods that are known for violence, poverty, poor health, poor housing conditions and pollution. The incidence of addiction and psychiatric disorders is higher in cities than in rural environments.[4] Rates of psychiatric disorders such as depression and psychosis are considerably higher in urban environments.[5] One might question why this incidence is so much higher. Do cities make people ill? Or are mentally ill people drawn to the cities?[6] Over the last 40 years several high-profile research projects worldwide have focused on those questions and have shown that the city is, on the one hand, a risk factor for mental and somatic illness while, on the other hand, it is also a magnet for those who are 'different.' People can live anonymously among masses of people, and there is greater tolerance of differences. Cities also have more healthcare treatment facilities. New treatments find scope to experiment more easily in cities than in rural environments. In general, the risks caused by city life are a complex combination and interaction of various factors which will be mentioned later.

From the nineteenth century on, people have had their prejudices about cities: the city as a dark uncontrollable monster or on the contrary a seducing nymph. One cliché is that cities are uncontrollable, dirty, and violent. The city doesn't care about the individual, and many people live in poor conditions with no future prospects. Cities had and still have their dark corners. As for mental health: growing up and living in an urban setting increases one's chance of experiencing a psychiatric disorder. It is not clear just why the incidence of mental illness continues to rise in urban areas and at what level it will peak, but given that humans are biological, social and psychological creatures, the answer must lie in the complex interplay of these three factors. The risk of developing schizophrenia, for example, is more than three times higher in an urban environment than in a rural environment.[7] Other disorders too, like mood and anxiety disorders, exhibit the same tendencies. Migration is another factor associated with an increased incidence of mental disorders.[8] Since most migrants move to cities, those cities have in them many people suffering from schizophrenia, depression, and other mental problems.

Although cities contain more people with psychiatric illnesses, those same cities also offer greater possibilities. The vibrant scientific, economic, and cultural life provide opportunities which do not exist in rural areas. Thus it is doing cities a great injustice to portray them only as unmanageable, cruel, and disease-promoting.

Addiction and cities: a challenge for public healthcare

Cities are the places to rock and roll, and drugs are always available. Although not everyone who uses drugs becomes a drug addict, the people who do get addicted are likely to live in cities.

In general, addiction is associated with a lifestyle that is likely to include financial problems, homelessness, criminality, and many related physical health problems. Mental illness, too, is often linked to addiction. Conditions such as schizophrenia, bipolar disease, and depression are important triggers for

drug use and make it more difficult to stop. Drug use is often a self-medication for people suffering from psychiatric disorders. Heroin, marijuana, cocaine, and alcohol are examples of the types of drugs people tend to use as self-medication. The combination of these problems in one person can result in the marginalisation of those affected. Marginalised populations in New York and Amsterdam have a great deal in common. In the 1970s, heroin became popular. Later other drugs such as speed and crack cocaine came into fashion. In the 1980s the AIDS epidemic came and hit this group hard. These patients were often marginalised, locked up, or simply died. They caused trouble in the cities through, for example, robbery, violence, and homelessness. These groups of people almost never come and ask for help. Health or government institutions are deeply distrusted and to reach them professionals have to be innovative and persistent. To solve these enormous problems, the (local) governments have had to find a way to cope with this group.

Amsterdam. Photo by Wilco Tuinebreijer.

In both cities local policy is crucially important in dealing with this problem. The GGD in Amsterdam and the Department of Health and Mental Hygiene in New York play key roles in the way the two cities cope with this problem.

In the last decade we have learned that addiction and other psychiatric illnesses arise from an interaction of biology, genes and social factors. The social factors of poverty and marginalisation have a disastrous effect. The teenage mother who has three kids by the age of nineteen is likely to be uneducated, traumatised and depressed, with few opportunities to raise her children competently. They in their turn will not finish their education, have the same genetic make up, and in the end will suffer from the same mental problems. One of the challenges for public healthcare is to break this cycle.

New York vs. Amsterdam:
health as a government responsibility?

The Dutch have enjoyed an open and tolerant society for centuries, and there is a long tradition of democratic discussion on important religious and societal themes. When drugs and HIV infection rates started to become serious, politicians and doctors quickly tried to control the damage.

Various strategies were followed. One example: the GGD opened outdoor clinics for addicts. People could get methadone and, later, prescription heroin in these government-financed clinics. The primary aim in these treatment strategies was harm reduction, which means that abstaining from drugs was not the main goal of the treatment.

In the United States similar initiatives were set up. However, in the US harm reduction is not embraced as it is in other parts of the world. For example, federal money cannot be used to support syringe exchange programmes. Additionally, many local municipalities have outlawed syringe exchange. Consequently harm reduction programmes such as this are thin on the ground even in New York City (it has eight syringe exchange programmes to serve a population of 19 million people).

Over the past few years, professionals from the GGD and Montefiore Medical Center/Albert Einstein College of Medicine in the Bronx, New York, have been visiting each other to learn from each other's programmes. There are similarities, but also enormous differences.

One striking difference is the scale: Amsterdam is a city of slightly over one million people while the Bronx is a neighbourhood of almost two million inhabitants within New York City, which itself has 19 million residents. The Bronx is a poor neighbourhood with a concentration of the problems described above. It is the epicentre of many epidemics, including drug use, violence, joblessness, frequent imprisonment, young single mothers, and HIV/AIDS. The concept of harm reduction has been accepted and implemented more in New York City than in many other parts of the US. Here, for example, one can see cases of opioid addiction, HIV and mental illness all being treated within one clinic or medical facility. Additionally, many healthcare facilities also work together with community-based organisations in an effort to address the complex needs of marginalised individuals. Visit the clinics that care for such marginalised humanity and you will find the waiting rooms packed with people, from young mothers to the elderly, all waiting to see their nurse, social worker or doctor.

If you drive, walk, or take the subway through the South Bronx, you are likely to be impressed by the energy and liveliness all around. Music with its roots in South America, Africa, and the Caribbean can be heard everywhere. The atmosphere is reminiscent of Latin countries around the world. You'll find cultures and people from South America, Central America, the Caribbean, Spain, Portugal and Africa blended together into a culture that is typically Bronx.

When you see the endless expanse of red-brick buildings containing small apartments packed with people you realise that behind those windows there must be enormous numbers of people with problems like addiction, mental illness, poverty, and violence. There is no way you can register every sufferer, every woman violated by her boyfriend or husband, or every youngster who drops out of school only to embark on a criminal career. And for a young person from a subculture that provides few opportunities, becoming a doctor, scientist,

or politician is almost unthinkable and unattainable. And yet behind much of the pain and problems in the South Bronx, one finds people who have incredible strength and survival skills. Watching these people navigate or 'work' the streets, the welfare system or the healthcare system shows how those survival skills have allowed them to survive what many would succumb to – poverty, violence, mental illness, and drug abuse.

In Amsterdam, the neighbourhood most comparable with the Bronx is the Bijlmer. Built in the seventies; cheap but nice apartments inhabited by incomers, people who came to the Netherlands for a variety of reasons. People from Surinam came after that country became independent and then became embroiled in an economic and political crisis. But it was not only people from Surinam who came in an attempt to make a living; people from all over the world who came to try their luck settled in this neighbourhood, and multiculturalism is its hallmark.

On a hot summer day the atmosphere of both neighbourhoods is much the same; the same food-smells, music, endless large apartment buildings, and of course the same drugs. In both neighbourhoods opiate addiction is a major problem, possibly more than psychiatric illness. Because of this, the focus of health-care tends to be on addiction and deviant and criminal behaviour, with psychiatric problems being overlooked.

Despite the similarities between New York City and Amsterdam, there are also many differences between the two cities. In the Netherlands, considerable efforts are made to prevent individuals from becoming marginalised. There is a rigorous public health system responsible for individual healthcare. It starts with paediatric care, the vaccinations children have to receive, compulsory education and the amount of help offered when things go wrong. Another example is the collaboration between the police and the GGD. Twenty-four hours a day, the police can request the assistance of a health professional. General practitioners and trained psychiatric nurses see anyone the police wants seen. Psychiatric screening and admission to hospital are also available around the clock.

It is important to realise that these services are part of the GGD and as such part of the municipality. Nurses, doctors and psychiatrists are civil servants, the budget is funded partly by the government and partly by the health insurance companies. It is all part of the conviction that public (mental) health is a government responsibility.

Attitudes and policies in the U.S., and specifically in New York City, are quite different. Given its history and economic characteristics, much less support is provided to prevent individuals from becoming marginalised. There are clear demarcations between the healthcare, criminal justice and education systems. Problems often arise that concern more than one of these systems, but these have to be formally addressed in just one arena – with the result that they are never properly resolved. For example, drug use is frequently treated as a criminal justice matter, with no offer of medical intervention. Similarly, psychiatric problems are dealt with in different locations and by different medical professionals from other medical fields. This is most apparent when we consider how treatment for substance abuse, mental illness and medical problems is financed and structured – they are all covered separately and in different ways by health insurance companies, treated by different doctors, and treatment takes place in geographically different locations.

Science and public health care

In recent decades advances in the medical sciences have been enormous. New information has become available on the relationship of the individual with his/her external world and the interaction between genes and environment as it relates to mental illness. Increasing neurobiological medical and sociological knowledge provides us not only with a more scientific view of the development of addiction and mental illness but also with new evidence-based treatments.

If you visit a city on a number of occasions you will never visit the same city twice, because we live in an age of speed, in which new information affects all our lives. Given our new knowledge of the gene-environment interaction and the effects of marginalisation, modern communications and the internet in par-

NYC. Photo by
Annaleen Louwes.

ticular make it possible to share new findings rapidly and to exchange information easily. These findings are important to allow us to develop methods of care which are based on scientific knowledge instead of prejudice or (political) trends. In a fast-moving society, the notion of 'ideal care' for those who are vulnerable does not exist.

An example of this is the enormous amount of paperwork which has to be done if you want to provide financial assistance to a patient. In Amsterdam the collaboration between healthcare and social services is simplified by locating programmes that address these services together in one building. In New York this is not the case; different offices work independently of each other, with little or no communication between agencies. An interesting recent development is that both cities are now investing in housing for those who are marginalised by reason of addiction or mental disorder, or by a history of detention which is

often linked to the previous two. Research shows us that people in accommodation are more able to accept and continue with their recommended healthcare, and therefore housing facilities are made available in both cities. The difference is however still the scope. In Amsterdam, housing facilities have been developed on a large scale. In New York, the recent focus has been on developing short-term solutions. That city, for example has special programmes that provide designated housing for homeless people with HIV. Other marginalised individuals often receive no support.

Sharing knowledge

New York and Amsterdam have a long relationship. In the twenty-first century they are both metropolises, with all the advantages and disadvantages of big cities. We have seen some of the similarities and differences between them in the field of public (mental) health. Each has found its own ways of creating solutions for those of their inhabitants with mental health and/or addiction problems. Some of them are strikingly similar, others very different. With globalisation now a major phenomenon in our world, regional solutions are becoming obsolete. Sharing knowledge and practical experience of what seems to work and what doesn't can be useful for healthcare providers, scientists, and politicians; and this is one of the reasons why these two cities should enjoy, profit from and nurture of their relationship. ∎

NOTES

1. Russel Shorto, *The Island at the Center of the World. The Epic Story of Dutch Manhattan and the Forgotten Colony That Shaped America.* New York: Doubleday, 2004.

2. Jeannette R. Folta & Leonard Schatzman, 'Trends in Public Urban Psychiatry in the United States'. In: *Social Problems*, July 1968, Vol. 16, No. 1, pp. 60–72.

3. S. Galeo & D. Vlahov, 'Urban Health, Evidence, Challenges and Directions'. In: *Annual Review Public Health*, 2005.

4. J. Peen & J. Dekker, 'Is urbanicity an environmental risk-factor for psychiatric disorders?'. In: *Lancet*, 2004.

5. Dinesh Bhugra, 'Globalisation and mental disorders'. In: *British Journal of Psychiatry*, 2004.

6. J. Peen & J. Dekker

7. J.P Selten, 'Social defeat risk factor for schizophrenia?'. In: *Journal of General Psychology*, 2005.

8. S. Galeo & D. Vlahov + M. de Wit, W.C. Tuinebreijer, *et al.*, 'Mood and anxiety disorders in different ethnic groups. A population-based study among native Dutch, Turkish, Moroccan and Surinam migrants'. In: *Soc Psychiatry Psychiatr Epidemiol*, 2008.

9. Since several years the Montefiore Hospital, part of the Einstein College of Medicine in The Bronx, New York City, exchanges knowledge and experience concerning urban health issues with the GGD. In the year 2009, the Hudson celebration year, a conference will be organised to celebrate both: the 400 year-old relationship between the two cities and the exchange concerning urban health issues. Experts from New York and Amsterdam will present the similarities and differences in the challenges this subject poses (www.henryhudson400.com).

Healing in Geel

[LISA BRADSHAW]

Sint-Dimpna church, Geel.
Photo by Lisa Bradshaw.

In Geel, a town of about 35,000 souls in the south-east of Antwerp province, Sint-Dimpna reigns supreme. There is a Sint-Dimpna Hospital, a Sint-Dimpna College and a Sint-Dimpna Church, all located right next to Sint-Dimpnaplein. The local Gasthuis Museum has an entire room dedicated to this Saint. And until about 30 years ago every girl-child born in Geel was given Dimpna as a first, second or third name.

Known as Saint Dymphna in English, the patron saint of the mentally ill has so inspired the residents of Geel that they have built a tradition of caring for these vulnerable members of society on her story. Though many places in Europe can claim innovative facilities for the care and treatment of psychiatric patients, Geel is unique in the world – because it's been doing it since the Middle Ages.

In about the year 600, so the story goes, Saint Dymphna was the daughter of an Irish king who was driven insane by the death of his wife, Dymphna's mother. He turned to his teenage daughter, who bore a striking resemblance to his lost queen. She refused his proposal of marriage and fled with her parish priest, Gerebernus, settling in the area now known as Geel. Her father pursued and caught up with them and, in a mad rage, beheaded them both.

And then the sick and insane began coming to Geel.

A method to the madness

'Geel became a place of pilgrimage,' explains Lieve Van de Walle, who manages the Rehabilitation Division of OPZ Geel, the town's world-class psychiatric hospital and care facilities. *'The clerics started developing rituals, and if you performed those rituals, then supposedly you would get better.'*

The mentally ill were housed and the supervision of rituals took place in the fifteenth-century Sint-Dimpna Church. Though the treatments were of doubtful efficacy, they were not cruel. At a time when the mentally ill were killed, locked up or put through extreme physical torture to rid them of their 'demons', Geel was asking them to walk in a circle around the church and collect grain from the neighbours.

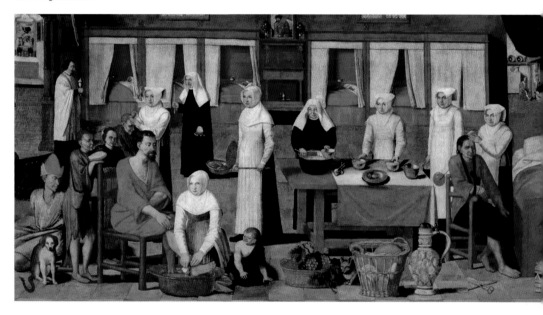

Eventually so many people were bringing mentally deficient relatives to Geel that the clerics paid local farmers to house them. Often the patients just stayed on – particularly when the family didn't come back to claim them. The farmers gained a helping hand, and Geel became a sanctuary for the mentally ill.

Anonymous, *Nursing the Sick in Geel*. 1639. Gasthuismuseum, Geel.

The earliest known record of this situation dates from 1500, *'but we're sure it's older than that,'* says Van de Walle, *'because in 1500 it was already an established system.'* For the people of Geel there was, from the very beginning, a method to the madness: *'It was an economic factor,'* explains Van de Walle. *'This whole area developed its wealth because of the extra hands available – of free labour.'*

A level of pragmatism still exists in host families, who have never stopped taking in patients. In the 1930s, there were 3,000 people in foster care with families in Geel, which at the time was 30% of the population. Says Van de Walle: *'Before the war, you only had two options in Belgium. Either you were locked up for the rest of your life, or you came to Geel and lived with a foster family.'*

But it wasn't just Belgians who wound up in Geel. Patients were sent from around Europe and even from the US to become part of a system that was deemed healthier than living in an asylum. After the Second World War, when facilities elsewhere began to improve, the numbers dropped. Now Geel families

Observation House, Geel.
Photo by Lisa Bradshaw.

house 400 patients, nearly all of them Flemish. But there appears to be no end in sight: 'People still knock on our door and ask to become a foster family,' says Van de Walle.

Van de Walle's department oversees the foster family care system, which has become a shining example to other countries, some of whom copy it and some of whom implement its core values in other creative ways.

When patients arrive at the psychiatric hospital in Geel, they are assessed to see if a foster family is a possibility. Then they spend a couple of months in a day programme at the Observation House near the hospital, where they are given a variety of tasks: preparing food, washing clothes, interacting with other patients and with staff. There is a garden where they grow food, and chickens to care for. Here the staff finds out what they are and are not capable of and if they can interact safely with other people.

Then the department tries to find a match. 'It's necessary to have a mix of all kinds of families because the patients are all different,' says Van de Walle. Some of them are psychotic, some are suffering from severe clinical depression. A few have Korsakoff's syndrome, usually caused by long-term alcoholism. But most have some degree of mental retardation.

After a patient moves in, a nurse visits at least once a month, and the department is on call 24/7. Some families have two or three patients living with them – three being the maximum.

I've lived here for 11 centuries

Jos Meynen has been a nurse in OPZ Geel's foster-family programme for 21 years now. He has 36 patients in 30 families, and he visits them all at least once a month. When he walks into a house the patients greet him enthusiastically. The more patients, the bigger the greeting, so at the home of André and Christiane Belmans the welcome is especially warm.

The Belmans, a retired couple, have been caring for three psychiatric patients for 22 years. All three were previously living with André's mother before her death. When she became ill Theo, a young-looking 75, asked: *'What's going to happen to us when she dies?'*

A fair question, and one that faces many patients, who find such stability in foster homes in Geel that they tend to live out their lives in them. The Belmans did what many families in Geel do – inherited the care of the patients. *'When someone dies or becomes too old to care for a patient, other family members take them in,'* explains Meynen. *'It's a very old tradition.'* The Belmans, though, moved themselves into the house where the patients had already been comfortable for years.

Though it seems like a huge responsibility, the families are quite casual about it. *'When I married into the family, I always knew it was a possibility,'* say Christiane. *'They just live in the house normally, like members of the family.'*

Down the street, Yvonne Geukens, a widow of four years standing, hosts Armand, who came to Geel a few years ago when his own mother had to move into a nursing home. Armand is very sociable and was happy to lead me through one of his regular chanting rituals while staring out of the front door. *'I've lived here for 11 centuries,'* he tells me.

Geukens has been caring for patients for 53 years. Her last boarder was with her for 41 years until he died. She says she has to keep a close watch on her home's doors and windows because *'he opens them and leaves them. You have to*

The Belmans family, Geel.
Photo by Lisa Bradshaw.

stay very alert.' Though Geukens is getting on in years, she wouldn't dream of giving up being a foster-care provider. *'I would miss him if he wasn't here,'* she tells me. *'I'm alone, and I would miss him. I would suggest to other people who are alone to take in a patient. If you don't have children at home or if you don't work, it's someone to take care of and it's company. I don't regret any of it.'*

Just as in the Middle Ages, foster families are paid to cover the cost of the patients. *'Even if people start doing it because they want a bit of extra money,'* says Van de Walle, *'they develop a bond. They'd rather die than bring a patient back to the hospital. Even if they weren't paid, they'd still do it.'*

Which is a good thing, since the pay barely covers the expenses. Families receive €450 per patient per month, *'and that's not enough,'* Van de Walle stubbornly insists. The rehabilitation division is funded by the federal government, which allocates it €41 per day per patient. After payments to the families, the department is left with a deficit of nearly €2 million per year, which the hospital has to find if it is to continue running the foster-care programme. *'A hospital bed is €220 per day, and we have to run these expensive services on €41 per day?,'* Van de Walle questions. *'Politicians we talk to always say it's ridiculous, but nothing changes.'*

Hospital reception, Geel.

Family therapy

But the system really does change the lives of patients. The rehabilitation department also provides independent living facilities on the hospital site for patients who are capable of living alone. But the foster families have a special effect. *'You have normal living conditions, with role models,'* Van de Walle points out. *'You're forced to be active. You have a family that acts as your engine, and it means you have neighbours, a social network. That's the therapeutic aspect.'*

Patients in foster care often need less medication, due to a reduction either in physical problems or in depression. A regular routine is extremely important

to maintain consistent behaviour patterns, and they find that regularity in ordinary homes.

But this raises the question: if these patients do so well in families, why can't their own families care for them? The reasons, Van de Walle explains, are numerous and complex. *'If you have a son or daughter, it's very natural to have expectations for them, and often these people can't meet such expectations. A foster family is different. They can deal with the deficit.'* In other cases the illness has caused the patient to act in destructive ways, and the relationship with the natural family has completely broken down. *'Here they get a new start,'* says Van de Walle. *'Getting a new start for people with psychiatric illnesses can be very important.'*

Geel as the measure of things

In 1975, Ellen Baxter won a fellowship enabling her to embark on independent studies overseas. The American could go anywhere she wanted, and she didn't hesitate. She went straight to Geel.

Ellen Baxter in Geel, c.1975.

Her parents worked for international institutions in The Hague, so Baxter had spent her youth in the Netherlands and learned to speak Dutch. During her university years back in the US, the plucky young woman – who as an undergraduate had persuaded her psychology professor to commit her to a mental institution so she could experience it from the inside – had read about Geel in a psychiatric journal. *'I was driven to understand,'* she tells me from her office in New York, *'why communities do not take care of people who need extra help. The idea of shutting them up in an institution...I felt there needed to be a different way.'*

She found that way in Geel, where she spent months living with host families, following the nurses around and haunting the cafes *'because that was where people would talk. There were 164 cafes in Geel, and the older people liked to talk*

to the young American on her bicycle.' The humanity she found in Geel had a profound effect on her. *'All I knew is that I was going to take what I had seen in Geel and make it happen in the United States.'*

Today Baxter is the director of Broadway Housing, which provides 400 private residences for the homeless of New York City. *'What Geel gave me was a model,'* she says. *'People will always need extra help to live decently and safely – every village needs a way to incorporate that.'* When she moved to New York just after her time in Geel, *'I was completely horrified. I got off the bus and went into the women's toilet at the station, and there were women living in it – lying on cardboard to sleep and washing their clothes in the basins. People coming and going to use the toilets in the middle of it all.'*

It was a long haul for Baxter, who is now famous in New York and among homeless activists across the country for being the first to win public funding for such an endeavour. *'Geel is still where I think about – where I get my bearings when I have to made decisions.'* ■

www. opzgeel.be
www.gasthuismuseumgeel.net

The book *Geel Revisited: After Centuries of Mental Rehabilitation* is a follow-up to Flemish anthropologist Eugeen Roosens' original 1979 book on psychiatric care in Geel. He and Lieve Van de Walle, manager of the OPZ Rehabilitation Division, cover the history of the facilities, the changes of the last 25 years and the day-to-day operations of the foster-care programme. It's in English and comes with a DVD of the 2006 documentary Geel, in which Flemish filmmaker Arnout Hauben follows three families over the course of a year. It can be ordered at www.maklu.be; the DVD can also be viewed at the Argos media centre in Brussels by appointment.

A longer version of this article was originally published in Flanders Today, 30 April, 2008. (www.flanderstoday.eu).

The Trivial Pursuit of Happiness

Happiness: reconciling oneself to everything one has not attained
(J.C. Bloem)

The Low Countries are ageing at a brisk pace. In 2007 Dexia Bank carried out an extensive survey in Flanders, in which it asked for as many as 160 different statistics. Based on these it compiled a complete socio-economic profile of every municipality in Flanders: incomes, size of dwellings, number of cars per family, number of internet connections, population, crime rate, size of road network, unemployment... it was all there. Municipalities were also ranked on the degree of ageing. You could see from a map whether there were a lot of older people in your municipality or whether, on the contrary, you happened to live in a 'young' community. The key to the map shows a *'very ageing population'* in the west (West Flanders) and a *'distinctly young population'* in the east (Limburg). In between there is, literally, a grey area with a *'somewhat ageing population'*, *'average degree of ageing'* and *'predominantly young population'*.

All in all, then, Flanders does not look very dynamic and young, but that should not be a reason to doubt our well-being. Granted, it means that modernisation and reform are essential, but demographic ageing is, of course, the result of advances on an individual and social level (better healthcare, to name but one factor). In other words we do not, on average, kick the bucket as soon as we once did, and of course that is a good thing. Or, as the French singer and actor Maurice Chevalier once said: *'old age is not so bad when you consider the alternatives.'* But Chevalier also sang, in the musical *Gigi*, *'Thank heaven for little girls'*. And if we look at the birth statistics in Flanders that young blood is not doing so well. So the estimated cost of ageing continues to rise, spending on pensions will increase considerably and healthcare will become noticeably more expensive. In addition, it appears from the figures that our pensioners run a considerable risk of poverty. Those who like to look on the dark side might describe the future of Flanders (and equally of the Netherlands) as follows: the grey leading the grey.

That, of course, is the doomsday scenario. In a recent interview the former Belgian Prime Minister Yves Leterme spoke much less apocalyptically about the phenomenon: *'We are, in general, much too negative about ageing. That our life expectancy has risen so substantially is actually the amazing dividend of progress and our excellent healthcare. (...) In fact I think it's a luxury problem. I see ageing mainly as a fantastic opportunity. When are people at their best? When they are taking care of each other.'* That sounds at once very 21st century and *'yes, we*

can'-ish (problems are challenges and challenges are the motor of our exist-
ence) and at the same time reassuringly old-fashioned. A bit like that solid
piece of advice that used to be found on a nice wooden plaque in many a Flemish
house in times gone by: *'Dààr alleen kan liefde wonen, / daar alleen is 't leven
zoet, / waar men stil en ongedwongen / alles voor elkander doet.'* ('It's only there
that love can dwell, / It's only there that life is sweet, / Where with no fuss, in
pure good will / We help each other in every need.')

Altruism...with fringe benefits

So without other people there can be no happy person, you cannot help thinking.
Charles Darwin spoke of 'social instinct' in that regard, which according to him
is good for the survival of the group. He noted that amongst animals that gained
from life in a close-knit group the individuals who derived most pleasure from
living in a community were those who most often escaped dangers of various
kinds. By contrast, those individuals who concerned themselves least with their
fellows and opted for a solitary life died in larger numbers. This is the survival of
the nicest: the 'survivors' not only experience pleasure in social interaction, but
are also ready to suffer to preserve the well-being of the greater whole.

 The Dutch sociologist Abram de Swaan wrote about that greater whole in his
magnum opus, *In Care of the State. Health Care, Education and Welfare in Europe
and the USA in the Modern Era* (1988): a well-wrought study of the present wel-
fare state and the long history that leads up to it. According to De Swaan, in the
course of history people began to identify more and more with other, unknown
individuals. Initially solidarity concerned mainly the immediate family, but little
by little the circle kept widening. The solidarity of the welfare state also extends
to anonymous fellow countrymen. And that circle could just keep on growing,
because at the end of the book he argues for a basic welfare state at a global
level, partly as a way of avoiding problems with immigrants from the Third World.
You can never be too visionary when it comes to happiness and well-being.

 There is very little mention of *'with no fuss, in pure good will'* in De Swaan.
When he discusses the history of poor relief, individual motives are subordi-
nated to the collective action. And that collective action serves a collective good.
True, he does see charity as a largely altruistic form of behaviour, but it is not a
purely two-sided relationship between the donor and the person on the receiv-
ing end. *Caritas* must also be seen in the context of collective action on the part

of the 'haves' designed to benefit collective interests, such as defending against factors that threaten society and maintaining a reserve of labour. He refers, for example, to the early agricultural communities, where donations were supposed to prevent the poor resorting to crime or even rebellion. Besides, the starving were easy prey for diseases which, in epidemic form, could undermine the community. On the other hand, if you kept your 'have-nots' strong by feeding, clothing and housing them, you built up a reservoir of labour that could be put to use when needed.

These are all ulterior motives. But does that tally, then, with the real meaning of altruism, which is a traditional virtue and a basic tenet of religion in many cultures? Whether one is Christian or Muslim, Jewish, Hindu or Buddhist, altruism always stands for 'selfless concern for the welfare of others'. It does not tolerate selfishness and will have absolutely nothing to do with such concepts as loyalty or duty. It is the art of goodness for goodness' sake, without moral obligations (to God, for example), higher ties (social benefit) or even abstract concepts (such as, for example, patriotism).

Mercy's interest rate

St Paul wrote that *'love seeks not its own interests'*. This is reminiscent of the maxim that Joannes Zwijsen gave his congregation in 1832: *'Love without self-love'*. Zwijsen, later the first Archbishop of Utrecht, but in 1832 still the parish priest of St Dionysius in Tilburg, asked a couple of young nuns to devote themselves to giving an education to poor children and looking after the sick and the elderly. Starting with only three women, this congregation of Sisters of Charity of Our Lady, Mother of Mercy grew rapidly to almost 4,300 members at its height in 1940. As the name suggests, mercy was central to Zwijsen's spiritual experience. He put it as follows: *'What is a Sister of Charity? A person who, without neglecting her own perfection, helps her fellow-men to the best of her ability.'* So one was required to put oneself entirely at the disposal of one's fellow-men without, however, losing sight of the prescribed prayers and spiritual exercises.

Mercy as the theme of a devout life has its origin in Christ's words in the Gospel according to St Matthew: *'Come, you that are blessed by my Father, inherit the kingdom prepared for you from the foundation of the world; for I was hungry and you gave me food, I was thirsty and you gave me something to drink, I was a stranger and you welcomed me, I was naked and you gave me clothing, I was sick and you took care of me, I was in prison and you visited me.'* This lists six out of the Seven Corporal Works of Mercy, or the core of altruism in Christian faith: to feed the hungry, give drink to the thirsty, shelter strangers, clothe the naked, tend the sick and visit those who are imprisoned. Not until 1207 did Pope Innocent III add a seventh Work: to bury the dead, taken from the Biblical Book of Tobit. There was a practical reason for the choice of this additional Work. In those plague-ridden days the difficult and dangerous work of burying the dead was indeed of special value, not least for public health. So there you have it once more: ulterior motives.

But let us stick to unselfish activity for the moment. Then mercy is, quite simply, taking care of our fellow human beings and offering them help and support in word and deed. The February Strike of 1941, the first large-scale act of resistance against the German occupation in the Netherlands, gave the people

Burying the dead: one of the Seven Works of Mercy, sculpted by Albert Jansz Vinckenbrinck for the pulpit of the New Church in Amsterdam (1649-1664).

of Amsterdam the word 'merciful' in the motto on the city's coat of arms. The motto was bestowed upon them by Queen Wilhelmina in 1947, as a mark of respect for the sense of justice and compassion for their Jewish fellow-townsmen which led to the strike, because – as we already said – people are at their best when they are concerned with the welfare of others. Or, more universally, in the words of Martin Luther King: *'An individual has not started living until he can rise above the narrow confines of his individualistic concerns to the broader concerns of all humanity.'*

Of course, one doesn't need religion to be merciful. But it certainly helps. I myself first became acquainted with the Works of Mercy as a child, in Willy Vandersteen's *The Seven Strings* (De Zeven Snaren). One of the heroes in this Flemish comic book asks passers-by and friends about the works of mercy, but nobody manages to name them all. What is worse, a magician has hidden the Harp with the Seven Strings. As a result the Seven Works of Mercy are no longer practised and the world is in serious danger of going pear-shaped. The story dates from 1968, and the concerned tone was obviously a sign of the times. In 1973 the Flemish magazine *Kreatief* published a special edition in which Jan Pieter Ballegeer did *'a research experiment into the topicality of an old theme in art'*. He collected more than 300 pictures of the Seven Works of Mercy spanning several centuries and from all over Europe. When he showed them to a number of young art students, he realised that *'the message'* no longer came across. Only one student in a hundred recognised the Works in the illustrations. Moreover, the young people reacted mainly to the form of the art works. That was also apparent when Ballegeer set them the task of illustrating the Seven Works themselves. One of the students sceptically turned everything around. In his work the thirsty were buried and the naked visited. Another made a *Suitcase of Mercy,* with two rubber hands attached to the inside of the case which if they were inflated could touch each other. Ballegeer concluded somewhat despairingly: *'Several solutions are purely formalistic and therefore completely miss the human content.'*

Once upon a time it was mainly about that human content. The Master of Alkmaar, whose seven panels from 1504 can be found near the front of this book, was commissioned to paint his Works of Mercy by the Brotherhood of the Holy Spirit for the Church of St Lawrence in Alkmaar, where they were intended to inspire the worshippers to concern themselves with the welfare of others. In Flanders, from the Middle Ages onwards such pictures were often hung above the so-called 'Table of the Holy Ghost' or alms table, because it was the Church that organised alms for the poor. And Caravaggio's well-known depiction of the Works hangs in splendour above the altar of the chapel of the Naples Mount Mercy, Pio Monte della Misericordia, where the needy could pawn their miserable possessions.

The Fleming Wenceslas Coeberger had become acquainted with these *Montes Pietatis* during his stay in Italy, and as court architect he pleaded with his bosses, the Archduke Albert and Archduchess Isabella, to establish similar charitable institutions in the Southern Netherlands, where the needy population could raise money on their possessions at reasonable interest. Starting in 1618 he built 15 Mercy Mounts in various cities, of which he became the superintendent. For centuries the less well-off could go there for a cheap loan if they left something behind as security. It even says *'Interest-free loans made to the poor here'* on the facade of Ghent's own Mount Mercy, the Gentse Berg on Abrahamstraat, which now houses the city archives, and above the entrance

Hofje van Noblet
in Haarlem,
built in 1761.

door is the inscription *'Mons Pietatis'* and the Implements of Christ's Passion.

Where the relief of the poor was concerned, then, the Church was never far away. What's more, long before social services were organised by the state the weaker members of society – the poor, unemployed, sick, elderly, disabled, widows and orphans – were dependent on their families and/or the Church. Gradually private initiative too began to play a bigger role, and it did so hand in hand with the Church or with church communities. Ministers and priests often received money from richer parishioners or members of the community to spend on poor relief. In the Amsterdam City Archives, for example, we find the will of Lijsbeth Cornelis Bruntendr who in 1565 left money to Amsterdam's two parish churches, to convents, monasteries and institutions such as the hospitals, the insane asylum and the orphanage. The Minderbroedersklooster (monastery of the Friars Minor) received 50 guilders a year for 6 years, and every child in the Burgerweeshuis (orphanage) was supposed to receive a farthing's worth of white bread and a pint of milk on the anniversary of Lijsbeth's death. But she also included clauses that were supposed to take care of her own salvation, because in return for all that posthumous mercy she stipulated that masses should be said for her and she also expected people to pray for her soul.

The Implements of
Christ's Passion above
the entrance door of
the Ghent 'Mons Pietatis'.

Other childless rich people who wanted to spend their money in a worthwhile way after their death had *hofjes* (almshouses) built – the forerunners of old people's homes and sheltered accommodation – where old people with little money could live for free. In Flanders these almshouses were called *godshuizen* or God's houses, but the principle was the same. They were meant to provide a limited number of impecunious elderly women, men, or married couples with accommodation and an annual allowance, and they were founded by people who saw charity as insurance for a nice spot in Heaven. To play it absolutely safe, the inhabitants of the almshouses were often obliged to pray regularly for the welfare of their benefactors' souls. It says in St Matthew's Gospel: *'Truly I tell you, just as you did it to one of the least of these who are members of my family, you did it to me.'* Those who did good were all set for the Hereafter – that was the dividend that mercy paid.

Private initiatives and civil involvement in general welfare have long played an important part in supplementing the efforts of the Church (and later also of the government) to relieve poverty, sickness and other afflictions. The first public playground in the Netherlands, at the Tweede Weteringplantsoen in Amsterdam, was opened in May 1880 by the manufacturer Nicolaas Tetterode. That was the start of the 'playground movement', which had people all over the Netherlands working to get a playground in their own district. And indeed, it was in the nineteenth century that the Dutch first started to be really concerned about the education and care of their own and other people's children. More and more reception houses or 'houses of correction' appeared, where children were sub-

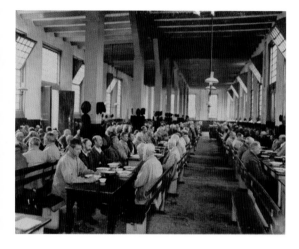

Inside the Amsterdam poorhouse, end of the 19th century.

jected to 're-education to become good citizens', with religion as the medicine because 'poor people hear nothing but swearing, shouting and yelling, one single proverb may perhaps calm the unhappy and rebellious mind.' Society could only become more orderly, happier, and better as a result.

At the end of the nineteenth century, especially, the 'social question' started to play an important role. Industrialisation changed the Netherlands fast, and not only for the better. The factory worker was born. And worked fourteen hours a day in dangerous, filthy factories. Dodgy working conditions, low wages and housing shortages gave rise to an urban proletariat and that caused the well-heeled middle class a lot of headaches. Benefit payments did not yet exist, children worked alongside their parents and often just as hard, and because of all the misery many workers took to drink as well. Poverty, alcoholism, 'rough manners and a lack of civilisation' could not fail to have their effect. Concerned citizens founded associations to fight prostitution, alcohol consumption and visits to the fair, as well as to educate the workers. They wanted to help solve the 'social question' – partly out of sympathy, but also from fear of a complete collapse of the social order. Gradually the government began to do its bit as well. A range of laws – such as the ban on child labour (1874) and a housing law (1901) – were supposed to make workers' lives pleasanter little by little. Initially, of course, the main purpose was to create more joy rather than more equality. In that sense Derek Philips' observation in his recent study, *Well-Being in Amsterdam's Golden Age* (2008), still applies: *'From the perspective of the politi-*

cal elite, the maintenance of existing inequalities and structures of privilege was crucial. (...) Social order required hierarchy and subordination. All should be in their proper place.' Social services were first and foremost supposed to maintain the established order. There was a price to pay for everything. In the poorhouse the impoverished elderly did indeed find shelter, but they had to work hard for their bread: weaving, spinning, combing flax, knitting, sewing and unpicking old rope. This compulsory work in the poorhouse was only abolished in 1957.

New words and old-fashioned concern

Nowadays you can read the history of welfare work in the Low Countries on the websites www.canonsociaalwerk.be and www.canonsociaalwerk.nl, by clicking a number of digital windows that mark out the long path from mercy and charity to the modern welfare state. The Flemish site starts with the Second Council of Tours where, as early as 567, a law was issued that every local community must feed its own poor and needy. So the needy should be taken care of in their own parish, from that parish's resources. And at present it ends in 2007 with the 100th edition of ALERT, a publication of the non-profitmaking organisation, 'Pluralistisch Overleg Welzijnswerk'. There are quotations from previous years, too: '*"Let us make it quite clear, the criticism quite rightly levelled at all the drop-in welfare centres is that there has been much too much 'seat-of-the-pants' assistance." (1990-1), "In recent years there has been a good deal of talk about counselling, but it is not always clear what comes of it." (1994-26), and "With preventive campaigns one is often aiming at very vague raising of awareness. Or with attempts to change behaviour one risks setting about it in a rather moralistic way." (1991-10)'.* Which shows more than anything that the modern welfare state with its street-

'Big City, Big Loneliness': a slogan in Rotterdam on the occasion of the Erasmus Year (2008).

'Students for sale' for a noble cause, *Music for Life*, Ghent, 2008.

corner workers, care farms, development pilots, volunteer care, youth work and guidance for senior citizens has also given us a welfare Newspeak.

Has this structured approach with all its facilities led to an erosion of mercy, as Ballegeer seems to argue in his 1973 essay? After all, he blames the igno-rance of the young people he questioned on the welfare state – it has all become a matter of course, the government takes care of everything and personal in-volvement is extremely limited or non-existent. That is, of course, to take a very dim view of things, because not everything is left to the powers that be. The soldiers of the Salvation Army still jump into the breach for all those who fall through society's net. The homeless, addicts, prostitutes and the lonely can still count as much as ever on the support of this 'church community with its sleeves rolled up', as it is called. In December 2008 the third edition of *Music For Life*, an annual fund-raising event organised by the young people's radio station Studio Brussel and Red Cross Flanders, managed with all sorts of spontaneous activities to rake in € 3,503,246 for 'Mothers fleeing war and violence'. In the Netherlands thirteen large social organisations have joined forces in Coalitie Erbij to tackle loneliness, because a good quarter of the Dutch feel lonely and this number is growing. *'Magna civitas magna solitudo'*, wrote Erasmus – big cities mean big loneliness. It was one of the slogans that were prominently displayed all over Rotterdam during Erasmus Year in 2008.

Artists, too, are still socially involved. In September 1999 the artist, Ida van der Lee, set up her *Wasgoed is goed* (Laundry is Great) project in her own long street: Vrolikstraat, in Amsterdam (see photo on p. 10). She roped in the people from the neighbourhood for the purpose. 175 lines of colourful washing ran from one house to another, literally joining up people from different back-grounds. It turned washing into a personal and human sign of life amongst all that urban stone. With this playful contravention of the rules – because offi-cially it is not permitted to hang washing in public or on the facade of a house – Van der Lee wanted to make it clear that the environment, which is more and more defined by regulations, looks livelier and more cheerful with a bit more freedom. It made the street appear more southern and less cold, and that en-couraged a sense of community. Beauty is consolation, and both should be shared. Just as in a more recent project by Van der Lee that can be seen at www. allerzielenalom.nl, in which artists and volunteers transform graveyards and memorial sites into attractive and hospitable places to meet in the evening, with snacks and drinks for the relatives. Artists help to turn memories and emotions into words, pictures or sound, and bring the living and the dead together again in the process.

A subject of ongoing concern

So yes... it is not only the government that is concerned about the welfare of the community – although the government's concern should certainly not be under-estimated. In the Netherlands the Social and Cultural Planning Office (SCP) keeps a finger on the pulse of the population's welfare, and in Flanders, too, the mood of society is checked on a regular basis. In February 2009 studies by or-ganisations such as Vrind (Flemish Regional Indicators) and SCV (Socio-Cultural Shifts in Flanders) still show that Flanders is a rather contented region, *'rather community-oriented, with high socio-economic expectations vis-à-vis the govern-*

ment, but with only moderate trust in that government, and always looking for a greater subjective experience of happiness and contentment.'

So, we may be at our best when we are taking care of others, but when it comes to happiness that subjective factor should hardly be underestimated. In scientific terms happiness is defined as subjective well-being. Of course, that makes it an extremely relative idea. Kant thought happiness a vague concept and Hegel called periods of happiness the empty pages of history. So happiness is pretty hard to grasp. Nonetheless, people are still trying to measure what they call 'gross national happiness' and to record the results of these measurements in a World Happiness Database. There is even a *Journal of Happiness Studies.* It was founded by the Dutch Sociology Professor Ruut Veenhoven of Rotterdam's Erasmus University. He has been doing research into happiness for years. According to him, people's happiness depends on *'freedom of choice, the extent to which one can lead an upright existence, enjoying a basic prosperity and having the chance to run your own life.'* Although he readily admits that a number of more banal factors also play a part; a moderate climate, for example – and we haven't even mentioned Wellness Centres and Prozac yet.

Wellness in Rotterdam.

The Pavilion of Temporary Happiness, built out of 33,000 beer crates in Brussels in 2008.

In any case, Veenhoven's calculations show that the role of the welfare state is not unimportant to the happiness of the individual. People need a few certainties to help contain the unknown. They want to be able to function within a social network. And it is not only Facebook that *'helps you connect and share with the people in your life'* – a good government system helps with that too. But, as we have said already, ulterior motives obviously come into it as well. At its best you could call the welfare state a form of management, at its worst it's crowd control. And that is why the Dutch philosopher Hans Achterhuis put his finger on the problem when he pointed to the increasing dependence of the individual in the welfare state and wrote that social utopia leads almost inevitably to enslavement and totalitarianism. Welfare may be a subject of ongoing concern, happiness should not. Happiness exists precisely by grace of the imperfection of our existence, in which we are, at best, caught between uncomfortable contentment and more-or-less comfortable discontent. Or, as Maurice Maeterlinck, the only Belgian ever to be so fortunate as to win the Nobel Prize for Literature, put it: *'Being happy means that you no longer worry about happiness.'* ∎

Translated by Lindsay Edwards

Anton Korteweg

Doing Extremely Well

I've already been asked to join the Rotary, which
is mainly my own fault, because
I've done extremely well and in spite of that
I've still kept some boyish quality.

Over these years my wife has actually
hardly aged at all, still dresses simply
but with good taste and spends the evenings
making textile pictures.

Our children we call the small fry, they are
exactly one boy and one girl, and they
are still the sunshine in the house, inspiring
envy or adoration in our friends.

If this goes on I'll not be able to resist
cutting a piece of plywood one day, misty-eyed,
and with a red-hot knitting needle burning on it:
'Where Love dwells, there the Lord bestows his blessing.'

Herrlich Weit

Reeds werd ik voor de Rotary gevraagd, waar ik
het zelf wel naar gemaakt heb, want
ik heb het herrlich weit gebracht en ondanks dat
nog iets jongensachtigs behouden.

Mijn vrouw werd in die jaren nauwelijks
wat ouder, eigenlijk, kleedt zich nog steeds
eenvoudig maar met smaak en maakt
's avonds textielschilderijen.

Onze kinderen noemen wij grut, het zijn
precies één jongen en één meisje, zij
zijn steeds het zonnetje in huis en wekken
bij vrienden afgunst of vertedering.

Als dit zo doorgaat houd ik het niet tegen
dat 'k eens met vochtig oog 'n stuk triplex afzaag
En daarin met een gloeiende breinaald brand:
'Waar Liefde woont gebiedt de Heer zijn zegen.'

From *Between Two Silences*
(Tussen twee stilten. Amsterdam: Meulenhoff, 1982).
Translated by Tanis Guest

Amsterdam.
Photo by Wilco Tuinebreijer.

Cultured Nature and Naturalised Culture

The Veluwe from 1908 to the Present Day

[PIETER LEROY]

A century ago, in 1908, a certain Anton Kröller purchased around 6,000 hectares of land in the Veluwe region in the east of the Netherlands. Kröller was a wealthy businessman, dealer and industrialist. He was not the only wealthy Dutchman from the traditional nobility or the newly rich bourgeoisie who bought land in this area. The Dutch royal family also purchased land there, gradually increasing their holdings to 10,000 hectares by the beginning of the twentieth century. Many others, too, especially from the world of industry and finance, bought considerable tracts of land in the Veluwe in this period.

In that same year of 1908 Anton's wife, Hélène Kröller-Müller, bought the painting *Four Withered Sunflowers* by Vincent van Gogh. It was not the first work by Van Gogh purchased by Mrs Kröller-Müller in this period, but it was certainly one of the most important. Right up to the 1930s she would collect a large

Vincent van Gogh,
Four Withered Sunflowers.
1887. Kröller-Müller
Museum, Otterlo

Entrance of the Kröller-
Müller Museum.
Photo by Walter Herfst
(courtesy of Kröller-Müller
Museum, Otterlo).

number of paintings, sculptures and other works of art. She and her husband
also commissioned the architect H.P. Berlage to build the architecturally strik-
ing St Hubertus hunting lodge on their estate in the Veluwe, where they lived
for a while. During this period numerous people, including the famous Belgian
architect Henry Van de Velde, were also hard at work drawing and planning a
museum to house and exhibit all these art treasures.

Helene Kröller-Müller
(1869-1939).
Photo courtesy of
Kröller-Müller Museum,
Otterlo

A double purchase followed by a forced sale

Between 1929 and 1932, in the wake of the stock market crash, the Dutch econo-
my took a downturn. The slump also impacted on the business activities of Anton
Kröller, who actually went bankrupt. The Kröller-Müller family had no alterna-
tive but to sell its considerable assets. In 1935 they entered into an agreement
with the State: the works of art were transferred to a Foundation and housed in
a museum. In 1938 Mrs Kröller-Müller even became – briefly – the museum's
first director. Both she and her husband died shortly afterwards. For all manner
of reasons the new museum envisaged in the agreement did not materialise,
although in the 1970s the existing building was – considerably – enlarged by the
addition of a new wing. Since then the museum has been constantly remodelled

and adapted to meet the demands of the day. The famous sculpture garden has also been substantially extended and remodelled. The whole complex has for a long time been known as the Kröller-Müller Museum, famed among other things for its impressive Van Gogh collection and its many paintings and sculptures, mainly from the nineteenth and twentieth centuries.

The original property has also largely been preserved intact: the St Hubertus hunting lodge and several other buildings, and above all the impressive family estate. The latter forms the basis of what is now the Hoge Veluwe National Park, of which the museum is literally the centre point.

Despite its forced sale, then, the Kröller-Müllers' double purchase – nature and culture together – has been preserved and a hundred years later is still in good condition and as contemporary as ever. Not only that, but both the museum and the estate are major tourist attractions. The museum can count on between 250,000 and 300,000 visitors a year, rising to over 400,000 in years when there are special exhibitions. The National Park does even better, pulling in more than 500,000 visitors a year, rising over 600,000 in peak years. Organisationally, the 'nature' (the National Park) and the 'culture' (the museum), have been entrusted to two different Foundations. This is logical not only from an operational point of view, but also because the management of nature and culture demand different and sometimes even opposing approaches. In any event, the Kröller-Müller is one of the few museums in Europe to be so deeply embedded in a nature park, and the park is the only nature reserve in Europe with a heavily visited museum at its heart. Yet park and museum are inextricably bound together. The two institutions themselves also think so, as is clear from their mission statements and strategies, which are dominated by precisely that combination of nature and culture. And their visitors evidently think the same: all surveys and studies show that they too greatly appreciate the combination of nature and culture. Which does not mean, of course, that this combination is still self-evident today, 100 years on.

The Veluwe as a region

The area that is broadly known as 'the Veluwe' lies in the heart of the Netherlands: between the towns of Zwolle to the north, Arnhem to the south and Apeldoorn to the east, and bounded in the north-west by the IJsselmeer. When defined as broadly as this, the area covers more than 100,000 hectares. The geological origins of what in the generally flat Netherlands is sometimes called – with some irony – the 'Veluwe Massif', lie in the early Pleistocene period, up to around 150,000 years ago, when glaciers penetrated to the centre of the present-day Netherlands via what is now the IJsselmeer. The Veluwe's characteristic hills, like those around the cities of Utrecht and Nijmegen, mark the edges of the old glaciers.

Photo courtesy of Fotowerkgroep De Hoge Veluwe.

This geological prehistory also explains the poor soil of the Veluwe; farming, in common with other forms of land use, has never been really economically viable here. In the middle of the nineteenth century, too, with the exception of a few agricultural enclaves, the area consisted of a more or less continuous, slightly hilly sandy landscape where heather was virtually the only vegetation.

After this, however, between the mid-nineteenth and the start of the twentieth century, the area was the scene of large-scale reforestation. This was profitable at the time because of the great demand for timber from the mining industry. At the same time, the plantations offered a means of stabilising the shifting sand to some extent. At the turn of the last century, however, the demand for timber gradually declined, so that this activity became yet another that was barely economically viable. The land was poor, of no agricultural interest, and

now also less attractive for forestry, and could therefore be purchased reasonably cheaply. This tempted wealthy aristocrats and industrialists into buying up sizeable tracts of land; these were used partly for hunting, and partly as country estates. The Kröller-Müllers too evidently saw it as a good investment. Like many landowners, however, they later sold their land again, of their own free will or out of necessity, for better or for worse.

After the Second World War especially, many of these estates came into the hands of public and private organisations working to conserve nature, forest and landscape. Of the Veluwe's original 100,000 hectares, 17,000 are now in the hands of the Staatsbosbeheer (State Forestry Service), 12,000 are held by the Vereniging Natuurmonumenten (the Society for the Preservation of Natural Monuments in the Netherlands), 6,000 by the provincial landscape organisation Geldersch Landschap and more than 15,000 by local authorities in the area. A further 13,000 hectares are owned by the Dutch Ministry of Defence. The Hoge Veluwe National Park itself covers 'only' 5,500 hectares. During the Second World War part of the former privately owned land was used by the Germans to build an airfield which is now owned by the Ministry of Defence. The area is thus divided up among a small number of large landholders. The pre-war ownership structure is still clearly visible, however, in the 10,000 hectares that belong to the Crown, and in the more than 20,000 hectares, often in large parcels, which are in the hands of a large number of private landowners.

The Veluwe as a nature reserve

As stated, the Hoge Veluwe National Park comprises only around 5,500 hectares. But it lies at the heart of the much larger area of 100,000 hectares which make up the Veluwe. This makes it the second largest contiguous nature area in the Netherlands after the Waddenzee. That such a large contiguous area has been preserved is entirely due to two factors: the poor quality of the land – nature reserves are more likely to emerge where economic activities are not (or no longer) viable – and the large size of the holdings, which prevents excessive fragmentation. Large tracts of the Veluwe now fall under European nature protection regimes, as well as under a mountain of constantly-developing Dutch nature policy. This is not to say that the Veluwe in a broad sense is managed in a uniform way: the aims and interests of the various owners differ too widely for this. Moreover, the authorities – for a long time mainly central government, but from the mid-1990s mainly the Province of Gelderland – have been somewhat inconsistent as regards nature policy. This erratic course is due mainly to constantly evolving scientific views on the one hand and the differing interests of the landholders on the other.

For all these reasons, in recent decades the Veluwe has become *the* arena in which virtually all the debates and discussions on nature management in the Netherlands have been conducted. Those discussions began as long ago as 1945, when the Dutch government first developed its own nature policy. Until then, nature management had been a matter for private organisations and wealthy individuals. But the discussions became more heated after the 1970s, when growing environmental awareness also boosted nature conservation, and along with ecology nature conservation too gained a (varying degree of) scientific legitimacy.

Photo courtesy of
Fotowerkgroep De Hoge
Veluwe.

One general discussion concerned the question whether 'nature areas' – placed between quotation marks because these were of course areas largely shaped by humans and by culture – should leave nature to take its course 'undisturbed' or whether a more 'hands-on' management policy was required. And whether those responsible opted for a highly extensive approach, preferably with an absolute minimum of human interference, or for the opposite – intensive human intervention – in either case the question then arose of precisely what kind of 'nature' was envisaged. What, in modern terms, was the ideal image of nature: what kind of nature was to be created? For the Veluwe, as indeed for many nature areas in Europe, the period around 1900 was and remains a historical reference point. It was in that period, as later became apparent, that the biological diversity of the Veluwe – an important indicator of the quality of nature – was at its greatest.

If this was a topic discussed mainly by biologists, ecologists and other nature scientists, a second debate was of a much more social and political kind. For some, there was little appeal in the idea of a commitment to 'nature'; they felt that areas such as the Veluwe should be managed not as a nature reserve but as a cultural landscape. This was partly a question of new cultural and historical thinking and an appreciation of cultural heritage. That heritage is particularly clearly visible in (nature) areas such as the Veluwe. Partly, however, the hope was that under a culture-based policy all manner of economic and other activities would be subject to fewer constraints. The large private landowners, for example, had no wish to see the value of their land diminished by it being designated a nature area. The same certainly went for the farmers who struggled to make a living from the few poor agricultural enclaves. It also

Photo courtesy of
Fotowerkgroep De Hoge
Veluwe.

applied, and especially since the 1970s still applies, to a rapidly growing tourist infrastructure of hotels, cafes, campsites and all the other accoutrements of the modern tourist industry. They too are keen to take advantage of the large numbers of visitors to the Veluwe. None of these groups, then, had anything to gain from a strict nature protection regime.

A third, constantly recurring topic of discussion concerns the question of whether the Veluwe should to some extent be 'screened off' from the outside world, in order to prevent erosion and fragmentation, or whether it should be open to all. In the 1960s, the prevailing idea was that nature areas should be segregated from the outside world; that the 'modern' outside world, with its industrial farming, its industry and pollution, its infrastructure criss-crossing the landscape and its noise, should be excluded. Whether inspired mainly by Jean-Jacques Rousseau, by romantic ideals or by ecological views, many nature conservationists saw natural monuments and nature areas as the last refuges of the pre-modern age. That strategy of shutting out the outside world helped to ensure that the Veluwe remained a relatively unspoilt, continuous area. Where cutting through the landscape with infrastructure could not be avoided, as with the A50 motorway, 'ecoducts' and 'wildlife tunnels' provided animal-friendly connections from the 1980s onwards. But the emergence of a new strategy, the more aggressive 'nature development', is taking contemporary conservation policy a step further: today a nature area must be embedded in its environment, must even try to influence it. It is for this reason that the Province of Gelderland now talks about 'the endless Veluwe': a concept which combines preserving the continuity of the area, with no internal barriers, on the one hand, with on the other the green 'arteries' which are designed to extend from the heart of the nature area and make the surrounding environment more nature-friendly. Among other things, the idea is to create 'ecological gateways' which would offer a larg-

er foraging area and more opportunities for migration to the rich local fauna. This would enhance the available resources, the intermingling and ultimately the resilience of animals of all kinds. But ranged against the idealistic picture of a Veluwe deer wandering through the Renkum valley to drink from the Rhine near Arnhem is the anxiety felt by farmers at the prospect of wild boar from the Veluwe wreaking havoc on their farms. In short, the debate about the isolation or opening up of nature areas is entering another new round. And once again, ecological rigour often conflicts with social acceptance.

The museum as a centre of culture

The history of the Veluwe reflects the changing and divergent ideals of Dutch nature policy, and in fact of nature policy throughout Europe. As the biggest nature area in the Netherlands, the Veluwe has often been both the debating chamber and the trial ground for national nature policy, with an added European dimension and impact. Participation in these discussions was also anything but optional for the Veluwe itself, where the combination of the nature park with the museum actually gave rise to extra tensions, or at least to ideals which were not obviously compatible.

Entirely in line with the wishes of its first director, Hélène Kröller-Müller herself, three elements were to guarantee the unique character and success of

Kenneth Snelson's aluminium and steel *Needle Tower* (1968) in the sculpture garden. Photo courtesy of Kröller-Müller Museum, Otterlo

the museum: the visual arts, architecture and nature. Where in 1938 painting was dominant, today it is – more than anyone could then have imagined – above all the sculptures and all manner of 'spatial objects' which set the tone. Along with the museum proper, the role of the sculpture garden has thus become much greater. And it is precisely that sculpture garden which in its own individual way provides a link between architecture, art and nature.

Maintaining that link is not always easy: in early 2007 the museum suffered considerable damage when a spring gale brought down about 20 trees. That is not a problem likely to trouble the average urban museum. This is a mere anecdote, but it does make clear that for a museum situated in the middle of a nature or park area just to exist, project itself and attract visitors is no simple matter. Its location inevitably imposes constraints on visitors, on their travel routes, on their ability to stay in the immediate vicinity, etc. Partly because of this, the museum pursues a very active marketing strategy. It employs all manner of activities in the effort to raise its profile, activities which deliberately stress the combination of nature and culture. One of its most recent initiatives was the children's book *Hélène's Secret* (Het geheim van Hélène, 2007) by the well-known Dutch children's author Lydia Rood, which tells the story of Hélène Müller and the way in which she established her art collection. More than a purely historical account, the book was primarily intended to arouse the interest of children in this special combination of civilised, tamed nature and carefully selected culture.

The National Park as a tourist attraction: nature as culture

The sculpture garden.

If there is a great deal of discussion about the management of the entire nature area known as the Veluwe, of course the same also goes for the Hoge Veluwe National Park. Without going into technical details, in managing the National Park, too, conflicting objectives have to be reconciled: nature conservation and tourism; nature education and the peace and safety of the flora and fauna. To some extent, as in other nature reserves, this is achieved by 'zoning': different parts of the Park are designated for different primary uses, each governed by different protection regimes, and with different activities permitted in them. For this reason, a clear distinction is made in the National Park between the heath lands (wet, dry and sparse grassland), the forested areas (reserve, coppice woodland and cultural woodland), the fens, sand drifts and a number of other areas. And the area of the Park immediately surrounding the museum is an out-and-out park landscape and is managed, or, as those responsible put it themselves, manicured as such.

This zoning and the various associated restrictions help to sustain nature in a civilised way. But anyone who visits the Hoge Veluwe National Park wants to be able to cycle around, preferably everywhere, and especially in those areas where there are animals to be seen. The educational objective that has been part of nature conservation from the start is no longer a matter of folders and boards didactically imparting information on the surrounding nature and its inhabitants. Spoiled by Discovery Channel and other spectacular and civilised images of nature, visitors to the park – and by no means only child visitors – are eager to see a wild boar, even more eager to see a doe, and yet more eager still to see a stag, the pinnacle of photogenic and endearing nature. And the Park

White bikes used to
cycle around the Hoge
Veluwe National Park.

does indeed advertise *'the chance of an unexpected encounter with a stag'*. But more or less guaranteeing such an attraction places considerable demands on the management of nature and its resident wildlife. A hundred years after Hélène and Anton's initial purchase, their ideal of intertwining nature and culture is as valid as ever; but it is no more self-evident today than it was then. ■

Translated by Julian Ross

National Park: www.hogeveluwe.nl
Museum: www.kmm.nl

Beneath the City Streets, the Beach

The Ideas and Work of Louis Le Roy

DAVID STROBAND

I first came into contact with the work of Louis Le Roy (1924-) in the early 1970s, when I was a youthful Frisian. My primary-school teacher very enthusiastically told us about a long narrow roadside verge in Heerenveen where nature was left to go its own way. Sowing and planting were haphazard, rubble from roadworks was dumped at the site and local residents used it to create all sorts of structures and constructions. All this was presented in class as being an absolute free state where anything was possible and which ultimately was likely to evolve – visually at least – into utter chaos.

That was my first introduction to Louis Le Roy. Now over 80, he studied at the Royal Academy of Art in The Hague and became internationally famous from the early 1970s onwards for his innovative insights into the field of town and country planning, approaches to nature, garden design, and cohesion between man and nature. As a nine-year old, I obviously had no idea of the meaning of Louis Le Roy's work. I thought of wild gardens as fun and adventurous; but at the same time many people then associated these natural environments with innovative alternative ways of living – something which we nine-year olds found somewhat strange and disturbing. But the name Le Roy became a sort of 'brand' for us. Whenever we saw a garden that was totally uncared-for, where plants, shrubs and flowers were growing into and over each other, we called it a 'Le Roy garden'. We had no idea whether it was a garden deliberately conceived according to Le Roy's principles, or whether the owner had simply neglected it. Actually, to be quite honest, we usually assumed the latter.

At the beginning of the 1970s, a strip of land amounting to one and a half hectares (1 kilometre long and 18 metres wide) in the central reservation of the Kennedylaan in Heerenveen was made available to Le Roy. Le Roy had taught drawing at a secondary school in Heerenveen for many years. He took quite a prominent role in the life of the town, and regarded his own garden in Oranjewoud as a laboratory where natural processes could take their course unchecked. He was then already convinced that nature contains all manner of underlying structures that only become truly visible with the passage of time. None of these processes should be disrupted or stopped; interesting natural structures would evolve if all organic life forms were given unlimited time to develop.

The original plan was to fill the central reservation of the Kennedylaan with a monoculture of ground-cover plants. Le Roy, on the other hand, mobilised local residents to work with him at the site, sowing, planting, piling things up and digging without restriction. Once sown or planted, the green area had to be left to develop in its own way. The plant communities would organise and (re-)group themselves: the organisms themselves determined their own place. The aim was to create an ecological strip (with autonomous natural processes), a natural 'tongue' that would, as it were, reach into the city from the surrounding countryside. Building rubble was dumped at the site and a wild garden evolved with all manner of vegetation and structures made from paving blocks, drains and kerbstones. It was forbidden to use machines or remove any (natural) waste. The site's layout was not based on any form of strategic thinking; any intervention was spontaneous and carried out without a preconceived plan. This was always intended to be an open-ended project. Eventually nature began to cooperate, giving rise to ever more complex structures. Man and nature had only to use their free, creative energy for a fruitful interaction between nature and man to evolve. Le Roy had envisaged working with local residents for thirty years to develop the site, but the time came when the Heerenveen local authority decided the project had gone on for long enough and pulled out of the project. The strip of land has now become a real woodland area; the structures are still visible.

Louis Le Roy, Garden, Kennedylaan, Heerenveen. Photo by Peter Wouda.

Wild gardening

The age in which Le Roy was working in the early 1970s was one in which everything that had seemed impossible became possible. In the 1960s Guy Debord had spoken of the yearning for the beach that lay hidden beneath the asphalt of the city streets, in a statement that seems to sum up the period well. Many peo-

ple discovered new freedoms, new ways of living and, above all, their own energy and creativity. In that respect, it seemed, the sky was the limit. Experimenting, ideally in cooperation with others, gave rise to all manner of new perspectives on the reality that surrounds us. Given this growing mood of breaking established boundaries, it is not surprising that Le Roy's theories proved particularly appealing. A great deal was written about the Heerenveen project in newspa-

Louis Le Roy at the eco-cathedral in Mildam. Photo by Peter Wouda.

pers and magazines, and in 1970 and 1972 Dutch television broadcast documentaries about it. In 1973, Le Roy published his first book, *Switching Off Nature, Switching On Nature* (Natuur uitschakelen — Natuur inschakelen), in which he formulated and illustrated his ideas about 'wild gardening'. He discusses all manner of ecological principles and argues strongly against the current thinking on garden and nature management, dominated by neatly mown lawns and regimented planting schemes. Le Roy regards the prevailing views on man's relationship with nature as impoverished and above all unnatural. In his opinion, dispensing with design and control will lead to a world that is far richer and more true to nature.

Le Roy then wrote a series of articles for the journal *Plan* in which, among other things, he fulminates against the French architect Emile Aillaud's design for the 'La Grande Borne' housing estate in Paris (1967-1971). The architectural press extolled this design as an example of new and promising design and construction. For Le Roy, it was a funereal form of architecture from which all life had been expunged and which would stifle all the residents' creativity. He predicted that they would lose all consciousness of time and space and any sense of involvement with their surroundings. Ten or fifteen years later, this urban area was struggling with immense social problems.

As a result of his Kennedylaan project, Le Roy received many commissions in the 1970s – including some from abroad. Cities such as Bremen, Oldenburg, Hamburg, Kassel, and Berlin invited him to create areas within their communities. All these initiatives foundered at a fairly early stage. Either there were objections to the project time-scale of at least 30 years, or the public participation – which Le Roy thought indispensable – caused problems. It was clear that the local authorities in these cities were afraid of losing their control over the processes involved in such a commission. This has done nothing to improve Le Roy's opinion of civil servants.

In Brussels Le Roy worked with Lucien Kroll and a group of students on a project in the Brussels university district of Sint-Lambrechts-Woluwe. It was not long before the project was demolished under police supervision. He was also commissioned to create green areas in the Paris suburb of Clergy-Pontoise but was sacked, according to the commissioning party, when it was discovered that he was concerned as much with people as with plants.

At the beginning of the 1970s, a six-hectare area of land in the new housing development of Lewenborg in Groningen was made available to Le Roy. Lewenborg was to be a green development, and Le Roy was deemed to be the person who could realise this in an inventive and cost-effective way. Again, public involvement was to be an important aspect. The area was to be created with, and above all by, the local residents. The process was somewhat slow to get off the ground. At first building walls and laying paths without any preconceived plan was too adventurous for many people. When one of the local residents impulsively built a model railway on the site, however, there was no stopping them. Suddenly Le Roy's plea to do away with all the boundaries between properties and gardens so that private and public land would be seamlessly integrated met with a massive response. People laid paths and extended their own grounds into the public areas. Many shared facilities were created, including tree houses, play areas, vegetable plots, a windmill and an apiary. The area burst into life and became increasingly overgrown. As often happened with Le Roy's projects, relations became polarised. There were more and more protests against this 'free state'; many people were afraid that this 'mess' would decrease the value of their houses. In 1983, ten years after the initiative had been launched, the Groningen local authority terminated its agreement with Le Roy. This led to heated debates, which were picked up by the media. A management group comprising local residents and local-authority officials was set up to manage the further 'development' of the area according to Le Roy's ideas. Against all the master's principles, however, the process had to be regulated.

A gardener with ideas

In the past Le Roy has often been described as a 'wild gardener'. Title of honour or not, this label does not do justice to the rich and complex thinking and ideas of this artist and cultural philosopher. One work that clearly demonstrates the complexity of his ideas and methods is his 'eco-cathedral' at Mildam, a village located a stone's throw from Heerenveen. This major project began in 1983. Le Roy had previously acquired the four-hectare site and with his own hands had built a studio out of scrap timber there.

On entering the eco-cathedral, the observer cannot immediately make out everything that is going on. Complications also arise if the observer decides to evaluate the whole thing directly as a work of art. Applying aesthetic criteria only leaves one somewhat disorientated; no regular design principles are apparent; rather, the overriding impression is one of formlessness. This area full of trees, bushes, plants and small piles of rubble does not reveal its true, intricate character until it has been observed in detail. In the specific area that used to be a simple monoculture, Le Roy set to work sowing and planting in his usual way. At the same time, lorries regularly arrived at the site to deposit rubble – ranging from road and paving materials to debris from a demolished

A piece of the wall of
Le Roy's eco-cathedral
in Mildam.
Photo by Peter Wouda.

prison. Le Roy carefully sorts and stacks all the material. This is a never-end-
ing process. On the one hand he lets Mother Nature take her course, but on the
other he enters into a dialogue with her by creating artificial structures such as
paths and low walls. Le Roy is actually creating a network of broad stone strips
on which are stacked two or more layers of stone, creating a network of thick
stone ledges with a strong vertical emphasis. Le Roy uses his materials dry,
without shaping or cement. The complex stacks and paths eventually enter into
a fruitful relationship with burgeoning nature. They allow plants and flowers
to grow in the gaps between the stones, and they 'regulate' the water balance.
Le Roy has a strong predilection for complex arrangements. In his studio in
Mildam there is a table covered with all sorts of apparently chaotic composi-
tions of stones and rusty nails, while in his house in Oranjewoud the windowsills
are piled high with coloured glass objects acquired from flea markets.

Once in the eco-cathedral, one follows a system of winding paths that leads
through the trees, bushes and plants. It is often necessary to climb over the
piles of stones to reach another part of the site. Most of the paths and stacks
are overgrown with vegetation and the visitor can imagine himself in a realm
of light-hearted and therefore free interaction with nature. One's movements
are gently directed, yet there is a sense of enormous freedom of movement. Le
Roy's ideas and mindset are partly inspired by the Frenchman mentioned above,
Guy Debord. As early as the 1950s, this leader of international situationism
formulated conditions which would allow people to move around freely and in
a non-prescribed way. The Situationist International encouraged small groups
of people to roam around cities at random. These wanderings were supposed
to have no goal or function, so that they were free to experience their surround-

ings in an open and value-free way, and hence to develop into free creative beings. In the 1950s the artist Constant Nieuwenhuys designed the utopia *New Babylon*. Within this fantastic labyrinth of variously shaped buildings, bizarre routes and multi-level spaces humans would be able to rediscover their freedom, their unbridled creative potential and sense of play and so make the most of their lives. In New Babylon, man and his environment should form a single whole. The urban environment draws people in, while at the same time encouraging them to use their free creative energy to the full. Stimulating this free and creative energy is very important to Le Roy. This is evident in his participation projects mentioned above, but also in the challenging question he asks himself: what can a man achieve in time and space? This question provides an important basis for his work on the eco-cathedral.

Louis Le Roy's eco-cathedral in Mildam. Photo by Peter Wouda.

Le Roy regards a number of concepts drawn from the French philosopher Henri Bergson as extremely important: *'Reason as an inheritance'* and *'Time as a Continuum and Engagement'*. *'Without free disposal over physical space, life cannot develop (...). Time is an equally essential factor. Short-lived actions or "spectacles" can indeed release creative forces for a brief while, but in the end they have to form part of a process, a temporal continuum, to bring about a true "creative evolution". Finally, commitment is an important factor; the investing of "free energy", of man's creative potential'.*[1]

The Belgian biochemist and Nobel Prize winner Ilya Prigogine (1917-2003) focused on concepts such as complexity, interactions, chance, unpredictability and the phenomenon of 'self-organisation'. *'Why is there order in the world, when the Second Law of Thermodynamics states that, if you leave all the atoms to their own devices, this will result in disorder. Give the world unlimited time, and ultimate*

chaos will result'.[2] Yet this is not the case. 'In the real world atoms are never left to their own devices, but are always exposed to a certain level of external energy and material. In a limited area, this can give rise to complex structures, which then organise themselves. Traditional science, which is geared towards predictability within closed and repeatable situations, had a blind spot as regards this type of self-organising system'.[3] According to Prigogine, this traditional view, with its blind spots, is to be found not only in science but also in our perception of organic processes and the way in which our society is structured. 'The elimination of chance and unpredictability seems to be inextricably linked to concepts such as power, planning, design, control, management and governance. Power promotes that which is equal, controllable and predictable, and is consequently in continuous conflict with anything that seeks to organise itself and thus departs from the prevailing order'[4] Prigogine campaigns against restriction and closedness, advocating open, dynamic systems within which time makes unpredictable possibilities possible. The thinking of Bergson and Prigogine provides a significant context for the ideas and work of Louis Le Roy.

As I already said, the visitor's first encounter with the eco-cathedral is not a particularly stunning visual experience. The beauty of the work lies much more in the concept of boundless space that underlies it and the time required for its completion. We associate the term 'cathedral' with generations of construction and with vast space, primarily in a spiritual sense but consequently in a physical sense too. Furthermore, a cathedral is unmistakeably a construction. In principle, so is the eco-cathedral, in both an organic and a conceptual sense. It is a beautiful experience to pay regular visits to this cathedral and see how the natural processes, being cultivated by Le Roy's work, develop over time and begin to organise themselves. You observe how, within a biotope – because that is what the eco-cathedral actually is – there is a constant struggle between chaos and order. The TIME Foundation, which protects and disseminate Le Roy's work and ideas, will ensure that the processes set in motion in the eco-cathedral can be continued until the year 3000. People will continue to work on the eco-cathedral throughout that period. To date, more than fifteen hundred lorry loads of building debris – in total over fifteen thousand tons – have been incorporated into the eco-cathedral. And many more will follow.

A liveable society

In addition to working on his projects, in recent decades Le Roy has given many lectures and published a number of books, including *Little Jokers* (Uilenspiegeltjes, 1984) and *Mondrian and Back* (Retourtje Mondriaan, 2003), in which he sets out a wide variety of thoughts on a more liveable society. Le Roy also has very definite ideas when it comes to urban and rural planning. He believes that in urban environments there needs to be much more room for ecological awareness. He views the modern-day city as a low-grade ecosystem: in his view, life is being banished from the city to make way for shoddy and monotonous systems. Le Roy remains convinced that every city should have a number of zones where nature can flourish unrestricted, and where people can participate and play a completely free creative part in it. In short: areas where self-organisation predominates and nothing at all is designed. For Le Roy, a mere 1% of the urban area and participation by 1% of the population is

sufficient for this. And we have to say it again: self-organisation produces more complex – and therefore superior – results than designed systems. Le Roy formulated ideas for green, open cities as early as 1973, in his book *Switching Off Nature – Switching On Nature*. He believes that the city should be a green, ecologically sound oasis (with allotments, among other things), with the surrounding countryside functioning as an organic production (industrial) area. This, then, is where organic agriculture is to be practised.

Le Roy formulated these ideas during the period just after the Club of Rome had published its ominous report. Today, things look no better for the world. Environmental damage, globalisation, commercialisation and the sad fact that fewer and fewer people take the time to contemplate the world we live in: all these things mean that Le Roy's thoughts and perspectives remain highly relevant. His arguments and his interventions in our public spaces attest to a well-thought-out, layered, 'clean' vision for a liveable 'western' world.

In February 2008, Le Roy was awarded the Gerrit Benner Oeuvre Prize by the province of Friesland. In 2002 he was awarded a prize for his oeuvre by the Netherlands Foundation for Visual Arts, Design and Architecture (*Fonds BKVB*). But I have to agree with the opinion of Huub Mous who wrote that it is not a good idea to offer Louis Le Roy a protected place within the canon of cultural or art history.[5] He must not become known as a utopian, a self-willed individualist who can think in a free and creative way and create spaces where one can enjoy spending time. The eco-cathedral must never become a museum or a monument. Le Roy's ideas and work must remain live, current and therefore organic. ∎

Translated by Yvette Mead

NOTES

1. Piet Vollaard, 'Time-based Architecture in Mildam. De ecokathedraal van Louis Le Roy (ca.1970-3000)'. In: *Natuur Cultuur Fusie: Louis G. Le Roy*. Rotterdam: NAi, 2002, p. 22.
2. Huub Mous, 'Waarom krijgt Le Roy niet de tijd?'. In: *Dansen tussen fundamenten; Essays over het kathedrale werk in Mildam*. Heerenveen: Stichting TIJD, 2004, p.15.
3. ibid. p.15.
4. ibid. p.15.
5. ibid. p.31.

LITERATURE

Manja van Herpen, *Ecologische kunst / exploitatie van ecologische processen als kunstuiting*. Heerlen, 2005. Dissertation, Open Universiteit Nederland. Webversie 2006. Chapter 3: 'Louis G. Le Roy, invloedrijk en onbekend'.

Huub Mous, 'Waarom krijgt Le Roy niet de tijd?'. In: *Dansen tussen fundamenten; Essays over het kathedrale werk in Mildam*. Heerenveen: Stichting TIJD, 2004, pp. 13-31.

Hagen Rosenheinrich, 'Louis Le Roy. Evolutie en maatschappij, orde of chaos?'. in: *Natuur Cultuur Fusie: Louis G. Le Roy*. Rotterdam: NAi, 2002, pp.47-56.

Vincent van Rossem, 'Anders denken, anders tuinieren'. In: *Natuur Cultuur Fusie: Louis G. Le Roy*. Rotterdam: NAi, 2002, pp. 75-81.

Louis G. Le Roy, *Natuur Uitschakelen Natuur Inschakelen*. Deventer: Ankh-Hermes, 1973.

Piet Vollaard, 'Time-based Architecture in Mildam. De ecokathedraal van Louis Le Roy (ca.1970-3000)'. In: *Natuur Cultuur Fusie: Louis G. Le Roy*. Rotterdam: NAi, 2002, pp.18-26.

Unveiling Dutch America

The New Netherland Project

[PETER A. DOUGLAS]

> To get the truth one must … go into the archives for the past,
> and let those long dead speak in their own defense.[1]
> (*William Elliot Griffis, 1843-1928*)

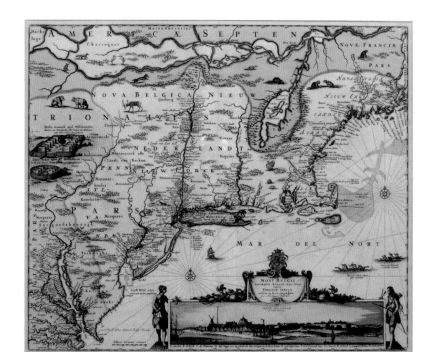

Justus Danckerts's *Novi Belgii Novaeque Angliae*, a map of New Netherland and New England. Mid-1650s, engraved as a copy of Nicholas Visscher's 1651 composite map. Photo www.nnp.org.

The New World colony of the Netherlands was called 'New Netherland' and extended from the Connecticut River to Delaware Bay, comprising much of the current states of New York, New Jersey, Pennsylvania, Delaware, and western Connecticut. It thus represents a significant slice of the continent, and yet its role in the development of this country has been little known. Today this important central region of the eastern United States still contains scores of communities whose names are of Dutch origin, whose inhabitants must thus be vaguely aware that there is some lost part to their history.

The Dutch period in North America began in 1609 with Henry Hudson's exploration of the river that would be given his name. In 1614 the New Netherland

Company was licensed by the States General of the United Provinces for fur trading in the newly discovered region, and in 1621 the West India Company was chartered to trade in Africa, Brazil, and North America. The Company sent the first colonists to New Netherland in 1624, and by 1664 the population is estimated at around 9,000.

While it's clear that there was a lot going on in Dutch America, it has undeservedly remained a historical backwater. The reason was the lack of usable primary source materials for critical examination and interpretation. In 1974 Dr Louis Leonard Tucker, then State Historian of New York, lamented *the primitive state of this area of American historiography*. He quotes George Zabriskie, who said in 1971: *The story of New Netherland is one of the best-kept secrets in American history.* *And so it is,* adds Tucker. *American libraries bulge with accounts of the English phase of our colonial history, especially of the founding and settlement of New England, but they are conspicuously lacking in works on New Netherland.*[2]

It was becoming clear that the story of New Netherland warranted a more extensive analysis. But how was that to be achieved? The answer was the creation in 1974 of the New Netherland Project, leading to Charles Gehring's translations of the surviving seventeenth-century Dutch records. This was a turning point in American historiography, and the work still goes on after thirty-four years. To understand the true importance of this work it is necessary to see how things were before.

Henry Hudson Memorial Column in Henry Hudson Park (Riverdale, The Bronx).

A lost world

Until recently a schoolchild's knowledge of colonial America – or anyone else's for that matter – was typically limited to the familiar Anglocentric story. According to New Netherland Project staff: *New Netherland got underway at about the same time the Pilgrims were settling Cape Cod and the Jamestown colony was establishing itself in Virginia, but you wouldn't know that from most history books.*[3] The implicit question is obvious: what was in the huge space in between – just wilderness and Indians? The English colonies are always endorsed as the unique beginnings of American society. Tucker writes that just a glance through textbooks on colonial American history shows how one-sided the treatment has been. *The story of early New York,* he says, *is generally sketched in broad, superficial strokes until the English assume control, at which point the scenario is developed in lavish detail.*[4]

Once, historians of colonial America dismissed the Dutch colony in a few lines or relied on English sources, which naturally portrayed it from an adversarial stance. After all, the English were commercial rivals, and for much of the late seventeenth century they were engaged in the Anglo-Dutch Wars for control of the seas and trade routes. The English got to tell their American story, while the Dutch, their language, and their once-thriving colony, withered into three centuries of shadows and distortion. Perhaps the name Peter Stuyvesant broke the surface, but little else. Part of this misapprehension stems from the writings of Washington Irving, whose droll Knickerbocker tales were taken as fact, consigning the American Dutch image to mere caricature and comedy.

New Netherland has been called *the forgotten colony*, *a lost world*, and *history's debutante*.[5] Why this is so is not hard to fathom. The records are in seventeenth-century Dutch, making them impenetrable to all but a handful of

The Dutch monument in Battery Park, NYC.

scholars who specialise in this rarefied linguistic interest. Despite partial early translations, this simple language barrier eclipsed the Dutch story, preventing historians from giving it its full and rightful exposure. And the victors write the history books. In this case the English, who took over the Dutch colony, provisionally in 1664 and then permanently in 1674. New Amsterdam became New York, and the sun set on the Dutch trading empire in North America. When the administrative papers of New Netherland were turned over to the English, the new rulers kept them for purposes of legal continuity but official records were thenceforth in English. For all the struggling cultural persistence of the Dutch, within a generation following the takeover the documents of New Netherland would have become indecipherable to those now running the colony, and of less and less interest and consequence. The result was that the vast space between the English-held lands was overlooked and the facts neglected or garbled by contemporary English versions. The story of America became the account of what happened in the colonies to the north and south of New Netherland.

Diverse dangers and misfortunes

What are these documents? Like any good bureaucracy, the Dutch administration kept copious records. These include Council Minutes, which are the records of the executive, legislative, and judicial activities of the colonial government in Manhattan that dealt with the affairs of the entire colony. The register of the Provincial Secretary contains court depositions, bonds, leases, deeds, and other legal instruments that formed the legal basis for land titles. The records contain matters relating to local communities as well as those dealing with various regions of New Netherland as a whole, including the Netherlands Antilles. There are also laws, ordinances, and correspondence between the Council, especially the Director General, and various individuals, officers, and the board of the West India Company back in Amsterdam.

The story of the New Netherland Project is inextricably fused with these documents. They are its raw material. Had the papers survived in perfect condition, the translators' hurdles would still have been substantial. However, they suffered many brushes with destruction over the centuries, rendering them physically very difficult to work with. Translators faced, and still face, two basic problems – the translation process itself and the poor condition of the extant manuscripts.

After passing into the hands of the English, the records endured countless hazards. The first major losses probably occurred around 1686-90 during the merger of the New England colonies known as the Dominion of New England. The Dutch records were moved to the administrative centre in Boston and then back to New York; it can only be imagined what was left behind or lost on these journeys. During the slave insurrection in 1741 in New York a fire broke out in the fort where the Dutch records were kept. The documents were thrown into the street to save them, and inevitably many were lost. The documents spent much of the Revolutionary War in the holds of English hulks moored in New York harbour and consequently faced many perils such as dampness and the gnawing of rats. Dr Gehring has translated many pages edged with teeth marks.

After these diverse dangers and varying amounts of wear and tear, neglect, carelessness, and indifference, the documents went to the Secretary of State's

office in New York. When Albany became the capital in 1797 the records were moved there. The restless documents were again moved to the New York State Library in 1881. However, they were far from safe there for it was their storage in the library that led to the worst misfortune of all to befall them.

In March 1911 the western end of the State Capitol in Albany burned – a great calamity as this was then the site of the State Library. The catastrophic fire destroyed some 450,000 books and 270,000 manuscripts, some of the latter being Dutch papers. Those that were not completely burned were singed or otherwise damaged. What remained of the records were heaps of baked and charred papers, water-damaged and frozen into black clumps. So many of them are now little more than brittle ovals with the corners and margins blackened or burned away. Even documents that were not exposed to the flames suffered heat damage; what had been black ink on white paper one day on the next had turned into light brown ink on beige paper. There is some irony in the reason why so many of the Dutch records survived. The English records, considered more important and thus stored on higher and more easily accessed shelves, fell on top of the Dutch documents and protected them.

Dr Janny Venema of the NNP examining a document, singed at the edges and missing bits, using a magnifier. Photo by Dietrich Gehring.

Despite the losses, primary source information on the Dutch colonies is not lacking as some 12,000 pages survived, preserved in the New York State Archives. For all that has been lost, the body of existing documents forms a

Portrait of
Peter Stuyvesant on
a stained-glass window
at St Mark's, NYC.

large collection of hitherto little explored fundamental records of this Dutch colonial society – official governmental records that are more fascinating than that label suggests, being the very fabric of the colony's life in all its rich and essential human detail.

Early translation attempts

Over the last two centuries several people have attempted to organise and translate these papers, but the results were unsound and selectively done, often with personal bias and bowdlerisation: anything considered salacious or offensive to nineteenth-century translators was passed over. The first concerted effort to make the documents accessible for historical research was in 1818 when Governor Clinton commissioned Adriaen van der Kemp to translate the records.[6] But his work was unreliable due to his failing eyesight, numerous

mistranscriptions and mistranslations, and the omission without editorial comment of passages that he considered dull or inconsequential. Though never published, this second-rate work nevertheless offered the only access to the New Netherland period throughout much of the nineteenth century.

The largest body of work was achieved by Edmund O'Callaghan (1797-1880), an Irish-born Canadian doctor, journalist, and political reformer. O'Callaghan devoted himself with indefatigable energy to the publication of documents relating to the colonial period. Before doing his own translations, in the 1850s he dismantled and re-assembled the Dutch records in accordance with his ideas of chronology and record type, destroying forever their archival integrity. As a translator O'Callaghan was an improvement over Van der Kemp, but his lack of knowledge of seventeenth-century culture was a limitation. Berthold Fernow (1837-1908) succeeded O'Callaghan. By 1883 he had published his translations of three volumes, but they contained only records that Fernow considered significant, and he divided his translations into geographical groupings, losing all sense of contextual connection and continuity.

For all their scholarly zeal, the work of these early translators was inconsistent and included only a small part of the total New Netherland archives. Their attempts were ambitious but unreliable, and limited by their imperfect understanding of the seventeenth-century Dutch experience, culture, and terminology. Systematic, careful transcription and translation of the documents were not undertaken until this task was approached by Arnold J.F. Van Laer (1869-1955), a learned Dutch immigrant who became an archivist in the State Library in 1899.

In 1910, dissatisfied with the previous shaky interpretations of the Dutch records, Van Laer decided to translate and edit them himself. His work has earned him the status of the brightest star in this early scholarly constellation. While he judiciously consulted the patchy work of his predecessors, he relied on his own encyclopedic background in languages and history, including the language and customs of the Dutch in the seventeenth century. His profound learning enabled him to decipher the meaning of misspelled words and ungrammatical constructions, and he was able to recreate the style of colonial Dutch writers in modern English. Although devastated by the fire, this became his life's work until he retired in 1939.

After Van Laer's death in 1955, any scheme for translating these Dutch records was all but forgotten. Until Dr Gehring's translations, historians had little choice but to rely on the small portion of the Dutch records that had so far been deciphered, and despite their deficiencies they were widely used for want of anything better. Most of the documents remained locked in their original language, and a thorough disclosure of Dutch America would have to wait.

Van Laer's work was finally published in 1974 under the auspices of the Holland Society of New York, stimulating a renewed interest in the manuscripts. This was not the only vital role that the Holland Society played in the creation of the Project, for Ralph DeGroff Sr., a trustee of the Society, was instrumental in its establishment. Peter Christoph of the State Library contacted Ralph DeGroff, who got in touch with fellow Holland Society member Cortlandt van Rensselaer Schuyler. Schuyler introduced DeGroff to Nelson Rockefeller, who, although no longer Governor, still had influence and connections. The result was the underwriting of the initial funding of the New Netherland Project. Christoph had money to hire a translator for a year.

And clearly it was time. Dr Tucker hailed the publication of Van Laer's translations by asserting in the preface that it was time to end *'the intellectual blackout which has darkened the early history of the Empire State.'* He fervently hoped that Van Laer's *New York Historical Manuscripts: Dutch* would bring this much needed illumination. *'If not,'* he said, *'the search must continue.'* [7] Fortunately, the search was over.

Charles Gehring and the New Netherland Project

Historian and librarian Peter Christoph wrote: *'When I became curator of historical manuscripts at the New York State Library I found it frustrating to have in my custody tens of thousands of ancient Dutch documents that nobody could read.'* [8] When Christoph made the acquaintance of Charles Gehring, a scholar with a doctorate in Germanic linguistics, at a history conference in the early 1970s it was an auspicious meeting. Charles Gehring was the ideal choice to be involved in the rekindled translation project, and his association with Christoph

Dr Janny Venema and Dr Charles Gehring of the NNP. Photo by Dietrich Gehring.

was the first step that led to the establishment in September 1974 of the New Netherland Project, under the sponsorship of the New York State Library and the Holland Society of New York, and with Dr Gehring as translator and editor of New York colonial documents. A full thirty-five years after the retirement of A.J.F. Van Laer in 1939, there was once more a translator of Dutch records. Charles Gehring's complex, demanding, and clearly long-term task was now to resuscitate the translation project and to help put the complete story of America's Dutch past squarely in the limelight.

The Project's purpose is to translate and edit for publication the surviving archival records of New Netherland. These are a major source for the study of early history, government, and culture in the region. The focus is one corpus of documents – the official records comprising the remains of the archives kept in the Provincial Secretary's office in the fort in New Amsterdam, covering the whole of New Netherland and not just the events on Manhattan Island. Secondary objectives are to collect copies of these seventeenth-century Dutch manuscripts relating to New Netherland held in other repositories to centralise the source material, and to publish documents online, starting with volumes of translations no longer in print.

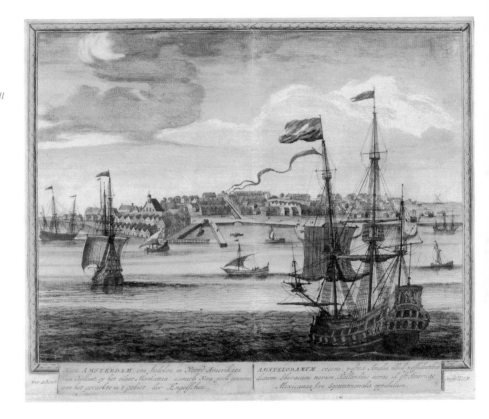

Peter Schenk's view of
'New Amsterdam, a Small
Town in New Holland in
North America, on the
Island of Manhattan,
Renamed New York
when it Became Part
of the Territory of the
English'. 1702.
Photo www.nnp.org.

The translation process

Since 1974 thousands of delicate pages have passed through Dr Gehring's hands. Now he takes a document from a filing cabinet drawer. The bindings are long gone, the leather covers and O'Callaghan's front and back matter having been discarded after the fire, leaving only the documents themselves. When he gently removes the document from its folder, one is not quite sure if the smoky smell of the 1911 fire again hangs faintly in the air. If it's still there, the translator says he doesn't notice it any more.

The fragile paper is baked to a tan colour and scorched black and cracked around its edges. The text is first painstakingly transcribed and then translated, the form and meaning of the writing wrung from the faint curlicues of ink at a rate that depends on the nature of the text and the condition of the manuscript. To the appalling physical state of the pages other problems must be added. The translator's art is difficult and frequently dissatisfying. Skill and patience are required to grasp the words' subtle layers of meaning and extract and convert their intended sense, balancing the literal meaning of the original with the correct and natural equivalent expression in English. Add to these customary prob-

lems of the translator those met when confronting a language spoken centuries ago, and it becomes much more than a cultural and linguistic issue; it becomes a historical one, too.

Like any language, Dutch has changed in the last 350 years, leaving its distant colonial forebear frozen as it was back in the seventeenth century, so a knowledge of modern Dutch helps only so much. Historical documents contain words that have not survived. Some refer to objects and concepts unknown or unfamiliar to twenty-first century readers, and the meaning of others subtly shifts over time through a variety of linguistic processes. The significance and usage of a word must thus be carefully derived as much from the historical context of the document as from the dictionary. The translator must have an acute cultural sensitivity and be steeped in the history and customs of the writers.

The orthography is not English, and this adds an initial unfamiliarity to the florid and sometimes challenging penmanship, which is very different from German *Frakturschrift* and English secretary hands. The Dutch devised their own secretarial style, though variations and irregularities are attributable to the techniques and personalities of numerous individual clerks over the many

Dr Martha D. Shattuck of the NNP. Photo by Dietrich Gehring

decades. Often phonetic spelling occurs, rendering the same word or name in a variety of ways, in the same and in different documents. Capital letters are tossed in at random, and this, along with idiosyncratic ideas of punctuation or its absence altogether, adds to the difficulty of knowing where one sentence ends and the next begins.

Translating is only part of the work, for after this comes editing and all the stages of publication. Dr Gehring has had help over the years, most notably, since 1985, the invaluable assistance of his colleague and now Assistant Director Dr Janny Venema, who graduated from transcribing the documents to translating them too. Since 1988 the demanding and essential tasks of research, editing, and indexing the translations have been accomplished by Dr Martha D. Shattuck.

Finally, we cannot ignore the human touch. One of the covert delights of translating is getting acquainted with the documents' writers – the personality of each as revealed through his writing. There is a strong personal relationship here, and the translators can't help but wonder about the writers with whom they might spend days or weeks, and speak of them as if they were old family friends, each with his individual quirks and personality.

The achievements of the project

The translations lay bare thousands of intimate vignettes and the workings of a long-defunct society. As the Project's website states, the translations give *'access to hearts, minds, and concerns of the men and women of New Netherland.'* Some accounts are as pompous as only official documents can be, and yet for all that the scenes are enlivened by the novelty of their historical perspective and our fresh glimpses of a departed world. Some succeed in being animated and engaging beneath the stilted bureaucratic prose, lives now discernible with much captivating human detail, awaiting recognition and review, a rich new vein of raw material for enlightened and inspired historians to notice, investigate, analyse, and integrate into their teaching and writing.

While these are administrative records and not social history, a careful examination reveals a lively image of this aspect of the era, the daily life of a vibrant seventeenth-century society. *'The social history is bubbling up between the lines,'* says Charles Gehring.[9] As each volume is published, it provides access to a fairer perception of the country's early history, the story of a non-English company colony containing a broad spectrum of nationalities, races, and religions, uncovered now from many viewpoints – archaeology, architecture, anthropology, politics, material culture, criminal justice, relations with the Indians, economics and agriculture.

The Dyckman House, the last Dutch colonial farmhouse in Manhattan, built c.1784 and opened as the Dyckman Farmhouse Museum in 1916.

One major problem was recognised from the start. The Project could not succeed as a purely 'ivory tower' operation. The objective was both to create the material and to make sure that the world found out about it. Unfortunately, the impact of such projects in the humanities is not always immediately apparent, for these undertakings have a slow fuse, creating very deliberately the building blocks for generations of scholars, and not making sparks or quick headlines. To fulfil their mission the Project staff require communication and interaction with the world they are helping. In 1991 Dr Gehring neatly summed up the job he faced, then seventeen years into the Herculean task and God knows how many from its conclusion. '*The challenge,*' he said, '*was to transfer the perception of translating seventeenth-century Dutch as an exotic exercise into a means of understanding American heritage.*'[10] The challenge is more than just to add volumes to library shelves; it is also to broadcast the availability of this new source material far and wide.

Beginning in 1979, the Project furthered interest in its work and in the Dutch period by organising the annual Rensselaerswijck Seminars – named for the historic patronship in the Albany region – on numerous topics relating to New Netherland. Few were aware of the Project's existence and achievements, and after five years it was time to go public. Originally, the seminars lacked an operating budget and the scale was small. Local scholars and researchers gave talks on the history of the Albany area, and the seminars were open to the public at no charge. Eventually it became clear that a wider horizon was necessary, and the seminars were opened up as a forum to present and share research on the broad theme of the Dutch experience in the New World. The seminars continue, offering an outlet for each year's fresh accumulation of New Netherland scholarship. Speakers are invited to give papers on aspects of an annual theme.

Another form of outreach, since 1985, is *De Nieu Nederlandse Marcurius*, a quarterly newsletter that contains news of the Project and details of associated activities, including exhibitions, conferences, publications, sources of information, general interest articles on Dutch matters, and research in progress. In this and other ways a community of scholarship and public interest is fostered and maintained on both sides of the Atlantic, in Netherlands old and new.

The New Netherland Institute is the Project's support structure, established in 2005 and originally set up in 1986 as Friends of the New Netherland Project. It sustains and promotes the Project and helps maintain its financial security, as well as fostering interest in the Dutch role in America's history. In its effort to push the Project's visibility, the Institute is increasing awareness of New Netherland through public programmes, services, and publications. The Institute's President Charles Wendell asserts that on the work of the Project '*rests most if not all that has been achieved in New Netherland scholarship to date.*' [11]

The work of the Project has proven valuable to a variety of entities with related interests. These include the city of Albany, whose mayor has enlisted the help of Drs Gehring and Venema in identifying sites for archaeological excavations. Specialists in restoration and preservation have consulted Project staff concerning Dutch barns, descriptions of house interiors, and decoration. Manuscript curators and archivists nationwide have been helped in the organisation and description of their Dutch holdings, and museums in the US and abroad have received support in furthering various research projects. Staff have taught courses and given numerous lectures. Assistance has been given with television documentaries, museum exhibits, books, newspaper articles, field

archaeology, and lawsuits. While time-consuming and a distraction from the essential business of translation, such activities help raise the Project's profile and influence in many areas, which is equally vital.

It was always considered important to make this source material available to the public and to schools. To inject the information into the world of formal children's education, Project staff worked with local schools and helped develop teaching guides and fourth and seventh grade 'Curriculum Packets Using Primary Documents.' This enables students and teachers to make use of these new primary materials in learning about the early Dutch settlers.

Most crucial has been the effort to penetrate universities, engaging the scholars who write the history books to get the real Dutch story told within the broader scope of the country's formative years by writers for whom the heretofore impenetrable language of the source material was the sole impediment. All this assiduous labour must be absorbed into a new continuum of America's story, made use of by historians who can finally get to grips with what has for so long been inaccessible, and so rescue the Dutch contribution from 'the dustbin of American history.'[12] It seems to be working. Profiting from the availability of new information as the colony emerged from its shadowland, the more recent books on New Netherland have been markedly different from the older histories. In 1987 John J. McCusker wrote: 'The recent spate of studies of the Dutch in America ... has been provoked by the efforts of archivists to make Dutch-language documents more accessible.' [13]

To date nineteen volumes of the New Netherland Documents series have been published, representing approximately sixty-five percent of the total. The Director estimates that it will take another twenty years to fulfil the project's mission, though many variables affect such a timeline, especially the availability of funding. In 2001 the journalist Paul Grondahl wrote: 'The work has become Gehring's Sistine Chapel.' [14] In fact, Michelangelo spent a mere four years on that ceiling, but we get the point.

In 1994, twenty years after the Project's inception, Dr Gehring's work on behalf of New Netherland was formally recognised when he was made an Officer of the Order of Orange-Nassau (Orde van Oranje Nassau) by the Netherlands' Queen Beatrix, a prestigious order dating from 1892 and the Dutch equivalent of the Order of the British Empire. This honour is for outstanding service to the Netherlands, and for the same reason was awarded to A.J.F. Van Laer in 1937.[15] The award is the highest honour the Queen can bestow on someone who is not a Dutch citizen. This recognition speaks volumes for the significance of the Project.

What really happened in 'old New York'

New Netherland is our new Cinderella, once undeservedly neglected and now lifted from darkness to recognition and significance. In 1974 the New York State Historian wrote: 'Some day the obscurity surrounding the beginnings of the Empire State will pass and we shall be in a position to determine what really happened in "old New York".'[16]

That day dawned with the founding of the New Netherland Project. Now using the original sources in English, historians can make a more informed, objective, and balanced assessment of the Dutch impact in North America.

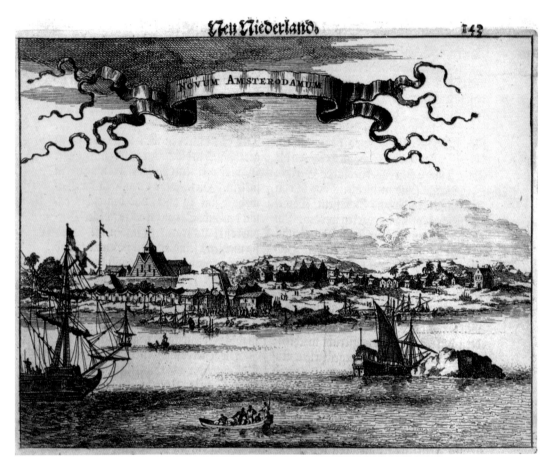

Novum Amsterodamum

Arnoldus Montanus'
Novum Amsterodamum
(1671). It depicts New
Amsterdam as it looked
in 1651. Photo www.
nnp.org.

The translation project is ongoing, and the information brought to light has already contributed much to the clarification and rehabilitation of the Dutch role in America's story. Thanks to thirty-four years of industry and diligence, the New Netherland Project has pried open the past to create a new historical dimension, allowing us to read the actual words of those no longer so enigmatic colonists, making, at last, vivid and clear this new Dutch landscape in the west. ∎

www.nnp.org
www.henryhudson400.com

NOTES

1. William Elliot Griffis, preface, *The Story of New Netherland*. Boston and New York: Houghton Mifflin, 1909, p. 2.

2. L.L. Tucker, preface to A.J.F. Van Laer, *New York Historical Documents: Dutch, Vol.1 Register of the Provincial Secretary 1638-1642*, Co., Baltimore: Genealogical Publishing, 1974, p. VII; ibid, p. VII, ibid, p. VII.

3. www.nnp.org

4. Tucker, op. cit. p. vii.

5. Laura Cruz, 'New Netherland: History's Debutante', 'Review of Joyce Goodfriend, ed., *Revisiting New Netherland, H-Atlantic*, November 14, 2006, (www.h-net.org/reviews/showrev.cgi?path= 73041168447180) (August 8, 2008).

6. Charles Gehring, 'New Netherland Manuscripts in United States Repositories'. In: *De Halve Maen*, August 1983, vol. 57, p. 5.

7. Tucker, op. cit. p. VII.

8. Peter Christoph, 'Story of New Netherland Project'. In: *De Halve Maen*, September 1988, vol. 61, p. 5.

9. Interview with Charles Gehring, August 6, 2008.

10. Charles T. Gehring, introduction to Nancy Anne McClure Zeller, ed. *A Beautiful and Fruitful Place: Selected Rensselaerswijck Seminar Papers*. Albany, NY: New Netherland Publishing. 1991, p. IX.

11. Charles W. Wendell, letter to the membership of the New Netherland Institute, December 4, 2007.

12. Paul Grondahl, 'Dutch Treat: A Rollicking History of Colonial Manhattan Springs Forth from State Library Records'. In: *Albany Times Union*, March 21, 2004, p. J1.

13. John J. McCusker, review of Oliver A. Rink, 'Holland on the Hudson'. In: *The Business History Review*, August 1987, Vol. 61, No.3, p. 480.

14. Paul Grondahl, 'Dutch Feat'. In: *Albany Times Union*, March 29, 2001, p. D1.

15. Kenneth Scott and Kenn Stryker-Rodda, 'Holland Society Publishes Van Laer Translations''. In: *De Halve Maen*, April 1974, vol. 49, pp. 5-6.

16. Tucker, op. cit., p. VII.

A Guided Tour of the Gilded Cage

Jan Van Loy Takes the Reader by the Ear

'It's not very nice when the rest of the world sees you as an idle layabout', Jan Van Loy (1964-) told the Flemish newspaper *De Standaard* in 2006. For years he had cherished the dream of becoming a writer, but not a single text had ever made it into print. 'In the end I became a computer scientist, because there was a shortage of those. The firm I applied to for a job wasn't in any hurry to take me on, but, well, there wasn't anybody else and I had a website that didn't look bad.'

And then his career as a writer suddenly took off. The short story 'Jan Foster's Hell' ('De hel van Jan Foster') won the Rabobank Lenteprijs for 2001. His debut novel *Scraps* (Bankvlees, 2004) received the Debuutprijs for new writers in 2005. His second book, *Alpha America* (Alfa Amerika, 2005), was shortlisted for the Gouden Uil, one of the most prestigious awards in the Dutch-speaking world. And if the book didn't actually make it all the way, so what – it was reason enough to look out for Van Loy's third book, published in the autumn of 2008.

The Pound (De heining) revolves round a gated community. Much against the husband's inclination, a young couple buy a fantastically expensive house in the Windroos, a neighbourhood that is completely fenced off from the world and closely guarded. (The title alludes to this total *com*pound ('*om*heining'); Van Loy has dropped the first syllable. That does not change the meaning, but it makes for a striking title). The pair have barely moved in when Van Loy dumps a torrent of calamities on them. The neighbouring village, it turns out, detests the people from the gated community. Racism, corruption, alcohol abuse... the Windroos has it all. The couple's relationship hits a crisis and things are not improved when a neighbour's little boy disappears from the face of the earth when the man was supposed to have been looking after him.

Quite a dense plot, and yet Van Loy tells the tale in a mere 160 pages. In 61 chapters you hurtle through a controlled nightmare with a happy ending. Sprinting, it seems, is what suits Van Loy best. His first book ran to barely two hundred pages; his second, *Alpha America*, is sometimes referred to – rather strangely – as a novel, but in fact the book consists of four clearly separate short stories; *The Pound* is roughly the same length as a single story from *Alpha America*. One interesting difference is that in his second book Van Loy employed a detached, almost documentary-like narrative style, whereas a good three-quarters of *The Pound* is made up of dialogue. Whatever his approach, Van Loy's

Jan Van Loy
(1964-).
Photo by Stephan
Vanfleteren.

narrative is always tight and cinematic. In *The Pound* his camera glides over the story and zooms in on every absurdity, every possible sign of something being amiss. And that makes the book unputdownable.

True, the message is on the simple side: a walled community may feel safe, but danger lurks in every corner (and will not hesitate to leap out). Nonetheless, *The Pound* is a thrilling tale – and that in itself is not so easy to write. It is only with this third book that Van Loy clearly reveals what his literary world is really all about.

Flight from predictability

To illustrate this, let us return for a moment to *Scraps*, a picaresque novel about two highly-educated twenty-somethings who opt out of the rat race and disregard all society's expectations of them. They live on welfare benefits, on handouts from rich people's children, and on the backs of accommodating girls who don't mind being prostitutes. The 'scraps' of the title is a synonym for 'trim-mings', discarded oddments of bacon or meat. The only meat the two of them

can allow themselves at the end of the month, is *'groin and fat trimmings and lumps of gristle and goodness only knows what other bits and bobs. (...). The good thing about a meal of meat scraps is that it stays in your belly as long as possible, because the money for food's almost run out.'* The anonymous main character and the diehard trouble-maker Celis are social off-cuts, the scraps of society. The meat metaphor is carried through into the chapter titles. 'Chicken' refers to the innocent chick who lets herself be pressed into service as a prostitute by Celis. In 'Carpaccio' the action moves to Italy and 'Strasbourg' is the name for the cold meats served to the main character in a psychiatric institution to which he has had himself admitted on account of the free meals and warm bed.

Scraps is an engaging novel about the longing to build a life that goes beyond the established patterns of expectation. For the main character that is just a phase, a delayed puberty: for his companion it is a way of life. *'Predictability'*, Van Loy fulminates as he describes what his anti-heroes are fleeing from: *'Being like this when you're twenty, and like that when you're thirty. (...) And material progress, and the conversations that are never about anything else. The house, the car, the next holiday, the photos from the last one. The kids.'* And in the end that is exactly the life he chooses.

In the margins of reality

In *Alpha America* too we see attempts to break free. In 'Manhattan on the left bank', set at the beginning of the twentieth century, a penniless Flemish man travels to New York where he amasses a fortune (see extract further on). In 'The train of tears' ('De trein der tranen') the singer Eddie Eijkelboom flies to the US, there to make a name for himself with his band. In 'Bodega Vespucci' the main character wants to 'make it' in Hollywood and, finally, in 'Pornology' ('Pornologie') the American credo of 'sex sells' is tried out on Flemish television. The link between the tales is as clear as crystal: America is seen as the continent for those with ambition, Europe as the place where people fail. And one by one Van Loy brings his characters back to Flanders.

Also striking is the fact that the stories take place right alongside reality. 'Pornology' begins as an accurate description of the Flemish television landscape of the 1980s, but then suddenly a fictitious broadcasting station is introduced. And 'Manhattan on the left bank', almost universally regarded as the strongest story in this uneven collection, could have been a true story – apart from the ending. The stock market millionaire returns to Antwerp, where he builds a city of skyscrapers on the Left Bank. However, people refuse to go and live in the towers. His city is destroyed by bombing in World War Two. Anyone who knows a bit about Antwerp knows that there really are a good many tall buildings on the left bank of the River Scheldt, but they do not owe their existence to Van Loy's stock exchange prodigy.

Failed rebels

As we have already said, stories about breaking free, every one of them. No wonder, then, that for his most recent (and best) book to date, Van Loy ended up with the controversial phenomenon of gated communities. Crucial to the novel

is Bril, the only inhabitant of the Windroos with whom the main character forms a kind of friendship. Bril is a cynical drunkard who now and then says something sensible. But he is also a typical Van Loy personage: a failed rebel. One minute he is calling a mobile phone an 'ankle tag': 'Telephone calls from the wife. Mobile controllability. Now, how can you trust one another if you don't give each other a chance to cheat?' But a bit later he is imploring the main character to stop him drinking that first glass next time: 'No! Bullshit. No personal responsibility. That cop-out of "leave him be" – bullshit! (...)...generations have let each other be...And this is the result. Where we are now. The Pound, that's the result.'

Bril is a man of independent means: thanks to an inheritance, he doesn't need to work. Yet even he ricochets back and forth between freedom (of speech, as regards sexual relationships...) and the longing above all to be kept in check (his drinking habits, his decision to go and live in the Windroos). Maybe that is the reason why he and the main character get on so well together, because the main character has these contradictory longings too: one minute he is trying to get himself rejected as a resident of the Windroos by the committee (much to the wrath of his wife), but a bit later he is putting down more money so they can buy the house.

The ear of the reader

So, after three books, we have a fairly clear picture of what interests Van Loy: modern, over-indulged, people and their relationship to the gilded cage in which they live. That theme gives scope for a lot of humour (as *The Pound* shows once again) and for feelings. Because *Scraps* is about friendship and *The Pound* about fatherhood.

'I am motivated by my dissatisfaction with contemporary literary prose: it's too often an excuse for amateur philosophy and pseudo-poetry', said Van Loy, in a (rare) interview in 2006. 'Or the umpteenth adulation of sadness and melancholy. For me it's all about the art of the narrative, in which the events contain the philosophy and the poetry, and the passages with lyrical or intellectual aspirations come only from the mouths of stupid and/or pretentious characters. W. Hermans, one of my idols, once said: "you have to take the reader by the ear and drag him through the story". That's my ambition. I want my own ear to hurt and to make my readers' ears hurt too.' (De Standaard)

Thus far he has given his readers mainly pleasure, because if there is one thing that sticks out a mile, it is that Van Loy is an extremely talented story-teller, particularly of stories to do with freedom and all the illusions that go with it. And thanks to his previous history as someone who spent years as an unemployed layabout, he is also someone who knows how it feels to pursue a dream. ■

www.janvanloy.com

Translated by Sheila M. Dale

An Extract from *Alpha America*

By Jan Van Loy

The Great Bear

On 17 January 1920 alcoholic beverages became illegal in the United States and stockmarket prices had already been falling for several months. The Twenties had begun, but as yet they were neither gay nor roaring.

O'Neill had timed his speculative activities to perfection: every day he was short-selling for all he was worth, shares that he didn't have, on the assumption that he would be able to buy them up later at a sharply reduced price. Every day he was shorter in the market, and although he spread his activities across various brokers, his intentions became public.

BOY PLUNGER is now
The GREAT BEAR
PETER O'NEILL
POUNDING AWAY AT STOCKS

was the *New York Times* headline above a single-column article on 3 February 1920 on O'Neill's great turnaround: once a 'bull', who had helped push prices up, which was considered favourable for the common interest, he had now become a 'bear', one of those contemptible speculators who hoped to make money from falling prices, causing nothing but misery to 'ordinary' investors, and hence also to the bulk of newspaper readers.

'The Great Bear' was a name previously given to several big speculators, but O'Neill had no preference for falling or rising prices.

'I just follow the movement of the market. I don't determine how it moves. Even if I wanted to, I don't have enough influence to set the direction. Nor do others, who would very much like to have.'

Thus read the quote in a follow-up article. However, these kinds of assertion, whether true or not, could not expect an understanding reception: speculating on falling share prices was pessimistic and hence un-American. Speculators such as Arthur Cutten, like O'Neill 'worth' several million dollars, refused to speculate on falling prices under any circumstances and took an eternally optimistic view: 'The economy is sound and share prices will recover' – anyone maintaining the opposite or even trying to qualify this view was close to being a threat to the state.

But while he was successful, the rich young upstart remained popular. In

1920 we find the first letters from a friend, Jack Henry, posted in what was then still a peaceful Californian village, where he worked as a public relations officer for Universal Studios.

'Keep on pounding, Peter! As long as you go on making me rich, you can unleash a real panic as far as I'm concerned.' (2 March 1920)

In the second decade of the twentieth century Jack Henry had been a very successful producer of musicals on Broadway and in that capacity had not only met but had become friends with the 'boy plunger'. Since Henry's lucrative move to California, his motto had been: 'Movies are the next thing, the theatre will die.' He was both right and wrong: in the 1920s Hollywood grew into the world centre of film production, but at the same time Broadway theatre experienced its absolute heyday.

Ex-chorus girl Fanny Lovejoy had no part in that heyday: she devoted herself single-mindedly to endlessly remodelling the three-floor apartment, emptying Fifth Avenue boutiques and ensuring that O'Neill had not a single evening's peace. He complained about this to Leen:

'There's a soirée almost every day, at our place or someone else's, or I have to go to a show in town. And it's becoming more and more obvious that she's expecting, but she won't calm down. I've rented an office in town where I lock myself away every day in order to be able to work in peace, without her coming in every five minutes to show me a new hat or something. Sometimes I think I should have stayed a bachelor a while longer, but anyway, I'll be glad when I have a son. A daughter will be just as good, it's all the same.' (20 January 1920)

Finding an office was no problem for O'Neill: stockbrokers provided separate accommodation for their top clients, and major speculators who by definition did a lot of trading and hence provided large amounts of commission were always good business.

O'Neill divided his office time between Brow-Lords and Dietrich, but in 1920 he used some fifty brokers to build up a huge short position. By the end of the year his (virtual) profit totalled eighteen million dollars. Henry received word that he would shortly be a dollar millionaire.

'I have the greatest confidence in your ability, but I don't understand how you can sleep at night. Not because of a bad conscience, but because of the fear of losing everything, which would plague me day and night.' (letter from Jack Henry, 23 December 1920)

O'Neill may have had trouble sleeping, but not because of the stockmarket: on 27 February 1920 Fanny gave birth to a bouncing baby daughter.

'Dorothy weighs eight pounds and is the cutest little thing you can imagine, really. She can yell so loud that people stick their fingers in their ears even in the servants' quarters. We have a nanny, because it seems to be driving Fanny crazy already and she has no patience. In the evenings, when the nanny has a day off I have to give the baby her bottle, me, a guy, what a punishment. I can't understand why Fanny never wants to feed the baby, when she's the mother, after all. Can you understand that? Anyway, I won't hide it from you, Leen, we sometimes have fights,' (7 March 1920)

Continuing as Usual

By January 1921 O'Neill had covered his short position in the market. He saw signs of an imminent turnaround: share prices would start rising again and he had eighteen million dollars available to make the most of it.

'OK, if you say I should wait to cash in, I'll wait.' (letter from Jack Henry, 28 January 1921)

Obviously Henry had asked to be paid his profit, but O'Neill thought it was better to wait until returns were even greater.

Prices kept falling. O'Neill had to limit his losses, but for the first time he allowed himself to be governed by his emotions. Suddenly he was no longer a tape reader but an emotional speculator, a dilettante who felt the market should follow him, instead of the other way round. He continued obstinately buying more shares. His margins were used up and he had to adjust. His millions melted away. His brokers made the same mistake: they had more faith in the 'boy plunger' than in the market, and when O'Neill had gone through all his capital, they lent him money, no less than two million dollars in all.

O'Neill was not himself. The reason why may perhaps be found in a letter to Leen:

St-Anneke, Left Bank, Antwerp, 2008.

'To my shame and sorrow I must tell you that my wife hasn't been home in a week. She left one night, after announcing that she was going out. Well, she's done that so often recently that I no longer care. But this time she didn't come back. I've already hired a detective. Dorothy is doing just fine.' (10 April 1921)

Two weeks later, under pressure from his brokers, O'Neill has to abandon his position in the market: he has squandered a fortune of over twenty million dollars and is two million dollars in the red. He still has forty thousand in a current account that the brokers and creditors know nothing about – a small amount, but still a stake to start all over again.

He has to fire his servants, give up his apartment, pay off his private detective and tell his friend Jack Henry that he has lost his money. At the bank an unpleasant surprise awaits him: his forty thousand was withdrawn by Fanny. On 6 May 1921, since he is unable to pay his debts, he files for bankruptcy. Three days later Fanny Lovejoy begins divorce proceedings on grounds of O'Neill's adultery with the nanny, Judy McKay. One of her demands is custody over Dorothy.

The number of letters to Leen, normally one every two or three weeks, falls sharply in this period. O'Neill, who by now is even in debt to his butler, brushes his problems under the carpet.

'Everything continues as usual here. How's Victor? I wish I could get away with Dorothy some time, you should see her.' (8 June 1921)

In a rare book from 1953, *The Great Speculators*, Theodore Lords, one of the partners in the stockbroking firm of Brown-Lords, is quoted as saying: 'Every great speculator has gone bankrupt at some time or other. The most harrowing case in my experience was Peter O'Neill. He's completely forgotten now but in those days he was a public figure in New York and was known as the 'great bear'. At the beginning of the 1920s he owed me a million, and I lost that money

when he went bankrupt. He had debts with other brokers too, and visited them all one by one to guarantee personally that he would eventually pay off his debts, although he was not compelled to do so in law. It must have been a humiliating procession. I was his biggest creditor and I can still see him standing there, he wouldn't sit down – he stood in front of my desk and said: I'll pay you back everything, with interest. And I thought: OK, fat chance. He'd been rich, and now he was living somewhere in a little hotel room with bedbugs and all that crap, you know. Not only had he lost all his money, but his wife had run off with a gangster, if I remember... The man was a wreck. But a great talent, as we all knew. He came and begged me for a new stake, so he could build something again. I was convinced he would manage it, and perhaps I might see my million dollars back. I made a hundred thousand dollars available for him to play with. If things went well he could keep the profit. I installed him in an office at our headquarters and a week later he had doubled the money. And a year later he paid me back a million, with interest, just as he'd promised. That man was really one of a kind.'

However deep O'Neill had fallen, returning to the old country was never an option. All he needed was a ticker tape and a telephone and he could have done that just as well in Muncie, Indiana – but he stayed in New York. While he tried to get back on his feet at his brokers' office, Judy McKay worked for nothing during the day looking after the baby. Occasionally he must have looked contentedly down from his sixth or tenth or twenty-first-storey window, at the bustle of what he now regarded as his city. He wanted to hear the horns of the automobiles and see the glow of the hundreds of thousands of bulbs in Times Square. 'Is New York the world's finest city?' wondered Ezra Pound in 1913. Of course it is, O'Neill would reply wholeheartedly, although he had seen scarcely any other city. ('Not far from it,' said Pound in reply to his own question.) When he was financially at rock bottom, his skin scarred by the bites of the bedbugs, O'Neill wrote an account to Leen, though she was not aware of his awkward situation:

'I spend most evenings at home, with Dorothy. If Judy, the nanny, can stay late, I sometimes take a walk down Fifth Avenue or Broadway, really wide boulevards like those in Antwerp, but much bigger and more brilliant, and when I look up, I think: nom de Dieu! How lucky I am to live here. Last Sunday I took Judy and Dorothy to the Statue of Liberty, and then we were able to look at the city across the water, the way I did when I arrived here on the boat. And we saw all those towers. Nom de Dieu! I must say that I... I don't know how to put it: happiness, do you know what I mean? I stood there with my little daughter on my arm and the sky was blue, and there was happiness. Knowing you're in your place, that you don't want to be anywhere else. Nom de Dieu, I kept saying, so often that the nanny asked: what is that, nom de Dieu? You should see it, Leen, this city. For the umpteenth time: I shouldn't come to Belgium, you should come here.' (4 September 1921)

'Nom de Dieu' is O'Neill's way of expressing what writer Mildred Stapley put better when at about the same time she described the special quality of the city that was rising ever higher:

> 'Money and greed may have produced it; but the thousands who lift their eyes to it daily, from ferry-boats and trains and bridges, are not thinking of the money behind it when they admire, rising out of the broken glitter of busy water at its base, the huge chain of buildings. The mass is beautiful. The commercial is lost in the esthetic.'

Fanny Lovejoy reaped what she had sown: before the adultery of which she had accused O'Neill could be proved, she herself was arrested in a raid on a speakeasy, an illegal drinking den. She was in the company of Artie Moskowitz and his entourage. As she was being taken to the police station, she protested vehemently that she was the wife of Peter O'Neill, the multi-millionaire, who at that moment was bottle-feeding his daughter in a room in the shabby Rivoli Hotel on Seventh Avenue.

The arrest featured in the press and the demands in Fanny's divorce petition no longer cut any ice. Artie Moskowitz seized his chance of making Fanny his once and for all and offered O'Neill a settlement: in exchange for a quick divorce by mutual consent Fanny would make no further claims on O'Neill, neither on any money he might one day have, nor on Dorothy. O'Neill accepted the offer eagerly.

In 1924, after Moskowitz was stabbed to death while leaving a drugstore, Fanny Lovejoy went to Hollywood, where following a few failed screen tests she started working as a call girl. In the 1930s she earned her living in that capacity in San Francisco and later in Miami, where she died in 1944 from the effects of syphilis.

A Simple Year

O'Neill's condition as a 'wreck' in the second half of 1921, at least in the memory of Theodore Lords, seems a normal enough one for someone who loses everything in such a short time. There are indications, though, that even without a trigger O'Neill suffered bouts of deep depression. In a significant aside Jack Henry wrote to a mutual acquaintance:

> 'Our boy plunger has, once again, plunged into the depths of despair.' (23 March 1924)

Still, things were looking up for O'Neill – not only on the stockmarket, where he seized every opportunity as never before to maximise his profit. He had moved to Riverside Drive, then an expensive, fashionable location, where he lived with his daughter and Judith the nanny.

'Business is great, but when I come home in the evenings the little one is there and that's true happiness. My Dorothy, she can't talk much yet but I talk to her, and when I do she looks at me as if she understands. I hope that you and Victor have lots of kiddies.' (letter to Leen, 19 March 1922)

'True happiness' was to prove insufficient, since O'Neill's ambitions just went on growing. After his bankruptcy, though, he had become more cautious: he insured himself against poverty and out of his profits bought annuities, not only for himself but also for Dorothy. For as long as they lived they would receive an annual allowance, without it being affected by any possible bankruptcy of O'Neill's.

In April he was again officially a bachelor. Two months later he married Judy McKay, who was ten years his senior. She was the complete opposite to Fanny Lovejoy: a homemaker, thrifty and a devoted mother to Dorothy. This latter consideration must have been a major motivation in O'Neill's decision to remarry. Although he would never have the 'fights' with her that he had had with Fanny, she obviously didn't meet all his needs. Jack Henry, who had risen to become a producer at Universal, wrote to him from Hollywood:

'Peter, will you please stop sending me your starlets who can't make it on Broadway? For a start I'm not an agent, and secondly we've got enough of those naïve farmers' daughters with more ambition than talent who arrive here through a male acquaintance in New York.' (2 January 1923)

Judy McKay too had something of the farmer's daughter about her, although she had grown up in Brooklyn: her appearance was plain, indeed even slightly elderly. In a photo of 1930 she looks like a dumpy matron who could be O'Neill's mother.

'As far as accumulation and leverage are concerned,' says O'Neill in the Memoirs, '1922 was my most successful year. Roughly one trade in ten failed – a very favourable ratio, and apart from that I was cold-blooded enough to keep a strict limit on losses. The successful trades usually yielded a profit of several hundred percent.'

In the summer of 1922, 'a simple year of simply rising prices', he was able to make a triumphant tour of the offices of Wall Street and pay off all his creditors. Jack Henry, naturally piqued about the loss of all his savings, was given a 'special remuneration' by O'Neill, after which their friendly relations could be resumed.

A year after his bankruptcy, after paying his debts, O'Neill again had a stake of two million dollars.

From *Alpha America* (Alfa Amerika. Amsterdam: Nieuw Amsterdam Uitgevers, 2005).
Translated by Paul Vincent

How the Form Forms Itself

Recent Developments in the Work of Composer JacobTV

The start of the clip looks like a home-made YouTube movie: a guitarist with a cool little beard, armed with a worn-out Fender guitar, is standing with his back to the window of his apartment. Night is falling. You can tell from the sky-high water tower in the background that the film must have been shot somewhere in downtown Manhattan. (During the ten minutes of the clip, more and more lights flicker on in the highrisers behind. Or is that just how it seems?)

Then, a rough voice shouts out, '*Speak it up... I said speak it up...*' This voice is the cue; it's the starter's flag that sends the cars squealing away from the grid, leaving behind them the scent of burning rubber. The American guitarist Kevin Gallagher races through his riffs with total concentration in much the same way. Sometimes he is seated in the side car of the voices, at others he is steady behind the steering wheel. The guitar, loaded with distortion effects, meets its match in the words. Seamlessly Gallagher shadows the voices, with the same jerking, swinging patterns, syllable for syllable. The voices, chopped up via cut and paste into aphoristic slices of sentences, form counterparts to the raw, but highly idiomatical guitar licks, at times reminiscent of Eddie Van Halen, or Stevie Wonder ('Superstition'), or the ultimate guitar icon, the late Jimi Hendrix.

Still from 'Grab it': guitarist Kevin Gallagher. Photo by Jan Willem Looze (courtesy of JTV).

'I tried to explore the "no-man's-land" between language and music,' says composer Jacob ter Veldhuis about this composition, called 'Grab it!' The pop idiom of 'Grab it!' would tend to make the listener forget that Jacob ter Veldhuis, or JacobTV, as he currently styles himself, is a genuine classical composer, one who writes concertos for solo instruments and full symphony orchestra, string quartets and the like. But JacobTV is also a genuine 'contemporary' composer – 1951 vintage – who views music with uninhibited eclecticism. As with many musicians of his generation, his roots lie in the pop music of his youth. Composition lessons from Willem Frederik Bon and studying electronic music with Luctor Ponse taught him all the necessary in compositional craftmanship. Ter Veldhuis brings together the whole broad spectrum of musical forms and influences to create meaningful syntheses. As a result, listeners who like to pigeonhole things may find it hard to classify what they are hearing. Is it pop? Is it jazz? Or could it in fact be 'classical' music?

The use of sampled voices has become one of JacobTV's trademarks. The way in which he uses these samples bears some resemblance to the work of American composer Steve Reich. Both employ samples in a documentary-like setting, but whereas in Reich's work the voices tell a story that relates to a tightly directed series of questions, the narrative of Ter Veldhuis' compositions is based more on the serendipity of the *objet trouvé*. Political and media phenomena are a fertile source of inspiration for Ter Veldhuis, but the proverbial man in the street also fascinates him, as do legendary musicians. JacobTV's oeuvre includes voices from, among others the *Jerry Springer Show* ('Heartbreakers') and an evangelical preacher delivering his message in Times Square ('Jesus is coming'). Jazz greats such as Billie Holiday ('Billie') and Chet Baker ('May this bliss never end') also put in an appearance, as do many other figures from the past and present, both familiar and less well-known.

'Grab it!' features the sampled voices of prisoners on Death Row, talking about their fate. Among the macho cries of *'Motherfucker'* and *'I'll bite your fucking nose off'*, we hear a desolate *'You lose everything'* or a defiant *'he went out the backdoor wrapped up in a green sheet'*. Of a suicidal prisoner we are told: *'He tied one end around the pipe, and he hung himself.'* Ter Veldhuis has explained that this world of the condemned *'on the fringe of society, with its heartbreaking verbal assaults, moved and inspired me'*.

Images of Manhattan emerge as the video clip progresses, with cops and yellow cabs appearing and, repeatedly, railway tracks in a tunnel. Pictures of the prison worm their way between the guitar riffs with increasing insistence: a network of cells, the worn faces of – mainly black – prisoners. In regimented lines, in obedience to an order we do not hear, they file out of their caged enclosures, all at the same time. In a way, they are like animals. A further visual narrative layer is introduced: snatches of sentences from the samples flash in white capital letters across the documentary images: supertitles in their most stratified form.

The clip of 'Grab it!' (one of the tracks on the recently issued second box in a series of three presenting the work of JacobTV in over seven hours of audio and three-and-a-half hours of video recordings) features a sophisticated mix of images. Michael Zeegers created these documentary pictures as a background projection for a performance of 'Grab it!' by the Dutch Metropole Orchestra dur-

ing the Nederlandse Muziekdagen in 2003. Dutch jazz saxophonist Hans Dulfer was the soloist on that occasion, but it was a performance that is perhaps better forgotten. The film, however, made a succesful reappearance in the video, combined with Jan Willem Looze's footage of Kevin Gallagher, which despite appearances was not actually recorded in his Manhattan apartment but on the stage of The Monkey.

The infinite variation of content

Ter Veldhuis is generally regarded as a Dutch proponent of ultra-tonal composition, a kindred spirit of composers such as Arvo Pärt, Giya Kancheli and John Taverner. And there's certainly a case to be made for this when you listen to Ter Veldhuis' multimedia oratorio *Paradiso*, with its scales that climb up and down in jubilant triads, in an account of a space voyage through Dante's paradise. In Ter Veldhuis' opinion the dissonant, traditionally a musical metaphor for conflict and tension, has become devalued as a means of expression. This, combined

Jacob ter Veldhuis
(1951-).
Photo by Klaas Koppe.

with the sickly-sweet images that Jaap Drupsteen created for the visual accompaniment to this work of just under 75 minutes in length (part of the first box in the series), could indeed make you think that Jacob ter Veldhuis is a composer who has lost all his sharp edges, a musician who is prostrating himself before a larger audience. Ter Veldhuis has even been accused of being a 'regressive' composer. Nothing could be further from the truth. There is ample reason to

Still from 'Grab it!',
edited by Kristien
Kerstens.

Photo courtesy of ITV.

argue that JacobTV is proving to be the very model of an avant-garde composer, a creator of music who, increasingly, is calling composition into question from an ontological point of view – as 'Grab it!' perfectly illustrates.

What then exactly is 'Grab it!' ? It's on the one hand Kevin Gallagher's screaming riffs, accompanied only by the ghetto-blaster playing the samples and the occasional touch of percussion. On the other hand it's also the version on the CD/DVD series featuring Kevin Gallagher and additional solos with his band Electric Kompany. And it's also the XXL version by the Metropole Orchestra. And it all started with the version for alto sax and ghetto-blaster, written for the virtuoso Aurelia Quartet saxophonist Arno Bornkamp in 1999, which premiered in the classical music temple in Amsterdam, the Concertgebouw. Since then there has been a massive demand for different arrangements of the piece, so you may come across versions for electric violin, for trumpet and for percussion all under the same title. Traditionally all these would be described as arrangements or adaptations, or, in the case of the video clip, even as a 'remediation', based on the 1999 original. But such descriptions do not do justice to the compelling originality of, for example, the Gallagher version – as if that could be described as anything other than original!

What JacobTV has done with 'Grab it!' closely parallels a recent development in television, where the concept of the TV genre appears to be giving way to the new phenomenon of the 'format'. The format of *Pop Idol* – to give just one very appropriate example – can now be seen in countries all over the world under similar titles and in different languages. But is the German version any less 'original' than, say, the Dutch or the French or the British? They all feature dif-

ferent performers, who follow local conventions and behave just that little bit differently from their counterparts in neighbouring countries, but the format remains the same, and, even though this is flexible, it fits the local conventions and cultures perfectly.

'Grab it!' shares similarities with this approach. It is not a *forma formata*, to use the terminology of the late Frits Noske: it is not music with a definite, fixed form to be performed on the same fixed set of instruments. It is instead a *forma formans*, a 'form forming itself', or maybe even an *argumentum formans*, content that is constantly finding a new form. Not so due to the fact that the work develops conceptually in a structural sense through improvisation, but because the form offers a framework, an outline within which the content is capable of infinite variation. Incidentally, in his day Bach did something very similar. In his work we frequently find the same notes appearing on different staves. (Is it a coincidence that at the time Bach too was derided as a regressive composer?)

Over the course of music history, the *forma formata* has achieved supremacy. JacobTV's current work calls this into question. 'Grab it!' is not a composition in the traditional sense; it is more of a performative concept. Ter Veldhuis thusly aligns himself with the true innovators from musical history. Whereas a groundbreaking composer such as Luciano Berio repeatedly enriched the virtuoso solo performance in his *Sequenzas*, Ter Veldhuis is now augmenting music with an adaptive format, like an artist who chooses to depict the same landscape in pencil, oil paint, watercolours, pastel, photographs or video. Reproducing the same image in a variety of materials can suddenly create new dimensions with many different meanings. I would gladly cope with that if I were a concert programmer. But how does it grab you? ∎

Translated by Laura Watkinson

www.jacobterveldhuis.com

JacobTV's music is available in three boxed sets (*Rainbow*: Basta 3091732 / *Shining City*: Basta 3091742 / *Suites of Lux*: Basta 3091752)

Emile Wennekes will hold a lecture entitled *'Grab it, Motherfucker, Grab it!' Multiple appearances of a single composition* at the annual conference of the International Musicological Society (Amsterdam, 10 July, 2009. See: www.iamlconference2009.nl)

Interviews with the Dead

Heddy Honigmann: Memory Made Visible

Heddy Honigmann's award-winning ode to life, *Forever* (2006), is set mainly in a cemetery. In this documentary she visits the famous Paris cemetery of Père Lachaise and brings the dead back to life by asking the people amongst the silent stones about the reason for their visit. A young Japanese pianist fondly explains how Chopin has helped her to keep the memory of her dead father alive. An Iranian man finds comfort in the work of writer Sadegh Hedayat because *'he wrote about things that people dare not speak about'*. And a South Korean attempts to express his admiration for Proust in broken English. Honigmann transforms the silent monuments into speaking stones whose expressive power is universal. This is an art in which she has no equal, and one that has won her many awards as a maker of documentary films.

Honigmann's 2007 European Film Awards nomination for best documentary for *Forever* was just one in a long series of national and international nominations and prizes which demonstrate the recognition her work has achieved from film critics, professional panels and the public. As well as many retrospectives all over the world and national and international awards for her individual films,

Forever (2006)

in recent years she has also won four prizes for her oeuvre as a whole: the Jan Kassies Oeuvre Prize from the Stimuleringsfonds Nederlandse Culturele Omroepproducties (Dutch Cultural Broadcasting Fund) in 2003, followed by the Humanistisch Verbond's (Dutch Humanist Union) Van Praag Prize in 2006, the Outstanding Achievement Award at the Hot Docs Canadian International Documentary Festival in 2007 and the San Francisco Film Society's Golden Gate Persistence of Vision Award which she won, also in 2007, at the San Francisco International Film Festival.

Bridge

A cemetery played a significant role in the creation of Honigmann's very first film, the documentary *Israel of the Bedouin* (L'Israele dei beduini, 1979). She decided to make this film after a trip to Israel during which she protested against the destruction of a Bedouin cemetery to clear land for a Jewish settlement. The politically aware Honigmann, then a student at the renowned Centro Sperimentale di Cinematografia in Rome, soon returned to Israel with fellow-student Carlo Carlotto and rolls of film to give the powerless Bedouin a voice. The film was shown at international film festivals in Venice, Rotterdam and London.

The cemetery returns in later films too, as a bridge between past and present, an anchor for memories and a source of inspiration for the living. In *Metal and Melancholy* (Metaal en melancholie), for example, a layered portrait of taxi drivers in Lima which was Honigmann's breakthrough film in 1994, she goes with a female *taxista* to visit a grave for the nameless dead on All Souls' Day. The woman tells Honigmann how she drew strength from a near-death experience. In *Good Husband, Dear Son* (Goede man, lieve zoon, 2001), a film about the murdered menfolk of a village in the former Yugoslavia, an old man who used to play at weddings and parties walks amongst the white columns of the village graveyard. Time and again he places his hand on one of the stones to introduce a member of his family, *'This is my eldest son... This is my brother... cousin... brother-in-law...'*. He then gives a brief account of the destroyed life that the memorial represents.

In her first fiction film with professional actors, *The Front Door* (De deur van het huis, 1985), two housemates, Johan and Karel, are pondering a sentence in a newspaper cutting from 1943, in which calamity and passion coincide: *'The world is disintegrating, and we pick precisely this moment to fall in love,'* Johan (Titus Muizelaar) reads. Then he wonders out loud: *'If you wanted to finish this report, who would you have to ask to find out about the missing pieces?' 'God, Johan,'* his housemate Karel (Johan Leyssen) responds, *'you're not going to go and interview dead people, are you?'* Anyone familiar with Honigmann's work will suspect that that is precisely what she would like to do: question the past so as to become acquainted with the dead, and so gain a better understanding of the present and of the living.

Favourite dish

Regarding the importance of memories in her work, today Honigmann says: *'It's to do with the way I grew up – in a family where so many people are no longer there. They're kept alive through stories. Memories shape a person.'* In the same way as the loss of memory slowly destroys a person, as Honigmann demonstrated in her first feature film, an adaptation of J. Bernlef's novel *Mindshadows* (Hersenschimmen, 1988) about a man slowly losing his world to Alzheimer's.

In the first episode of *The Way to the Heart is through the Stomach – Recipes that must never be forgotten* (Liefde gaat door de maag: Recepten om nooit te vergeten), a series of twelve short documentaries about food-related memories which Honigmann made in 2004 for the public broadcasting network, Honigmann's mother Sonia prepares 'vrennekes'. This is Heddy's favourite dish and it comes from Grabowiec, the Polish village where Sonia lived with her Jewish parents and sister until they all fled to Peru, just before the German invasion in 1939. While she prepares the food, Sonia talks lovingly about the people who stayed behind, the aunts, grandparents and great-grandparents murdered by the Nazis whom Heddy knows only from photographs. Honigmann's father, an Austrian Jew who survived Mauthausen concentration camp, arrived in Peru only after the war. There he met Heddy's mother, who was studying drama and was a promising actress, but after her marriage settled for life as a housewife. Her father became a well-known cartoonist in Peru and, later, a businessman. Heddy Honigmann was born in Lima on 1 October 1951.

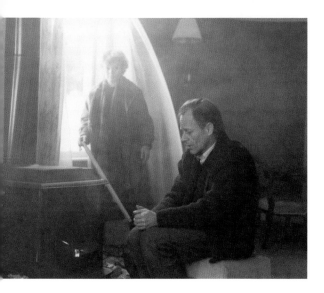

Mindshadows
(Hersenschimmen). 1988.
Nederlands Filmmuseum,
Amsterdam.

Soon after her parents emigrated from Peru to Israel in 1971 the twenty-one-year-old Heddy completed her studies in biology and literature and then left the country of her birth because there was no film academy in Peru. She travelled through Mexico, Israel, Spain and France, before going to Rome to study film-making, where she met the Dutch conceptual film-maker Frans van de Staak. It was love at first sight. She followed him to Amsterdam, where they married. Honigmann has been a Dutch national since 1978. Recently she has completed a new documentary film – *Oblivion* (El Olvido) – for which she returned to her birth-place, Lima in Peru, to create a further portrait of *'a forgotten city, a forgotten peo-ple and a forgotten country'*. This time, unlike in *Metal and Melancholy,* it's not the taxi drivers who give us their take on things but the waiters and barmen who keep the country's political and economic masters supplied with food and drinks.

The filmmaker's gaze

Honigmann's development as a film-maker is apparent in her oeuvre, which falls roughly into three periods: her early opinion pieces from the beginning of the 1980s; her fiction films from the late 1980s and early 1990s, in which

monologue often plays a major role; and, finally, her documentaries, from the mid-1990s to the present day.

Honigmann's work initially took the form of political opinion pieces: *The Fire* (Het vuur, 1981), *The Other Side* (De overkant, 1982), *The White Umbrella* (De witte paraplu, 1983), in which she investigated herself and the world, often with a philosophical slant in the style of Van de Staak. In her fictional work (*The Front Door*, *Au Revoir* (Tot ziens, 1995), *Mindshadows*, her attention shifts to life's big issues, such as fear and love. The passionate, life-affirming side of Honigmann's work, as a counterpoint to the dead past, can perhaps be seen most clearly in films such as *Au Revoir*, a movie about an impossible love, which was nominated for the Golden Leopard at the Locarno International Film Festival in 1995, and *Your Opinion Please* (Uw mening graag, 1989), a short and humorous story

Your Opinion Please
(Uw mening graag, 1988).
Nederlands Filmmuseum,
Amsterdam.

from 1989, in which an insecure young woman asks the viewer whether she is really attractive enough. However, that passion and humour are not lacking in Honigmann's later documentary work either. To see this you only have to watch *O amor natural* (1996), in which Honigmann uses Carlos Drummond de Andrade's erotic poems to get elderly Brazilians talking about their own love-lives, with mischievously sparkling eyes.

In retrospect, the fiction films in monologue form (*Mindshadows*, *Your Opinion Please*, *Four Times my Heart* (Viermaal mijn hart, 1990), *Stories I Tell Myself* (Verhalen die ik mijzelf vertel, 1991), *Knitting-Needle in Aquarium Fish* (Breinaald in aquariumvis, 1993), *How Many Strips to Calcutta?* (Hoeveel strippen naar Calcutta?, 1993) almost seem to be preliminary studies for the portraits that Honigmann was to produce in her later documentary work, when she shifted her gaze to the world around her and entered into conversation with the people she encountered there. It was with these films (*Metal and Melancholy*, *O amor natural*, *Underground Orchestra* (Ondergronds orkest, 1998), *Crazy* (1999), *Dame la mano* (2004), *Forever*) that she made her name and gained international recognition.

O amor natural (1996)

The mind's eye

Although 'memory' is still the driving force behind her films, she usually speaks of 'survival' as the central theme of her work. The survivor has looked death in the face and escaped, against all odds, thus demonstrating the passion and vitality that Honigmann celebrates in her films. Whether she is portraying the taxi drivers of Lima, who use their ingenuity to cope with the recession in *Metal and Melancholy*, the street musicians living in exile in Paris in *Underground Orchestra* or the Cuban community in New Jersey that meets up every week at La Esquina Habanera to dance the rumba in *Dame la mano*, the stories they tell give the people in her films a face and a history.

The magic of Honigmann's work lies in how she makes visible the history and memories of the faces. Her layered approach to presenting people and their memories can perhaps best be seen in the opening sequence of her documentary *Crazy*, in which she spoke to Dutch servicemen about their experiences during UN missions abroad. In this film she swiftly transforms a completely unfamiliar face into one whose history is plain to see.

'*I am a captain with the Royal Netherlands Army,*' announces a man's voice, ac-

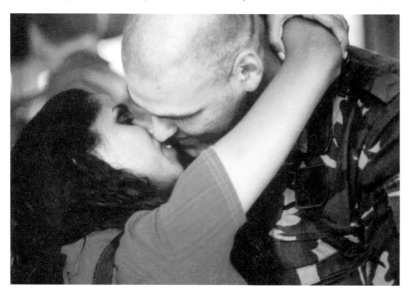

Crazy (1999)

companied by images of a white UN helicopter taking off, beautiful cloud forma-
tions seen from the air, and a long take of railway carriages full of refugees, all
accompanied by 'Nessun dorma' from Puccini's opera *Turandot*. '*From October
'92 to May '93, I worked in Cambodia for the UN organisation there,*' the voice con-
tinues. Even before we see his face, he tells us that he took this music with him
to Cambodia, where he drew a great deal of strength from it. '*Whenever I hear it
I'm back in Cambodia, with those people and their terrible situation,*' says the man.
And then we see his face for the first time, in a close-up that lasts over a minute.
As he listens to the music in silence, we are already starting to form an idea of
what the man's inward gaze can see. The history playing out before his mind's
eye can be seen flickering on the projection screen of his face.

Joan of Arc

Honigmann's interest in the expressive power of faces goes back to her child-
hood in Lima, when she used to spend all her pocket money on going to see
any films that were on in the city, not only at the ordinary cinemas, but also at
the university film club and the Museo del Arte which showed classic films. She
has particularly fond memories of Carl Dreyer's silent film *La passion de Jeanne
d'Arc* (1928), with Maria Falconetti in the title role. Honigmann says, '*I dedicated
a poem to her face, to her expressions. The way the film's edited allows you to* hear
*her suffering. Even though it was a silent film, you could hear her whispering: Help
me, God. What are they doing? I am innocent.*'

The faces that Honigmann presents in her films are never just talking
heads; they are faces that speak to us and come to life through their stories.
Honigmann does not interview these people; she has a conversation with them.
In interviews, the answers are often fixed beforehand, but Honigmann wants to
be surprised by her conversations. For this reason she does not edit her own
voice out of her films, but places herself as a guide between her subject and her
audience. She is a link between the past and the future, both as a survivor – if
it had been up to the Nazis, she would never have been born – and as a mes-
senger, someone who passes on stories to other people.

She often gives the subjects of her documentaries something to do while
they're talking, so that they forget the camera and reveal their story in a more
natural way. This ranges from everyday actions, such as watering plants or
making a cup of coffee, to activities that are relevant to the story, such as pre-
paring food, tidying a grave or demonstrating some action that is connected
to a lost love. In many of her documentaries she employs themes to which the
speakers can pin their memories: music in *Crazy*, *Underground Orchestra* and
Dame la mano; poems in *O amor natural*; and objects in *Good Husband, Dear
Son*. She always keeps the focus firmly on the unadorned storytellers, avoiding
any prettification, because that would detract from what her work is all about:
making visible the stories behind the faces. ■

Translated by Laura Watkinson

www.heddy-honigmann.nl

Walking as an Art Form

The Work of Francis Alÿs

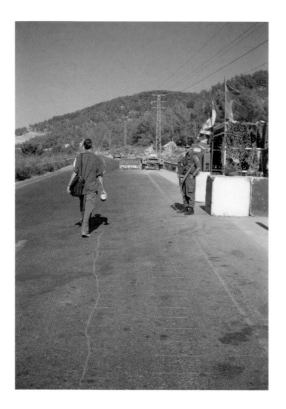

Francis Alÿs, *Sometimes Doing Something Poetic Can Become Political, and Sometimes Doing Something Political Can Become Poetic*. 2005. Photo courtesy David Zwirner Gallery, New York.

Can artistic interventions create a context for change? This is the question that visual artist Francis Alÿs asked himself and his audience in his exhibition early in 2007 at the renowned David Zwirner Gallery in New York. He was presenting a project that he carried out in Jerusalem in 2005, when he walked through the city with a perforated pot of green paint, leaving a green trail behind him. Alÿs followed the ceasefire line that Moshe Dayan drew on the map with a green pen in 1948 after the Arab-Israeli war as a border between the Israelis and the Palestinians, and which has gone down in history as the Green Line. In this work Alÿs is questioning the value of borders. However, his work is also about the relevance of art as a commentary on political matters. The title that Alÿs gave to the work clearly demonstrates his own belief in this relevance: *Sometimes Doing Something Poetic Can Become Political, and Sometimes Doing Something Political Can Become Poetic.*

In physical terms, little remained of the action performed by Alÿs in *Sometimes Doing Something Poetic*. The green line that he created had virtually disappeared within a couple of days. The only evidence of the walk is the film recording made by the artist in collaboration with Julien Devaux. Alÿs included this film in the exhibition, along with documentary material about the Green Line and his interviews with Palestinians and Israelis. A series of 'guns' that he made from found materials and a number of his typical small-format paintings also featured in the exhibition. However, the essence of *Sometimes Doing Something Poetic* lies in this transient action, which leaves behind no piece of art except for a film recording and some documentation.

This immaterial manner of working is a theme that runs right through the oeuvre of Francis Alÿs, who was born Francis Alijs in Antwerp in 1959, trained as an architect and architectural historian in Doornik and Venice, and moved to Mexico in 1987 as a volunteer on a construction project. He remained in Mexico, where he modified his surname because his new compatriots had difficulty pronouncing it and, far more significantly, changed his profession: the architect became an artist. Alÿs had a very practical reason for this career switch. Previously he had always lived in small provincial towns, but in Mexico City he found himself in a metropolis with a population of millions. The experience was a shock for him, not least because of the serious economic crisis that Mexico was going through at the time. He attempted to process his love-hate relationship with Mexico City by going for walks through the city, his so-called 'paseos'.

On one of his first walks, he pulled behind him a magnet on a string in the form of an angular tin dog, *The Collector* (1991). As he walked around the city, a second skin of metal grew around the animal, staying with it as it continued on its walk. In the same way Alÿs used his walks to collect ideas, impressions and conversations with people, which he would then make the subject of his work. In this way, in a far more immediate manner than through architecture, he gained an insight into the urban rituals and unwritten codes of the big-city environment. At the same time, the effect he has on the existing urban structure as an artist of ephemeral work is much less intrusive than the 'footprint' he left behind as an architect in the concrete form of schools, aqueducts and dams. Alÿs has consciously chosen to disrupt the dynamics of his environment as little as possible.

These *paseos*, which Alÿs began in 1991 in Mexico City and which have become an essential element of his creative process, are closely related to the urban walks of the 1960s French situationist Guy Debord.[1] In most cases Alÿs documents his walks in photographs, slides or videos, accompanied by notes, drawings on tracing paper and small-format paintings, always depicting the same walking man. During the fifth Havana Biennial, the artist walked around in *Magnetic Shoes* (1994), which, like *The Collector*, carried the story of the city along with them. He took his walks through Copenhagen under the influence of a different drug every day. *Narcotourism* (1996) became the story of being physically present in one place, whilst being mentally elsewhere. In Ghent and São Paulo, Alÿs explored the area while leaving a trail from the gallery with a leaking pot of paint (*The Leak*, 1995).

'When you're walking,' says Alÿs, 'you're receptive to and aware of everything going on in your immediate surroundings: small incidents, smells, images, sounds...'.[2] Sound is very important in *Railings* (2004), one of the seven walks

Francis Alÿs, *Turista*.
Mexico D.F. 1996.
© Francis Alÿs.

that Artangel commissioned him to take in London. In this video, he walks past the snow-white houses of Regency London, rattling a stick along their black iron railings. The distance between the houses and the corners of the streets where the railings are interrupted determines the rhythm of both the film and the accompanying recording. In effect, *Railings* sketches the spatial arrangement of this typical district through the rattling of the stick.

Social involvement

Alÿs not only maps the city in spatial terms, he also investigates its political, social and economic dimensions. He has previously described his work as: *'Politics in the sense of the Greek word polis: the city as a site of experiences and conflicts, from which materials are taken for invention, art and the creation of urban myths.'*[3] In the previously mentioned series of walks in London, *Nightwatch* (2004) focuses on Bandit the fox, released by Alÿs in the National Portrait Gallery at night. Using images from the museum's advanced camera system, the artist made a video showing the disoriented fox walking around amongst the portraits. The work refers to the security cameras that are present everywhere in London, not only on the streets, on the Underground and in shops, but also in other locations.

However, the majority of the works that showcase Alÿs' social involvement have been prompted by the political and social situation in Mexico (and Latin

America). *Re-enactments* (2000) is one of Alÿs' most subversive works, with its very literal presentation of the violent character of the city where he lives. The artist's plan was to walk through the busy streets surrounding his apartment, carrying a loaded 9mm Beretta, until he is picked up by the police. This is not so much about trying his own nerve as about putting reality to the test and exposing the way social control and the police force work in the violent metropolis of Mexico City. The police stop the artist in less than twelve minutes but then, with their consent, he repeats the action one more time. The two films, projected alongside each other in the work, hardly differ from each other. This raises the question of the evidently very fine line between fiction and reality. If the two films resemble one other so closely, who can guarantee that the first version was not also staged?

Between 1992 and 2002 Alÿs made the work *Ambulantes*, a slideshow of street vendors, men and women who push simple barrows, often made by themselves, crammed with boxes and bags through the streets of Mexico City, and thus offer their wares for sale. This series, with its colourful images, is a tribute to the survival of these men and women of the street, performing a Sisyphean task as

Francis Alÿs,
Los Ambulantes.
1992-2002.
© Francis Alÿs.

they push the weight of these staggeringly high piles of goods. The images in *Ambulantes* were gathered during one of Alÿs' many *paseos* and show the daily routine in a Latin-American metropolis such as Mexico City. They are a reflection of harsh reality, or, as the artist expressed it himself in an interview with *De Morgen*: 'Sometimes I'm sitting in my studio and I really need to go out into the street to buy cigarettes. The contrast hits me so hard that I wake up and realise: "This is the reality." I live in a world of artists, but there is a very different, harsher world outside. What I can do is comment on certain things, give them a value, document them, demonstrate that change is possible.'[4]

Alÿs attempted to do this in a very literal way in his large-scale project *When Faith Moves Mountains*, which he created for the Lima Biennial in 2002. When Alÿs was devising this project in 2000, Alberto Fujimori was ruling Peru with an iron fist and Lima was plagued by serious riots sparked by dissatisfaction with

Francis Alÿs,
*When Faith Moves
Mountains*. Lima, Peru,
11 April 2002.
Video still. MUHKA,
Antwerp/Vlaamse
Gemeenschap.

his policies. Alÿs wanted to come up with a spectacular counter-gesture and combat the prevailing pessimism. He recruited five hundred men to move a mountain of sand on the edge of Lima's slums by ten centimetres. Standing side by side, the volunteers shovelled sand for a whole day. Whether they actually moved the mountain and by how much is not really important. *When Faith Moves Mountains* was primarily a sign of hope for a country in a huge political crisis: the faith that we can change things if we really make an all-out effort.

Removing art from its pedestal

However, *When Faith Moves Mountains* is also an attempt by Alÿs to deromanticise the Land Art of Richard Long and Robert Smithson. When Long went on his walks through the desert of Peru, the social context was probably the last thing on his mind: his walks were contemplative undertakings. And Smithson's *Spiral Jetty* (1970), a spiral of black basalt constructed in the Great Salt Lake, resulted not from the strength of local people, but from the skill of engineers. In contrast, Alÿs speaks of *When Faith Moves Mountains* as the accomplishment of the common man, Land Art by people who own no land. Alÿs had previously taken on the Minimal Art of artists such as Donald Judd. In *Paradox of Praxis part 1: Sometimes Making Something Leads To Nothing, Part 1* (1997), he pushed a gigantic block of ice through the streets of Mexico City until, at the end of the day, nothing remained except a puddle of water. The rectangular block of ice is an allusion to the language of forms employed by the minimalists: ultimately, however, it is nothing more than frozen water.

In *Rotulistas* (1993–1997), Alÿs raised the issue of artistic authorship. He gave his own paintings, the reflection of his walks, to a number of advertisement painters, or *rotulistas*, of which there are so many in Mexico City. Each of them was asked to create a new work based on the paintings, in a larger format and with the addition of their own stylistic elements. Using these as a basis, Alÿs created new works and sent them, once again, to the *rotulistas*. This created an

endless flow of paintings, in which it is no longer clear which is the original and which is the copy. Alÿs sold the paintings at democratic prices, but he had to put an end to the project when it became so successful that he feared he would become trapped within his own system.

It is not only art itself that Alÿs views in a critical manner; he also targets the art world, inflated as it is by its own sense of self-importance and vanity. He did not participate in the 2001 Venice Biennale, but instead sent a number of pea-cocks, which were free to move about amongst the art lovers. He clearly could not care less about the whole art business and prefers to work on his own projects, far away from the centre of the art world.

Out of sight, out of mind?

Nevertheless, in the international art world Francis Alÿs has achieved great success. He has had solo exhibitions at important museums such as the MACBA in Barcelona, Kunstmuseum Wolfsburg, the National Portrait Gallery in London,

Francis Alÿs,
Sleepers.
1997-2004.
Series of slides.
© Francis Alÿs.

Kunsthaus Zürich, the Martin-Gropius-Bau in Berlin and the Hirshhorn Museum and Sculpture Garden in Washington and has participated in various biennials and exhibited his work at respected galleries. In 2006 he was the only Belgian artist included by the art magazine *Flash Art* in their list of the top one hundred promising artists and international gallerists placed him at number nine in their top one hundred. His work is to be found in international collections such as those of the Musée de la Ville de Paris and the Centre Pompidou in Paris, the Art Institute of Chicago, Fundació La Caixa in Barcelona, the Guggenheim Museum in New York, LACMA and LAMOCA in Los Angeles, the Tate in London and the Walker Center for the Arts in Minneapolis.

Strangely, however, Alÿs' oeuvre is rarely exhibited in Flanders. In 1991 one of his works was included in the group exhibition *Addenda* at the Museum Dhondt-Dhaenens in Deurle near Ghent; ten years later a series of drawings appeared at *The Big Show* at the NICC in Antwerp; in summer 2003, *When Faith Moves Mountains* was exhibited in the same city, this time at MuHKA; and in

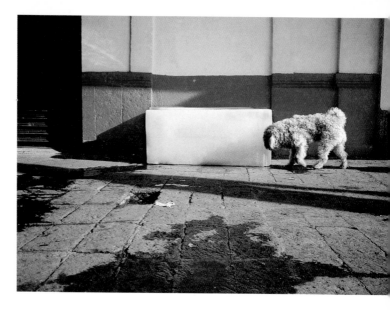

Francis Alÿs,
Plaza Garibaldi.
2004. Video still.
© Francis Alÿs.

2004 *Re-enactments* featured in the first exhibition at Extra City, also in Antwerp. *Sleepers* (1997), a slideshow in which Alÿs alternates sleeping homeless people with sleeping dogs, was shown at the beginning of 2007 in *Commitments* at Cultuurcentrum Strombeek. However, as yet there has never been a solo exhibition devoted to the work of Francis Alÿs in Flanders (or in the Netherlands, for that matter) and only one of his works is in a Flemish collection. The Flemish Community acquired *When Faith Moves Mountains* in 2003 and gave the work to MuHKA on long-term loan.

We can only speculate as to the reasons behind this lack of interest in the country of his birth. Maybe it is because he has now been so far away for so long and appears to have focused entirely upon Latin-American life. Perhaps it is because he maintains such a distance between himself and the media and the art-world networks. Alÿs is, for example, not tied up with any one specific gallery and at the beginning of 2007 he refused to be nominated for the Flemish Cultural Prize for the Visual Arts. Perhaps this refusal was his way of saying that Flanders has some catching up to do first before it can start handing out prizes to him.[5] ∎

Translated by Laura Watkinson

NOTES

1. Guy Debord, in his 1958 *Théorie de la dérive,* describes the *'dérive'*, the idea of walking through the city with no specific destination, in order to surrender oneself anew to the stimulus of the surroundings and the resulting encounters.

2. Quote from Francis Alÿs, *Mapping the City* exhibition, Stedelijk Museum Amsterdam, 16 February to 20 May 2007.

3. Quote from Francis Alÿs, *Satellite of Love* exhibition, Witte de With, Centrum voor Hedendaagse Kunst and TENT, Rotterdam, 27 January to 26 March 2006.

4. *De Morgen*, 9 October 2004, interview by Lillian Van Den Broeck.

5. Alÿs indicated that he believed the prize should go to a younger artist than himself.

Constant: The End of the Avant-Garde

'Today's artists have given up the fight, they have become socially integrated. They are no longer out to destroy the "ideological superstructure" – even though no one believes in cultural "value" any more – but above all to preserve the stylistic gains, to preserve the avant-garde itself. The quasi-neo-avant-garde is basically conservative... What they are now fighting for is to capture a position on the art market. The one and only raison d'être *of a work of art now seems to be its commercial value – or rather its investment value.'*[1]

To read the Dutch painter Constant's essay 'Rise and fall of the Avant-garde' is a sobering experience. Although it was published in 1964, it seems as if it was written yesterday. One only has to think of the way the media's coverage of art concentrates mainly on money, visitor numbers, record prices at auction and other spectacular matters. And also of the applications for subsidies submitted by the last critical museum directors who try to keep alive the discourse about the future of art and the future of their institutions.[2] This essay seems more topical than ever.

The subject of the 'Rise and fall of the Avant-garde' was Constant's famous New Babylon project. But he was also settling accounts with the 'quasi-neo-avant-garde' of his day. By this he meant both the neo-expressionists and the New Realism 'neo-dadaists', Zero (whose artists worked mostly in monochrome in an attempt to make the relationship between man and nature more harmonious and avoided all traces of individualism in art) and the whole of Pop Art. What is remarkable is that he also repudiates his own past. The CoBrA movement, which from 1948 on rejected academic art and sought to celebrate spontaneity and primitivism, is dismissed as *'the harebrained optimism of those who try to suggest that modern art is overflowing with vitality.'*[3] But the real jolt from reading this essay comes only when one recalls that two years later, in 1966, Constant seemed to explode the whole avant-garde concept. In that year he represented the Netherlands at the Venice Biennale and exhibited an installation of the New Babylon project. But while wandering around Venice he was suddenly deeply moved by Titian's *Pietà* (1571) in the Accademia and decided to take up painting again. The man who ten years before had consigned painting to the scrapheap of history even had to go out and buy a new easel. As his last avant-garde action and in the seclusion of his studio he devoted himself to colourism, the tradition

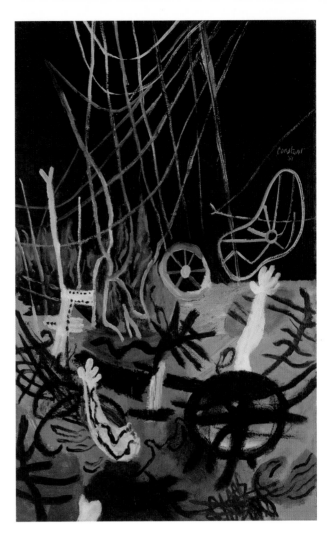

Constant,
Scorched Earth. 1951.
Canvas, 120 x 75 cm.
Stedelijk Museum,
Amsterdam (© Sabam
Belgium 2009).

of representative painting, until his death in 2005. Who was this ever-contro-versial man, who greatly influenced architects like Rem Koolhaas and who at the eleventh Documenta in Kassel in 2002 was presented as a forerunner of the socially engaged art of the Nineties?

Creative Power

Constant (the pseudonym of Constant Nieuwenhuys), who was born 21 July 1920 in Amsterdam and died 1 August 2005 in Utrecht, was the most versatile, visionary and important Dutch artist of the second half of the twentieth century. Although he regarded himself first and foremost as a painter, he was just as much of a sculptor, architect and theoretician. In addition he was also the spokesman of avant-garde movements as divergent as CoBrA and the Situationist Interna-tional. These diverse activities are accurately reflected in the extensive oeuvre he left behind him. For simplicity's sake, his work is usually divided into three periods: the CoBrA phase (which is the best known to the general public), the

New Babylon phase (from 1956 to 1966), and the period after 1966 when Constant at first hesitantly, later definitively, returned to classical methods of painting. But no brief survey can possibly do justice to his versatility.

When trying to create a portrait of Constant it is wiser to emphasise the similarities and to refrain from making the differences in his oeuvre greater than they actually are. Even though he supported or brought into being many groups and movements in the forties and fifties of the last century, he always went his own way. Characteristic of all his work was an experimental starting point that had its roots in the ideas that occupied and inspired him at that moment. Another ever-present factor is the union between emotion and intellect. Right from the founding of the Dutch Experimental Group in 1947 (together with Karel Appel, Corneille, Anton Rooskens and Theo Wolvekamp) Constant clarified and provided a (written) theoretical framework for his work and that of his comrades. A third common factor is that right from the start he believed in the social function of art. In the New Babylon period in particular the artist was expected to give up his own privileges and contribute to the struggle *'for a creative way of life for everyone'*. Helping to create a better world was his most important task. In addition to this 'engaged' attitude and a strong belief in the creative potential of ordinary people, Constant also greatly valued international contacts. Even by present-day standards he had at his command, especially in the 1950s, an extensive international network that was equal to that of the nomadic artist of today.

In 1945, for instance, with the war scarcely over, Constant met the Danish artist Asger Jorn in Paris. Two years later he co-founded the Dutch Experimental Group and in 1945, partly through his contact with Jorn, he became a co-founder of CoBrA (Copenhagen-Brussels-Amsterdam). His association with Jorn and other Danish experimentalists was instrumental in inspiring him to follow their modern interpretation of Surrealism and Expressionism. The fantasy animals he painted in 1946 are not only reminiscent of the Danish examples, they also herald the free, spontaneous and associative art which CoBrA (1948-1951) was to make commonplace. In those days the aim was to allow a painting to evolve as far as possible without any pre-determined viewpoint. Nor was it permitted to aim at any particular aesthetic. A painting was the result of a direct interaction with the materials and the images that came to mind during the act of painting itself.

After CoBrA

As his relations with Jorn deteriorated in the course of 1949, Constant also began to drift away from CoBrA. He also became more and more conscious of the social inadequacy of the typical CoBrA idiom of plants, animals and mythical creatures. The more these images began to form a language or system, the greater his dissatisfaction with CoBrA became. Constant's characteristic dislike of dogmatism led him to go in search of new images.

In 1950, much to the horror of most of the other members of CoBrA, he developed his own variant on Socialist Realism. Instead of innocent, naïve mythical creatures, in 1950/51 he painted a whole series of pictures referring directly to World War II, among them *Scorched Earth* (1951). The threatening, doom-laden, violent mood of these war paintings is fundamental to almost all his work. World

War II casts its shadow over Constant's entire oeuvre. When he realised that the experimental movement's evocative imagery and the message of his war paintings had little or no effect, he again went in search of something new.

Constant began to paint abstract fields of colour which he regarded as studies for the application of colour in space. In 1952 together with the architect Aldo van Eyck he developed what came to be called 'Spatial Colourism'. It was a plea for form and colour as a unity and for colour to play an active role in architecture so as to bring about a new perception of space. For an exhibition in the Stedelijk Museum in Amsterdam in 1953 Van Eyck designed a space for which Constant created a painting. Their room was a cube with walls consisting of large L-shaped pieces of dark purple and blue. Between these shapes was space for a painting of four by four metres. About this first involvement with architecture Constant said in an interview in 1980: *'It was rather an eerie space, people usually didn't stay in it for long; sit for a moment on the bench inside and then they were off'*. [4]

169

Constant, *New Babylon:
Red Sector*. Metal (iron,
steel, aluminium,
copper), ink on plexiglas,
oil on wood,
24 x 96.5 x 77.5 cm.
Photo by Har Oudejans.
(© Sabam Belgium
2009).

Feeling that art had become a retrogressive activity, the last refuge of outmoded individualism, Constant turned more and more to architecture. Soon he had expanded his interest to include architecture in a broader sense: the city. After spending some time in London and Paris he began experimenting with space. He made a number of open and dynamic constructions out of aluminium, wire and Plexiglas, which were the forerunners of the New Babylon project.

The whole build-up to this phase is typical of his way of working. Constant is said to have been fond of wandering around bomb sites and areas devastated by the war. On these wastelands, which at first even increased in size as demolition work progressed, he saw new buildings rising which he considered

stultifyingly unimaginative. He observed that a second industrial revolution was taking place in the cities, and that artists were being excluded from participating in it. The artist was unable to take part in the changes brought about by the new urbanisation.

When in 1956 he attended a congress held in Alba by the so-called 'Mouvement Internationale pour un Bauhaus Imagiste' (an organisation set up by his friend Jorn) he spoke for the first time about his ideas for shaping a new culture appropriate to the urbanisation and increasing mechanisation of society. At this congress he also got to know Guy Debord, with whom he developed the concept of unitary urbanism. In a 'declaration d'Amsterdam', in the second bulletin of the *Internationale situationniste*, a movement started in 1957, the objectives of

this unitary urbanism were laid down in eleven points. The aim was to urbanise in such a way that lifestyle and environment would be in tune with one another. For Constant, this notion of the city as generating conditions for a creative way of life for everyone formed the starting point for new activities and new forms of cooperation. In Alba his ideas were already taking concrete shape. At the request of the painter Gallizio he designed a permanent gypsy camp with moveable partition walls so that the space could be divided up according to the number of inhabitants. Constant's romantic preference for gypsy life and the notion of 'man the player' which he derived from Huizinga's 'Homo Ludens' in 1951 became the benchmark of the New Babylon project.

New Babylon was intended to become a Nomad City where people could 'live in freedom, unemcumbered by conventions and restrictions'. It was a model for a different kind of society and a new utopian reality. It was to be composed of a number of sectors, each of 20 to 50 hectares, which would be raised about 16 metres above ground level and linked together, spreading in every direction and enveloping the landscape. In this way a metropolis would be created that would span the earth like a net. The ground would remain available for rapid f transport and for agriculture, nature reserves and historic monuments. The roofs of the sectors would serve as airfields and walkways. Constant published an article on his project in the *Internationale situationniste* and he also joined this movement. But already in 1960 he felt obliged to resign, criticising the movement for its lack of cooperation and insufficiently radical ideas.

Henceforth Constant was to be the designer, theoretician and spokesman of his one-man-movement New Babylon. He constructed innumerable mysterious models, wrote countless articles, gave lectures all over Europe and exhibited his drawings and models as an architect. But all in vain. When the social revolution failed to materialise and the whole project remained in the realm of ideas, he not only broke with the project but also with the traditional concept of the avant-garde. Once more he felt free to devote himself to his former passion: painting. For the last thirty years of his life he dedicated himself to well-crafted, classically constructed paintings, watercolours and drawings. Yet the break with his own past was anything but total. For the work of this period, no less impressive than what had gone before, also deals with Constant's longstanding themes: war, the nomadic gypsy life, and above all freedom. ∎

Translated by Elizabeth Mollison-Meijer

NOTES

1. Constant, 'Opkomst en ondergang van de avant-garde'. In: *Randstad 8*. Amsterdam-Antwerp, 1964, pp. 8, 9 and 29

2. See the debate sparked in the Netherlands when the 'Stimulation Prize for Cultural Diversity' was awarded to the Mondrian Foundation in 2006

3. See note 1, p. 8

4. Paul Groot in an interview with Constant, *NRC Handelsblad Cultureel Supplement*, 24 October 1980

Between the Lines of the World

Klaas Verplancke, an Illustrator with Passion

In my drawings I create my own stage, my theatre,
where I can use surrealistic tricks to make things digestible.
(*Klaas Verplancke*)

Klaas Verplancke (1964-) is one of the most important representatives of the 'Flemish school': a group of 'young savages' who are revitalising Flemish illustration and causing more and more of a stir both at home and abroad. Both in Flanders and beyond his work is constantly winning prizes and can be found in translated editions almost all over the world. But that is not all. With astonishing flexibility he steers a zigzag course between theatrical productions, designing advertisements, illustration work and writing his own texts. In addition he is also an assiduous organiser of exhibitions as well as being the driving force behind the Flemish Illustrators Club (VIC), an organisation that seeks to mentor and provide opportunities for budding illustrators. A man of many parts, then, and a very active one, at home in many different markets. A man, too, who takes his job and both his juvenile and adult public seriously.

After training as a graphic designer at the Sint-Lucas Academy in Ghent, Klaas Verplancke quickly opted for the world of publishing. His record shows over 130 book designs and illustrated books, as well as a number of picture books for which he has done both text and illustrations. Add in regular publications in newspapers and periodicals, and he is certainly exceptionally productive. Moreover, he reaches a very broad public: from toddlers to adults, and from China to Canada. His work repeatedly wins awards: the Flemish Boekenpauw 2003, for example, for the beautiful, ingeniously conceived tarot cards in Henri Van Daele's *Little Witch Toad's Wart* (Heksje Paddenwratje, 2002), and a Dutch Vlag en Wimpel for *Djuk*. In 2001 he was the first, and thus far the only, Fleming to receive the prestigious Bologna Ragazzi Award in the category of fiction for children aged 6 to 12 for his illustrations to *Ozewiezewoze* (2002), a collection of old songs and rhymes compiled by Jan van Coillie. This was a thoroughly deserved award, for the task was certainly no sinecure: to illustrate nonsense texts from times long past in a way that is fresh and meaningful for today's children. Verplancke's solution was brilliant: he 'illuminated' three or more verses at a time in one expansive and funny illustration. In 2004 he had a place on the international jury of the Bologna Illustrators Exhibition – another first for Flanders.

Illustration as extension

Since his debut in 1990 Klaas Verplancke has evolved from a semi-realistic, accessible style of drawing to a highly individual and eloquent idiom that is still constantly shifting. His work can be recognised by its unique combination of surrealistic humour, unbridled fantasy, surprising perspectives, cinematic layering, striking colour contrasts and astonishing craftsmanship. For every book he thinks up a new and unique creative approach. To this end he employs a range of techniques: scraperboard, acrylic paint, collage, photographic materials, pen and pencil and computer. With a great sense of humour and figuration he sets down on paper caricatural, almost grotesque, figures, in which no obvious proportions can be found.

From *Little Witch Toad's Wart* (Heksje Paddenwratje, 2002).

In recent years he has been increasingly selective in the commissions he accepts. He wants to set a clear stamp on the book with his illustrations, to mean more than the obligatory 'embellisher' of someone else's story. Or as he himself says in an interview: '*Illustration is sometimes also described as illumination, as if our work must only be light and airy, as if it serves only to make texts easier to digest. I refuse to submit myself to that servile role. On the contrary, as far as content goes I want to give the reader even more space. I want to go a step further, demand more mental effort from the reader.*' Klaas Verplancke does indeed succeed in expanding stories and adding his own pictorial value in a credible and inventive way. His pictures suggest a personal interpretation. They tell their own story and in a subtle way make a substantial addition to the text.

That is clearly the case in *Jot* (2000), where Verplancke was responsible for both text and drawings. In word, image and striking typography *Jot* tells the tale of a near-obsessional longing for fame and recognition. A little fellow with a long nose spends page after page brooding about ways of thinking up something new to make him immortal. It is a funny and touching book, in which text and pictures in turn take over from each other. The extravagant detail of his earlier work has gone from this. Everything is reduced to a sober essence in calm colours.

From *Jot* (2000).

Roots, or the Time whose Name is Waiting (Wortels of de tijd die wachten heet, 2003), which was awarded the Publieksprijs of the Vlaamse Cultuurprijzen in 2004, is much more than a picture book. Here too Verplancke wrote the strange, philosophically tinged story for this book with its equally strange illustrations. And again there is a tormented protagonist. A shy, eccentric loner, a short, stocky, grumpy little man (*'no bigger than a couple of sneezes'*), with a sturdy helmet on his head to protect him from unwanted intruders, sits waiting like a hill warden on the top of his mountain. What he is waiting for he does not know *'and it never comes'*. It all sounds good Beckett stuff. *'There's time, a lot of time, the time whose name is waiting.'* The valley below is the enemy, a black, greedy snake that snaps at anything that comes down the slope. Until Kerel appears out of nowhere, a warm-hearted caring friend and a natural storyteller who draws his inspiration from his roots and from the earth. In the end Kerel opens up undreamt-of prospects for the hill warden: his felled trunk is like a footbridge ready to let his friend explore the world. *Roots* is a sparingly written book, with functional, repetitive passages and sober, often minimalist illustrations. The subdued use of colour and the cunning composition complete the whole thing.

Verplancke also wrote the text to accompany his illustrations for *Johnnymoon & Lankyjack* (Jannemaan en Langejan, 2002), three stories intended for reading aloud. Again the pictures are a feast for the eye. And the two heroes, the moon and a gangly beanpole of a giant, are appealing characters who by their own nature also seem to form a perfect expressive duo. The whole architecture of the book is beautifully balanced and very colourful.

Giant (Reus) and *Nopjes* (both published in 2005) form a splendidly designed diptych: two picture books that complement each other perfectly, both in content and in their impressive layout. The tone here is restrained and philosophical. The subject is friendship and homecoming, and the seeking and finding of

From *Giant* (Reus, 2005).

warmth and shelter in stories and in the liberating world of the imagination. The understated and layered illustrations in coloured crayon open doors to the economically restrained text. We are a long way here from the first, easily accessible books for tiny tots with which Verplancke made his debut. These picture books demand the full attention of those who look at them and read them. There is more to them than at first meets the eye.

In *For Love's* Sake (Vanwege de Liefde, 2007), a story by Edward van de Vendel, Klaas Verplancke shifted his boundaries yet again. A naked, curly-haired cherub falls from the sky and lands in the fishpond belonging to Benny-Bob and Sjarelisse and their children Loei and Tufje. He comes for love's sake and immediately subjects his surroundings to an investigation on that subject. Benny-Bob's predilection for bratwurst with curry sauce, Sjarelisse's obsessional devotion to her immaculate garden, and Loei's ultimate hobby of bad behaviour scarcely feature in his research. Only quiet little Tufje, with her unconditional adoration of the neighbours' dogs, seems to fit his mission. But her time, so it turns out, has not yet come. In a telling composition Verplancke has drawn two contrasting worlds: that of a rowdy, banal, macho father and ditto son, who fill the whole page with their cumbrous tattooed bodies, and the delicate, modest pale blue world of the little girl Tufje – a contrast that is also cleverly reflected in the typography. A touching and powerfully drawn story.

From *For Love's Sake* (Vanwege de Liefde, 2007).

A Flemish Master of our time

Verplancke likes to draw inspiration from the Great Masters of the Low Countries: *'I feel myself more and more drawn to the collective memory and in particular to the medieval pictorial language of the Flemish Masters. That universality that you can't pin a time on, that intrigues me more and more. Nowadays we've become much too explicit and we still have little understanding of the symbolism that those painters used.'*

The influence of the sturdy Flemish painter Constant Permeke (1886-1952) is omnipresent in *Djuk, the Coal Horse of Fort Lapijn* (Djuk, het kolenpaard van Fort Lapijn, 2002), written by Henri Van Daele and inspired by a story from a lower-class district in Bruges. A horse tells very expressively about his master's tiny house, where he had to go through the hallway and the kitchen to get to his stall, about the hard work and the rough people in the neighbourhood, about the haughty city horses and people. But also about festivals and fairs. Klaas Verplancke has provided the tale with very appropriate and humorous pictures, with striking composition. For *Little Witch Toad's Wart* and *Glamp! Or How Toad's Wart Cheered Up Goblin* (Glamp! Of hoe paddenwratje Kabouter opkikkerde) by Henri Van Daele, Verplancke drew witty, slightly ironic and cleverly worked out parodies of medieval miniatures and tarot cards.

And then there is *Reynard the Fox* (Reinaart de Vos), without doubt one of the

most intriguing Mediaeval texts from the Dutch language area. With Henri Van Daele – again – Verplancke created a splendid contemporary interpretation in 2007. It is hard to imagine a more perfect combination of text and picture for an undertaking such as this: a folksy-sounding authentic Flemish narrative style and a graphic signature inspired by the Flemish Masters go harmoniously hand in

From *Confidences in a Donkey's Ear* (Confidenties aan een ezelsoor, 2005).

hand here. In eleven wonderful pictures, almost tableaux vivants, he has ingeniously intertwined countless stories, just as Hieronymus Bosch or Bruegel did. You never get tired of looking at them, and you keep discovering new and surprising references and symbols. The legendary Till Eulenspiegel also got a surprising new lease of life in the recently published version *Till Eulenspiegel. Faithful Right to the Begging-Bowl* (Tijl Uilenspiegel. Trouw tot aan de bedelzak, 2008).

With his playful, narrative style of illustration Klaas Verplancke increasingly appeals to an adult readership. His highly individual interpretations of the fables of Frank Adam, *Confidences in a Donkey's Ear* (Confidenties aan een ezelsoor, 2005) and the 2003 *What the Donkey Saw* (Wat de ezel zag, an original version of the Christmas story) are full of cunningly contrived hidden meanings, humorous winks and subtle digs at society. He is also regularly in demand as an illustrator of columns and articles about reading and literature.

Klaas Verplancke is always on the lookout for new challenges, and as a consequence his work is constantly developing. He refuses to sit back in the comfortable security of a 'Verplancke signature' and an established position. Over the years he has evolved from handy 'gap-filler' to an immensely inspired artist of exceptional virtuosity, an 'illustrator' (as he likes to describe himself) who tells stories in words and pictures with vintage and sturdy professionalism. With humour and gravitas, at once light-footed and philosophical, he explores the world around him with amazement and masterfully depicts what he finds there 'between the lines'. ∎

Translated by Sheila M. Dale

www.klaas.be All illustrations courtesy of Klaas Verplancke.

The Tale of a Frog

Max Velthuijs, an Artist with More than One Talent

From *Frog in Love*
(Kikker is verliefd, 1989).

All over the world the friendly, green, ever-so-naïve Frog in his red and white striped swimming-trunks is a much loved figure in families, schools, nurseries and libraries. His father and creator Max Velthuijs, a modest Dutch artist who was *'only trying to do the best he could'* never achieved the same fame as his green alter ego. He died on January 25, 2005, only four months after he received the Hans Christian Andersen Award for Illustrations in Cape Town, still busily creating new stories about his best friend Frog. *'Velthuijs has proven many times over that he understands children, their doubts, fears and exhilarations. His books are little jewels of image and text that come together to comfort children and reassure them as they venture out into the world around them,'* commented the international members of the Andersen jury. The award winner was amazed and delighted at this recognition, since for him children were the most hopeful thing there is in life. *'Children are still pure, not touched by sin or guilt. It's they who drive us to do whatever we can do. We can't take away the evil and sorrow from them, but as long as we also provide hope and respect they will be able to cope.'*

A spirit of togetherness

Max Velthuijs was born in The Hague in 1923, the youngest in a family of four children. Both his parents were trained schoolteachers, but his mother never actually worked as such. As was usual in those days she was kept busy looking after their three daughters and late-born son, a fanatical drawer, sketcher and musician who hated school life. During the Second World War his parents were forced to move to the east of Holland, a change in his life which enabled

Max to join a class in graphic design in Arnhem. As soon as the war was over he moved back to The Hague. There he started working for newspapers (producing political prints and cartoons) and came to be in great demand as a designer of stamps, book jackets, advertisements and posters for big international companies such as Shell and KLM. He also started teaching at the Royal Academy for Visual Arts. Only when a Dutch publisher asked him to give a fresh new look to an old book of nursery rhymes did he discover the pleasure of working for children. In *Poems We Never Forget* (Versjes die wij nooit vergeten) his admiration for Henri Rousseau is clear to see.

Shortly afterwards his powerful and original talent was recognised by Dimitri Sidjanski of Nord-Süd Verlag in Germany, who at the time published a wide range of international illustrators such as David McKee, Josef Paleček, Fulvia Testa, Ralph Steadman, Binette Schroeder and Štěpán Zavřel. In this company of talented artists Max was challenged to combine his pictures with his own words – as he discovered, a much more satisfying activity than illustrating somebody else's text. And one which was not without results. His third picture book, *The Good-Natured Monster and the Robbers* (Het goedige monster en de rovers, 1976) was awarded a Golden Pencil, a prominent Dutch prize for illustrations, and this was soon followed by numerous national and international awards both for his pictures and his writing.

Right from the start, with *The Boy and the Fish* (De jongen en de vis, 1969) followed by *The Poor Woodcutter and his Doves* (De arme houthakker en de duif, 1970), his picture books strongly embodied the spirit of the seventies. They were playful pleas for freedom, to make peace not war, both on the

From *Poems We Never Forget* (Versjes die wij nooit vergeten, 1962).

international and the personal level. In Velthuijs' opinion the most important thing in life is to accept yourself, to be who you are and enjoy what you have. Consequently, a lot of his books end with some kind of togetherness: eating, drinking, dancing, chatting...

Aestheticism and psychology

At the beginning of his career as a maker of picture books Max Velthuijs used strong, virtually primary colours comparable to those used by Picasso, Klee and Janosch. The outlined figures and the combination of blocks of colour and lines, especially when integrated with hand-drawn letters, demonstrate his qualities both as graphic artist and painter.

It was important to him that his 'pictures' were not seen as art objects for a museum, so he made sure his work was reproduced only in printed form. In this way many more children would be able to enjoy what he had made – an attitude which again reflects his strong social engagement.

With *Little Man's Lucky Day* (Klein-Mannetje heeft geen huis, 1983) and *Duck*

Little Man.

and Fox (De eend en de vos, 1985) his style slowly began to change. The palette became more lucid, simple and transparent like the paintings of Morandi. Many a scene painted in gouache is placed within a frame which provides the story, the reader and very likely the artist himself with a feeling of security. Velthuijs once explained this development as follows: *'My illustrations used to be heavier: strong outlines, thick paint. I was primarily concerned with the painting as such, the pleasure of doing it. My work was in the first place decorative; the characters were not so important. Since they have come to the fore, both in writing and in drawing I can leave out more and more.'* The development from narrative into aestheticism and psychology began with Little Man, a bold little man who looks like Max himself. In the three books about Little Man Velthuijs experimented with a new approach in style and technique. *'I wondered how one could paint glass, water, ice and other transparent materials. The best I could think off was contrasting the transparency with something colourful.'* And so a green frog landed in a jam jar.

And from a purely technical device the frog with no capital developed into a character with a capital and an identity of his own.

On becoming a frog

With the green frog through which he could express all his emotions and thoughts a whole new life began for Max Velthuijs. All thirteen picture books about this friendly character – from *Frog in Love* (1989) to *Frog is Sad* (2003) – were published by Andersen Press in England and spread around the world in some 35 different languages.

In *Frog in Love* (Kikker is verliefd, 1989) Frog is so uncertain about his feelings that Hare has to explain to him that the thumping he feels in his chest might be love for Duck. This charming and humorous story is, quite understandably, popular with children and young lovers. *Frog and the Birdsong* (Kikker en het vogeltje, 1991), the first book to receive a major Dutch award for text and pictures

From *Frog in Love*
(Kikker is verliefd, 1989).

combined, deals with the mystery of death. *Frog in Winter* (Kikker in de kou, 1992) is the perfect combination of nature, atmosphere and colouring in only twenty-one pictures, all extremely well composed. Frog, who has no suit of feathers like Duck, no fat like Pig, no fur coat like Hare but only his green naked skin, is suffering. The ever-stronger zigzag line of his mouth reveals his fear, cold and loneliness. When his friends find him on the slippery ice, carry him home and nurse him with food, fire and stories, the rescue comes as a true catharsis. The warm red and yellow tones Velthuijs used in these later pictures contrast perfectly with the thin grey and cold blue of the beginning. *Frog and the Stranger* (Kikker en de vreemdeling, 1993) exposes prejudice and xenophobia in a very convincing way. *Frog is Frightened* (Kikker is bang, 1994) and *Frog is a Hero* (Kikker is een held, 1995) demonstrate the two sides of fear and heroism. And all the subsequent Frog books deal with universal questions like 'who am I?', 'what does being a friend mean?', 'what causes sadness?', expressed in matching colours and subtle details: a bird looking backwards, a cloud announcing danger....

Until the very end of his career Velthuijs wondered why people all over the

world, children and grown-ups alike, loved his little green Frog so much. He had no idea. For him there was only the concentration on a balanced chromatic spectrum, the optimal brush-stroke, the ideal composition, the line of the mouth expressing Frog's feelings, the striking details of a sunset, the horizon or the endless distance. And so Frog became the incarnation of Max's feelings and thoughts about love and death, fear and happiness, friendship and hostility, prejudice and solidarity, loneliness and the pleasures of life. In the fifteen years of creating his Frog books Max turned into Frog; Frog became Max's alter ego.

Octogenarian fame

The Frog stories are a distinct literary genre, not fables in the traditional sense. The world in which Frog, Duck, Hare, Pig, Rat and Little Bear meet, is not that of the fairy tale where things happen according to a formula. Rather, they are meditations on life itself, self-portraits of huge and difficult topics, masterpieces of graphic and narrative simplicity. More than any of his other books, the Frog stories grow out of the image. The picture demands that the animals match each other in dimensions, nature and circumstances. Each animal has its own character and skill. Sex is not important; status doesn't exist. Frog is the child just born that hasn't yet a view of his own, a dreamer in thought and deed. Like all children he looks at the world with great expectations. Freedom is just as important to him as security, loyalty and friendship. *'How lucky am I,' said Frog, admiring his reflection in the water. 'I am beautiful and I can swim and jump better than anyone. I am green, and green is my favourite colour. Being a frog is the best thing in the world.'* (Frog is Frog). Not that he is all on his own. Fortunately Frog has friends he can rely on: the sweet, ever-so-childish and talkative Duck; Hare a real father with a great many books and wise words; Pig who is always

caring and arranging things; Rat the stranger, always curious/enquiring and the most reliable of all.

The great international success of the Frog books came relatively late in Velthuijs' life, at a time when most people give up work and settle into retirement. Not so with Max, who became world famous on reaching his eightieth birthday. The Literary Museum in The Hague set up an exhibition covering all his activities and drawings; the Queen of Holland made him a Knight of the Order of the Golden Lion; Joke Linders wrote his biography *How Lucky to be a Frog* (Ik bof dat ik een kikker ben, 2003), followed soon after by the supreme international recognition, the Hans Christian Andersen Award for Illustrations. Three years after his death, his touching stories are being transformed into 26 animations that will be shown on television in many countries, ensuring once again a whole new life for this sympathetic green figure. ■

All illustrations by Max Velthuijs, courtesy of Uitg. Leopold & Ploegsma, Amsterdam. www.leopold.nl

Max Velthuijs
(1923-2005).

The Monk and the Samurai

On the Work of Tommy Wieringa

[LUT MISSINNE]

Tommy Wieringa (1964-).
Photo by René Koster.

The Polish journalist Ryszard Kapuściński wrote up his travel notes in the form of a *Lapidarium*: '*A lapidarium is a location (a park in a town, courtyard in a castle, patio in a museum) where found stones, bits of statues, fragments of buildings are placed (...) things that form part of a whole that does not exist (no longer exists, does not yet exist, has never existed), and that cannot be used for any other purpose.*' Tommy Wieringa, who quotes this passage at the beginning of his own small notebook *Plea for the Potsherd* (Pleidooi voor de potscherf, 2005) sings the praises of fragments and potsherds since he feels that such miscellaneous jottings epitomise the oeuvre of a travel writer. The rest of the oeuvre can be seen '*as the scaffolding round a work in construction; if you remove the scaffolding, then the actual construction appears. Bare, leached out, autonomous*'. It is tempting to apply this statement to Wieringa's work as well. Although he has not confined himself solely to travelogues, travelling assumes an important place in all the books he has so far published. This is naturally the case in his 2006 collection of travel accounts and reports, *I have never been to Isfahan* (Ik was nooit in Isfahaan), but it

is also true of his very first novels *Dormantique's Failing* (Dormantique's Manco, 1995) and *Amok* (1997). Characters travel half round the world to try and escape the chaos of their existence. *Everything about Tristan* (Alles over Tristan, 2002), Wieringa's third novel, is about a biographer following the trail of his subject, the mythical poet Viktor Tristan. And *Joe Speedboat* (Joe Speedboot, 2005) is also in a sense a book about travelling. In this case, travelling is contrasted with the inertia of the river village where half of the book takes place.

Those bent on travelling can be driven by curiosity, the urge to learn or the hankering for adventure, but for Wieringa travelling is first and foremost linked to the experiencing of the sensation of freedom, the *'intoxication of Wanderlust and untraceability'*, a feeling that came over him for the first time when as a schoolboy he ran away from home and enjoyed the sensation of a hitherto un-known freedom: *'I had control of everything. I could go to the left or to the right, go back or straight on, the only restriction on my freedom lay within myself and did not come from anyone else. (...) I had disappeared, had dissolved into the whole wide world.'* Out of that freedom from constraints, outside the radar range of teeming social and family life, life can begin anew.

I have never been to Isfahan contains three kinds of text: stories, reports and postcards. They deal with travels to all corners of the world, the Caribbean, the Cape Verde Islands, Central and North America, Cambodia, Syria, Lebanon, with a marked preference for Africa. Egypt and Ethiopia seem to be favourite destinations. Wieringa is a particularly acute observer and writer. He focuses his attention not on landscapes or the cultural heritage but on the people he encounters, with a mildly ironic feeling for linguistic and cultural confusion. A dialogue in Egypt:

'What's your name?'
'Thomas.'
'Too much?'
'Thomas.'
'Ah, Thomas. Welcome Thomas. My name is Mahmoud.'
(*Plea for the Potsherd*, p. 36)

An ever-present danger for travel writers – and one that Wieringa is very con-cerned about – is that the capacity for perception can become dulled by famili-arity and blunted. *'Do you have to learn to see other things when you no longer notice your thousandth sunset?'* he asks himself in his *Plea for the Potsherd*. Memories will always adhere to every experience – there is a danger of feelings hardening. Here, too, Kapuściński is his model: *'Analytical writers with a clear style are medicine for this mental glaucoma.'* Noting down travel impressions must be seen as a creative act, it is a question of seeing for the first time. The traveller is *'the Adam who names the things on earth afresh'*. For that reason, he must search for the precise formulation; he only has one chance to do so. A travel writer must also be on his guard against the urge to be exhaustive; he must restrict himself to flashes of insight or alienation that have great expres-siveness. Out of the multiplicity and profusion and richness he must be able to highlight one particular facet. *'A traveller, and by extension a travel writer, must be satisfied with a simple passage'*, he cannot reveal more than *'splinters of the richness of life on earth'*.

Wieringa's travelogues and travel notes have been written with great precision

and humour and get really close to the country and its inhabitants. Occasionally, the essayistic and reflective passages on travel lack the element of surprise, especially in 'Postcards', the last part of *I have never been to Isfahan*. They make less impact than the travel reports, in which he introduces genuine or fictitious characters. A fine example of the latter is 'On Motion as the Beginning of All Life' ('Over beweging als begin van alle leven'), the tale of the fictitious explorer Count Hubert von Zinzendorf, who imagined himself to be some sort of descendant of Columbus, the first white man to cross the Ogaden desert on foot and who mocked at death with his tales of heroism. Death *'laughed back patiently'*.

The travellers in such tales do not behave like so many flies on the wall; in the foreign land they are ready with *'a great gentle ear for the sufferings of others'*, as in the short story 'Hell Hotel' ('Hotel Hel'). Sitting at a breakfast table in a steamy basement among drying machines, the first-person narrator gets to hear the life story of Madame Victoire, whose husband worked for the secret service until one day he was returned home in an urn. Since then, she keeps a Colt 397 in her room. After breakfast, she embraces her table companion, *'I am a true friend,'* the latter thinks. Conversations with chance travel companions can get bogged down in unbearable small talk, but they can just as easily extract the essence of a person's life with surprising speed.

The author himself sees the power of his travelogues as lying in *'the way in which they bring out human striving and longing. The life of desires that almost always prevails over reason and the consequent tragic failure.'* His compassion for those who fail and the restlessness that compels one to travel are themes that inextricably link his travelogues to his novels and autobiographical notes. In 'White Horse' ('Wit paard') a train journey in China reminds him of earlier train journeys to school: *'And I dreamt of a vehicle that I never needed to leave, on which I could constantly be travelling. (...) I longed for uninterrupted movement and a certain* lack of any destination.'

The lime-twig of autobiography

Wieringa may now be considered among the cream of Dutch writers, but his first novels had to fight an uphill battle. The reactions of both critics and public to *Dormantique's Failing* and *Amok*, both published by In de Knipscheer, was decidedly lukewarm. *'A tome of a novel with a lot of misery in it,'* was Alfred Kossmann's judgment on the first book. And yet in this book, more strongly than in *Amok*, the germ of Wieringa's authorship was already apparent. The main characters of both novels are young men of around thirty, who live miserable lives and suffer from being crossed in love. In the first book we see Bas Dormantique, a dishwasher in a restaurant – the beginning of the book reminds one of Khalid Boudou's *The Schnitzel Paradise* (Het Schnitzelparadijs, 2002) – who lives in a horrible rented room, has bizarre experiences, including a scene with SM peep-sex, gets into trouble with his boss, loses his job, and finally sets out southwards in his little car, heading for Spain and Morocco. Every day Bas has to struggle against the laws of misery. His failing is that he remembers everything. *'If I have a disease, it is that of never being able to forget.'* Someone he cannot forget at any rate is Nina, the love of his youth. When he was at school, he did not dare pursue the beautiful middle-class Nina, because he was afraid

it would jeopardise his friendship with two burly, cynical, half-crazy brothers. But his longing for Nina, whom he meets again years later in possession of a husband, house and child, is unsatisfied. Bas has to live with this pain, pain like that of a phantom limb, pain at 'a world that was no longer there'. In *Amok* too, the main character Léon Fischer is faced with a choice: a bourgeois existence in a house on the edge of a wood, or non-conformity and eternal dissatisfaction. Léon is a funeral haulier by profession, which means that he brings the mortal remains of compatriots back to the Netherlands, so that they can be buried at home. He is entrusted with the problem cases. An original line of approach, but the whole story never really gets off the ground.

Wieringa's first two novels are marred by an excess of relationship problems and post-adolescent moaning. Especially in his debut work it is clear that the author initially wanted to do too many things at once: a love story, a travelogue *and* a picaresque novel. There is too much deliberate pessimism, the threads of the story unravel into loose ends and, apart from a few striking one-liners, the narrator's smart-alecky comments seem intrusive. Wieringa traces the weaknesses of his first books back to their semi-autobiographical nature: they were written too much 'out of a personal chaos', with too much 'unassimilated personal anger at my uprootedness', as he admitted in an interview. Giving his imagination its head was subsequently to send him along new paths. After the books from the nineties, the author has for the most part abandoned the recognisably autobiographical elements, but not the nostalgia and melancholy. Fortunately, for otherwise we would have been without a couple of fine travel stories in *I have never been to Isfahan*.

Nor has the pure essay genre yet produced any spectacular results. His most recent publication is a small collection of texts that he wrote as visiting writer during a stay at Delft Technical University: *The Dynamics of Desire* (De dynamica van de begeerte, 2007). It is a reasoned account of desire that is held in check by shame, good taste, a sense of values and self-respect. A hotel room is the point of departure for everything in this essay: the offer of porn via the pay-per-view movies, a Bible and *The Teachings of Buddha* on the bedside table. Both Buddhist teaching and Christianity offer a solution to suffering that results from longing and desire: the restraint, the asceticism, that calls for moments of pause and reflection. Pleasure and revulsion are two poles between which Wieringa observes the movements of desire. In the book's final text, a Vermeer lecture on pornography, he includes a critique of the media and of contemporary culture. He condemns the pornofication of our society, narcissism, the entertainment programmes in which shameless desire is displayed. Anyone who compares this with Willem Jan Otten's essays in *Thought is Lust* (Denken is een lust, 1985) cannot but conclude that all these reflections are somewhat superficial. They remain at the level of statements, and nothing much is done with them. The aphoristic pronouncements, the kicking-in of open doors, is the Achilles heel of Wieringa's work.

The myth of Tristan

Everything about Tristan (Alles over Tristan, 2002) proved to be the start of Wieringa's real writing. The book is about the quest of a young biographer, Jakob Keller, who wants to write a blockbuster biography, 'the *standard work*

on Viktor Tristan, that comet-like apparition on the poetic firmament, who had blown the dust off words, dismantled poetry and single-handedly re-assembled it.' Seventeen years after Tristan's death, the conscientious Jakob attempts to unravel the mysteries surrounding this Rimbaud-like poetic figure. Tristan was a mystic, with an inspiration for poetry that bordered on the maniacal. He wrote two collections of poetry, *Visions* (Visioenen) and *Exaltations* (Exaltaties), *'god-drunken texts', 'hermetic but also shamelessly sensual'*. His private life too is full of mysteries and secrets. Jakob is determined to dispel the myths surrounding this figure. The story takes place in an undefined Mediterranean, Iberian region, which with place names like Mercedal, Malgretout, Tomés, and the Os Lusiades, the harbours, and the journey to Lago conjure up an atmosphere reminiscent of J. Slauerhoff, the 'Frisian Rimbaud'.

The more the biographer succeeds in discovering the truth about Viktor Tristan, the further he is himself from his original aim. For when he decides to reveal what he has found out, he brings about his own downfall. In the meantime, he has fallen in love with a woman who seems to be entangled in the net of his subject's life. The biographer *'as the dubious destroyer of reputations'* has to choose between truth and his beloved. In the end both his missions turn out to be failures. He has failed as a biographer, for *'whoever withholds a life's myths and mysteries is unfit for the profession'*. The divulged secret has made both *'his work worthless'* and *'his love corrupt'*.

Everything about Tristan is written in a poetic style and at times it offers reflections on the scientific detective work of biographical researchers, on their *'limitless urge to collect and their compulsive desire to determine things'*. But the most attractive thing about this book is the way in which the tension is built up round the web of secrets and the unravelling which, paradoxically enough, does not take the biographer a step further. *'The biographer finally gets stronger and stronger, while the hero become less and less of a hero,'* according to Wieringa. Keller ends up by deciding to allow the world to keep its myth.

Motion and inertia

If Wieringa gained recognition as a writer with *Everything about Tristan*, it was with *Joe Speedboat* that his appeal reached the public. This novel, nominated for the AKO, Gouden Uil and Libris awards, threatened at first to become the eternal prize nominee, until it finally gained the Bordewijk Prize. At present, *Joe Speedboat* is also being promoted among younger readers through reading motivation projects.

The unusual narrator of the book is Fransje, who on the first page of the book is lying in hospital. While lying in a field of grass he had been run over by a rotary mower. For over 200 days he remained in a coma and when he wakes up he sees his situation as follows: *'This is the state of affairs: I, Fransje Hermans, one functional arm with forty kilos of paralysed flesh attached. I've known better days.'* The action takes place in Lomark, a sleepy riverside village that lies next to a motorway and that admittedly has a noise barrier but no motorway exit. The inhabitants are shaken awake by the arrival of Joe Speedboat – the name by which he calls himself – who descends on the village like a meteorite. In this instance *'like a meteorite'* should almost be taken literally, for one day his father's lorry crashes into Christof's living room. A strange friendship develops

between Christof, Fransje in his wheelchair, 'half man, half vehicle', and Joe, a bundle of energy. 'Here was something that would free him from the oppressive stagnation of this village,' Christof knows as soon as Joe emerges from the cloud of smoke enveloping the lorry's cab. Joe's vitality is immediately apparent. He manages to detonate a bomb in the school toilets. When the boys hear that the woman next door sunbathes in the nude, there can only be one solution: to build themselves an aeroplane. 'I had never met anyone before for whom an idea so automatically led to its implementation, on whom fear and conventions had so little hold,' Fransje thinks. Joe becomes not only his friend but also his hero. Someone who has the nerve to devise his own name and so proclaim that he has taken his fate into his own hands must surely have a higher concentration of energy or talent than the average person. Joe is the catalyst of everything that happens. He turns possibilities into realities, makes dreams come true. When his stepfather, Papa Africa, sets out one day on a felucca he had built with his own hands to return to Egypt, Joe creates 'the heroism of an Odyssey'. If Joe believed it was possible, who was Fransje to say that it was not?

After meeting Joe, Fransje attempts to see the world through his eyes and to see it as better than it actually is. In this way, he can participate as an out-sider, be part of all the adventures, and he writes everything down – between spasms – in his chronicle of the *History of Lomark and its Inhabitants*. In this way, Fransje is a kind of stubborn travel writer: he makes sure of always being on the move, gives his eyes plenty to feed on and meticulously notes down everything he sees. But the reader is not granted any comfortable outsider's position: he is, as it were, drawn into Fransje's head. He looks through Fransje's eyes and reads his words.

François le bras

For Fransje, recording events constitutes the first path in the samurai code of honour, which prescribes 'the twofold path of the brush and the sword'. Fransje is a master of the brush or the pen; the sword is more difficult for him to handle. In the second part of the book Joe trains his friend with an eye to winning arm-wrestling competitions and he takes 'François le bras' with him as a champion arm-wrestler to the seedy backstreets of Liège, Poznàn or Rostock. On one of their excursions they are accompanied by Picolien Jane, 'piedzjee', a stun-ning South African girl who has recently come to live in the village. What Joe does is nothing less than offer Fransje a place in the world that he could not otherwise have occupied. Fransje is looking forward to the confrontation with the great champion, the 'Arm-holy' Islam Mansur, a perfect human machine, with protruding, white-flaring eyes. Fransje exerts all of his superhuman pow-ers, but loses when the champion breaks his arm. When he notices at the hotel that Joe has spent the night with PJ, yet another illusion is shattered. Joe the saviour has become Joe the betrayer. Joe's decline as a hero also has to do with his real name, which PJ sneakily discovers by reading his passport. Longing, jealousy, betrayal and defilement have corroded their friendship. The farewell sequence has begun. Fransje abandons the samurai sword and returns to the Netherlands. Once back in Lomark, Joe builds a heavy shovel truck with which he intends to take part in the Paris-Dakar Rally. Fransje is left behind with a feeling of alienation. 'The hope that Joe's arrival once aroused has faded, we are

once more what we were and always will be. Joe is a saviour with no promises; he has not brought about any advance, only movement.' He is convinced that at some point Joe too will become a human being, naked, afraid and lonely like everyone else.

Joe Speedboat is a novel about friendship, but first and foremost also about the desire to exceed one's limitations and the longing for purity. While Fransje is countering the attack by the wrestler Mansur, his thoughts turn to a story about perfection and purity: *'All my life I had longed for and sought something that without flaws, without impurities, and in the dreamlike state I was now in, I recalled a story about purity – about Chinese craftsmen, masters of the art of lacquerwork, who boarded a ship and only started work when well out to; on land, tiny particles of dust would sully and spoil their work.'* It is also no coincidence that Joe, the saviour, is constantly associated with light and that Fransje so often yearns for light. This begins at once with Joe's spectacular entry into Christof's house, where *'the image of the boy in a flood of light'* appears, filling Christof with a longing to cast aside his old life. Looking back on his life, Fransje has to confirm that probably he *'was not even seeking truth or something of the kind, but something that produced light.'*

With the entrance of PJ, the purity of the boys' friendship is definitively at an end. Because of her, not only does the growing-up process accelerate but the illusion of love also lies in tatters. PJ is unmasked as *'the Whore of the century'*: it appears that she has slept with all their friends, and even Fransje is unable to escape her. What is striking is the role the written word plays in this story line. PJ's real unmasking comes about through the novel written by her boyfriend, the pretentious writer Arthur Metz – a sobering account of her nymphomaniac past. Whenever intimate writing becomes public, it seems to function as a weapon in the hands of the enemy. In a similar way, things also go wrong when PJ, with a rapacious gleam in her eyes, asks to read a page from Fransje's personal exercise books. He cannot resist the request, but in doing so delivers over to her cruelty the friend to whom he reveals his emotional life. *Plea for the Potsherd* opens with a similar passage. There, however, the writer is smart enough not to grant the beautiful Antillean who whispers that she is in love with him because of his notebook so much as one look at his writings: *'I did not want to be the thief of my own myth.'*

Despite all its lightness and cheerful cynicism, *Joe Speedboat* is a gripping account of the power of the utopian dream, the inevitable disappointments and the experiencing of human limitations. Just as Jakob Keller leaves the myth of Viktor Tristan and opts for his own life, so Fransje also resigns himself to a life without a myth. In spite of the great pace and dynamism of the novel, there is no real progress. The characters do not escape from the village, with the exception of Papa Africa, who with his boat gives the stay-at-homes the go-by. In the end, mediocrity and submissiveness eat away at the characters. The whole of life consists of dealing with inadequacies.

Wieringa relates fantastic and slightly absurd events in detailed descriptions in which all the technical facts seem to tally. For the description of the building of the aeroplane he sought out the artist Joost Conijn, and the instructions sound convincing. He also has an eye for slight absurdities and genuine coincidences that are more surprising than any imagined world.

Wieringa maintains the light and vivid tone of this complex *Bildungsroman* to the very end. His humour does not flag, never becomes corny, and emerges

on practically every page in the form of a surprising image or original cameo. This is how Fransje introduces his mother: *'We are condemned to each other, my mother and I. I, her bruised fruit and highly personal disaster, and she who, just like old horses, carries the sorrows of the world on her back.'* Names that are frequently mentioned as spiritual fathers of *Joe Speedboat* are John Irving because of the absurdity of the events and Paul Auster, who also has a preference for coincidences in the plot. Wieringa himself, however, refers rather to the lightness and transparency of John Fante or J.D. Salinger and the regionalism of John Steinbeck. Atte Jongstra has characterised his writing splendidly: *'warm, well-crafted, laconic, (restrainedly) humorous and long-lasting'.*

For Wieringa, writing is retiring to a sacred core where it is still and calls for self-castigation and asceticism: *'If I believed in God, I would be a phenomenal monk.'* He has aptly described his own development as a writer: *'I have removed all signposts, commandments and prohibitions from my system, but I needed the discipline of my previous book in order to emerge here. At last I dared to admit chance. But then again, to become a good dancer you first have to master all manner of styles and become proficient in a whole range of techniques.'* After the strictness of Tristan he has dared in *Joe Speedboat* to allow himself the freedom of someone who has mastered his craft. ∎

Joe Speedboat (translated from the Dutch by Sam Garrett). Portobello Books: London, in preparation since 2006 (will appear June 2009).

SECONDARY LITERATURE

Arjen Fortuin, 'Spiritual fight'. In: *Jan Campert-prijzen*. Nijmegen: Vantilt, 2007, pp. 69-77.

Hans Hoenjet, 'Marquez in de polder'. In: *HP/De Tijd*, 10 June 2005.

Atte Jongstra, 'Lang houdbaar'. In: *Leeuwarder Courant*, 5 May 2005.

Alfred Kossmann, 'Jonge garde ouwehoert wat af'. In: *Provinciale Zeeuwse Courant*, 9 June 1995.

Maarten Moll, 'Wieringa's ontketende verbeelding'. In: *Het Parool*, 12 February 2005.

Maarten Moll, 'De wereld is een gigantische verzameling borreltafels'. In: *Het Parool*, 15 April 2006.

Jeroen de Valk, 'Gebaat bij de leegheid van de polder'. In: *Noordhollands Dagblad*, 4 February 2005.

Nell Westerlaken, 'Als je reist neem je afstand van die literaire blaaskakerij'. In: *de Volkskrant*, 31 March 2006.

Translated by John Irons

An Extract from 'I have never been to Isfahan'

By Tommy Wieringa

The family Enroute

My Uncle Sal could say 'Thank you' in thirteen languages and 'Can you tell me where the toilet is' in eleven. It would have been better if he had learned to say, 'Where is the emergency exit?' in Thai, as he might then have got out of the burning building in Bangkok alive.

His will was a nightmare. During the division of his property the family's behaviour resembled an ethnic conflict in the Balkans. As the result of one of Uncle Sal's final whims I became the curator of his art collection. As he was pretty rich, it was assumed that he had collected a lot. It would be my task to catalogue everything. It had all been stored in a shed, because Uncle Sal didn't have a house to put it in. He loved the Hopper-like aimlessness of hotels. That preference was all about death. According to my mother, as a young boy he already had panic attacks at the thought that one day he would no longer be here. As long as he kept moving, death would not be able to find him. That despite his efforts death was waiting for him in a boys' bordello in Pat Pong must have come as an unpleasant surprise to him.

I didn't meet Uncle Sal very often, but when I did see him he made an impression on me. His eyes wandered around without focusing on anything and he couldn't sit still. 'Listen,' he said, 'I invest ex-clu-sive-ly in unfinished art. One day the world will understand that the only real art is unfinished art. The entire career of an artist, all his sweat, blood and tears, achieves its ultimate meaning in his. Every artist worth his salt has at least one of these, one great work that he will never finish, because death intervenes or because of a sudden lack of inspiration, like being becalmed at sea. That work is the real thing. Klimt's Damenbildnis en face, eternally en route to the completion it never achieves. Gogol's Dead Souls, pure genius – and we can only guess what else he intended to do.'

I went to the shed, prepared for the worst. Just above the ground floated a blanket of mouse-grey dust. The sun fell on a snow-white sculpture group, perhaps once intended for the Academy and only half wrested from the stone. From the ceiling hung aerodynamic magical machines from the Renaissance, there were cherrywood cupboards filled with scores by Beethoven, Brahms and Schubert – sheets with sometimes only ten tadpole-like notes on a stave, a forest of high-minded intentions not one of which had been realised. Not a single note of these had reached the public, not one sculpture or painting had ever been exhibited. It was a symphony of interruptions, from wild swipes on canvas to manuscripts that stopped in mid-sentence.

The first thing I did was to look for the original score of Mozart's Requiem, the one his pupil Franz Sussmayr never got his mediocre hands on. But of course it wasn't there and so the value of Uncle Sal's Palace of Last Sighs, after deducting auction costs and taxes, turned out to be more or less zero.

It was also clear from Uncle Sal's will that his ashes were to be scattered over the East Frisian island of Borkum, north of Eemshaven. There he wanted to be reunited with the place where he had guarded fifty Wehrmacht prisoners of war after the Second World War. With two of them he had developed a warm friendship. After the war they had become business partners in Germany, which meant that the bulk of Uncle Sal's capital was expressed in D-marks.

On a golden-blue morning, what's left of the family after the Battle of Uncle Sal's Legacy gathers in Eemshaven. My mother has put the urn in an overnight bag, which is being carried by Uncle Louis, who isn't a real uncle but an ex-lover of my mother's who's having trouble letting go. I greet my sister. Kamahl is there as well, an aristocratic Nubian from Upper Egypt, whom we secretly call Papa Africa because he is my mother's new husband. This is his first visit to Holland. He and my mother got married last year in Cairo. I can still recall the morning when the telephone rang – my mother. The connection wasn't perfect, but I had no difficulty understanding her.

'I just got married', she shouted from a court building somewhere in Cairo.

'To whom, mother?'

'To Kamahl, you knew about this!'

'Congratulations, this is a big day.'

'Don't be silly, it's only a formality, so that he won't get into trouble with the police. They are so uptight about it here. Even walking hand in hand with a foreign woman is a punishable offence. This isn't exactly a fun country.'

My mother is Papa Africa's third wife. That's allowed in his religion. If his Egyptian wives were to take lovers, he would beat them to death. That also is allowed in his religion. My mother is twenty years older than he is, he is five years older than I am. His religion has no problem with that either.

We are sitting on the deck of the ferry with the sun in our faces. All around us Germans are drinking Warsteiner. The coast is dotted with windmills, from approaching sailing boats people wave to us.

'Lothar!' a woman yells to a passing ship, 'Lothar! Hello!'

She waves with her beer bottle. We think that she hasn't had breakfast yet. Papa Africa observes it all from behind his sunglasses, my sister is leaning back with her eyes closed. Meanwhile my mother is wrestling with a knot around her neck, a knot made up of the cord of her sunglasses, the cord of her regular

glasses, a necklace of semi-precious stones as big as pigeon's eggs, and the tur-
quoise shawl she is wearing. Failing to disentangle this Gordian knot, she says,
'Kamahl, come and help me.'

Papa Africa gets up. Uncle Louis looks away across the sea.

In the Ranselgat, halfway between Eemshaven and Borkum, my mother directs
us all to the back of the deck. I realise we are going to honour Uncle Sal's last
wish here.

'Didn't he want to be scattered over Borkum?' I ask, surprised.

'Do you know how expensive that is?' answers my mother and unscrews the
lid of the decorative bronze urn.

She walks to the railing. Beneath us the screw is churning up the water as if
it is boiling.

'Music,' she says.

Papa Africa takes a tape recorder from the overnight bag and rummages
among the tapes. From the sun deck German holidaymakers are looking down at
us. I try to assume a respectful pose as Schubert's unfinished Eighth Symphony
resounds across the deck. My sister and I glance at each other when my mother,
her eyes closed, makes gestures of blessing above the urn. When she's done with
that she nods briefly, as if she has just reached an agreement with the spheres.
Then she picks up the urn, lifts it over the railing and turns it upside down over
the sea. I watch intently, for you do not get to see the remains of an illustrious
relative every day. But nothing comes out of the urn. My mother shakes it and
then looks inside.

'It's stuck a bit,' she says.

Under her eyes specks of black kohl are crumbling. Uncle Louis runs
towards her.

'Perhaps some moisture got in,' he suggests.

'It's been standing outside for a while. I didn't want that dirty thing in the
house.'

One by one we peer into the urn. It is filled with a grey-black substance.

'Just dump the whole thing,' I say, but my mother thinks there's some kind
of deposit on it.

'Bring spoons,' she says to Papa Africa.

'Mother,' my sister says, seething with reproach, 'colonialism's finished, you
know.'

After the fight which erupts from this like a nuclear cloud, we spoon the
dough-like substance out of the urn and throw it into the sea. Papa Africa, mean-
while, sings a mind-numbing native lament for the dead.

From *I have never been to Isfahan* (Ik was nooit in Isfahan. Amsterdam: De Bezige Bij, 2006)
Translated by Pleuke Boyce

Hasselt: The Taste of the City

I arrived at Hasselt station and, like everyone else, jumped on a bus without paying. Public transport has been free in Hasselt since 1997, when the socialist burgomaster Steve Stevaert launched the idea. Critics said he was just being a populist and started calling him Steve Stunt, but the plan turned out to be a huge success. It led to a thirteenfold increase in passenger numbers over the next decade and brought transport planners from all over the world to study a little town in Limburg province.

I was there as a tourist, not a public transport planner, so I hopped off the bus at the next stop and started to wander the streets looking for sights. I soon realised that Hasselt doesn't have many. There's no big square, no great art collection, none of the sense of ancient history you feel in nearby towns like Tongeren or Maastricht. Yet it's somehow quietly appealing.

The smell of malted barley

Perhaps jenever has something to do with that. Hasselt is a distilling town in the same way that Leuven is a brewing town. They have been producing the stuff for centuries and organise a festival every year to drink a glass or ten.

Jenever is something of a speciality of the Low Countries; people have been distilling it in the damp cities of Flanders and the Netherlands since the sixteenth century. It was originally made from malt wine produced in a pot still, just like single malt whisky, and gets its name from the *jeneverbessen*, or juniper berries, that were added to improve the flavour and, so people hoped, cure various illnesses.

The Flemish jenever industry was more or less wiped out in the early seventeenth century when the Archdukes Albert and Isabella banned it. But it survived in the Dutch Republic, where it was served in dark *proeflokalen* (tasting houses) and exported to England as Hollands gin, or Geneva. It became associated in the minds of the English with debauchery and sin, helped along by Dutch artists like Frans Hals and Jan Steen who liked to paint tavern scenes with merry jenever tipplers holding aloft their tiny glasses as they drooled over some smiling Dutch serving girl.

Advertising poster for Orange Bitter Hasselt jenever. The line in French at the bottom warns the reader to '*avoid imitations*'. Nationaal Jenevermuseum, Hasselt.

Hasselt's jenever industry survived because the town fell under the rule of the Prince Bishops of Liège and when a count was made in 1850 it boasted 24 distilleries. They gradually closed down in the twentieth century, leaving just 15 in the early 1980s. Only one local distillery has survived to this day producing Hasselt jenever, which is now, like Champagne and Cheddar, a protected name under European legislation. So when you drink a *Hasseltse jenever*, you know it comes from Hasselt and not some shiny new factory in Japan.

The industry may be in decline, but the jenever tourist industry is in rude health. Hasselt's main tourist sight is a marvellous museum devoted to its local speciality. It is located in a rambling brick building which was originally a farm belonging to the order of White Nuns, but was turned into a distillery in 1803 and a museum in 1982.

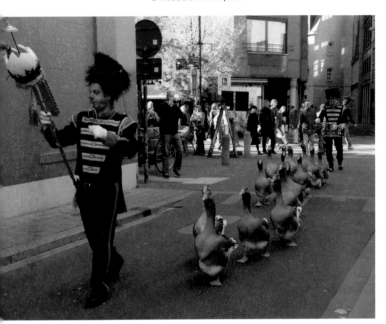

The Hasselt jenever festival, 2007. Photo courtesy of Stad Hasselt.

Inside the Nationaal Jenevermuseum, Hasselt.

I paid for a ticket at the desk and was handed a small token which could be exchanged at the end of the visit for a glass of jenever. Things were already looking up, I thought, as I wandered around the old industrial spaces learning about the allure of jenever, the complex flavours that can be added to pep up the taste and the social culture that has grown up around this distinctive alcoholic drink. The visit takes in the different stages of the distilling process, including the vast cellar where the grain is germinated and the malting tower where the smell of malted barley still lingers in the air from the last distilling session.

In spotlit interiors the visitor is surrounded by old relics of jenever drinking, like the slender stoneware jars in which it is sold and the typical small drinking glasses shaped like tulips. There is also an exhibition of old signs and advertising posters that reveal the various creative attempts over the years to expand the drink's appeal beyond its core market of greying old men.

The free tipple on offer when I visited was the museum's own Sint-Lambertus-drèpke, a sublime combination of jenever and 15 different herbs and spices. When I asked for the recipe, the lady behind the counter shook her head and told me that it's a closely-guarded secret. Much like Coca-Cola.

Standing in the wood-panelled *proeflokaal*, I couldn't help thinking that, despite the branding, there is still something old-fashioned about jenever. You might find a bottle in a Flemish friend's drinks cupboard, but it will probably be covered in a layer of dust, having last been opened when an elderly uncle visited ten years ago. It rarely gets ordered in the fashionable urban bars where young people drink.

Even the look is old-world. Jenever comes in brown stone bottles stopped with corks that have been sealed in place with a blob of red wax. When you order it in a *proeflokaal*, the bartender slowly pours the clear liquid into the glass until it reaches the very rim. You can't pick up the glass, or the contents will spill on the counter, so you have to bend over, hands behind your back, to take the first little sip. The ceremony is really a bit too Masonic for young people to embrace.

Yet the organisers of the jenever festival try their best every year to combat the image of an old man's drink. One memorable year, they sought to rebrand it by producing posters showing a pretty young woman sipping from the same glass as an old man. '*Jenever gets sexy,*' ran the excited headline in the local edition of *Het Nieuwsblad*.

The museum only produces about one thousand bottles of Sint-Lambertus-drèpke a year, and they don't sell it anywhere else, so it's quite difficult to leave without picking up one as a souvenir. And so, with a small brown earthenware bottle tucked into my coat pocket, I set off to explore the town's other attractions.

Innovation

First on the list is the town museum. I had been there before, about ten years ago, when it had just been modernised. But Hasselt doesn't like to let things stand still too long, so it has been modernised again, this time removing every last trace of the old museum, including the name, which used to be Museum Stellingwerff-Waerdenhof but is now Het Stadsmus.

The Hasselt beguinage.

The abbreviated museum is a cool place with white walls where children stand in front of paintings listening to headphone commentary while groups of older people learn about the history of the town. I suppose I had been hoping for something a little more cluttered, like the Huis van Alijn in Ghent or the glorious muddle of the local history museum in Ostend. But the Stadsmus isn't that kind of place and I left the building thinking that it is possibly only a matter of time before someone decides that the name must be further simplified to Mus, or perhaps ultimately M.

Hasselt is the sort of town that is always modernising. That became clear when I wandered into the Begijnhof – the beguinage, hoping to spot an elderly woman in black emerging from her little house. But of course the Beguines have all died out, and Begijnhofs all over Flanders are being converted to new

St Quintinus Cathedral.
Photo courtesy of
Stad Hasselt.

uses. The one in Hasselt has been colonised by internet companies and small businesses doing clever things. It's inevitable, of course, but sad to think that no one is still counting rosary beads behind lace curtains.

I then took a look around St Quintinus Cathedral and followed a sign to the carillon museum, which is installed at the top of the tower. Several flights of wobbly wooden stairs led up to the bells, some of which have been hanging there since the fourteenth century, which is something of a small miracle given that the heaviest weighs more than 3,000 kilos.

A final very steep ladder leads into a tiny room high above the city streets furnished with pine walls, a framed romantic poem by the English writer Patience Strong and two fire extinguishers. This curious hideaway is where the

town carilloneur, René Vanstreels, plays concerts on the bells every Sunday. Judging from the sheet music piled up next to the keyboard, he has a wide repertoire, ranging from Mozart to Jacques Brel, not forgetting his own carillon composition, 'The Singing Tower'.

Back at street level, I quickly realised that Hasselt is a seriously upmarket shopping town. The ground floor shops along the eighteenth-century Kapelstraat are all occupied by top designers like Jean-Paul Gaultier, Armani and Krizia. Someone around here is making money, I thought, even though the jenever industry is almost dead and the Limburg coal mining industry collapsed decades ago.

One of the shops caught my eye. It was called Helsen Tailors, the name in English, and it claimed to have been selling gentlemen's suits since 1939. I had

Upmarket shopping in Hasselt.

no need of an English tailor, but took a quick look inside to see what it had to offer. The staff looked smart and professional behind the polished mahogany counters, as if expecting a duke to appear at any moment. Wandering around the interior, I noticed a well-padded leather sofa, a set of English hunting prints and a scarlet hunting jacket.

How very traditional, I thought. But I was only partly right. The family firm is now run by Stijn Helsen, who, he claims, made his first pair of trousers at the age of 12. After studying fashion in Milan and working for a time with the flamboyant London designer Vivienne Westwood, he carved out a niche for himself designing costumes for Hollywood blockbusters such as *Spiderman II* and *Pirates of the Caribbean*.

He has another shop in Hasselt called the Stijn Helsen Concept Store which is much more modern. Soothed by glass and purple lighting, his customers browse a stylish collection of clothes, beds, lamps, mirrors and vases.

Intangibles and *Limburggevoel*

As I continued to wander aimlessly, I began to realise that a town like Hasselt, or any town in fact, is more than just a collection of buildings. Travel writers often forget that. They think that you just need to list the buildings, the restaurants and a recently-opened boutique hotel. It's not that easy. A city is also a place of unfamiliar smells, tastes that stay in the mouth, fleeting glimpses of other lives. It's hard to pin these down. They do not have opening times. You can't rate them with stars.

Hasselt is a town that has these intangibles in abundance. A few years ago, it was voted the most pleasant city in Flanders. I can understand that. Its cobbles are briskly clean. Its restaurants are quietly cool.

Still from *De Smaak van De Keyser*.
Photo courtesy of VRT/ Toerisme Limburg.

In 2006, Hasselt won another award as the *Hoofdstad van de Smaak*, the capital of taste. The label has stuck. It has even led to a TV series launched in December 2008 on Eén, an epic ten-part drama titled *De Smaak van De Keyser*. Set in a Hasselt jenever distillery, it tells the story of three generations from a distilling family as they experience war and love and tragedy.

On the subject of 'smaak', it's hard to think of anyone with more of it than Steve Stevaert, a former bar owner with an odd Limburg accent that people outside his home turf like to mock as quaint. In 1995 he became Hasselt's first socialist mayor and won enormous popular support as well as considerable criticism for his free public transport scheme.

By 1998 he had moved his office to Brussels and taken up a job in the Flemish government as minister responsible for public planning. He soon gained coverage in the media by ordering the demolition of prestigious villas that had been

put up in the open Flemish countryside without proper planning permission. For several months, Belgian newspapers printed astonishing photographs of luxury villas being felled by bulldozers, everything down to the gold bath taps and Tuscan floor tiles reduced to rubble. Steve Stunt had earned his title. But the rough world of Brussels politics finally proved too much for his health and he eventually settled into the less demanding role of Limburg provincial governor.

A few months ago, I opened my *Knack* magazine and out fell a glossy publicity folder. The cover image showed two clenched fists with the slogan ♥ LIMBURG written in black ink across eight fingers. Flicking through the shiny pages, I was reminded that Hasselt was the capital of a fiercely proud province. It has become something of a running joke in the Flemish press that any phone-in competition in Flanders will be won by the Limburg candidate. The competition for the nicest town in Flanders was won by Hasselt. A competition to choose the most deserving building to restore went to a small syrup factory in Borgloon. And no one was particularly surprised when last year's contest to choose the prettiest village in Flanders was taken by Oud-Rekem in the province of – you can probably guess.

The press started to talk about a *Limburggevoel* – a Limburg feeling – to describe the fanatical loyalty of the Limburgers. It leads to energetic local people setting up committees and organising mass text messaging campaigns, simply to ensure that the winning village or crumbling monument lies in Steve Stunt's province.

It can get irritating after a while. Every time a TV series is set in Limburg province, *Limburggevoel* goes manic. A few days before the launch of *De Smaak van De Keyser*, the provincial tourist office sent out an eight-page glossy folder in *Knack* in which this epic drama was viewed as little more than a bright showcase for Limburg regional products, the word 'smaak' cleverly interpreted by the tourism marketing department to include tasteful hotels where you might want to spend a night in a *Smaakkamer*.

Then I remembered that Noel Slangen came from Hasselt. He worked as an advisor for Steve Stevaert and then moved on to help Guy Verhofstadt smooth out his image in his successful 1999 federal campaign. Slangen was a new type of political adviser in Belgium closely modelled on Britain's despised spin doctors. The fact that *slangen* means 'snakes' in Dutch merely confirmed his slimy reputation.

Towards the end of the day, I was beginning to understand Hasselt, at least as well as anyone can. It is an immensely proud town, fanatically independent and hugely supportive of its local celebrities. It is, I had recently discovered, the birthplace of the Belgian singer Axelle Red, who was named Fabienne Demal by her parents, but now sings in French, lives in Brussels and barely seems Flemish at all. For a long time, I assumed she was French, but then I heard her once on radio speaking in a beautiful soft Limburg Dutch accent and realised where her roots lay.

Limburggevoel kicks in again. They are hugely proud of Axelle Red in her home town, even if she sings in French and has all the mannerisms of a Parisian. Hasselt University recently awarded her an honorary degree, not only for her music but also for her 'worldwide citizenship,' and Hasselt residents voted her *Straffe Madam*, or Iron Lady, in 2007, which is apparently an honour in these parts.

A search on YouTube for Axelle Red singing in her native language yields nothing, but I finally found a track on her internet site called 'Grootvader

Photo courtesy of
Toerisme Limburg.

Geplant' in which she sings in Dutch of a grandfather's funeral. She renders this sad song in a beautiful warm Limburg Flemish voice that sounds far more authentic than her French persona. As I listened, I tried to imagine a competition to find the sexiest female voice in Flanders. And it would be won by Axelle Red, of course, because she's a Limburger.

At the end of my day in Hasselt, I took a free bus back to the station and caught the train to Brussels, thinking over what I had experienced. I hadn't seen any famous paintings, or discovered any memorable cafe, but I had smelled coriander and tasted jenever and finally come to understand the stubborn local conviction that this is the best of all possible towns in the best of all possible provinces. I believe you would call this *Limburggevoel*. ◼

www.hasselt.be

Remco Campert and the Dubious Lightness of Being

If ever a writer in Dutch literature was blessed with eternal youth, that writer was Remco Campert. For decades his books bore witness to an almost provocative insouciance, which was perfectly expressed by the boyish, slightly mocking laugh in most of his portraits. His own preferred image of himself was as he appeared on the jacket of the collection of short stories *How I Celebrated my Birthday* (Hoe ik mijn verjaardag vierde, 1969): with a grin on his face, surrounded by five scantily clad, flirtatious-looking blondes in graceful poses.

Campert – poet, short-story writer, later also a columnist – seemed to be immune to the serious side of life, to brooding introspection, to the regrets and cynicism of the ageing writer. No greyness, no Calvinist gloom; in Campert's universe every day was a party. Until in 2004 he came out with a short novel, *A Love in Paris* (Een liefde in Parijs), followed in 2006 by *The Satin Heart* (Het satijnen hart): books which are not only about Campert's escape from the 'dreadful joylessness of life in the Netherlands', but also about the implications and consequences of that escape. Both books lend themselves to being read as a commentary on the ode to frivolity, the lack of concern, and the irresponsibility of the early short stories and novels.

Un-Dutch levity

Remco Campert – born in 1929 – made his debut as a poet in 1951 with the anthology *But Birds do Fly* (Vogels vliegen toch). He was one of the 'Vijftigers', a group of young, rebellious poets who demanded greater personal, cultural and artistic freedom in the post-war climate of reconstruction. But of them all – Lucebert, Gerrit Kouwenaar and Jan Elburg are the best known – Campert was not only the youngest but also the least experimental. Influenced more by the matter-of-fact approach of William Carlos Williams than by the inimitable, ground-breaking excursions of the surrealists and Dadaists, Campert's grammar remains intact.

Although his earliest poetry contains references to 'charred and rusted fragments/ of bombers that have been shot down', of 'bird-sounds shot to ribbons' and 'seriously wounded syllables', these marks of violence seem to be mainly rhe-

torical in nature, an obligatory bow to the critical *esprit de corps* of the young generation of poets, not the expression of a strictly personal pain experienced by the poet. In my opinion the poetry written in the spirit of jazz, of '*the drunkenness that there is no stopping*', of the '*world that is swinging like crazy*' is closer to that personal voice. That is the world, as sparkling and pleasure-loving as it is blasé, that Campert would also describe in his early prose, from the inside, not as a detached witness.

These were the books with which he broke through to a wider public: *Party Every Day* (Alle dagen feest, 1954), *The Boy with the Knife* (De jongen met het mes, 1959), *A Miserable Good-for-Nothing* (Een ellendige nietsnut, 1960) and above all the novels *Life is Luverly* (Het leven is verrukkuluk, 1961) and *Love's Pretences* (Liefdes schijnbewegingen, 1963). The last two of these have been reprinted countless times down to the present day. *Life is Luverly* anticipates the eruption of hedonism, spirit of freedom, craziness and 'creativity' that would become so characteristic of the Dutch version of the Sixties. The book sets itself apart from all Dutch prose of that period by its un-Dutch light-heartedness. That is partly due to the absence of history, both in the book as a whole and in the lives of the characters. They live in the here and now, improvising, not held back by or burdened with any past, not focused on any future. Also, there is no storyteller to set their lives in any kind of historical or social context. Where more serious-minded authors look back on the war or their wretched childhood, in a quasi-naïve manner Campert celebrates the lightness of being that in him is far from unbearable.

Far more than 'great' Dutch writers such as Harry Mulisch, W.F. Hermans and Gerard Reve, and far more self-evidently than Jan Wolkers a little later, Campert provides an initial foretaste of the massive emancipation that awaited us, especially in the field of sexuality, but he does so without any preaching, philosophical ponderousness or political pretensions. What is so delightful is that Campert immediately ridicules all ideological claims to that emancipation, including those of the avant-garde artist filled with missionary zeal on issues of liberty and morality. Though he does not name them specifically, those of his friends who professed their artistic calling with the fervour of a new religion are also taken to task. The artist is no visionary, and when he presumes to adopt that role Campert takes him down a peg. Campert's ode to liberty, to unfettered, irresponsible existence is in no sense a programme, nor is it in any way elitist or exclusive.

The book is witty not only because of its ironic debunking of all sorts of portentousness in favour of a frivolous existence without ties or obligations, but also because of its playing with language – inspired by Raymond Queneau and also practised in a similar way by Campert's friend Rudy Kousbroek. He writes 'difficult' loanwords or compounds in a quasi-naive phonetic or analytical fashion, so that 'chewing gum' is transformed into a Chinaman called 'Tsjoe-win-k'um' (Chuwin-kum) and marijuana into 'Marry-you-Anna'. Sometimes that play on words crystallises concepts in an unexpected way: '*seksuele verkeer*' (sexual intercourse) becomes '*sexjuwelen verkeer*'(sex jewel intercourse) and '*fysiek plezier*' (physical pleasure) 'viesziek plezier' (literally 'filthy sick pleasure'). This last transformation is all the more effective as it occurs in the context of an indignant petty bourgeois tirade about the amoral and dissolute youth of today.

In this book, then, Campert already shows he has an aptitude for satire, although that talent is not fully developed until later. In that connection one must

Remco Campert (1929-).
Photo by Klaas Koppe.

make particular mention of the extremely witty and subtle *Crikey!* (Tjeempie!, 1969). The author has never made a secret of the fact that this book is in a certain sense an imitation of *Candy* (1958), the sensational success by the Americans Southern and Hoffenburg, who rewrote Voltaire's *Candide* for the sexual revolution. Like Candy, Campert's principal character Liesje, fifteen years old, naive and uninhibited, goes in search of the meaning of sex; with this difference, that Liesje actually only wanted to interview modern writers as part of an Easter holiday project. The quality of the book resides mainly in the way it imitates the various styles. Campert's satire is fed not by rancour or aggression but by delight in nailing the behavioural and linguistic characteristics of well-known writers, including some who were his friends. That makes *Crikey!* a *roman à clef*. To appreciate the controlled hilarity of these portraits to the full one needs to know the original models. Among them are Jan Wolkers and Jan Cremer, authors who were well known in the early Sixties, and in conservative circles were regarded as downright notorious for their violent breaking of sexual taboos in literature. No less powerful are the portraits of Harry Mulisch, *'the best-dressed writer in the Netherlands'*, and Gerard van het Reve, *'laborious toiler in the Lord's vineyard'*, whose philosophical mumbo-jumbo and tawdry religiosity respectively come under attack. But in every case the concern is first and foremost with Liesje's naively stoical inauguration into the world of sexuality.

A sense of failure

In the Seventies, by which time his name had long been firmly established in the Netherlands (although his lack of seriousness was probably responsible for the fact that he was never reckoned among the truly great), Campert must have undergone a creative crisis, at least if such a diagnosis does not clash too badly with his casual approach to life. The fact remains that during that period he published virtually nothing of significance. None the less, in 1979 he was honoured with the P.C. Hooft Prize for Poetry, the most prestigious non-commercial literary distinction in the Dutch language area. After that, and possibly inspired by it, new work began to appear again, both prose and poetry.

In 1980 *After the Speech from the Throne* (Na de troonrede) was published, a slim volume of four short stories that still show traces of creative block. The first story is about a writer who never gets around to writing and passes his time with short-lived erotic adventures, while the final story features the old, failed writer Max Brood (an allusion of course to Kafka's publisher Max Brod), who is quite unable to get his memoirs down on paper, since he cannot find any line whatsoever in his life. It is obvious that in these rather shaky stories Campert was trying to probe or document his own feelings of failure. In an interview from that period he said, among other things: *'I think every artist must surely feel he's failed to some extent. Because he himself knows what he set out to achieve.'*

It is possible that with *After the Speech from the Throne* Campert wanted to usher in a new phase in his career as an author. His style is still light and transparent, but the tone has become somewhat brooding. Also, he seems to have bidden farewell to a number of the very stylistic features that make his earlier prose work so attractive today: the understatement, the euphemism, the irony (directed at himself), the play on words, I say 'seems' because his next prose book, *The Harm and Miepje Kurk Story* (De Harm en Miepje Kurk Story, 1983), once more depends largely on these playful elements.

This book, *'a sketch on the morals of the eighties'* consists of short fragments with a strong satirical streak. The main character, the writer Rompe Terkamp (an anagram of Remco Campert, of course), is only interested in brief encounters, not in loving relationships. And with that we are back on familiar, all too familiar, territory. Although the book contains the compulsory hilarious fragments and Campert again shows himself a meticulous observer of fashions and clichés, as a whole it is too much of an exercise in repeating the past, in which this time the author fails to reach the level of *Life is Luverly*.

Delayed pain

The poetry from the late Seventies on also varies in quality. Anthologies such as *Theatre* (Theater, 1979) and *Scènes in Hotel Morandi* (1983) contain as many weak, sometimes downright sentimental verses as they do powerful and profound ones. In one fairly well-known poem, '1975', from the first of these anthologies, he speaks of *'weird years, these years,/ nothing funny, many failures'*. And a little further on he confesses to the social failure of the poetry of the 'Vijftigers': *'But we too, when we aimed at the highest/ had nothing to offer anyone/ that would provide shelter/ food in the belly/ shears to cut through barbed wire.'* These verses are not unproblematic. Unlike some of his poet friends (Lucebert,

Bert Schierbeek), Campert has always been appropriately sceptical about that *'aiming at the highest'*. Moreover, this enumeration of effects that failed to materialise sounds rather pathetic, particularly from this poet.

Far more convincing, and justly famous, is the poem 'januari 1943' from *Scènes in Hotel Morandi*, which is dedicated to his mother, the actress Joeki Broedelet. This poem contains a double reminiscence on the death of his father, Jan Campert, author of the most famous and popular Dutch Resistance poem of the Second World War, 'The Eighteen Dead Men' ('De achtien doden').

This poem is a reaction to the first death sentence to be carried out on the Waalsdorpervlakte in Schevening, when eighteen resistance fighters were executed. Jan Campert, who died on the 12 January 1943 in Neuengamme concentration camp, in circumstances that have never been fully explained, attempts to think himself into the minds of the condemned during the night before the execution. Many years later Remco Campert realised that when as a child he had learned of his father's death he had felt nothing, although he *'knew that he ought to feel something.'* The pain only came later, and never went away.

Cutting your own flesh

Of the later prose books the first we should mention is *A Love in Paris* (2004). It came as something of a surprise, considering that Campert had published no prose of any substance for fourteen years. It is true that from 1996 he was more than ever in the public eye (including that of the non-literary reader) on account of the much talked-about columns he published every other day on the bottom left of the front page of the *Volkskrant*. Since he published hardly any poetry in this period, the column, two hundred and fifty words of poetical meditation on daily existence and Dutch idiosyncrasies, became his pre-eminent genre. It is certainly a fact that Campert raised the genre of the column, used by other people mainly to air their opinions, to great heights. It can hardly be mere chance that in 2006, shortly after giving up his niche in the newspaper – to the disappointment of countless readers – that for the first time in a long while he once more published an anthology of poetry.

A Love in Paris is a prose sketch, with virtually no plot, in which an ageing writer, unmistakably an alter ego of Campert, revisits memories of earlier phases of his wild life as an artist in Amsterdam, Antwerp, and above all in Paris. He is impelled to do this when he is greeted in the last-named city by a *'well dressed, elegant woman'*, whom, to his irritation, he cannot place. Later she turns out to be the mother of a son, whose father he, the old writer, must be. That comes as a shock, at least to the writer, who had always avoided responsibilities like the plague and kept asking himself how he could get this attractive woman, with her husky voice and the *'expectation-arousing breasts beneath her blouse'*, between the sheets. No shock to the reader, though, for whom the key point revealed in the last sentence is little more than a, for Campert, painful cliché.

I find *The Satin Heart* (2006), another slim novel, much more powerful. Where apart from nostalgia the memories in *A Love in Paris* are dominated mainly by the youthful bravado of long ago, and not by its problematic aspects, in this book Campert cuts considerably deeper into his own flesh. The chief character is again an old and infirm artist who is dependent on his half-sister, in this case

not a writer but a visual artist. This elimination of the autobiographical charac-
ter creates distance, and with it the possibility of personal reflection and self-
criticism. This possibility is further strengthened by the presence of a second
artist, a friend, with whom he nonetheless differs on fundamental matters of
opinion. That leads to a great deal of dialogue and disagreement, to doubt and
self-knowledge.

The artist friend seems to be based on Harry Mulisch, although naturally that
name is not mentioned. He is 'committed', chases after every banner and is
exceptionally egocentric. The narrator detests every kind of fashionable art,
focused solely on creating an effect, and will have nothing to do with political art
either. He is rich and famous, has exhibited all over the world, but now finds
himself – a familiar theme, this – in a creative impasse. On top of which he is
compelled by his friend to reflect on what his overwhelming passion for art has
meant for his personal life. And then of course it is primarily a matter of his
frivolous behaviour towards women. His rule was to drop them after one night,
fearful of being tied down. For him art came before anything else, even love.

Yet slowly but surely cracks begin to appear in his armour-plated devotion to
art. Memories of the childhood of his much younger half-sister, especially,
cause him to realise that he has 'neglected' a lot in life. 'The harm's done, it's too
late now to get sentimental about it, but I still feel the regret searing in me like
a jet of flame. I curse art, the idea that it could be more important than everything
that was closer, the vanity of it, the internal bragging, the egocentricity that pre-
vented me from begetting children and being like a father to them (...) Art is one
great sham, a house of cards, self-delusion.'

And then after all he makes one last desperate attempt to set his artistic
house in order also. He realises that his current work is no good, that he is has
got in too much of a rut. After ripping up an unsuccessful gouache, he is left –
knowingly – empty-handed, he wants to put an end to all the self-deception, all
the tricks, all the earlier 'successes'. He asks himself what he still expects of
himself, 'I'm burning with the desire to discover that.' In the final sentence of the
book he has reached that point; he finds himself in his studio, 'alone in a mur-
muring silence, the sound of art. My eyes explore the empty canvas.' What is going
to appear on that canvas will be of no less harrowing authenticity than what
Campert has just confided to the reader in this book. ◾

Translated by Sheila M. Dale

An Extract from 'Life is Luverly'

By Remco Campert

'Why don't you say something?'

She's right, I've got to say something.

'You're beautiful.'

That always works.

'You think I'm beautiful?'

'Yes.'

'Do you think my breasts are beautiful?'

'Yes, beautiful.'

Oh, where is the language that great lovers come out with without bursting out laughing. Great lovers never burst out laughing, that's why they're great. Your breasts, let me see, I must find a good metaphor.

'I once had a boyfriend who thought they were too big. Do you think they are too big?'

'Too big? Not at all. That boyfriend probably wasn't accustomed to much.'

'Do you find them too small then?'

'No, no, not too small either.'

A metaphor, before it is too late. She deserves one. I'll do anything. Devote my life to lepers. Build a dam in China. Pay taxes.

'So what do you think of them?'

Here it comes: 'English hills by moonlight.'

Ridiculous nonsense. God, how I hate poetry. Breasts are breasts. Beautiful breasts are beautiful breasts. Why else do we have the word 'beautiful'? I'll just say it.

'Beautiful breasts are beautiful breasts.'

'And mine are beautiful?'

'Yes. The most beautiful.'

Today they are anyway. And perhaps they will always be. Everything is always the most beautiful. She lets her small fingers run across my breast, my stomach, down my thigh to my knee and back up again. She had been wearing panties with little blue flowers. Little blue roses. Do those even exist? Or were they violets? Where I lived with my mother there were flat-bottomed barges in the canal, filled with crates of violets. And on the other side of the canal lived the Italian from the Italian restaurant, a fat man, of course, with oiled black hair, who every Sunday let his motorcycle roar for hours along the quiet canal. His wife left him and started her own restaurant a few streets away: Henrietta's Escape. Above the canal the gulls would shriek and there was birdshit on the window. I had to eat porridge and looked up at the birdshit and felt sick. I was really small then. When I close my eyes I'm still sitting at that table in front of that bowl of porridge.

When you close your eyes everything is right now. The first thing my grand-
mother gave me when I arrived at her place with my game under my arm and the
letter tucked between my shirt and my chest ('otherwise you'll just lose it') was
a raisin bun slathered with butter. I was given the room at the side, the 'closet' as
it was called, where my uncle normally slept, but now he had to sleep in his own
room on a divan. My uncle was in his late twenties and everyone thought that he
would be a bachelor all his life. He smoked a pipe and believed in communism;
he probably doesn't do that any more. I haven't seen him for at least ten years.
The street where the house stood was boring and hot; the sea was a long way
away. After dinner I played a board game with my grandmother and uncle. But
what does it all matter now. It happened, it happens again when I close my eyes,
but it happens in the same way every time; it can never happen any differently.
I'm standing at the bus stop, cold, stiff, dry-eyed. I'm sitting in the bus, at the
front, looking at my father's second wife, who's walking away after giving me
a quick wave. I listen as the engine starts up; I don't think of anything, fiddling
the figures on my game. I can feel the letter, angular and alien, against my chest.
When I bend over a little, the letter rises up and sticks out above my shirt.
I see a friend walking along, he's only wearing swimming trunks and is carrying
a football under his arm – they were still all made from leather then.
'And what else? What else do you think about me? Do you think I'm good?'
'Yes. Very.'
'I mean for my age?'
'I think you're a miracle, regardless of age'.
'Why?'
'Because you're a miracle.'
'A miracle is a miracle?'
'A miracle is a miracle.'
A satisfied smile. It takes so little to please a child. To please anybody. As long
as you tell the truth. Her back is a miracle. And her buttocks. My hand overflows
with softness. A pillow here. Left right, right left.
'Do you think they are beautiful? Do they excite you?'
'Mmmm.'
For this I was born, that much is clear every time. Her legs around my legs,
a haystack of skin. Those two small, damp, sensitive spots, together become one
over-heating haystack. There go all higher thoughts, ambitions, good table man-
ners, the desire to be president, treasurer, an artist. Love and money, that's what
it's all about, she was right. Love for love's sake and money to preserve love,
to protect and feed it, for poverty screws up all love. Love for love's sake and
money for love's sake. Love. She bites my shoulder, I gently pull her hair.
I brush my tongue over her eyes, push my tongue into her ear, while under me
she throws herself from left to right, one moment clamping her legs around me
and the next spreading them so wide I can't feel them anymore. Matching
sounds. Soon now. I empty myself in her. That's how all children should be
made, I think, being able to think again; any other way would be pathetic.

Sun. A house with all its windows open. The loquacious greenery of the trees. It could be a farm. A privet hedge, blackberry bushes. I am crawling through a hole in the hedge, young grass, yellow grass, trampled grass, small pebbles, an ant with a piece of straw, an empty matchbox, faded from the sun. Further on is the ditch, where the milk cans are washed. Yes. An excellent plan. Put the matchbox in the ditch and see where it goes and how quickly. Put a few ants in it as its astonished, fearful passengers. At the wooden staging they can go ashore again, sadder and wiser ants.

'Are you asleep?'

'No. I'm just lying here, thinking.'

I think I will never do anything again, just keep lying here forever, submerged in the moment. I can hear them strolling along the paths in the park, the mothers blessed with children, with the fathers walking sedately beside them, bored without knowing it, in their Sunday suits, a fragrant cigar between their stubby fingers, while they secretly ogle other people's wives with their washed-out blue Dutch eyes. Big breasts, big buttocks, under flowery dresses. Oh, it is such a democratic park, open to all ages, all races and all sexual preferences, approved by the Christian, the Catholic and the Humanist Boards of Inspection. The boys are kicking a red plastic football with their shiny black shoes. Analyse this sentence from the textbook for the young!

'What are you thinking about? Me?'

'You too. *Inter alia*, Boelie would say.'

'So what else are you thinking about?'

'Everything. It suddenly occurred to me what a big part the flagstones on the pavement play in your life when you are small. You know, those grey, square flags. You know them better than you know your parents. And later you forget all about them.'

'And what were you thinking about me?'

'That you're one of the sweetest girls I've ever slept with.'

'Have you been here with many girls?'

'Hundreds of them.'

'But I'm the sweetest?'

'One of the sweetest. Oh, nonsense, you are the sweetest.'

'And the most beautiful too?'

'Yes, the most beautiful too.'

'And the most exciting?'

'Yes.'

Yes, it's true. But it is always different.

From *Life is Luverly* (Het leven is verrukkuluk. Amsterdam: De Bezige Bij, 1961)

Translated by Pleuke Boyce

Five Poems
by Remco Campert

January 1943
for Joekie Broedelet

I was walking along the cart track
on a sparkling winter day

my mother came to meet me
a figure in the distance

the night before I'd had a dream
I'd been sailing my little boat

my hand skimmed the duckweed
in the gleaming waterway

the boat sailed to the other side
and stranded in the rushes there

when I looked up I saw my father
thrusting his arm through barbed wire

he gazed at me with pleading eyes
my father asking me for bread.

On that country road mother
you held me tight for ages

your eyes were red
your jacket smelled of city

the Germans had posted us a card
informing us that he had died

in Neuengamme bitter word
they'd murdered him.

I felt nothing then but knew
there was something I should feel

I looked past my mother's sleeve
towards the deep enticing wood

when I got the chance I told her all
about the things that interested me

the trap I'd set
at the entrance to the rabbit warren

the hut that I was building
in a tree I alone knew

only later did I feel a pain
pain that never went away

that still floods through my body
as I write this

long ago and yet so near
time lasts a lifetime long.

From *Scenes in Hotel Morandi*
(Scènes in Hotel Morandi. Amsterdam;
De Bezige Bij, 1983)

Januari 1943

voor Joekie Broedelet

Ik liep over het karrespoor
op een krakende winterdag

mijn moeder kwam me tegemoet
figuurtje in de verte

de nacht ervoor droomde ik
dat ik een scheepje zeilen deed

mijn hand streelde het kroos
in de blikkerende sloot

het scheepje zeilde naar de overkant
en raakte klem in het oevergras

ik keek op en zag mijn vader staan
hij stak zijn arm door prikkeldraad

hij keek me smekend aan
mijn vader vroeg aan mij om brood.

Op die landweg moeder
hield je me minuten vast

je ogen waren rood
je jas die rook naar stad

de Duitser had per kaart gemeld
mijn vader hij was dood

in Neuengamme bitter oord
daar hadden ze hem vermoord.

Ik voelde niets
maar wist dat ik iets voelen moest

keek langs mijn moeders mouw
naar het lokkend bos

pas toen het kon vertelde ik honderduit
over wat me werkelijk bezighield

de strik die ik had gezet
voor het konijnehol

de hut die ik aan het bouwen was
in de boom die niemand kende

eerst later voelde ik pijn
die niet meer overging

die nog mijn lijf doortrekt
nu ik dit schrijf

lang geleden toch dichtbij
de tijd duurt één mens lang.

Memo

Write it down quickly before I forget:
in the car with D. and her father
cutting across America's seasons
muggy sunlight in Santa Barbara
wet snow in Denver
and in every Best Western hotel
the TV's flickering light
on her dear sleeping face
like a young girl once again

but writing down the words
alters what I want to remember
that which had no words
was a living, breathing image
so now I have two versions of the same
today I can superimpose them
but tomorrow when I'm gone
only the words will remain
evoking something
that no eye sees any more

From *New Memories*
(Nieuwe herinneringen.
Amsterdam; De Bezige Bij, 2007)

Notitie

Gauw opschrijven voor ik het vergeet:
in de auto met D. en haar vader
dwars door Amerika's seizoenen heen
de vochtige zon in Santa Barbara
de kletsnatte sneeuw in Denver
en in alle Best Westerns
het knipperlicht van de televisie
op haar lieve slapende gezicht
van weer heel jong meisje zijn

maar het schrijven van de woorden
verandert wat ik niet vergeten moet
dat wat geen woorden had
enkel levend, ademend beeld was
zodat ik nu twee versies van hetzelfde heb
die ik vandaag nog over elkaar kan leggen
maar waarvan morgen als ik weg ben
alleen de woorden resten
die aan iets herinneren
waar geen oog meer weet van heeft

Antwerp Girl

It was late in the evening
rain caught in lamplight
beat down on the tarmac
of the Old Mechlin Road
you were wearing an off-white dress
I'd have guessed you were fifteen
you were walking down the street
as I was crossing
cars passed by
braked rode on
you asked me the way to the Muse Café
the bar where Ferre was on
Ferre Grignard singer of your song
you'd heard his voice on the radio
and now you were on your way
'Just follow the tram lines
you can't go wrong'
and like a fool I let you go

Antwerp girl
you're still on my mind
what have I done
with my life

From *New Memories*
(Nieuwe herinneringen. De Bezige Bij, 2007)

Antwerps meisje

Het was laat in de avond
regen in lamplicht gevangen
sloeg neer op het macadam
van de Mechelsesteenweg
je had een offwhite jurkje aan
ik schatte je op vijftien
je liep langs de straat
waar ook ik overging
auto's passeerden remden af
reden weer verder
je vroeg de weg naar de Muze
café waar Ferre optrad
Ferre Grignard de zanger van jouw lied
zijn stem die op de radio geklonken had
en waarheen je nu op weg was
'volg de tramrails maar
dan vind je hem vanzelf'
en ik onnozelaar liet je gaan

Antwerps meisje
dat ik in mijn hart draag
wat heb ik toch gedaan
met mijn leven

The White Rose

It was late in the year
actually I mean the end of November
the twenty-ninth if I'm not mistaken
round about four in the afternoon
(it's hard to tell precisely
whether it was before or after
only at the time could one be sure
but then I wasn't thinking about the time)
when the last petal
fell from the white rose
and floated downward
to the darkening ground

From *New Memories*
(Nieuwe herinneringen. De Bezige Bij, 2007)

De witte roos

Het was laat in het jaar
ach eigenlijk bedoel ik eind november
de negenentwintigste als ik het wel heb
zo om een uur of vier in de middag
(op de minuut af weten is moeilijk
zowel van tevoren als achteraf
slechts tijdens had het gekund
maar ik lette niet op de tijd)
toen van de witte roos
het laatste blaadje losliet
en neerwaarts warrelde
donkerende grond tegemoet

Overtoom, Amsterdam.

On the Overtoom

It's thawing on the Overtoom
yet the frost's setting in again
or so my feet tell me
that measure my day
I stick close to home
ever closer
that's my age
clouds swell with a wan colour
yesterday's smell still clings to me
I ate with my friend
we broke bread together
and talked about our dead
we're almost out of sight
though we still laugh
what else can you do?
hug each other goodbye
after all you never know

From *New Memories*
(Nieuwe herinneringen. De Bezige Bij, 2007)

Op de Overtoom

Het dooit op de Overtoom
maar het vriest ook alweer op
melden mijn voeten
die mijn dag verlopen
ik blijf dicht bij huis
steeds dichter
dat is mijn leeftijd
wolken worden zwaarder van onkleur
de geur van gisteren hangt nog aan me
ik at met mijn vriend
we braken het brood
en deelden de doden
we zijn al bijna uit zicht
wij lachen nog
wat moet je anders?
omhelzen elkaar ten afscheid
misschien je weet maar nooit

All poems translated by Donald Gardner

The Last Belgians?

The German-Speaking Community in Belgium

[JEROEN DEWULF]

Whenever the King of Belgium enters the federal parliament, he is officially announced in Dutch, French and German – *De koning, le roi, der König*. In fact, contrary to the widespread assumption that Belgium is a bilingual (French/Dutch) country, German is also an official language in the Kingdom of Belgium. Because of their patriotic disposition, the approximately 73,000 German-speaking Belgians are often referred to as 'the last real Belgians,' as opposed to the Walloons and particularly the Flemish who increasingly identify themselves with their own region. In recent decades Belgium has become a multilingual nation that, paradoxically, no longer projects itself on the basis of its multilingual Belgian identity, but rather on each area's local, monolingual identity. In the eyes of many, Belgian identity has become an empty box, an anachronistic creed that survives only in a handful of nostalgic patriots, the royal family, the national soccer team, the smurfs and...the German-speaking community. A closer look at this community's position within the Belgian state, however, allows a totally different interpretation, one which we might even call: 'the Belgian of the future.'

'New Belgium': The East Cantons

Belgium received its German-speaking territories as indemnity after World War I. These territories had traditionally been referred to as 'Eupen-Malmedy', from the names of the former cantonal capitals. When they became part of Belgium in 1920, they were first called 'New Belgium' and later the 'East Cantons' or 'East Belgium.' This new Belgian territory consisted of two parts: the 'Eupener Land' in the north, and the regions of Malmedy and Sankt Vith in the south. The two territories are separated by the High Fens, an upland area between the Ardennes and the Eiffel highlands. Historically the north had been part of the Duchy of Limburg, whereas the south had been part of the Duchy of Luxembourg. With the exception of the bilingual (German-French) city of Malmedy, both territories had traditionally been exclusively German-speaking. The abbey of Malmedy was the religious centre of these intensely Catholic regions. After Napoleon's defeat at Waterloo both regions had been allotted to

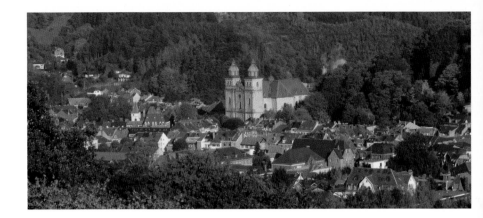

Malmedy

Cathedral, Sankt Vith.

The abbey of Malmedy.

Prussia, while the Treaty of Versailles placed them under Belgian administration. Official Belgian historiography decreed that the regions had always been Belgian territory and therefore referred to them as *'cantons rédimés'*, as parts of Belgium that had finally been reunited with the mother country.

Initially the East Cantons were run by Herman Baltia, a general who had made his career in the Belgian Congo. The government counted on Baltia's colonial experience to impose Belgian rule and transform the new citizens as quickly as possible into 'real Belgians.' In actual practice, this entailed the elimination of all references to Germany and the imposition of the French language. One of Baltia's first official acts was the removal of the monument in Malmedy commemorating the Franco-Prussian War of 1870. As required by the Treaty of Versailles, Baltia organised a referendum to determine whether the East Cantons would be permanently separated from Germany and annexed to Belgium.

General Herman Baltia
(1863-1938).

However, the vote was not secret. Every opponent of annexation had to write his name and address in an ad hoc register. As a result only 271 out of some 34,000 voters dared to do so, and consequently the regions officially became Belgian territory. Historians later termed the referendum '*la grande farce*'.

The fate of these 'new Belgians' might have been the same as the so-called '*deutschsprachige Altbelgier*', who had been part of Belgium since the establishment of the Belgian State in 1830. These German-speaking Belgians, around 50,000 in all, had been completely integrated into the French community and had lost their German roots. However, although Baltia was awarded the title of Baron for the great service he had done his country, the Belgian government was surprisingly hesitant when it came to the future of the East Cantons. Significantly, soon after the referendum Belgium entered into secret negotiations with Germany to sell both regions back.

If we look at events in Flanders during the same period, we get a better understanding of this surprising change in attitude. In 1866 the city of Antwerp had

Postcard with Belgian
soldiers in 1914.

1914... Soldats Belges - Abri contre le froid | **1914.** Belgian soldiers - A shelter against the cold

15ᵐᵉ Série

adopted Dutch as the official language of its administration. In the 1870s the Flemish Movement celebrated two other important victories: Dutch became accepted in the courts and later in the administration. In 1883 Dutch also became an optional language of instruction in state secondary schools, and with the Equality Law of 1898 the Belgian constitution became officially bilingual. These changes indicate that by around 1900 the traditional idea that Belgium could only exist as an entirely francophone nation was already obsolete. It is telling that even members of the Socialist Party, who traditionally had been sceptical about the demands of the elitist Flemish Movement, started to link social with linguistic reforms.

Although after World War I the Flemish Movement lost credibility as a result of some of its members' collaboration with the German occupier, it was clear that there could be no return to the 1830 situation. The days when French was considered the only language of progress and cultural refinement were defini-

tively gone. Moreover, the war had demonstrated with terrible clarity how dramatic the consequences of traditional Belgian politics could be. As almost all senior officers in the army were Francophone, communication with Flemish soldiers was generally lamentable. These grievances against the Belgian State, which asked them to fight bravely but at the same time treated them as second-class citizens, was a key element in the ongoing Flemish drive for autonomy. At the same time, the economic development of Flanders and decline of Wallonia proved unstoppable. In the light of these factors, the very idea of the compulsory Gallicisation of an entire German-speaking region in the name of Belgian unity seemed not only unrealistic but also completely outdated.

In fact, the dismantling of the Belgian State as created in 1830 proceeded inexorably. In 1930 the University of Ghent replaced French with Dutch as its language of instruction, and soon new laws laid the foundation for the federalisation of Belgium – the post-war transformation of the centralist, Francophone Belgian state into a federal state, divided into an exclusively Dutch-speaking Flanders and an exclusively French-speaking Wallonia. Within this concept there was no place for a tiny German-speaking region. Besides, the calamine ores in the East Cantons had proved of little interest to Belgian industry. In the eyes of many Belgian politicians, selling the region back to Germany seemed to be the best option.

World War II: scapegoat politics

Yet the outbreak of World War II and the new occupation of Belgium by German troops reshuffled Belgian politics. After two decades of clumsy Belgian governance in the East Cantons, it was no surprise that the German troops were welcomed with open support. What followed was the annexation of the East Cantons – 'Heim-ins-Reich', the induction of the male population into the Wehrmacht and, finally, the almost complete destruction of the region during the Battle of the Bulge in December 1944. After the war, the East Cantons returned to Belgium and suffered extremely harsh retribution. People were encouraged to demonstrate their true Belgian patriotism by betraying others, causing deep wounds that in some cases persist to this day. Considering the scale of the legal proceedings – a quarter of all the inhabitants, women and children included, were accused of collaboration – one cannot help but suspect that the East Cantons were treated as a scapegoat. In the following years, the old policy of ruthless assimilation was reintroduced, particularly with regard to the young population. The school-system suffered a 'restauration culturelle' based on the Alsatian model, with the hilarious effect that children whose fathers had fought as German soldiers now learned about the heroic resistance of the Belgian troops against the German barbarians.

The population of the East Cantons did its best to adapt to the post-war political situation. Identification with Germany was avoided at all costs. Until 1971 politicians refrained from creating specifically German-speaking political parties, and instead participated in Belgian and later Walloon parties. Although the East Cantons had never been bilingual, local politicians favoured a bilingual administration for the region as part of the (French-speaking) Walloon electoral district of Verviers. Suggestions for political and cultural autonomy tended to be labelled – even within the community itself – as 'Deutschtümeleï'. As a

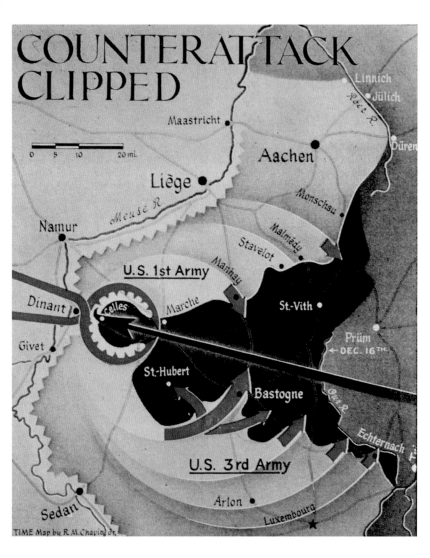

COUNTERATTACK CLIPPED

'Counterattack Clipped'
after the Battle of
the Bulge.
Time Magazine.

result, nowhere in Belgium was the voting abstention rate higher than in the East Cantons, where it could reach as high as twenty per cent of the electorate, despite the fact that voting was (and is) compulsory. It is telling that when in 1971 the first specifically German-speaking party, the Christlich-Unabhängige Wählergmeinschaft, participated in the elections, it explicitly mentioned on its posters that it was not a '*Heim-ins-Reich*-Movement'. It is therefore no surprise that the region eventually did not opt for the name 'German Community,' but rather for 'German-speaking Community,' in contrast with the French-speaking Belgians, who decided to call themselves the 'French Community.'

Political and social change finally came about as a result of Flemish pressure. Although the war had caused a temporary interruption in the progress to Flemish autonomy and the Flemish Movement once again lost credibility because of collaboration with the occupiers by some of its radical members, the pressure to continue with the federalisation process had not ceased. In the 1960s the decision to federalise Belgium was officially enacted. Whereas in 1830 Belgium was founded on the basis of a French revolutionary model as a 'nation elective,' unit-

Ted Paluch (left),
a survivor of the 1944
Malmedy massacre of
84 US soldiers in Belgium,
compares a photo taken
of the scene then and
how the area looks now.
Photo by Ken White.

The government seat
(Council of the German-
speaking Community)
in Eupen

ed by the idea of freedom, the federalisation process established internal bor-
ders according to linguistic principles. These language boundaries, drawn in
1963, reflected a territorial principle based on historical and ethnic grounds. And
so, along with the Dutch- and French-speaking community, the German-speak-
ing Belgians were able to achieve linguistic and cultural autonomy while avoiding
any suspicion of irredentism. They simply had to echo the Flemish demands in
order to have their own ambitions implemented. In 1970 the German Cultural
Community was formed. In 1983 the German-speaking Community was officially
established, with a proper government and parliament.

The German-speaking community in Belgium is now one of the best protected
minorities in the world. Awareness that the Flemish were sympathetic towards
the German Belgians was crucial to this. There are several explanations for this
sympathy. One important factor was religion. The East Cantons are traditionally
a deeply Catholic region and in this respect are still quite different from the
strongly socialist Wallonia. For decades the Flemish had fought for the right to
use their language in education and in the courts, for cultural and political au-

tonomy, and thus they recognised similar problems in the German-speaking community. For many people in Flanders, as in the East Cantons, the liberation in 1944 had been a traumatic experience. Not only were large parts of conservative Flemish society shocked by the moral laxity in the days after the liberation, but also in many parts of Flanders the punishment of both real and alleged collaborators was out of control. In its initial phase this chastisement of collaborators was not a legal process. Rather, it was the mob taking to the streets in order to exact justice, in some cases using the opportunity to settle old scores. Another important point is that, in contrast to the Netherlands, in Flanders after the war there were no strong anti-German feelings. It is quite remarkable that as soon as Germany and Austria recovered, both the Catholic Rhineland and the Bavarian and Austrian Alps became favourite destinations for Flemish tourists.

German-Speaking Community: a place in the Belgian labyrinth

Becoming patriotic Belgians was undoubtedly an interesting option for the population of the East Cantons. The Belgian passport helped the German-speaking population to forget and in some cases also to conceal what had happened dur-

'Council of the German-speaking Community', Eupen.

ing the war. At the same time, the process of federalisation enabled the German-speaking community to preserve its German character. Belgium had, in fact, developed into a patchwork of two seemingly opposing interpretations of nationalism. On the one hand, the Belgian State – represented by the national government, parliament and the monarchy – reflected and still reflects a common Belgian identity, in the sense of Ernest Renan's model of identity as a voluntary association. The autonomous regions, on the other hand, have been established according to linguistic criteria clearly influenced by the Romantic idea of a "Kulturnation", where a nation is defined on the basis of ethnicity and language. The region of Brussels, however, represents an important exception, as it remains the only officially bilingual part of Belgium. This unusual con-

Eupen

struction, which the Belgian journalist Geert Van Istendael has called 'the *Belgian Labyrinth*', made it possible for the German-speaking community to identify with a new state without relinquishing its own cultural identity.

Other German-speaking minorities in Europe had more difficulties in this respect; while a victorious skier from South Tyrol who refused to sing the Italian national anthem on the podium could cause a scandal, in Belgium almost no one knows the lyrics to the 'Brabançonne'. This lack of national patriotism in Belgium also made it easier for the German-speaking Community to engage in cross-border activities within the European Union (Euregio Maas-Rhein, Grossregion Europa, etc.). In recent years, however, the German-speaking community has been confronted with an unexpected consequence of border-crossing. Because of its favourable tax-system, Belgium has attracted many citizens from neighbouring countries. In some municipalities in the south-eastern part of the country almost half of the population now consists of German immigrants, many of whom continue to work in Germany and only use Belgium as their country of residence for tax purposes.

Beside the increasing number of German immigrants, another somewhat contentious issue is whether the German-speaking Community should be allowed to develop into an autonomous region. At present its autonomy is basically restricted to language and cultural matters, with social and economic affairs still under the jurisdiction of the Walloon Region. The creation of an autonomous German-speaking Region would obviously weaken the political power of Wallonia, which strongly opposes this political course. Significantly, Jean-Claude Van Cauwenberghe, the former Minister-President of Wallonia, used to refer to the population of German-speaking Belgium as '*Walloons who speak German*'. Whether it actually makes sense to concede economic autonomy to a region of barely 73,000 inhabitants remains an open question, especially bearing in mind that due to massive immigration in the 1960s and 1970s other minorities like the Moroccan or Turkish communities, who have no language rights at all, far outnumber the German-speaking Belgians.

St Maarten celebration
in the 'East Cantons'.

Due to their high birth rates and tendency to import marriage-partners from their countries of origin, these immigrant communities are growing steadily and will inevitably change the social structure of Belgium. In this context, the disparaging reference to Belgian identity as an *'empty box'*, might also be seen from a positive perspective. In fact, emptiness gives newcomers the necessary space to integrate. It is not by chance that descendents of immigrants tend to identify more with Belgian than with Walloon or Flemish identity. In times of globalisation and migration, the very vagueness of its national identity could prove to be Belgium's salvation. The successful integration of its German-speaking community is proof that it is possible for a new community to identify with Belgium. Combining loyalty to the new state with the preservation of cultural self-awareness, the German-speaking Community represents an interesting model for the integration of newcomers in Belgium. It is even possible that those whom today we call 'the last Belgians' will eventually become a role model for Belgium's future. ■

www.dglive.be

From Armed Peace to Permanent Crisis

Cracks in the Belgian Consultative Model

[MARC HOOGHE & LUC HUYSE]

Jan Albert Goris, better known by his pen name, Marnix Gijsen, spent many years in the US as minister plenipotentiary. In 1946 he wrote in his 'Belgium: Land and People': 'At first sight, so many centrifugal forces appear to be at work in Belgium that her existence as a political unit seems paradoxical.' It is an opinion that been expressed many more times in the media, especially abroad, since the lengthy crisis of 2007-2008. A number of international newspapers have already predicted the country's demise. Belgian politics have always been thoroughly conflictual, but evidently the old pacification mechanisms are no longer working as they should.

Belgium's political system is by definition notably divided. There are, of course, the traditional differences between labour and capital, and the associated socio-economic conflicts. And as in many traditionally overwhelmingly Catholic countries a conflict also developed between the Catholic Church and those who sought to reduce that church's impact on public life. A third fault line is of course linguistic-political, with a sometimes sharp division between Dutch-speakers and French-speakers. Despite the presence in the Belgian political system of these three fundamental antagonisms, we have to state that the country has never descended into extreme violent unrest. That in itself is relatively exceptional; other divided societies, such as Lebanon, Cyprus or Northern Ireland, have indeed suffered this type of conflict.

In the 1960s and '70s people sometimes talked of 'The Belgian Paradox': despite all the reasons for conflict, the Belgian political system seemed to manage to function relatively well. True, there was no question of any real reconciliation between the opposing groups, but a complex form of compromise politics led at any rate to what is called an 'armed peace'. These pacification politics were based on a number of clear principles. To start with, the rule that the majority decides, the gold standard in just about all Anglo-Saxon countries, did not apply here. Confronted with sensitive matters, the political elite preferred 'government by mutual agreement', whereby the minority could always explicitly or implicitly exercise a right of veto. That applied to both ideological and linguistic minorities. A far-reaching form of decentralisation is also part of the rules of the game. In delicate issues such as education or culture, the option chosen was to leave many decisions to the political groupings (called 'pillars' in Belgium), or to the socio-economic interest groups or the language communi-

ties, rather than reserving them for one central authority. The few goods that were at the government's disposal (government jobs, subsidies, positions on government bodies, etc.) were shared out among all the interest groups according to carefully worked-out rules. In this way all the members of the political elite also had sufficient incentives to keep the system in being. The game was played by these rules for decades and they ensured that conflicts did not develop into uncontrollable confrontations. The differences did not disappear, they lay dormant under the surface. But at least the pacification mechanisms did manage to prevent a complete implosion of the political system.

The fundamental question now is whether these trusted pacification rules have lost their meaning. It does indeed look as if the old mechanisms are now a good deal less self-evident. So, is the Belgian pacification model finished? To answer that we must first look back and see why this model was able to function so successfully in the past.

Conditions of success

A first important condition was the existence of strong political parties and interest groups. Historically, compromises were always reached by the leaders of the different political groupings. Although these senior figures came from radically different ideological backgrounds there was a consensus among that elite on the way in which the political system should be kept going. Once the pact had been made, the party leaders made sure that the rank and file accepted the compromise without too many complaints. The leaders wielded a great deal of authority and party members often remained faithful to their organisation from the cradle to the grave. These docile followers also made it possible for the elite to actually make a pact with the other camps and then have that pact implemented.

Secondly, there was a constant interaction between the three fundamental fault lines in Belgium through which they too, to some extent, neutralised each other. Whenever one of the sources of conflict came to the fore and monopolised the political agenda, the other differences moved into the background. So there was a constant process of tension and détente, of heating up and cooling down, of mobilisation and demobilisation. Acute economic problems, for example, could ensure that differences over language disappeared into the background for a while and vice versa.

A remarkable balance of power grafted itself onto this. The Christian Democrats formed a majority in Flanders, the free-thinking Socialists a majority in Wallonia; the former had a vulnerable minority in Wallonia, the latter in Flanders. It was a healthy stalemate because it tempered the aggression of, in particular, the Walloon Socialists and the Flemish Christian Democrats, the protagonists in virtually all Belgian conflicts. The powerful Christian Democrat pillar in Flanders had to put up with the Socialists and Liberals getting their share of the subsidy cake, but in return the same thing happened on the French-speaking side. At the national level, Dutch-speakers agreed not to play on their numerical preponderance and in exchange French-speakers were prepared to give Brussels the status of a bilingual capital region even though French-speakers were in the majority there.

Finally, there was the strong economic growth during the period 1958-1972. Government budgets increased strongly during 'the long Sixties' and it was

therefore relatively easy to buy off each other's claims. The 1958 school pact, for example, which reconciled the defenders of the state school system and the Catholic education network, actually boiled down in practice to both school networks getting more government subsidies. Initial agreements on constitutional reform also led to both language communities getting more funding. In this period of constantly increasing government resources it was possible to engage all the groups in society with the pacification model.

United colours of Belgium.

The system under pressure

During the last decade of the twentieth century, however, the trusted pacification model came under more and more pressure. The problem-solving capacity of the Belgian political system gradually diminished. That can be explained by the fact that the conditions that governed the pacification model slowly became more negative.

In particular, there was a process of de-pillarisation. The traditional Christian, Socialist and Liberal pillars which had controlled public life in Belgium for decades gradually lost their hold over Belgian society. On a personal level, ties between citizens and their social organisations became looser. Unpredictability took the place of electoral and organisational loyalty and obedience. At the so-

cial level, too, the pillars began to crumble. A good many interest groups refused to be bound exclusively to one political grouping. In addition many new groupings developed which also laid claim to a place at the negotiating table but which no longer fitted into the traditional pillar system. As a result it became more and more difficult for the political elites to ensure compliance with the agreements they made. It was still perfectly possible to conclude agreements, but they became meaningless if you could no longer successfully impose them on a docile rank and file.

On top of this, the traditional political geography of Belgium changed in this period. It evolved from a relatively well-organised entity with three fault lines to a relatively complicated entity made up of large and small conflicts. The popular unrest that erupted in 1996, when it emerged that the police and judiciary had made a number of errors in their handling of the Dutroux case, was characteristic of this. The 'white campaign' that developed then, and brought hundreds of thousands onto the streets in a protest march, did not fit at all into the traditional fault-lines model. The political elite had no suitable instruments to deal with this discontent. And we also have to take into consideration a general shift in political decision-making. Politics is no longer just a matter of professional politicians meeting in Rue de la Loi/Wetstraat. The media, the judiciary and the European institutions are becoming increasingly important in political decision-making, and they care little about the traditional prescriptions of pillarisation. Which makes their actions harder to reconcile with the famous Belgian pacification model.

The subtle equilibrium of power, too, fell by the wayside. The Christian Democrats, in particular, lost ground electorally in Flanders, whilst on the Walloon side the (conservative) Liberals gradually grew stronger. As a result mutual deterrence also disappeared to some extent. Christian Democrats could no longer claim to be the unique and only representatives of Flanders, but they had to engage with electoral rivals within the Flemish community. Little by little the Liberal grouping became stronger on both sides of the language border, but this did not really lead to any clear new balance.

And finally, again in the Nineties, a strict programme of national budgetary reform was implemented, particularly by the then Prime Minister, Jean-Luc Dehaene (a Flemish Christian Democrat). Dehaene made sure that the budgetary deficit was largely eliminated, so that Belgium met all the criteria for membership of the eurozone. However, this cost-cutting process meant in practice that there was much less government manna to hand out. The various parties and pressure groups, then, had far fewer incentives to remain loyal to the system. With fewer goodies to distribute, concluding great historic pacts also loses some of its attraction.

The wider horizon

Obviously, many of these developments were not confined to Belgian politics. Often they are general social developments that can be found in other European societies too. But the Belgian political system was particularly vulnerable to these developments. Precisely because the underlying tensions are such a powerful presence in Belgian politics and can in theory erupt at any moment, the pacification model is very heavily biased in favour of stability. Political elites

do not necessarily look for the optimal solution, but for one that can bring stability and predictability because they fear what might happen should the system be totally derailed.

However, all Western political systems are confronted with the task of learning to live with an unfamiliar and relatively unpredictable society. There are various reasons for that. To begin with, there is the process of globalisation and enlargement of scale – what happens abroad is becoming more and more important to our own political system. Certainly within the European Union the transnational decision-making level has become dominant, so that the Belgian political elite no longer has the power to push through whatever decisions it wants by itself. There is a trend, then, towards what is called 'multi-level government': political decisions are taken at different levels, and coordinating all those different levels makes decision-making extremely complex. Precisely because the Belgian level is already relatively fragile, it is difficult for the Belgian political system to adapt to this.

The general social trend towards individualisation also puts pressure on the stability that is so keenly desired. Individual citizens are no longer disposed to follow the instructions of the political elite. This increases the degree of unpredictability – political conflicts are no longer played out along the traditional fault lines, instead they can occur in the most unexpected places. Who could have predicted that a tragic but relatively banal robbery and murder in Brussels' Central Station (in 2006) would lead to protest on a huge scale? The course of these protests is equally unpredictable. These kinds of emotionally driven campaigns blow up suddenly and disappear again just as suddenly. This means that the political system barely has time to react to such flare-ups. The most that can be achieved is some intensive form of crisis communication, but it is hard to reconcile the rapid succession of events with the laborious and above all slow search for a compromise which is typical of pacification democracy.

The derailment in 2007-2008

The search for political stability has clearly become much more complex, but still Belgian politics enjoyed a period of relative peace at the start of the 21st century. There were no major incidents and, in addition, the successive Verhofstadt governments (1999-2007) succeeded in staving off demands for further federalisation of some powers. In 1999 the first Verhofstadt government was still unique – for the first time in half a century the Christian Democrats disappeared from the majority and the Socialists and Liberals formed a 'purple' coalition. The first Verhofstadt government worked on a number of issues which could, in principle, have revived the philosophical differences – the liberalisation of euthanasia and the introduction of homosexual marriage were pushed through rapidly, making Belgium an international pioneer in that field. But even here the pacification model was not completely abandoned; during the parliamentary process the arguments of the Christian Democrat opposition were also taken into account. But in general it was apparent that the philosophical fault line no longer had a mobilising effect. In contrast to the situation in the United States, homosexual marriage is absolutely not an issue with Belgian public opinion. The current law on euthanasia is also accepted or even supported by the majority of the population.

The 2007 elections, however, put an abrupt end to this relative peace. Despite months of negotiation, no community pact emerged. A great deal has already been written about the causes of this failure, and obviously personal and strategic elements also play a part in it. But if we look at it with a measure of objectivity, we have to ask why the traditional Belgian pacification model does not seem to work in this case. But at the same time some degree of caution is advisable. Although journalists keep breathlessly announcing that this really is a 'historic crisis', we need to remember that in the past, too, it has sometimes taken years for a 'major compromise' to be worked out.

There are indications, however, that decision-making in community matters has become more difficult. The party elites are clearly less able to control their followers. During the negotiating process it really seemed on occasion as if a compromise would be reached, but time after time the negotiators were curbed by their own grass roots (who were often very limited in numbers, but extremely noisy). This lack of leadership was partly the result of a pre-election cartel formed between the Flemish Christian Democrats and the Flemish nationalist party, the N-VA or New Flemish Alliance. The more radical rhetoric of the N-VA sometimes seduced the Christian Democrat representatives as well, so that they no longer heeded their chief negotiators. The party elites' ability to lead was also sometimes thwarted by the presence of the mass media in greater numbers than ever before. Traditionally the great historic pacts of Belgian politics were born in secluded meeting places, preferably in some charming castle in one of the suburbs of Brussels. The press were kept at a safe distance; at most one might hear something at the entrance to the castle grounds when the top politicians left the negotiating table. This time, however, the ubiquitous mobile phone ensured an endless string of leaks. Even while the negotiations were in progress information was constantly being passed to the press. This then led to further sensational headlines and the associated urge on the part of some politicians to use them to boost their image. Although the chief negotiators repeatedly called for the media leaks to stop, they never really gained control of the process.

The subtle game of checks and balances hardly works any more either. Amongst the Christian Democrats, in particular, the mental breach between Dutch- and French-speakers is almost complete. For example, the Flemish Christian Democrats no longer feel called upon to defend the interests of the Christian education network in the French Community. Flemish politicians, too, concentrate more and more on their own level of government, i.e. the Flemish Community. That means that they are no longer so concerned about the fate of Dutch-speakers in Brussels (some 150,000 people in total, at most 1.5 percent of the whole Belgian population). So the moderating influence of all these balances of power is disappearing. Theoretically this is interesting, because thirty years ago various authors were already predicting that a federal system in which the regional institutions exercised a great many powers autonomously was no more than a halfway house on the road to the break-up of the country's various language communities. The prediction at the time was that the political elites would concentrate more and more on their own communities, and so attach less and less importance to the principle of federal loyalty. To some extent this prediction has proved true, partly because there are no longer any federal parties in Belgium (which is quite exceptional). There is now not a single party that represents the whole country. Each party is elected within its own com-

munity and must then ensure that it finds sufficient allies on the other side of the language border to form a federal majority. This is why a number of groups have advocated creating a 'federal constituency', so that politicians could once again win votes across the whole country, and therefore also in both language communities.

A final point of difference, moreover, is that the federal budget is structurally insolvent. So there are no more gifts to be handed out. In the past, peace between the communities was often bought by channelling lavish subsidies. In Belgium this is referred to as 'waffle-iron politics', because as we all know a waffle-iron makes exactly the same impression on both sides of the dough. If the Flemings needed money for a new port, the French-speakers automatically got a similar amount for their economic needs. That sort of mechanism no longer works, so there is really no incentive any more to accept a compromise on issues in which one has no vital interest.

The result of all these factors, then, is that it has become much more difficult to apply the traditional pacification mechanisms. The question is, however, whether there is an alternative. All the studies clearly show that the presence of Brussels is enormously important to the whole Belgian economy. Brussels is *the* economic centre, drawing in hundreds of thousands of commuters from both sides of the language border. Brussels cannot be split into a Dutch-speaking and a French-speaking part, so the two communities will have to keep on finding ways of managing that shared economic wealth together. Obviously the old prescriptions for the Belgian model do not work very well any more, but that is not to say that Belgium is likely to fall apart. As Belgians tend to put it, one can easily operate to separate Siamese twins. But if the twins are joined at the head, there is no way they can be separated without fatal consequences. ∎

Translated by Lindsay Edwards

UNStudio:
Architecture between Art and Airport

[DIETER DE CLERCQ]

UNStudio,
New Amsterdam
Plein & Pavilion,
New York City,
2009

New York will be celebrating its 400th anniversary in 2009, and to mark the oc-
casion the city will acquire a tangible expression of its Dutch origins. In early
February 2009 it was announced that the Dutch architect Ben van Berkel (1957-)
will be building a pavilion there. That pavilion will stand on the precise spot
where the Dutch colonists came ashore four hundred years ago, at the south-
ernmost tip of Manhattan. It is to be completed by the end of September 2009.

That it should be Ben van Berkel who is to design this building is not particu-
larly surprising. He is the first Dutch architect to be given the chance to build
a skyscraper in New York. And so he joins the series of 'starchitects' who have
got a foot in the door in Manhattan, a list which includes Herzog and De Meuron,

Jean Nouvel and Rem Koolhaas. His design for the block of luxury flats at Five Franklin Place in the popular TriBeCa district is going to be hard to miss. Van Berkel has ornamented this twenty-one storey tower with thick bands of metal that narrow, widen and twist in a seemingly random manner. From a distance it will look as if the building has been swathed in a shining satin ribbon, all ready to be unwrapped. In reality, as these bands pass around the building they function alternately as the railing for a balcony, a frame for a panoramic view and a shield against the sun. The building consists of three separate layers of flats that differ in size and amount of light. The lower ones facing the surrounding houses are conceived as loft dwellings with double-height storeys to make the best use of the natural light. The flats higher up, the 'city homes', which rise above the surrounding houses, are deeper in colour and have a different texture. Above these again, the three-storey penthouses have – in addition to a fabulous view and spacious terraces complete with jacuzzi – an open fire, a private lift and an outdoor kitchen. It seems there is little sign of the credit crunch in the top echelons of the New York housing market.

UNStudio, Five Franklin Place (facade detail with balconies), New York City, 2007-2009 (© Archpartners 2009).

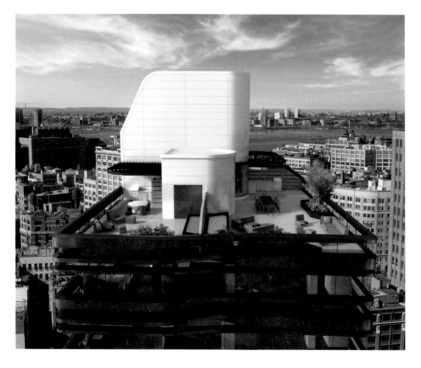

UNStudio, Five Franklin Place (outdoor space), New York City, 2007-2009 (© Archpartners 2009).

The building as one point in a whole

The work produced by Van Berkel and his partner, the art historian Caroline Bos, is extraordinarily varied; from furniture design, interiors and buildings to urban development plans and major infrastructure projects. Their work is characterised by streamlined, curved forms, sharp angles and inclined planes. This architecture undulates, bends and folds in a variety of ways. And this is certainly the case with Five Franklin Place. But however handsome, extravagant or complex Van Berkel and Bos' designs may be, to really understand them it is important to realise that the built objects are only individual points in

a broader, ever-changing context. After all, those designs emerge from and fit themselves into a new image of the city and a modified view of the architect's role in the building process. They see the city as a dynamic force-field in which a great many parties exert an influence on the design. For them it is essential to the building process to take seriously the views of all those concerned – from property agent to structural engineer and contractor – and to involve them in the design as early as possible.

Van Berkel and Bos call all these influences the 'mobile forces', and once brought together in a synthesis it is these that ultimately shape the design. Their architecture is the result of a design *strategy* that encourages input from a variety of disciplines and makes use of design models: a series of principles or *leitmotifs* that help in the selection and implementation of the right parameters and which can also be transferred from one project to another. Van Berkel and Bos try to assemble all the data about a project, which the computer then combines into synthesis in the form of a diagram that orders and generates the design.

Diagrams

For Van Berkel and Bos diagrams are a sort of benchmark for the communication and the 'models' of the final project. They conceive these diagrams in the manner of Gilles Deleuze, as a characteristic, schematic plan that coincides with a specific social and societal force-field. A good example of this sort of

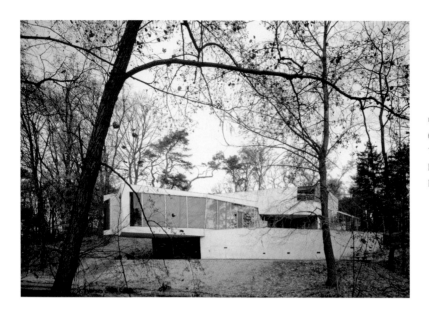

UNStudio, Möbius House
(exterior), 1993-1998,
't Gooi, the Netherlands.
Photo by Christian
Richters.

diagram is the panopticon prison, which is highly stratified and contains a multitude of levels of meaning: '*A diagram is composed of concretised situations, techniques, tactics and functions*'. The diagram is not a blueprint for the design, nor can it ever be directly applied to architecture; it is an intermediate form derived from the actual design and its material configuration.

The diagram that forms the basis for what Van Berkel and Bos called the Möbius House (1993-98) is, of course, the Möbius strip. The Möbius strip not only

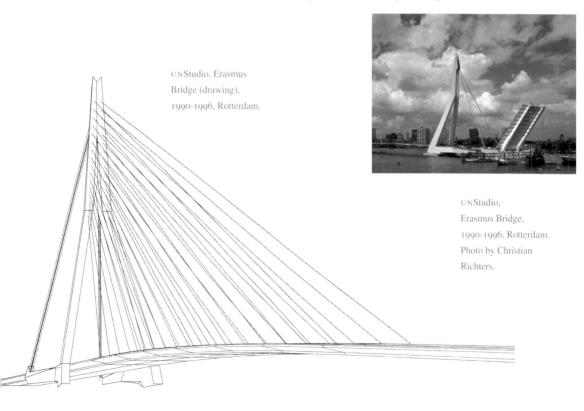

UNStudio, Erasmus
Bridge (drawing),
1990-1996, Rotterdam.

UNStudio,
Erasmus Bridge,
1990-1996, Rotterdam.
Photo by Christian
Richters.

structures the organisation of this house into an extensive circulation with no beginning or end, it also organises the cycle of sleep, domestic life and work. The twisted figure-of-eight diagram was also a decisive factor in the choice of materials and the spatial sequence of internal and external walls. As in the Möbius strip, inside becomes outside and vice versa, so that facades turn into internal walls, and glass and concrete swap places with every change of direction. In Van Berkel's more recent projects the computer is brought into the design process earlier and earlier. Van Berkel had his first experience with mathematical design models when working on the Erasmus Bridge in Rotterdam (1990-96), a commission which brought him international renown. The computer made it possible to communicate with structural engineers and contractors alike on the basis of the same information while still keeping the complexity of the project under control. This bridge is an example of the integrated design approach in which the design is constantly modified and fine-tuned. Its unusual asymmetrical shape and height of 139 metres make of it a highly idiosyncratic sculpture that has a character all its own when viewed from any of a variety of angles.

A different spatiality

The history of UNStudio – United Network Studio – is rooted in the Van Berkel & Bos architectural firm, which was founded in 1988. In 1999 the firm's name and organisational structure was changed, and since then it has presented itself as a sort of network that facilitates the best possible communication between a range of specialists in the fields of architecture, urban planning and infrastructure working on various projects in teams of varying composition. The firm's emphasis on the organisation of processes acknowledges the differing circumstances in which architecture comes into being. The increasing complexity of architectural projects, the building and legal conditions in other countries, alternative design techniques and innovative production methods have led to the development of new working strategies. The design process is dynamic, non-hierarchical, and is constantly being challenged by technological developments. Over the years, UNStudio has made increasing use of the possibilities of digital technology. On this point, Hans Ibelings writes in his book *Contemporary Architects of the Low Countries*: *'The firm's new architecture is an amalgam in which requirements, construction, infrastructure, circulation, form and space merge seamlessly together.... Van Berkel and his staff do not see spatial models and diagrams as a scientific basis, but as sources of inspiration for an architecture with a sort of spatiality different from that which has been common up to now.'*

This approach is well expressed in recent creations such as the Mercedes-Benz Museum in Stuttgart. The organisational structure of this extremely complex building is based on constant changes in the visitor's orientation and a dynamic alternation between inside and outside. The shape of the building is that of two interlocking spirals, corresponding to the building's focus on the motorcar. The idea for the design came from road-building; in this case the architects were inspired by the lobes of the cloverleaf junction at the nearby motorway intersection. The 'twist' that circles the atrium and connects the various floors makes for a gradual transition in which the various planes merge together. This makes it hard to define where one level changes to another; the multiplicity of curves means there is hardly any distinction between vertical walls and hori-

UNStudio,
Mercedes-Benz Museum,
2001-2006, Stuttgart.
Photo by Christian
Richters.

zontal floors. The lines are infinite, running into the distance or being absorbed into planes; there are quite simply no redundant points. This car museum is not an example of computer-generated architecture, which often comes up with entirely new spatial dimensions which, when put into practice, are often a poor reflection of what was promised on the screen. In this building, with this function, the single-surface approach is so entirely logical that it is hard to imagine how it could have been designed any differently. The building is the ultimate symbiosis of form and function, in which the organisation of the building and the objects exhibited blend into one another.

Experiential Architecture

Unlike many architects of their generation, at UNStudio they have no need to cling dogmatically to any particular idiom or theory. Although Van Berkel and Bos have expressed their views on architecture exhaustively in various articles and books, it is above all the buildings themselves that – often literally – unfold and develop their ideas. They generate new forms of organisation and elicit contrasting interpretations, thus expanding our understanding of them. UNStudio creates experiential architecture, *'architecture between art and airport'*, as Van Berkel and Bos themselves put it. They see the network of airports as a hyper-condensed city where fiction and reality are constantly clashing, as a hectic and transient world where commerce reigns supreme and where such emotions as fear, happiness and sadness are experienced to extremes. At the other end of the spectrum is art, which is associated with purity, contemplation and reflection. It is in this area of tension between the sublime and the commonplace that UNStudio's experiential architecture unfolds for the viewer, user or occupant. ∎

Translated by Gregory Ball

www.unstudio.com

The Battle for Quality

The Strange Career of Gerard Mortier

[JOHAN THIELEMANS]

Toni Morisson and
Gerard Mortier at
An American Memory
(New York City Opera,
September 2007).

Gerard Mortier is currently regarded as an important authority in the interna-
tional opera world. He has directed both the prestigious Salzburg Festival and
the Paris Opera. As I write this, that still seems rather unreal. The principal
reason for this is that Gerard Mortier comes from a country that had no great
reputation for opera. He himself was born in Ghent, in East Flanders, in 1943,
and his initial contacts with the world of opera consisted of visits to the local
company. It was the epitome of a provincial house, where opera was put on for
enthusiasts who turned a blind eye to the poor theatrical quality, imposed few
musical criteria, yet still dressed up in their Sunday best to go and listen to a
beautiful aria. In the cultural life of Flanders and Belgium the Ghent opera was
a sort of relic from a dying tradition. And yet: accompanied by his mother,
Mortier discovered important works there. Performances such as *The Magic
Flute* lodged in his mind and fired his imagination. For him, opera was the most
beautiful thing in the world.

A painful imperfection

But the child became an adolescent and felt more and more dissatisfied. The painful imperfection aroused in him an insatiable hunger for quality which was to determine his whole future life. With a little money in his pocket he went to Salzburg, and what he saw there made such an impression that for the rest of his life Mozart would remain a genius to be worshipped.

When he was studying at Ghent University he got to know Jan Briers, one of his professors. Briers was a leading figure with Flemish radio, and was equally well aware of the deficiencies in the musical life of Ghent. He had established the Flanders Festival with a view to effecting radical improvements, and when he found among his students someone with a great passion for music, he immediately enlisted him in his organisation.

Meanwhile, the young Gerard Mortier had developed a rich and multi-faceted view of the evolution of music and cultural life. Jan Briers' tastes were conservative, but his young colleague was convinced that a major festival must also include contemporary composers. When Mortier had work by Ligeti performed in Ghent, it was seen as a sort of heroic gesture. Of course he also wanted to put on opera performances, to show the locals that opera was a fully-fledged theatrical form. So he had the Prague Opera perform Leoš Janáček's *The Cunning Little Vixen* in that temple of bad taste: the Ghent Opera House. He also firmly believed in the talents of a young Flemish stage-manager, Gilbert Deflo, whom he asked to create a 'modern' production. Both Janáček and Deflo would play a significant part in his later career.

Culture and democracy

Through his activities as the person responsible for the Festival's programme he made international contacts; he also found work in Germany. It seemed then that he had said his final farewell to Ghent, Flanders and Belgium, because for him Germany was a sort of operatic and theatrical paradise. Frankfurt, Hamburg and Düsseldorf were outstanding training grounds for the future cultural administrator. Later he would complete his apprenticeship in Paris.

At that time much of his thinking on opera and culture had already taken shape. Mortier sees culture as one of the significant gauges of a democratic community. The artist's imagination nourishes the political debate. Culture is perpetually evolving. Therefore a cultural experience based on nostalgia or routine is totally wrong. But Mortier also knows that conservative forces are a powerful presence in the cultural world. They are his enemies, be they sponsors, big recording companies, egotistical stars, politicians or undemanding audiences. Consequently, he sees his own efforts as a battle. This explains why he so frequently and so readily takes part in the cultural debate. In doing so he does not eschew controversy, and an aggressive stance in the public arena often seems to be his trade mark. Moreover, he has always wanted as many people as possible to be able to share in the artistic achievements that sustained his own life and thinking. He has constantly sought to reach out to a broader public, both to young people and to social classes who had not yet discovered opera.

In strictly operatic terms, this meant that Mortier was looking for a particular kind of director. One who would be prepared to come up with a new take on an existing work. Cultural criticism, as practised mainly by German directors post-1968, provided Mortier with fertile ground. The great monuments of culture, say the operas of Mozart, are often buried under a noncommittal approach in which dazzle, good taste and elegance are paramount. But Mortier is convinced that in his own time Mozart was revolutionary and subversive. If Mozart is to retain his significance today, the director must search the text and the score for these contrary elements. If Mozart is critical of the society he lived in (think for instance of *Le Nozze di Figaro*) then he is putting at risk the acceptability of the *ancien régime* and already heralding the modern period. And it is precisely from the perspective of this – now existing – modern period that today's spectator looks back on the work. So every historical text needs to be examined from two points of view: from the time when it was created and from the present situation. Only in this way can a score from the great tradition be of significance for today's audience.

Opera for the twentieth century

When the post of director of the Muntschouwburg in Brussels became vacant in 1981, Mortier applied for the position with the intention of turning his ideas into reality. In the Belgian cultural context of the time this was a radical volte-face. The company Mortier inherited was not getting a very good press just then, the weakest link being undoubtedly the orchestra. Mortier knew the standard had to be cranked up, and here he had the opportunity for a thorough reorganisation. He needed to look for suitable conductors and succeeded in attracting the Englishman John Pritchard to the company. Pritchard offered both musicality and expertise, together with considerable familiarity with an operatic orchestra. Alongside the experienced conductor Mortier placed a young and very promising French talent: Sylvain Cambreling. As well as the orchestra, the chorus too was in need of rejuvenation.

Once all this was done, Mortier had at his command an instrument fit to produce opera for the twentieth century. During the 1980s the Muntschouwburg blossomed amazingly. Mortier opened the doors wide to international talent. He linked up with the German tradition of stage-management by setting Karl-Ernst

Muntschouwburg,
Brussels

and Ursula Hermann to work in Brussels. Hermann had been Peter Stein's sce-nographer at the Schaubüne in Berlin, a company then at the highest level of German theatre. In Brussels Hermann for the first time had the opportunity to direct a production. With astounding productions of Mozart's *La Clemenza di Tito* and *Don Giovanni,* his work immediately won international acclaim.

Mortier also managed to entice Peter Stein, Herbert Wernicke and Patrice Chéreau to Brussels. With talents like these the Muntschouwburg could regu-larly be relied on to provide unforgettable evenings. As an ardent film buff he believed that film directors could come up with surprises when least expected. He dreamed of commissioning Fellini or Coppola, and did manage to persuade the Belgian film-maker André Delvaux to direct Debussy's *Pelléas et Mélisande.* We must also add to the list the American Peter Sellars, when he was still a young and unknown *enfant terrible.* This young director made a modern ver-sion for Brussels of *Giulio Cesare* by Handel – yet another composer of operas who was being rediscovered at the time. Because Mortier was convinced that opera could only avoid being branded museum art if new work too was being created, he asked Sellars, together with the American John Adams, to write a work about an acute present-day problem. This was *The Death of Klinghoffer* (1991) with a libretto based on real-life events. It set Israelis and Palestinians against each other and set off a heated debate in the United States, as a result of which Adams and Sellars were accused of anti-Semitism. Since then this opera has developed into one of the classics of the twentieth century. That the work fuelled a political discussion strengthened Mortier's belief that modern opera can have a place at the centre of society.

A fresh wind in Germany

The successes in Brussels gave Mortier considerable influence in Belgium. Since he presented himself as a visionary, those in power often called on him. He collaborated on new directions for Belgian orchestras and reorganised the Flemish Opera in Antwerp and Ghent – a task which gave Mortier particular satisfaction because it gave him the opportunity of ensuring properly produced opera not just in the city where he was born but also in 'his' first opera house.

But his reputation was not confined to Belgium. In 1991 he was invited to direct the prestigious Salzburg Festival. Although as a young man he had

discovered high-quality opera in this city, he was nonetheless now convinced that the festival was too respectable and too bourgeois. Salzburg, once the dream of Max Reinhardt and Richard Strauss, had degenerated into the place where Austrian high society held its annual get-together. Mortier wanted to change that drastically. Salzburg needed to connect with contemporary artistic practice. To begin with Mortier put an end to the reign of Herbert van Karajan, once the festival's idol. He let it be known that big-name performers – and so also the big record companies – were no longer welcome at the festival unless they were prepared to cooperate with the new artistic policy. The outcome was that the likes of Ricardo Muti or Pavarotti were no longer to be seen in Salzburg. They were replaced by the artistic friends who had made Brussels such a success. As conductors he chose Sylvain Cambreling, his comrade from Brussels, and Christoph von Dohnányi, the man who had first given him his opportunities in Germany, together with Nikolaus Harnoncourt, the man behind the revival of baroque music. Of course Peter Sellars, Patrice Chéreau, Herbert Wernicke and Mr and Mrs Hermann also accompanied him to Mozart's city. And Mortier discovered the work of Christoph Marthaler and Jossie Wieler.

Festspielhaus, Salzburg.

Mortier also had an ambition to build up a more adventurous theatre programme. In the Low Countries he found two directors whom he considered well worth introducing to an international public. He got Luc Perceval to make a German version of a successful adaptation of Shakespeare's history plays, under the title of *Schlachten*. He also invited the Dutchman Johan Simons to bring to Salzburg his stage production of Visconti's *La Caduta degli Dei* – a piece that dealt with the Nazi past, and was of special relevance in Salzburg. Both directors clearly made a great impression in the German-speaking world, because Perceval will become the artistic director of the Thaliatheater in Hamburg in September 2009 and Johan Simons of the Kammerspiele in Munich in 2010.

Looking back on the Salzburg period, we can see that Mortier made his mark on events there. Naturally this also involved a good deal of heated debate. The innovative opera productions were promptly labelled 'Eurotrash'. He was forever having to defend his ideas to a board of directors that favoured a more circumspect policy. In doing so he had constantly to call on one of his chief talents: his powers of persuasion. Particularly when Mortier attacked the rise in right-wing extremism, he found himself in the eye of a storm. But there, too, we see how consistent he is: if art is to stand surety for a healthy democracy, then artists and those who manage the art must also defend these principles outside the theatre, in the public forum.

In posh and pricy Salzburg he wanted to reach a different audience. So he set up a tent in a working-class district and put on *Die Zauberflöte* in it. This was mainly an indication of his good intentions, because now the ladies in expensive outfits paraded past modest little dwellings on their way to Mozart. But these actions did succeed in attracting the attention of policy-makers in the Ruhr. Around Essen and Bochum there are a great many empty factory buildings, and the intention is to use them for cultural purposes. The idealist vision is that the former workers will now come to performances in premises with which they are familiar. It is culture open to all, but then culture of the highest quality. After Mortier left Salzburg, he seemed to be exactly the right person to carry out this plan. And here too we saw Chéreau, Peter Sellars or Johan Simons at work. Mortier formulated a clear policy, which still forms the basis for the continued existence of this Ruhr Triennial.

Boos in the Bastille

After the empty factories of the Ruhr, Paris and its opera beckoned. In the 1980s Mortier had been very much involved in drawing up the plans for the Bastille, a gigantic theatre that could appeal to a broader public, exactly in line with Mortier's intentions. Expansion was the buzzword of Jack Lang, the then Minister of Culture, and of Pierre Boulez. So it was with great ambitions that Mortier moved to the Paris opera in 2004. Now that he is leaving the company in 2009, this Parisian adventure leaves a sour taste in the mouth. The Parisian first-night public did not like what they were offered, and there was nothing they enjoyed more than protesting noisily. Bastille and 'Boo' became synonymous. That certainly surprised Mortier, because he had thought to find the French capital more open-minded. In the end there were two sides to the story. The press and the first-night audience were often downright hostile, even when there was no reason for it. But once the 'ordinary' public came to look, some of those rubbished productions were very successful. An opera director has of course to learn to live with that first-night audience. Mortier would not do so; he wanted to argue it all out. Some of his friends advised him not to take the negative reactions too much to heart, but then they failed to take his temperament into account. It did nothing to improve the relationship.

Opéra Bastille, Paris.

So his time in Paris was not an unmixed success. It hurt him badly. As ever, his artistic friends had followed in his wake. Initially Mortier put on productions that he himself was proud of. It looked as though he was playing safe, but that too was a miscalculation. Marthaler had created a startlingly original *Katia Kabanova* for him in Salzburg. The Parisian public reacted with hostility. Later he came up with some particularly interesting initiatives. For instance, with Handel's *Hercule* Luc Bondy delivered one of the finest productions ever seen of a baroque opera. He asked the Austrian filmmaker Michael Haeneke to produce *Don Giovanni*; the result was an impressive, dark version of Mozart's opera. The first-night audience turned their noses up at it, vociferously; but despite that Haeneke's original approach can be sure of finding a place in the rich history of this opera's productions. A rare exception was *Tristan und Isolde*, in which Peter Sellars co-operated with video artist Bill Viola. Not only was the production musically of the very highest quality, but visually it exerted a strange and mysterious power. And for once its quality did not escape the Parisian audience. But that did not alter the fact that there was a gulf between the product, the director and a large section of the public. A real faction fight, one might call it, without in any way criticising the director's choices. In this case it was the public that became disenchanted. But Mortier, stubborn as he is, stuck firmly to the course he had marked out. That he held so firmly to his vision in often difficult circumstances truly merits our admiration.

Financial constraints

On leaving Paris he has faced two further disillusionments. He wanted a Music Forum for Ghent. It was to be an institution for the twentieth century. He wanted to bring to it all his experience as a visionary cultural administrator. The project proved too expensive for his native city, and it was turned down. Also, for a very long time Mortier had dreamed of working in the United States. Now it seemed

he would have the opportunity, when he was offered the job of running the New York City Opera, an institution which was in desperate straits. Straightaway Mortier formulated a – by American norms - revolutionary concept. He wanted to introduce work from the twentieth century and new operas. He immediately commissioned a piece on Walt Disney from Peter Sellars and John Adams, and wanted to have the film *Brokeback Mountain* reworked as an opera. But when the

Teatro Real, Madrid.

board of directors saw the financial implications of the plan, they were horrified. Moreover it seemed that sponsors, without whom there is no cultural life in New York, were not eager to step into the unknown. They preferred to talk about *Aida* rather than Messiaen. Mortier felt compelled to relinquish the position.

These two last instances have certain features in common. Mortier has constantly sought to launch new ideas, but time and time again he has come up against financial constraints. His whole career has been characterised by this, but in many cases he has managed to persuade the authorities to invest more resources in culture. In Ghent, however, the subsidising authorities decided that the proposal was just too large for them. And in America Mortier realised that until then it was the European system of support for artists that had made his artistic dreams come true. One cannot emphasise enough just how much artistic space this European system of subsidies makes available.

Happily, consolation came from a rather unexpected quarter. Madrid's opera house was looking for a new director. The Spaniards made Mortier a very attractive proposal. In Madrid he would have at his disposal the same budget as he had had in Paris. So once again he would be free to go his own way. The situation he has found in the Spanish capital suits him down to the ground. The opera there is of a conservative nature. So the battle to create opera that is exciting and relevant to the twenty-first century can be fought again on a new battlefield.

So everyone has nothing but praise for Mortier as an authority, a source of inspiration and a moderniser; people describe him as enthusiastic, visionary, tireless, original and gifted. But sometimes his dreams have fallen foul of harsh reality. The pity of it is that the reverses in Ghent and New York should have happened at a time when he could display a brilliant record of service. He is now sixty-five years old, but has no intention of resting on his laurels. Other opportunities are beckoning: Los Angeles has already approached him, and then of course there is Madrid. On his birthday Mortier said with a sigh that he will now be taking things a bit more quietly. Not that any of his friends believed that for a moment. And a single phone call from Madrid changed the outlook radically. An active senior citizen like Mortier can only be good for opera as a whole. ∎

Translated by Sheila M. Dale

Portrait of the Artist as a Posthumous Work in Progress

Van Eyck and the Politics of Posterity

Jan Van Eyck,
*Portrait of a Man
(Self Portrait?)*, 1433.
Panel, 26 x 19 cm.
National Gallery, London
© National Gallery.

'*My Son took large Notes of what he saw in Holland, and Flanders*', wrote Jonathan Richardson, the leading English art connoisseur of his day, in 1722, '*but little more than a Summary Account is given of These. To have done otherwise than we have done would have been too great a Drudgery for Us, and too Tiresome for our Readers, and our Book would rather have been of that sort that one reccurs to Occasionally only, than what is to be read Through with Pleasure.*' While Richardson's ambivalence towards Netherlandish art was common among those from outside the Low Countries in the age of the Grand Tour, with its focus on Rome, it is hard to imagine the landscape of European old master art being so described today, without its Northern lights. Van Eyck, Vermeer, Rubens and Rembrandt are household names, global commodities, globetrotters even, when the latest international exhibition demands it, yet, as Richardson's remarks demonstrate,

their artistic celebrity was not always assured. Indeed, the posthumous rise to fame of the earliest of these artists, the Flemish painter Jan Van Eyck (d.1441), who was celebrated during and after his lifetime but, like Vermeer, only reborn a hero in the nineteenth century, paints a particularly vivid picture of the shifting nature of artistic status. Above all, Van Eyck's story reminds us that often canonical greats are not born but made, refashioned not simply to suit changing taste, but specific cultural politics. It took the interventions of Napoleon, the Treaty of Versailles and Hitler, for example, to bring Van Eyck to worldwide attention. His was a name remade not only by changing artistic fashions, but by the politics of nation-building during the emergence of modern Europe.

Today, Van Eyck is seen as the artist who bridged the gap between the medieval and the modern, his extraordinary realism the cornerstone of his international reputation which was cemented in the boom years of art history itself during the twentieth century. In 1945 we find that quintessential modernist Clement Greenberg, the American art critic better known for his promotion of Jackson Pollock and Abstract Expressionism, citing the portraits of Van Eyck and his school, with their unrivalled depiction of the human psyche, as early art at its most modern. For Ernst Gombrich in *The Story of Art*, first published in 1950, Van Eyck was a revolutionary, the first to show the light in a horse's eye, the stark naked human figure of a life study, a '*corner of the real world... fixed onto a panel as if by magic.*' This tendency to see in Van Eyck the fountainhead of modern art is particularly evident in the words of the Viennese art historian Otto Pächt during the 1960s, who thought Van Eyck's style, '*has a prophetic message that is all its own, pointing forward to Vermeer and Cézanne, the two other great representatives of painting as an art of pure, will-less contemplation, of Being as a coloured still-life, of narrative-free, silent, unalterably mute imagery*'. The global recognition which Van Eyck's image now commands gives little indication that he first had to be rescued from obscurity as recently as the nineteenth century, after Napoleon looted panels from his masterwork, the Ghent altarpiece, and took them back to the Louvre in 1794. The Enlightenment had quietly placed Van Eyck in the Gothic tradition, but with his work centre stage in the greatest art gallery of the time he could be reinvented in the image of the nineteenth century.

The inventor of oil painting

The roots of Van Eyck's modern rediscovery lie in his literary reputation as the inventor of oil painting, a legend which originates in Giorgio Vasari's *Lives of the Artists*, the sixteenth-century chronicle of Italian Renaissance art told in a series of successive biographies of artists from Cimabue to Titian. Emulating classical traditions, the narrative structure of the *Lives* was driven forwards by colourful anecdotes such as the story of Van Eyck's invention, told in the life of the Venetian artist Antonello da Messina (d.1479). The limitations of the Italian method of painting in egg tempera during the fifteenth century, writes Vasari, were overcome and the future brilliance of Italian art secured, when Antonello da Messina travelled to Flanders to learn the secret of oil painting from a celebrated Fleming. Vasari's Van Eyck, schooled in alchemy as well as art, stumbles upon a new method of blending linseed and nut oil with his pigments, giving such lustre and durability to his works that word of his fame reaches Italy. In the nationalist spirit of such histories, Vasari naturally saw Van Eyck's invention as a handy

service to the Italians rather than as an integral part of his own artistic endeavours. In the Low Countries, on the other hand, in Karel van Mander's adaptation of the story for his *Schilder-boeck* (1604), it became the foundation for the whole Northern tradition. Although modern scholarship has all but purged popular culture of the myth, which was first challenged as early as the eighteenth century by the antiquarian Rudolf Erich Raspe, himself better known for his *Adventures of Baron Munchausen* (1785), the legend took on new life in the nineteenth century when it was revived by the Romantics, thus rekindling interest in Van Eyck.

The main source for the Van Eyck legend's revival was Jean-Baptiste Descamps' *Vies des peintres flamands, allemands et hollandais* (1753-64), a fashionable handbook in the biographical genre, and the first history in French of Netherlandish painting at a time when Flemish genre painting of the seventeenth century was particularly in vogue in *ancien régime* France. Descamps was himself a member of the French Academy as a genre painter in the Flemish style who had trained in Antwerp. The French were first alerted, he tells us, to the rich artistic heritage housed in Flemish town halls and churches but a step from their border by the French occupation of Flanders between 1746 and 1748. And to encourage French connoisseurs to look beyond Italy, as it were, on their art travels, Descamps' 1769 *Voyage pittoresque de la Flandre et du Brabant* documented the contents of numerous churches in such painstaking detail that the *Voyage* became the definitive handbook of its day for continental travellers to the Low Countries. It was used, for example, by Sir Joshua Reynolds, the first president of the Royal Academy in London, during his tour of Flanders and Holland in 1781.

Portrait of Hubert Van Eyck
(engraving).
In: Jean-Baptiste Descamps,
La Vie des peintres flamands,
vol. 1 (1753).

Jan and Hubert Van Eyck,
Portraits of the brothers
Van Eyck in the
Ghent Altarpiece
(detail of the
Righteous Judges).
145 X 51 cm.
Image courtesy of
Lukasweb.

Descamps' most important legacy, however, is to have roused the interest of Napoleon's looting committee in acquiring the Ghent altarpiece for the Louvre, irrevocably changing Van Eyck's fortunes when its four central panels were taken from St Bavo's Cathedral to Paris in 1794 and placed on public view. After all Diderot himself, art critic and founder of the *Encyclopédie*, had noted the limitations of Descamps' own works of art. 'The one who's crying', he wrote of a child painted by Descamps in the Flemish genre style, '*if it's because of the enormous head you've given him, he has good reason*'. Since we know that Napoleon's experts used his handbooks to select the main spoils of the Flemish churches, however, it comes as no surprise that they wanted what Descamps describes as the first oil painting in the history of art. Descamps had reinforced the point with a specially-made engraving of Jan's older brother Hubert (d.1426), who, according to a local Ghent tradition repeated in Karel van Mander's *Schilder-boeck*, had begun the altarpiece, before it was completed by Jan in 1432. The engraving included a quaint reminder of Jan's invention in the brushes, bottles and flasks to Hubert's right, and his likeness derives from the portraits of the brothers in the left wing of the altarpiece. Following Descamps, the images of Hubert in the fur hat and Jan in the distinctive tied *chaperon*, much like a turban, were deliberately adapted from the altarpiece during the following century as their names re-entered the canon. Their Ghent likenesses were copied into the newly fashionable pantheons of artists (Delaroche's *Hémicycle* in Paris, for example), and carved in stone on monuments (including Armistead's Albert Memorial in London). Originating in the antiquarian books of a now long-forgotten French academician, followed by a spectacular display in the French capital of the cultural trophies of war, put on in symbolic representation of Napoleon's defeat of nations, Van Eyck's pan-European revival had begun.

Van Eyck and the Romantics

If Napoleon's was the first of a series of nationalist appropriations of Van Eyck and his school as the cultural identities of modern Europe were worked out, others followed, perhaps because Van Eyck's style was still unfamiliar – unclaimed territory, as one might say. The most influential of these appropriations for Van Eyck's future legacy was not Napoleon's vision of French power politics in the museum, however, since the altarpiece panels were returned to Ghent in 1816, after Waterloo, before they could become a permanent part of French cultural heritage. Instead it was the German Romantics who adopted Van Eyck's school as their own, after they saw the plundered art at the Louvre. Early Flemish art attracted new admirers in Goethe and Hegel, and sparked a culture of collecting the style in Germany which gave rise to the modern academic study of the subject. For the Germans, Van Eyck became an ancestral figure, a Gothic forebear of their own national style at a time when such associations mustered patriotic feeling following the French occupation of their lands. If German thinkers were looking, as Till-Holger Borchert has put it, to create a cultural identity for the future German state, the deeply pious feeling of the early Flemish painters was particularly compatible with their Catholic ideals. The rediscovery of what the Romantics saw as an essentially German heritage, 'the art of the fatherland' even, was likened by, for example, Johanna Schopenhauer, mother of the famous philosopher and herself a cultured art critic, to a bright, clear day, 'by

H. Brown, Jan Van Eyck
(wood engraving).
In: Jean-Baptiste Madou, *Scènes de
la vie des peintres de l'école flamande
et hollandaise* (1842).

Aimé de Lemud,
*Légende des frères Van
Eyck* (lithograph).
In *L'Artiste* (1839).

the light of which we recognise ourselves, our surroundings, I would even say our ancestral home, after a long period of blindness'.

It was in this context of German Romanticism that the Ghent altarpiece underwent a further upheaval which for much of the nineteenth century sealed Van Eyck's fate as an honorary German. In 1816, just when the central sections had been returned to St Bavo's Cathedral from Paris, the wings of the altarpiece were sold to an art dealer to raise funds for the building's fabric. The dealer was L.J. Nieuwenhuys, who had already put Hans Memling's *Seven Joys of the Virgin* on the German market in 1813; it had previously belonged to Josephine Bonaparte after being confiscated from Bruges during the Revolutionary period. By 1817 the Ghent altarpiece's wings were in Berlin. By 1821 they had entered the Prussian royal collection, and in 1830 they became the pride of German connoisseurship when the royal collection was transferred to the public Berlin Gallery. The Flemish reckoned the majority of their treasures lost to the Germans, the altarpiece now dismantled for good; the wings would not be returned until 1920, in accordance with the Treaty of Versailles.

In the wake of his rediscovery, other identities for Van Eyck were forged to suit the ideologies of particular audiences. For the French Romantics, he became a quintessential painter's painter in the context of their fascination with secrecy and experiment in the hallowed space of the studio, a well-worn trope in word and image during this period. In one such novella, serialised in *L'Artiste* in 1839, Van Eyck is a mad scientist who works through the night in an underground laboratory perfecting his secret formula. In true Vasarian style, although the original tale contained no such thing, Van Eyck's sister Margaret

– a spinster who spurned marriage to follow her brothers in art, according to a local Ghent myth – artlessly shares Jan's secret with an eager Italian who has wooed her on false pretences. Van Eyck turns would-be murderer to protect his secret, catching up with the Italian as he flees to the coast – Jan's horse spurred on by a magic potion – where he leaves the imposter for dead.

While the French revelled in the romance of the Van Eyck legend, it was its nationalist implications that were exploited in his homeland, where it was patriotically adopted to bolster the cultural identity of the new Belgian state. At a time when the figure of the artist-hero universally carried the weight of chauvinistic agendas, the value of underlining an illustrious artistic past was felt particularly urgently in Belgium following its independence in 1830. With an explicit nod to Descamps, for example, the Brussels academician Jean-Baptiste Madou produced a folio of engravings after the lives of Flemish and Dutch painters for the Society of Fine Arts at Ghent in 1842. Opening with a whimsical image of Jan instructing Antonello da Messina, who has his traveller's bag across his shoulder, in the art of oil painting, the volume stressed the importance of the Flemish contribution to the history of art. Madou's was an exclusively Northern pantheon of artists which intentionally deprived the usually-ubiquitous Italians of their leading role.

Jan Van Eyck,
Portrait of Giovanni(?)
Arnolfini and his Wife.
1434.
Panel, 82.2 x 60 cm.
National Gallery, London
© National Gallery.

William Orpen,
The Mirror. 1900.
Canvas, 68.2 x 58 cm.
Tate, London.

An artist for the modern age

The crucial shift in Van Eyck's identity, from the Romantic figure of the Vasarian legend to the image he has today as the first artist of the modern age, as one who rejects dogma and convention for the real world, who makes the ordinary man his subject, occurred in the middle of the nineteenth century. The trigger was the newfound fame of the *Arnolfini Portrait* which was first brought to London after Waterloo by an English officer, probably looted from the Spanish royal collection. Acquired by the National Gallery in London in 1842, and followed by Van Eyck's self-portrait in a red chaperon in 1851, the rediscovery of these works encouraged a particular view of Van Eyck in the context of developments in realism and photography during the nineteenth century. Van Eyck's identity was remoulded once again to fit a particular set of values, this time those associated with the rise of the modern realist tradition from the English Pre-Raphaelites and Impressionism onwards. Coupled with the period's obsession with self-portraits and the image of the artist, the developing realist trajectory allowed painters to make explicit links between Van Eyck's and their own aspirations, calling on him anew as an ancestral figure. William Orpen's

Bruges, 'La Place Jean Van Eyck', c.1900. Postcard.

The Mirror (1900), for example, projected a self-identity for the artist that was simultaneously of the moment and part of a longer tradition. Like Van Eyck, Orpen portrays himself in the mirror as a witness to his scene, asserting the authority of the artist's gaze as he directs the model from his easel, a modern-day gas lamp in place of Van Eyck's brass candelabra with the burning candle. *The Mirror* goes beyond pastiche to function as a declaration of the power of the artist, Orpen's confident style hovering somewhere between the fifteenth century, in the Van Eyckian carpet, and Manet.

By the turn of the century, Van Eyck's star was in the ascendant, his turbaned image a symbol of tourist Bruges itself. Indeed, issues of nationalism never resonated more strongly in Van Eyck's reception than in the period that followed, arising out of precisely those questions of nationhood and boundary, of artistic heritage and its proper custodianship which had surrounded his rediscovery since the Enlightenment. A bare two decades after the wings of

Public invitation to the
ceremonies marking
the return of the *Ghent
Altarpiece*, October
1945. Image courtesy of
Lukasweb.

the Ghent altarpiece were returned to Belgium by the Treaty of Versailles, the
altarpiece, this time in its entirety, was taken back to Germany in 1942 on the
personal orders of Hitler. Placed in Neuschwanstein Castle, and then hidden in
an Austrian salt mine, the altarpiece was made to stand for Hitler's rejection
of the treaty itself and for his vision of an exclusively Germanic history of art,
which, as we have seen, had continuously been part of the altarpiece's aura
since the Romantic period. The return to Ghent of the Van Eycks' masterwork
by American forces in 1945, conducted by truck, police escort and an official
parade which ended in the sung mass and the ringing of St Bavo's bells, thus
sought to efface the work's association with German cultural power inscribed
upon it since the Napoleonic era. To the strains of the hymn of praise which has
usually marked the election of a pope, a royal coronation or the canonisation of
a saint, Ghent's most powerful resident was returned to its original setting. ∎

FURTHER READING

Jenny Graham, *Inventing Van Eyck: The Remaking of An Artist for the Modern Age*. Oxford and
New York: Berg, 2007, 288 pp.

The Pen that Circumscribes a Being

A Portrait of Erik Spinoy

Erik Spinoy (1960-).
Photo by David Samyn.

Anyone wishing to zoom in on Erik Spinoy (1960-) cannot ignore Dirk Van Bastelaere (1960-), and vice-versa. Two years after their joint debut *Golden Boys* (1985) came *Argue with Us* (Twist met ons), an anthology featuring poems by Spinoy and Van Bastelaere alongside work by Bernard Dewulf and Charles Ducal. In a highly polemical introduction their fellow-poet Benno Bernard attempted to sell the whole venture as the 'coming out' of a new generation and the breakthrough of postmodernism in Flanders. That this was not the case has – after two decades of *Argue with Us* – been said often enough. Dewulf and Ducal were and are fairly traditional poets, and in 1987 it was somewhat premature to stick a 'pomo' label on Spinoy and Van Bastelaere – Spinoy himself has admitted that it was only Barnard's introduction that really got him thinking about post-modernism.[1] One positive result of that thinking was his contribution to the poetics issue of the literary periodical Yang (1989–90), which was far more im-portant in profiling Flemish postmodernism than *Argue with Us*.

Looking back, the poet also referred to that much discussed anthology as being primarily *'a moment of consecration, of public recognition of [him] as a poet'* that launched him on *'the capricious course that is the trajectory of [his] poet-hood'*[2]. It is true that Spinoy, who nowadays finds it extremely irritating to be tarred with the postmodernist brush and who regards himself as an *einzelgänger*, an individualist, in the tradition of the Flemish modernists Paul Van Ostaijen and Hugo Claus, regularly re-invents himself. It is, however, possible to point to many constant features in his work, the principal one being its high quality. The oeuvre of Erik Spinoy is a feast.

Hunters in the snow (De jagers in de sneeuw) – the title is taken from a painting by Pieter Bruegel the Elder that is now in Vienna – appeared in 1986. In that collection Vienna is a décor, a hat stand. What is important here is the human aberration of wanting to order the world – and the senselessness of that frenzied attempt. Against his better judgment, man searches for the soul of a universe that is soulless. In order to discover sense and meaning, he is constantly on the move: there is a lot of motion in this poetry. The lifelong quest, however, is hopeless. Everything is doomed from the outset. It would be better for man to shake off *'every feeling of desire and expectation'*, but they are *'like dandruff and hairs on one's collar'*: unwanted and obstinate.

Desire is a (necessary) tormentor for Spinoy, just as identity is. In *Hunters in the Snow* the word 'I' is printed a couple of times in italics – and thus problematised. The intangibility of what is desired and the doubtful nature of identity recur in the collection *Susette* (1990), which, among other things, deals with the relationship of the German poet Friedrich Hölderlin (1770-1843) and Mrs Jacob Gontard. The blurb poses some pertinent questions: *'Who is Susette? Is she (1769–1802) Hölderlin's mistress? Is she described, as history? Or is Susette a name, a blank space, a sign of the times, the mark of a longing that torments us all or of emotion that never fades?'*

In *Susette* Spinoy's postmodernism would seem to have come into bloom. The poetical jacket blurb tells the reader that the collection contains open texts that *'misuse'* the most diverse writings and forms of language and demand to be treated in the same way – with respect, humiliation, protest. All that is certain, it says, is that one answer is never sufficient here – and that that is not a bad thing. These poems seek, sometimes violently, to set in motion the imagination and the linguistic competence of the reader. In the process such sacred cows as unity, coherence and seriousness must be relegated to the background. The reader, then, is to co-write these poems. He is expected to work just as hard as the author, well knowing that the haul of meaning can never be captured in its entirety.

A master of collage

The blurb of *Pranks* (Fratsen, 1993) explains to the reader that these poems pull faces (another meaning of *'fratsen'*) because they are grimaces at an inexplicable pain and because they are also pranks one laughs at in the way one laughs at something absurd: gaily and grimly at one and the same time. Furthermore, they make tangible something that never becomes visible, the 'sublime' – this in accordance with the interpretation Kant gave to the word *Fratze*. Even more convincingly than in this collection from 1993, the sublime is made tangible in the bibliophile volume *The Taste of It* (De smaak ervan, 1995). That which is – more broadly – unnameable features prominently in all of Spinoy's poetry; he likes to surround 'it' with images. Just as Susette's hand did in the poem 'Childhood' ('Kinderjaren'), Spinoy's hand too follows 'the pen that circumscribes a being'. Very often that being seems to be a void.

One way of circumscribing a core is by cutting and pasting. In the substantial collection *Wicked Wolves* (Boze wolven, 2002) Spinoy has shown himself a mas-

ter of collage (or of composition). The highly diverse elements he has juxta-posed here lend colour to each other. As an introduction to the first cycle, for example, a biblical quotation ('*For we walk by faith not by sight*' – 2 Corinthians 5, 7) and the slogan from *The X Files* ('*The truth is out there*') fraternally rub shoulders. What is important in these poems is not only man's impotence and ignorance but also his eternal subjection to some belief or other, some doctrine or other – Spinoy is extremely good at puncturing such illusions. In another series, which seems to quote from a variety of old documents, the poet exposes the danger of superlatives by linking the massive adulation of sports heroes to the rise of fascism in the 1930s. The series about Frank Lloyd Wright, the archi-tect of the Guggenheim museum, who believed that he was handing humanity a Model with his organic art but who himself did not shrink from financial and other shady dealings, then transitions almost seamlessly into a cycle which lovingly tells the story of a simple woman, a grandmother. It may well be that not all of Spinoy's narratives are equally true to the facts – and who is to say what the truth is anyway? The first poem of the FLW series concludes with: '*And this is what / beforehand / might have taken place*'. What is certain is that the poet – in a jumpy and unobtrusive but unmistakable fashion – knows how to grasp truths about our existence, and that he always gives death – the empty core of everything – the last word.

Unpleasant truths

With *L* (2004) Spinoy would again seem to have produced a kind of report, this time on the repeated rise and fall of the dream of brotherhood. In 1967 the Beatles sang their 'All You Need is Love', a message that did not fall on deaf ears. The whole of hippie culture can be summed up in one letter: the L of '*love, love, love*' but also the '*L / of lazy [...] and of languid, laid-back / of long hair / glut-ted lice*'. All very Lovely, but two years later there was the somewhat over-vehe-ment Beatles fan Charles Manson, who heard references to the Apocalypse in *The White Album*. Manson, the self-declared new Man-son, felt that the end of days was nigh, expected a rebellion by the blacks against the whites, and thought someone had to light the fuse. By allowing his disciples – giggly young-sters – to go on a lunatic killing spree, in Roman Polanski's home among other places, the charismatic leader generated disenchantment. Disenchantment also came in the 1980s, after new hippies seemed briefly to have appeared on the scene. In their drugs and dancing the yuppies also sought intoxication and unity – even if only the unity of the happy few. They deliberately closed their eyes to all the misery in the world. And so the dream of '*Alle Menschen werden Brüder*' had already been reduced to rubble even before the Wall was.

Of course, *L* is not simply a report. With Spinoy, anecdotes are always a pre-amble. This poetry is cultural analysis decked out in rich attire. In *L*, one of the things that strikes the reader is that a 'we' invariably leads to self-loss of the individual, *and* has an annoying tendency to react against a 'they'. But first and foremost this collection wants to show the path taken by every argument – one of the author's hobby-horses. Spinoy is a cerebral, critical, even a satirical poet, even though his poems often retain a sober, registering tone.

Two of the most important features that make this poetry poetry are lan-guage-play and intertextuality. The finest example of the former from L has to

do with soldiers in Iraq: '*First to come into the picture was / soldier Samantha S. // who receives a small fuchsia / from an elegant dark man / [...] // and laughs. // [...] see here / Lynndie E. now stands. [...] // she is smoking a cigarette / and laughing / while straining at the leash / and showing / genitalia.*' After the mention of the small flower, the reader might perhaps fleetingly think, when coming upon the word 'genitalia', of some sweet little sister of the primula, while 'fuchsia' conceals the word 'fuck'. As far as intertextuality is concerned, the mixture of high and low culture is striking. '*Only yesterday / the walls of the cell fell down flat, merely by song / and sound of trumpets*' is a reference to Joshua 6, while '*from Africa to America*' is a quotation from the 'poetry' of the immensely popular Flemish children's pop group K3.

In *Hunters in the Snow* the word 'I' is placed in italics on several occasions and thereby problematised. In his most recent collection *I, and Other Poems* (Ik, en andere gedichten, 2007), Spinoy has gone deeper into the thematics of identity and identification, and he has also gone much further as regards typography. Incidentally: that the potential of typography is exploited here and elsewhere in his work may well remind the reader of Paul van Ostaijen (1896-1928). And it was on this Flemish poet that Spinoy, who lectures in Dutch and Flemish literature at the University of Liège, wrote his doctoral thesis.

The I is a poem, a text, a construction, a fiction. Yet, however makeable it may be, the I remains ungraspable, even to itself. And in these poems too a being is being circumscribed. In the opening series 'I', a pathologist-anatomist circles round mortal remains and around the gruesome fascination with them that remains incomprehensible, even to the protagonist. 'Image and likeness' zooms in on a supposed societal core that forges a link between people. There is dancing, with perverse and aggressive gestures, round the fundamental hole in our existence, death, and the senselessness of everything that results from it in 'In a noose'. The new catechism 'All new' attempts to make that hole less black. The final series 'Cordyceps' shows how exotic fungi live as parasites on insects – everything, everyone carries within it the seed of its own destruction – and how futile is our eternal '*turning just monotonous / and hopeless / like itself*'. The circle of life and death, the entire dynamic, is one big zero.

Unpleasant truths, that is what Erik Spinoy confronts his readers with. Despite this, his oeuvre is one long, beneficent flash of beauty. Even someone already aware of the magnificence of Dutch is continuously surprised when reading this poet, whose words seem to tally in more than one sense. In *Hunters in the Snow* he wrote about the language of the child: '*The word had still been nothing else than flesh / the sun thus named because it gives warmth and / light, and carries out only for yourself / its task laid down / by your father. // A rose was a rose was a rose. Language / an etymology.*' That lost paradise is what Erik Spinoy restores to his readers. ■

The author wishes to thank Nora Jackson-Meurs for language advice.

NOTES

1. Karl Van den Broeck & Bart Cornand, 'Twist met ons. Vier dichters over poëzie in Vlaanderen'. In: *Knack* 36 (2006), 20: pp. 70-75.

2. Tine Hens, 'Als iedereen je Willy noemt'. In: *Standaard der Letteren*, 19 May 2006.

Translated by John Irons

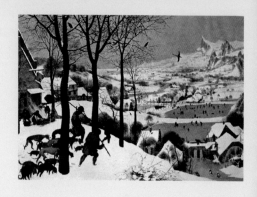

Four Poems
by Erik Spinoy

Pieter Bruegel the Elder,
Hunters in the Snow (Winter).
1565.
Panel, 117 x 162 cm.
Kunsthistorisches Museum,
Vienna.

Hunters in the Snow
[1]

Returning

from a midnight flit – stooping figures of
hunters, hounds come into the field of vision.
On their shoulders lies the endless
hammock of the light. A meagre

take, a fox – only visible to one who is
observant. Only one who truly has eyes
understands. For only with averted face
do they reveal the mask of regret. Where

they have been remains a secret, what's seen
is inexpressible. But that they know is
plain as a pikestaff. And also, that this
is a retreat, their unforeseen

arrival in a house of
penned-in open sky.

De jagers in de sneeuw
[1]

Een terugkeer

met de noorderzon. Gebogen lopen
jagers, honden het gezichtsveld in.
Op hun schouders ligt de eindeloze
hangmat van het licht. Met moeite

buit, een vos – alleen wie toekijkt
kan het zien. Alleen wie waarlijk ogen heeft
verstaat. Want slechts met afgewend gezicht
ontbloten ze het masker van de spijt. Waar

ze waren blijft geheim, en wat ze zagen is
niet uit te spreken. Maar dat ze weten
staat als bomen bij hen. En ook, dat dit
een aftocht is, hun onverhoopte

aankomst in een huis van
ingesloten open lucht.

From *Hunters in the Snow* (De jagers in de sneeuw.
Antwerpen: Manteau, 1986)

Logic

Logica

Your form of resistance
is that you refuse to speak
where you have to keep silent.

So bring the world close to
that never comes true.

This is not advice
but a command.

Het verzet dat je pleegt
is dat je weigert te spreken
waar je zwijgen moet.

Breng zo de wereld dichterbij
die nooit bewaarheid wordt.

Dit is geen raad
maar een gebod.

From *Pranks* (Fratsen. Antwerpen:
De Arbeiderspers, 1993)

In the right side of the cub
gapes the wide-open wound the size
of a palm and make-up pink
redder than peonies or coral
or crimson

with in shallow clefts the black
of night and darkness
and in that fleshy
chrysanthemum calyx

carnation-coloured
turning with their
mute, festering-white
heads, a thousand
tiny slender feet

a teeming
quivering nest
of finger-thick
pale worms

blossoming life that
knows no dying.

Rechts in de zijde van de welp
gaapt de wijd open wond een
handpalm groot en make-uproze
roder dan pioenen of koraal
of karmozijn

met in ondiepe kloven zwart
van nacht en duisternis
en in die vlezige kelk
van een chrysant

anjelierenkleurig
draaiend met hun
stomme, etterwitte
koppen, duizend
dunne pootjes

een krioelend
popelend nest
van vingerdikke
bleke wormen

bloesemend leven dat
geen doodgaan kent.

From *Wicked Wolves* (Boze wolven.
Meulenhoff, Amsterdam, 2002)

Look
this here is a glorious
chosen master race
and this here clearly ain't

Kijk
dit hier is een heerlijk
uitgelezen herenvolk
en dit dus niet

this is wild
and hip great cool far out

dit is onwijs
en hip gaaf cool te gek

and this so utterly impure
and lawless to be sure

en dit volstrekt onrein
en ook nog wetteloos

and look
this sky-blue whatsit here
is so out of this world

en kijk
dit hemelsblauwe dinges hier
het is van deze wereld niet

and this then
fluttering in the wind
it is our black and yellow
sorry
is our black and yellow – and our red

en dit
zo wapperend in de wind
het is ons geel en zwart
pardon
ons rood en geel en zwart

and look
that's no way of doing things
that's really how you do things

en kijk
dit zijn toch geen manieren
dit zijn me pas manieren.

Look
how people
turn your head
always and everywhere

Kijk
hoe men je
het hoofd verdraait
altijd en overal

this head
that otherwise has
never found its feet.

dit hoofd
dat anders nooit
zijn draai gevonden had.

All poems translated by John Irons.

From *I, and Other Poems* (Ik, en andere gedichten.
Amsterdam/Antwerp: Meulenhoff/Manteau, 2007)

Staring through the Surface at an Elusive Truth

Viviane Sassen's Sense of Image

The composition is deceptively calm. The geometry of shapes and lines comes together seamlessly, weaving a layered texture of frames within frames. A grid of paving slabs, illuminated from above and at an angle, runs diagonally beneath the rhythmic poles of a fence, and provides a supporting surface for a horizontal body, lying concealed among striped shadows of branches and leaves (*Cardinal*, 2004). A man stands on the street, against the backdrop of the space between two houses, and rests a large mirror on the ground. His head disappears behind the upright mirror, while part of his body is doubled, reflected as a mirror image (*Mirror Man*, from the series Flamboya, 2004). An interior of a shack, the walls papered with immense Western advertising posters, reveals a view of a street scene in a South African shantytown through the hole that serves as a window (*untitled*, from the series *Cape Flats*, 2005).

Viviane Sassen,
Cardinal (from the
Flamboya series,
2004).

Viviane Sassen,
Untitled/Aïsha/Rubedo
(from the *Ultra Violet*
series, 2007).

Fantastic colours, sensual bodies. Strips of brightly coloured prints on African fabrics and Le Coq Sportif-style sports clothing, naked skin, bare arms and legs, all burst out of the picture, in surroundings of dry red clay, sand or rough plasterwork. Colour, skin, form, structure create an exciting texture, where one element dissolves into another and everything becomes connected. Parts of bodies are concealed: by a hole in the wall, a shadow, pieces of clothing, another body. Often the shadow of something outside the picture hides the face from view, the intangible imprint of a branch, a hand, a black shape imposed over the image.

The layered nature of the composition is as complex as it is clear, with a natural sense of incongruity. The chemical interaction of all pictorial elements within the frame possesses its own internal logic. Beneath the surface lies a network of oppositions: fantasy and reality, empiricism and perception, fear and longing, death and sex, light and shadow. The one does not serve to legitimise the other. Everything is intertwined and constantly relating to everything else. Relationships are not fixed. They are connected to the perception, stimulated by beauty and cultural discomfort.

Viviane Sassen,
Mirror Man (from
the *Flamboya* series,
2004).

Viviane Sassen, *Untitled*
(from the *Cape Flats*
series, 2005).

Proximity and unattainability

The proximity of beauty contains a two-fold sense of distance. There is a desire
to merge with the beauty, to be as it were astrally irradiated by it. And yet there
is a feeling that it is impossible to reach this beauty, and an awareness of its
construction. Viviane Sassen's work places this stalemate within a contempo-
rary perspective. Her pictures entice, intoxicate, touch the viewer on a subcon-
scious level. And at the same time they bring viewers face to face with their own
projections and with the blind spots in their perceptions, which are inspired by
the contextual collective perception from which we derive our way of looking.
Those who grasp for stereotypical connotations, reaching out, with a fixed gaze,
in search of expected meanings or intentions, may see just what they expect to
see, and slide over the smooth surface, untouched.

A woman leans against a car. Her eyes are focused on the mobile phone
in her hands. She stands there, casual, relaxed, her feet in flip-flops, one leg
crossed loosely in front of the other. Her black skin is covered with red pigment,
on her face, arms and legs. Her laid-back stance contrasts with the drama of
her dyed red skin. She remains herself, in spite of her red skin and the photog-
rapher's attention. Given the absence of narrative clues, we can only guess as

to the ritual significance of the red. It is not easy to see the woman independently of the redness. A comment by Sassen during her exhibition at FOAM (late 2008–early 2009) indicates that this red skin is a reference to *rubedo*, the fourth and final phase in the alchemical process. Is she hinting at an enlightened consciousness in which spirit and matter are one? To what extent is knowledge of the underlying systems of meanings required in order to see a picture and in order to create one? It is perhaps as important as it is impossible. (*Untitled/Aïsha/Rubedo*, from the series *Ultra Violet*, 2007)

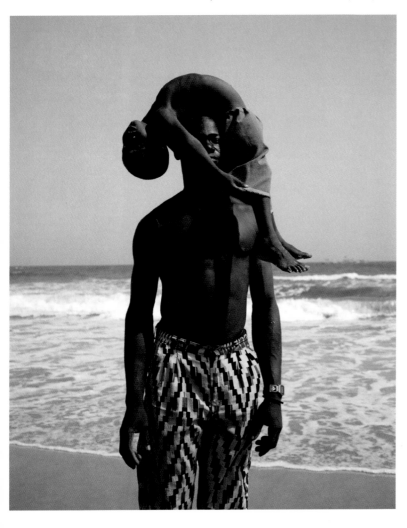

Viviane Sassen, *DNA* (from the *Ultra Violet* series, 2007).

A black man, in medium close-up, stands on the beach with a calm ocean behind him. A large, naked torso, a round head, long, muscular arms, an intriguing expression, resigned, ready. A boy lies draped over the top of the man's head, his head dangling upside down beside the man's larger head. Both of them look into the lens with an obvious resemblance in their gaze and temperament. This double portrait is suffused with an atmosphere of intimacy and continuity, but also an almost oppressive sense of predetermination and the impossibility of escaping one's origins (*DNA*, from the series *Ultra Violet*, 2007).

Staring

These are large portraits of real, beautiful people. Enigmatic presences with striking expressions, in semi-informal poses, in a mixture of documentary situation and composed setting. The visual form alludes both to art photography and to contemporary fashion and commercial images. These appear to be balanced compositions in terms of their form and clearly spring from a collective reservoir of imagery. However, their effect is enigmatic – alluring on the surface, but with impropable depths.

Viviane Sassen's photographs suggest an elusive world: a dream reality hiding beneath the surface, associative perceptions residing in the folds of empirical reality. They open a way through to an existence of a different kind, a reality that runs parallel to the pictures in which we exist. Shuttling between consciousness and the subconscious, between being consciously present and not being there at all. Between looking alertly and staring with a wide gaze, with a vast depth of field, so that a detail or a perceived state of mind unexpectedly provides the key for insight, as in a state of staring without distraction, where everything is as close by as it is distant.

This sense of mystery is accompanied by an unpredictable dramaturgy. Different points of focus and trajectories of looking are possible. The bodies of the protagonists create a sense of scale in the pictures. The settings suggest a context that lends meaning to the situations. But the situations and the intentions of the protagonists are unfathomable, partly because we often cannot see their whole faces. Shadows punch holes in our methods of interpretation. Contextual clues are few and are detached from everyday life, events, social and political background. There appears to be no causal dramaturgical division between subject and context. Sassen presents body and situation as an inextricable entanglement of cultural, anthropological, social, psychological and conceptual aspects.

The bodies in the photographs appear to say more about a state of being, a real sense of resignation, than about the life stories of specific individuals. Sassen's bodies offer protection, but they are also all about exposure. They do not represent what the body once was or has been in the past. They draw outlines around an elusive identity and give the perceptive experience a space in which to exist. Sassen's pictures appear to be reaching out for a social psychology that is more likely to reveal itself in an unconscious gesture than in a calculated self-image. They explore the layered nature of the underlying human condition.

From Kenya to Zutphen

Viviane Sassen (1972-) works in a number of different fields. In addition to her work for clients such as Diesel, Nike, KPN, Siemens, the Rijksmuseum in Amsterdam, UN Studio, her photographs also appear in a wide range of magazines, including *Vogue*, *Blvd.*, *Purple*, *Sec*, *Fantastic Men*, as well as *I-D* and *Frame*, the *Volkskrant*'s magazine, and the edgy *Butt*, *Kutt* and *RE-magazine*. She has also done fashion shoots for companies including Miu Miu, SO by Alexander van Slobbe, and Christian Wijnants.

Sassen began her studies in Arnhem, concentrating on fashion. Following

two years of Fashion Academy, which she combined with work as a model, she decided to go into photography. She studied photography at the academy in Utrecht and rounded off her studies at the Ateliers Arnhem.

She exhibits her artistic photography on a fairly regular basis, as she did at the end of 2008 at FOAM in Amsterdam. In 2007, Sassen won the prestigious Prix de Rome for her photographic project *Ultra Violet*, which she created in Ghana. Sassen spends a lot of time travelling in Africa. Her father was a doctor and worked in Africa for a while, and Sassen herself grew up in Kenya. When she was five years old, she and her parents moved from Kenya to Zutphen. While her belief system was formed largely in the Netherlands, her early African impressions have strongly influenced her way of looking at the world. She is drawn to African atmospheres and to African people. Although she feels connected to the place, she is, at the same time, an outsider. The same is true in the Netherlands. This is a significant position for a photographer.

In 2002 Sassen travelled around South Africa. Although she had not visited Africa since she was a child, she immediately felt less inhibited there than she did in the Netherlands. She recognised the atmospheres, remembered very early impressions, and again encountered the concept of parallel realities that she had unwittingly formed at a young age. In spite of her intuitive sense of comfort and security, she still felt the sober and terrifying awareness of never being able to know the other and other cultures.

Most of the work that she did in South African townships in 2002 was of a documentary nature. During the many trips that followed, including visits to Kenya, Ghana and Tanzania, she took photographs based on memories of her childhood. In more recent series Sassen increasingly appears to be composing a mood, a human condition that is hard to describe.

Projecting in both directions

Sassen involves her African models in the shoots in the same way as the Western models she commissions. Interaction forms an essential part of the process. The question is whether her African models truly understand the visual language and the references within which Sassen presents them. This is a question that Sassen's work appears to counter with the counter-question: *'Is that not equally true of Western protagonists and models?'*

In the photographs set in the West, the provocative appearances of the models in Sassen's world will be seen as a self-referential instrument, a critical reflection of the media zeitgeist. Removing the identity of the western models by blacking out the faces in the photographs is a dramatic intervention with enchanting effect – in line with Sassen's exploration of extremes. But when Sassen cloaks the faces of black people in shadow, she appears to be inadvertently taking a political stance. The photographs from her *Afrika* series might even be seen as a counterpart to the images of Africans that we are accustomed to seeing in the West – exploitations of poverty, oppression, misery and dependence, or of exoticism, projections of primeval power, intriguing animism and sexually charged rituals.

Reviews of Sassen's work usually mention the balance of power between the photographer, armed with a camera, and the people she photographs. Sassen's pictures counter insinuations of amorality, as though asking: *'Isn't*

it time to forget about such stigmas and to leave those distorted stereotypes be-hind?' Maybe the people in her *Afrika* series help to remind the viewer of the possibility of seeing these people as formidable, self-confident, unfathomable, attractive, close to the elements, naturally connecting the dream world with reality, accepting death as part of everyday life? That would be pure projection. Scandalous cliché. Perhaps they help to remind the viewer of the influence of the collective subconscious on the perception, and of the contextual determi-nation that no one can avoid.

Sassen once said that she finds black bodies more aesthetically beautiful. This could be seen as a shocking statement. With its note of provocation, the attitude that this statement reveals might be part of her generation's desire to express themselves freely, a wish to say what she thinks without any ethical prudery. But Sassen always tones down her stance in some way, distancing herself from opinions about social issues that she is aware she cannot know everything about. She does not proudly insist on a particular way of looking at things. Her pictures do not follow the fashion for tendentious statements pack-aged in aesthetically contrived persuasion. Truth is, after all, ambiguous, end-lessly varied, extremely subjective and far from comprehensible.

Dormant truths

These photographs are like dormant images, which root themselves in the sub-conscious, and may be understood only years later: as alchemical reactions of memory, fear and desire, as fragments of subconscious imagery, which, when they are reactivated at an unguarded moment, unleash a chain reaction of associations.

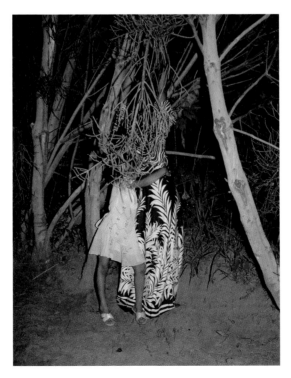

Viviane Sassen,
Untitled (2008).

It is as though, without being able to foresee the possible implications, Sassen is attempting to make visible the inner images that bombard her, and the mental processes that determine her perception – images and processes that cannot be grasped. She appears to give shape to these images within an intriguing situation that she has happened upon, making use of the actions, phenomena, atmospheres that she encounters, which carry her back into her imagination. Her language of choice is atmosphere rather than narrative. Reality is just a starting point. Photography appears to be Sassen's way of confronting the friction between reality and truth.

She goes to great lengths to compose the dream-like reality in the image, using clear cues to direct what she cannot control. She takes risks as she plays the aesthetic game. With unfailing intuition, she explores the unknowable potential, using her instinct to lend proportion to the inevitable absurdity and imperfection as to direct the credibility of the image.

Sassen's images sound out very large concepts, such as universal connection and existential doubt. A desire to be connected to something all-encompassing, in order not to float, not to disappear. A desire for a world that functions outside of the real manner of being. She is motivated by a great sense of curiosity, about the magic of life and its strange beauty – and also by an oppressive fear of death, a fear that death is something lonely and cold. Shadows and closed eyes are references to death. But death does not have the last word. For Sassen, it is not the opposite of life, but an invisible extra dimension of being.

However forceful the intuition, the fact remains that the elusive world beneath the surface is unfathomable. The awareness that we cannot know the other is painful. The realisation that we can never look in a way that is open and unprejudiced is unsettling. The power of the intangible is thrilling.

Wondering, taking impulsive mental leaps and doubting all apparent logic – these processes take the gaze to a place where reason cannot follow, a volatile magical potential that the intellect cannot grasp. It is a deliberately chosen naive perspective. Every point of view that chooses the path of least resistance, moving along patterns of prejudice, will lose its footing. Sassen's sure-fire sense of the image and her sharp sensitivity clear the way for a re-evaluation of exploring the unknowable and of the 'not-knowing' as a virtue. ∎

Translated by Laura Watkinson

www.vivianesassen.com

All photos courtesy of the artist and Motive Gallery, Amsterdam (www.motivegallery.nl).

>

Mark Manders, *Parallel Occurrence*. 2001.

Aluminium fox with aluminium letter, iron chain, iron block, closet, table, three newspapers. Dimensions variable.

Collection: The Art Institute of Chicago

(purchased with funds provided by The Buddy Taub Foundation, Jill and Dennis A. Roach, Directors).

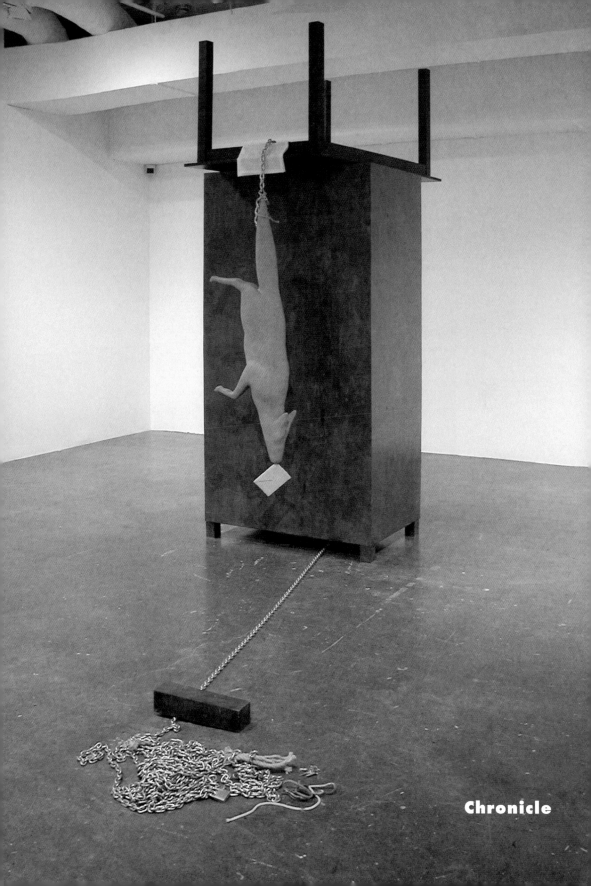

Chronicle

Architecture

American Dreams
Frank Lloyd Wright and the Netherlands

A researcher once kept a tally of the age at which re-nowned architects produced their first and last famous works. He came to the conclusion that for centuries the glory days of most architects were from their thir-ty-third to their fifty-eighth year. This was certainly not the case with Frank Lloyd Wright (1867-1959), who went on much longer and was working on what is per-haps his most famous building, the Guggenheim Museum in New York, while in his seventies; it was completed six months after his death in April 1959. In spite of this, Wright attracted the most attention in ar-chitectural circles with the work he did between his thirtieth year – starting with a series of houses in

Amerikaanse
dromen
*Frank Lloyd Wright
en Nederland*

Uitgeverij oro

Chicago – and his sixtieth, when he designed the head office of the Johnson Wax company (1936-39) in Racine (Wisconsin), built the Falling Water House (1935-37) in Bear Run, not far from Pittsburgh, and started on his own house, Taliesin West (1937) in Scottsdale (Arizona). At the start of the twentieth century, Wright developed what is called the 'Prairie Style', in houses with enor-mously projecting eaves and masonry walls with large areas of brick, foremost among them being the Robie House (1908-10) in Chicago. And it is primarily the work from this period that was also highly regarded in the Netherlands, in fact especially in the Netherlands. This is partly due to its promotion by H.P. Berlage, who

had seen the American's work with his own eyes in 1910 (though he did not meet Wright himself) and who subsequently brought Wright's work to the attention of his fellow architects on several occasions.

Wright appealed to architects of various persua-sions: both of the Amsterdam School (including H.T. Wijdeveld) and of De Stijl (R. van 't Hoff), and he influ-enced W.M. Dudok, Jan Wils, Jan Duiker, Gerrit Rietveld and a whole series of now lesser-known architects who, in the twenties and thirties especially, showed a prefer-ence for an architecture in which one can sometimes find an extraordinary number of visual similarities to Wright's work.

In architectural history, the notion of influence is a slippery concept, and this is what the book *American Dreams* (Amerikaanse dromen) is all about. The influ-ence that may be exercised by certain ideas is hard to trace, because ideas can take many forms or even re-main unseen. On the other hand, people will often quickly conclude, on the basis of external similarities or a few complimentary words that someone once put down on paper, that the object praised was an inspir-ing example, or was directly imitated. This book will certainly not have the last word on the exact nature of Wright's influence on the Netherlands, how Dutch ar-chitecture made off with Wright's work, and why it should have been the Netherlands that took such an interest in Wright.

American Dreams is a follow-up to the concise exhi-bition the architect and architectural historian Herman van Bergeijk organised for the Hilversum Museum in 2005. Van Bergeijk also edited the book, which is pub-lished half in Dutch and half in English and comprises several articles on Wright and the response he found among Dutch architects. It also contains reprints of two articles on Wright originally published by Jan Wils and J.J.P. Oud in 1921 and 1925 respectively.

One of the articles, by the Wright specialist Anthony Alofsin, inveighs strongly against the often rather un-subtle way architectural historians interpret influence: *'Historians have tended to rely on simple visual analo-gies that reduce the phenomenon of making architecture to a crude transitivity: if A looks like B, then B has influenced A.'*

Film and Theatre

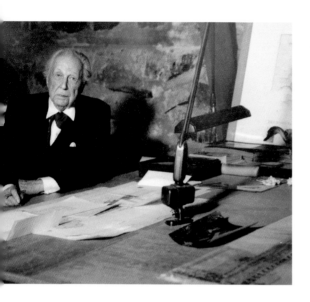

Frank Lloyd Wright, just months
before his death in 1959.

Although Alofsin argues for a more nuanced approach, with its wealth of illustrations this book shows that in this particular case there really is a convincing argument for these simple visual analogies. The pictures show an often striking similarity between Wright's work and the numerous Dutch projects from between the wars that can hardly be called anything other than 'Wrightian'. Exactly what influence Wright had is left somewhat open in this book – but how could it be otherwise – but it is crystal clear that his work was an important visual reference point for many architects working in the Netherlands between the wars.

Hans Ibelings
Translated by Gregory Ball

Herman van Bergeijk (ed.), *Amerikaanse dromen: Frank Lloyd Wright en Nederland*. Rotterdam: Uitgeverij 010, 2008, 192 pp.

New Opportunities, New Freedoms
Dutch Animated Film and the Digital Image Culture

In recent years a renaissance in the genre of the short animated film seems to have been taking place in the Netherlands. Never before have there been so many active producers of animation films. This is all to do with the digitisation of the image culture, which is radically changing the way films are produced, distributed and screened. The equipment and techniques for making animated films are becoming more and more user-friendly and also cheaper. Moreover, digitisation allows the makers of animated films to bring the various aspects of film-making increasingly under their own control.

Where ten years ago there was still a clear watershed between computer animation and traditional animation techniques, today the two worlds merge seamlessly into each other. The rostrum camera has been replaced by the digital miniature camera that can register each image in a resolution up to 4k (comparable to 70mm film). The emergence of digital media has given rise to a new wave of vitality in the world of animation.

One clear supporter of the digital image culture is the maker of animated films and multimedia artist, Rosto. In 2005 he received the major award Canal+ for *Jona/Tomberry* at the Cannes film Festival. His new film *Thee Wreckers: No Place Like Home*, about a one-eyed former TV presenter, looking back at repeats from better days with his now deceased sidekick, recently had its première at the Holland Animation Film Festival in Utrecht.

The hallmark of Rosto's work is visual excess. You could almost call his films baroque, were it not for the fact that that excess is not so much directed at giving pleasure to the spectator, but rather at creating a state of bewilderment. 3D and 2D computer animations, photo montages, film collage, graphic additions, digital effects and colour shifts – Rosto uses all these elements to create an atmosphere reminiscent of the mysterious world in the tales of Edgar Allen Poe. Rosto's films are very much like an interior, or better

Rosto, *Jona/Tomberry* (2005).

'subinterior' monologue. If ever a machine is invented to print our dreams, nightmares and delusions directly onto celluloid, then Rosto will probably be the first to buy one.

As well as making animated films, Rosto is also a musician and an internet artist. His internet sites can be seen as an extension of his films, intended not to promote them in accordance with modern marketing principles, but to explore his ideas, images and music in a new way.

The internet can also be a visual artist's most important platform, and Han Hoogerbrugge is the living proof of that. Until the mid-nineties Hoogerbrugge worked as a painter and cartoonist. The purchase of a computer with an internet connection brought about a radical alteration in his way of working, and he applied himself to making internet animations for his website. In mid-2008 a book entitled *Modern Living, The Graphic Universe of Han Hoogerbrugge* was published – yes, printed paper! – accompanied by a DVD with examples of, and information about, his work.

As the basis for his animations Hoogerbrugge uses video images in which he himself appears as an actor. In this technique, also known as rotoscoping, live-action images are pulled across, image by image, by hand. The result is a drawn image with an extremely natural pattern of movement. His drawn alter ego is depersonalised: a man stuffed into a dark suit and divested of any history, identity or context. He is everyman – comparable to the continually re-appearing man in the bowler hat in the paintings of René Magritte – not a person, but an icon of modern man. The setting within which this 'everyman' is placed is abstract. Sometimes one or two stage props are present, but often the entire focus is on the curious behaviour of Hoogerbrugge's alter ego. Inimitably, with a mixture of absurdism and humour, Hoogerbrugge shows how sinister passions lurk beneath the everyday routine.

The digital image culture leads not only to fresh ways of depicting things and new channels, but also to new models for producing animated films. Broadband and the internet make it possible to work on a project with a team, the members of which are scattered all over the world. The availability of increasing amounts of affordable, and sometimes even free, professional animation software makes it possible to create low-budget films that are technically as good, or almost as good, as productions by the big high-budget animation studios. In April 2008 *Big Buck Bunny* had its première, an eight-minute 3D animation made by an international team under the direction of the Dutchman Sacha Goedegebure. The film is the second Open Movie project by the Blender Institute in Amsterdam.

The term 'Open Movie' derives from the software world's term 'Open Source' and refers to software that in many cases is made available free of charge, often developed by internet communities, and which can and may be adapted at will by any user. *Big Buck Bunny* was made using open source software (the Blender 3D animation package) and is available on the internet free of charge. Not only the film, but every frame in the original resolution, all the designs, all the animation databases and the entire musical score can be downloaded and re-used as anyone sees fit.

Technically the film is the equal of animations from the Pixar Studio, which has set the norm for 3D computer animation with films like *Toy Story* and *Monsters, Inc*. However, *Big Buck Bunny* does not seek to identify itself with family entertainment from Hollywood. The superfluity of violence, black humour and the lack of a positive hero make *Big Buck Bunny* a comic anti-film. But maybe *Big Buck Bunny* is first and foremost a state-

ment. With the emergence of digital techniques, making animated films – even full 3D animation films – is now within the reach of individual, independent film makers. Whether projects like *Big Buck Bunny* really herald a new way of making films still remains to be seen. Certainly, an important new potential is being tapped here.

Another recent example of a computer animation that harks back to the culture of film is *The Phantom of the Cinema* by Erik van Schaaik. This film has a few scenes with full 3D animation but for the most part employs traditional silhouette animation, a technique that is known mainly from the films of Lotte Reineger from the 1920s. In his film

Big Buck Bunny,
made by an international
team under the direction
of the Dutchman Sacha
Goedegebure (2008).

The digital image culture is applicable to all facets of film-making, but the pictorial language of film and film history remain an important source of inspiration, including for young film makers. A good example of this is the film *The 3D Machine* by Erik Verkerk and Joost van den Bosch. The film is a computer animation, but as regards design and narration, and also technique, it harks back to the classic films of the twentieth century. The story is based on the classic theme of the mad scientist: the learned man, as genial as he is deranged, who considers the pursuit of everlasting fame more important than the fate of the world.

The 3D Machine is not just about 3D, it also is 3D. Verkerk and Van den Bosch hark back to an old procedure, so old it has almost sunk into oblivion, that was used for a short time in cinemas to create a 3D effect: the red-blue system. The principle of it is simple: project a red image and a blue image on top of each other in such a way that each colour shows a different angle of vision and look at this double image through spectacles with one red and one blue lens. The result is a startling spatial effect.

Erik van Schaaik uses not real silhouettes but virtual ones, which allows more nuances and greater control of the image. Nonetheless, broadly speaking, the procedure is the same.

The Phantom of the Cinema takes place behind the screen in a film theatre. The running of the film is plagued with technical hitches. Every time the film is interrupted the light goes on behind the screen and we see a triptych with the shadows of the characters carrying out their increasingly strange routines. *The Phantom of the Cinema* plays with varying levels of reality: the reality of the film on the screen, the reality of the characters behind it and finally the reality of the cinema-goer sitting watching all this. But that is not all: the film also plays with film design and mixes modern 3D animation techniques with 2D animations from the distant past.

The digital image culture is having repercussions on every aspect of Dutch animation: design, manner of narration, technique, manner of production and distribution. We are living in an age when

the existing modes and methods of working can no longer be taken for granted. Boundaries are being explored and shifted. To some extent this means a break with tradition, but at the same time that tradition is, and continues to be, an important source of inspiration. The culture of the digital image presents the makers of animation films with hitherto unknown opportunities and freedoms, while at the same time continuing to build on traditions. Animation is no longer a marginal phenomenon; it is shifting – as Minister of Education, Culture and Science Ronald Plasterk writes in his memorandum on animated film – towards the centre of image culture.

Ton Gloudemans
Translated by Sheila M. Dale

www.rostoad.com – www.hoogerbrugge.com
www.bigbuckbunny.org
www.ka-chingcartoons.com/3dmachine
www.phantomofthecinema.com

Flemish Popular Film: from *Cut Loose* to *Loft*

The Flemish film industry has always been a strong competitor for the favour of its home market. And when it has dealt with local subjects, on occasion it has attracted an unexpectedly broad public, often in large numbers. Think of the priest Daens (a popular historical figure), who in autumn 2008 followed his success in Stijn Coninx' well-known film with sell-out success in the musical.

Forceful statements are usually only half true, and that applies in this case also. Take for instance the Flemish box-office hit *The Alzheimer Case* (De zaak Alzheimer) by Erik Van Looy (with ticket sales of around 750,000), a film with no very strong Flemish flavour to it. On top of that, although the author of the book was the Fleming Jef Geeraerts, director Eric Van Looy followed Anglo-Saxon models for every little bit of his film. But because the film was so very convincing, the public poured in. That 2003 success by Erik Van Looy

was a real shot in the arm, for it was then some years already since Flemish films had attracted such large audiences to the cinemas.

It was a long time before Van Looy produced another feature film: not until the autumn of 2008 (and it became an all-time number one Flemish box-office hit). Meanwhile, the film-maker Jan Verheyen had several hits with a series of deliberately popular films that lacked the broad appeal of an *Alzheimer*, but when taken together did bring in a similar public. The two *Team Spirit* films, *Alias*, *Gilles* (Buitenspel) and more recently also *Missing* (Vermist), were able to post substantial audience figures.

With *Cut Loose* (Los), based on the novel by Tom Naegels, Verheyen to some extent distances himself from the broadest conceivable audience and takes on a more social, and therefore less popular, topic. That is nothing new in Verheyen's career, incidentally: he did the same thing in 1996 when he adapted Tom Lanoye's novel *Everything Must Go* (Alles moet weg) for the big screen. On that occasion too he had in mind a more cultured audience that had probably not seen his other films.

One of the characteristics of Naegels' book is that it is the novel of a journalist who is also an essayist and columnist, and to whom it is second nature to speak his mind about social problems (for further evidence of this, read his essay in this yearbook). Yet at first sight the opposite seems to be true: *Cut Loose* is indeed a seemingly rather biographical story about a character called Tom Naegels who faces a number of difficult moments in his private life. His relationship with his girl-friend breaks down, (because) he has a new girl-friend: the attractive Pakistani immigrant Nadia. This relationship, too, proves more difficult than expected. In addition to Tom's love life there is also a grandfather who is ill and demands the right to decide for himself when he will die. Naegels recounts all these events with an atmosphere of self-mockery and irony, rather as Woody Allen has done throughout his career. However personal it may all seem, you soon get the feeling that for Naegels-the-author these events are first and foremost the stimulus to think about a number of important subjects: about euthanasia, about socie-

Cut Loose (Los, 2008),
directed by Jan Verheyen.

ties in which different cultures find it hard to live to-
gether. Often the narrative is very close to the real
problems in society, as for example the street distur-
bances with Moroccan youths that took place in the
Antwerp district of Borgerhout in 2002.

Verheyen remains faithful to most of the themes
and story lines in the film. As regards the structure, he
corrects the chronology that was less clear in the nov-
el. He sometimes shifts the accents and gives a few
characters a more important role than in the book. The
most striking change is that Verheyen and his script-
writer have opted to reproduce the main character's
reflections as short intermezzos in which he turns to
face the viewer directly against a white background.
Opinion is divided on whether this works or not. The
answer depends on whether or not people think the
actor is a good Tom Naegels. And whether the actors
wouldn't have needed stronger direction, and whether
the whole thing couldn't have been spiced up a bit be-
cause the characters seem rather bland, certainly
when compared to the energy and the dedication of the
actors in director Christophe Van Rompaey's debut
film *Moscow, Belgium* (Aanrijding in Moscou). A movie,
incidentally, that got the Krzysztof Kieslowski Award
for Best Feature Film at the Denver Film Festival. This

decision was motivated by '*its warm and witty portrait
of a working class woman, a film which transcends
the stereotypes of the romantic comedy genre*', as the
Denver Film Society reported.

My own diagnosis is that the thinking behind the
direction in *Cut Loose* is too close to what we are famil-
iar with from television fiction, which seems somewhat
anaemic in the darkness of the cinema. Not everyone
will agree, because the film did reasonably well in
the cinema and was screened at various festivals:
Montreal, Utrecht, Nîmes, Hamburg, Cairo. Its subject
certainly played an important part in this. In a review in
Variety the verdict was as follows: '*Though the screen-
play occasionally skirts TV territory, this good-humored
pic about weighty issues remains involving.*'

Not long after *Cut Loose* came the release of Erik
Van Looy's long-awaited film *Loft*. In the time it had
taken slow film-maker Van Looy to produce two films,
fast film-maker Verheyen had completed four. Mean-
while Verheyen is also involved with *Dossier K.*, a new
Jef Geeraerts adaptation that was originally to be have

Loft (2008),
directed by Erik Van Looy.

been shot by Van Looy. The content of *Loft* is very different from that of *The Alzheimer Case*. Yet stylistically there is considerable continuity. The actualisation and finish of *Loft* is extremely meticulous, undertaken with great professionalism and with a high production value, to use the official term. Unusually for our part of the world, but that may also be partly due to the fact that in Flanders films rarely seek to adopt the idiom of the American suspense thriller so literally. Even exceeding it in certain respects, for it is not without reason that the reviewer on twitchfilm.net describes it as follows: '*Smart, stylish and, yes, sexy – the trailers embedded below would be definite red-banders here in North America for both blood and lady-parts – this looks every bit as impressive as Van Looy's breakthrough film.'*

The sound mix – a perpetually running soundtrack which includes rhythmic staccatos – keeps the dynamics permanently high, artificially high. A paper bag of groceries falling to the ground hits the floor with the effect of an exploding grenade. The spectator is immersed in a manipulative mechanism that he, or she, submits to willingly and compliantly. Anyone who resists this process is not the ideal viewer for this film.

Not only the radical choice of genre, but also the particular type of set design gives the film a rather anonymous personality. The interior of the eponymous loft that the five friends in the film share with each other to carry on their extramarital adventures, looks like the interiors in glossy magazines: lonely, chilly and clean, as if they do not really belong in real life but

only in expensive design boutiques. It was not by chance that the newspaper *De Standaard* latched on to the film with a competition to give the lucky winner the interior in the film as a prize: '*Win the fatal interior from LOFT, worth 72,000 euro!'*

The main character in *Loft* is not a single individual; here we have a group of individuals, friends who clearly spend a great deal of their lives together and share good and ill with each other. Over the course of the story it gradually becomes apparent that the strongly professed camaraderie and friendship is no more than a facade, and that behind it there lurks a less attractive underlayer of deceit and treachery. In *Loft* it is a murder that sets in motion the inevitable mechanism of general unmasking. The search for the perpetrator proceeds, as in a real *whodunit*, according to the rules of logical deduction, the technique Hercule Poirot was so good at.

It is a form of drama in which the plot is regarded in a rather structuralistic and mechanistic manner. This approach is less concerned with a reality that the plot refers to, than with the mechanism that makes (or fails to make) that plot efficient enough to surprise the viewer, to wrong-foot him or her, to arouse, to scare, etc.

In this method the way the characters are depicted does not create any real depth, but rather pegs for the plot to work with. Similarly, the one-liners the characters come up with are shrewd and functional rather than psychologically revealing.

To sum up one can say that *Loft* displays more virtuosity than profundity, entertains and titillates more

than it puts forward a view on anything whatsoever, even the central theme of adultery. In this respect the subject seems better suited to the raunchy and commercialised climate of television, in which voyeurism and unbridled curiosity have become second nature. Or to the games culture that seems to have become so essential in the media world. Or to both together: the endless flood of reality programmes, in which reality is presented in the form of a game.

Erik Martens
Translated by Sheila M. Dale

Cut Loose: www.losdefilm.be – *Loft*: www.woestijnvis.be

Away from the Dutch Clay
Alize Zandwijk's Theatre

Alize Zandwijk (1961-), since 2006 artistic director of the Ro Theatre in Rotterdam, is one of the most interesting theatre directors in the Dutch-speaking world. Her work has by now been seen in many other parts of Europe, yet in her own country it hardly receives the acclaim it deserves. This will probably change now that she also has a foothold in Belgium as a regular guest director at the Royal Flemish Theatre. The odds are, though, that she will move to Germany, following in the footsteps of Luk Perceval and Johan Simons. After all, at Hamburg's Thalia Theatre they worship her.

For director Alize Zandwijk, her acquaintance with German theatre has had deeper and more far-reaching consequences than for most of her colleagues from the Low Countries who sometimes work in Germany. Theu Boermans, Ivo Van Hove and even Johan Simons tend to export their own style to Germany. Alize Zandwijk, on the other hand, brings something of that German theatre back with her to Holland. And she has done something special with it. Zandwijk allows actors to shine, and that is something new in the Netherlands.

Ideas about acting couldn't differ more between Germany and Holland. The same goes for what constitutes a sense of humour. This was most painfully apparent a few years ago in the performance of *The Gambler*, based on the novel by Dostoevsky. This production, staged by Johan Simons at the Berlin Volksbühne am Rosa Luxemburgplatz, was one long series of disagreements about what theatre should mean and how it should be acted. At the centre of this disastrous evening was the German star actress Astrid Meyfeld, who for two hours tried to blow her Dutch and German colleagues off the stage. This wasn't entirely her fault, but the result of Johan Simons' failure to really persuade her of his Dutch approach to acting.

German actors are virtuoso technicians, who can master a role in record time. They will then play their part in a way that is a horror to many Dutch people: exalted, over the top, loud and clearly enunciated. German ideas about getting into character are totally at odds with those of the Dutch: under the motto of *'act normal, that's quite crazy enough'* the Low Countries has developed a style of acting characterised by sober restraint, small gestures and emotions kept firmly in check.

To get an inkling of what German theatre practice would mean for the Low Countries, we have to look at Zandwijk. One sees it most clearly by drawing a line from *Night Shelter*, in 1998 her first production at Ro Theatre, via *Leonce and Lena* to more recent highlights such as *Platonov*, *Innocence*, *King Lear* and *Baal*. Among these, *Night Shelter* stood out as a very 'Dutch' play compared to Zandwijk's later work. It was a sober, bare, egalitarian piece and so extremely flat that it actually became funny again, although 'funny' is perhaps not the most suitable word here. The production was spectacular in its severity, but it was also imbued with that inimitable humour that puts things in perspective which is so typical of Zandwijk's work when she is at her best.

Then suddenly, in 2002, there was *Leonce and Lena*. This youthful work by Büchner brought out the very best in Zandwijk. The power of that production still reverberates in her more recent work, while at the same time it was a culmination of everything she had done in the previous fifteen years. For that's how long Alize Zandwijk has been at it, that's how long she has been working at the very top of her profession. At the Amsterdam Theatre Company she twice created a

youth production as a counterpart to the adult production that was being performed by the company's professional actors at the same time. Those two shows – *Spring Awakening* in 1989 and *King Lear Junior* in 1990 – have become legendary, not only because of the violent content of the plays but also because of the freedom with which the adolescent actors – often without any clothes on – moved about the stage. It gave her the reputation of a director who had forced her young and innocent players to extremes from pure ambition, but the opposite proved to have been the case. The children themselves had demanded it. After they had passed the auditions of the professional adult company, these boys and girls wanted to do everything that in their eyes constituted real theatre. And as it turned out, for them taking off their clothes was one of its most important characteristics.

Zandwijk didn't stay with the Amsterdam Theatre Company. She opted for a freelance existence and eventually became a permanent director at the subsidised youth theatre centre Stella in The Hague. This is where she created her first legendary productions of classic plays that she approached in her own particular way. The highlight was her version of *Othello*, with her favourite actor Jack Wouterse in the lead next to other big names like Marc Van Eeghem, Monic Hendrickx and Sanneke Bos. It was a scintillating performance that evolved like a rough night at a disco, complete with the embarrassing moment at the end when the neon lights go up and reveal that evening's battlefield.

This production, together with her earlier and equally intense version of Hugo Claus' classic play *Friday*, was awarded the Proscenium Prize by the Society of Theatre and Concert Hall Directors. More than ten years after her promising debut, this was a late but justified reward for Zandwijk, who has an unrivalled feeling for what goes on in the heads of young people. That she was appointed one of the company's directors by Guy Cassiers was a logical result of this, though she had absolutely no desire to become a 'youth specialist'; her position would have to be the same as her colleagues. Zandwijk wanted to be regarded as a normal director. That her audience was a

Ro Theatre's *Leonce and Lena* (2002), directed by Alize Zandwijk.

good deal younger than Cassiers' was just something she would have to accept as part of the deal.

It has never been so much the form, but rather the feeling and atmosphere of her work that makes Alize Zandwijk's theatre so attractive to young audiences. Running through *Leonce and Lena* there was a layer of emotion that turned this play by Büchner into a really swinging piece. But her work was still deeply rooted in the Dutch clay. Only since *Platonov* has it gradually become a lot more transparent and lively, even though its message is often still as bleak as that of *Night Shelter* and *Leonce and Lena*. But now Zandwijk permits a lot more freedom. Her actors are allowed to take liberties that were previously almost unthinkable. In fact, it goes even further than that: Zandwijk forces her Dutch actors to do things that the average Dutch actor is trained out of at drama school. This too can be attrib-

uted to the influence of Germany, where actors use their parts to aim for effect. At the Thalia Theatre, where she has directed a number of eye-catching productions in recent years, she often has to persuade her actors not to lay it on so thick, whereas she has to push her Dutch actors to show more fire and visible sparkle. In this, by the way, she is helped by her Flemish employees.

In 2005 I was present at a number of rehearsals for *Platonov*. That was unusual, for Zandwijk's relationship with publicity, and especially with the press, is a difficult one. But as it turned out Zandwijk handled her actors very cheerfully, she made jokes and gave casual directions, while the actors took their time working out scenes for themselves. Even when she did blow up just for a moment because things weren't going the way she wanted, everybody put up with her outburst patiently. Next day everything was back to normal and they continued working hard and in good spirits.

Zandwijk gives solo performers a lot of room. You can see it in *Innocence* and *King Lear* and definitely in her more recent production *Baal*. It must be wonderful for actors to be allowed to approach a role so freely. And it is exactly this freedom that challenges Alize Zandwijk's actors to go further than they would ordinarily expect of themselves.

A good example of such a development is Fania Sorel. At the start of her career, this actress' appearance tended to work against her, or for her, depending on how you looked at it. Her big eyes, her dreamy gaze and curvaceous figure made her the ideal beautiful girl. But, thanks to the wild influence of Alize Zandwijk, Sorel was able to turn Baal into an androgynous punk hero, as repellent and at the same time attractive as Brecht must have intended her to be, if he had ever allowed himself to think about it.

Alize Zandwijk still regularly complains about the lack of recognition for her work. Rightly so. When Ivo Van Hove, Theu Boermans or Johan Simons are invited by foreign theatres, that is news, sometimes it even makes it onto the front pages of the newspapers. Zandwijk's foreign successes, however, are mostly ignored or are, at best, not given their proper due. When *Night Shelter* receives rave reviews in Edinburgh and eventually goes on tour all the way to Moscow, it only warrants a small paragraph in the press.

Perhaps this lack of interest in her work is due to her strained relations with the press. Being based in Rotterdam, a difficult city for culture, doesn't help either. And nearly all of Zandwijk's productions have the rough edges of society as their subject. Theatre-goers do not always appreciate this; just as they did 2,500 years ago, people would rather watch kings suffer than people of their own class. And as for compassion with the underclass, Zandwijk's trademark, we only have room for that a couple of times a year. That's how it is, sadly enough, with a chronically bourgeois theatre audience.

But perhaps there is an even more banal reason – one that exposes even more clearly a deep fault in today's theatre world. Could the lack of recognition for her achievements in Holland perhaps be simply because she is a woman and her successful colleagues are men? Even though since January 1 2009 she is in the company of Ola Mafaalani, who then became artistic director of the North Netherlands Theatre Company, while Mirjam Koen has been for years one of the directors of the Independent Theatre – with so few women in the top jobs, theatre in the Low Countries is actually lagging behind, and that could become a problem.

Wijbrand Schaap
Translated by Pleuke Boyce

www.rotheater.nl

History

The First Replica of the *Halve Maen*

Helping to celebrate Henry Hudson's arrival 400 years ago on the shores of what is now New York, will be a replica of his ship the *Halve Maen*. This ship has been sailing up and down the Hudson River for many years. Captain Chip Reynolds witnessed the attack on the Twin Towers on September 11 2001 while his *Halve Maen* was moored in the Hudson in New York City. This is the second replica of the *Halve Maen*, after the first came to a sad end in upstate New York.

One hundred years ago, in 1909, the city of New York organised festivities to celebrate the tricentennial of the arrival of Henry Hudson. The Hudson-Fulton celebrations of 1909 also commemorated the first sailing of Robert Fulton's steamboat in 1907. A replica of his ship, the *Clermont*, was built. The celebrations lasted for two weeks and were one of the highlights of the year.

In 1905, when the Hudson-Fulton celebrations were being planned, it was decided to construct a replica of the *Halve Maen*, the ship in which Hudson had crossed the Atlantic. The Dutch offered to build the vessel, even though the original ship's plans had been lost. The replica which was constructed was based on the plans of a sister ship, the *Hoop*, and the notes of Robert Juet and the knowledgeable historians of the *Halve Maen*.

The replica Halve Maen, which was built in less than six months, arrived in New York in July 1909 aboard the freighter *Soestdijk*. The ship was rigged and made ready to sail in New York harbour and up the Hudson. On September 25 the official part of the festivities started. Impersonators of Henry Hudson and Robert Fulton made long speeches about the importance of the events. By accident the *Halve Maen* and the *Clermont* collided, but without doing too much damage. The celebrations were a success. The intention was that the ships would find a permanent home in New York's Central Park. That plan came to nothing, however, because the mast of the *Halve Maen* was too tall to fit under the Elevated Railroad.

Another solution then had to be found, which unfortunately changed the destiny of the ship. It was decided that the ship would be berthed at Popolopen Creek in Palissades Park near the Hudson, some

Ship lifted aboard:
the replica of the *Halve Maen*.
Photo by P.F. v.d. Ende.

distance north of New York City. The Hudson-Fulton Commission imposed some demands: the ship should be kept afloat, it should be properly maintained, the public should have access to it and it must be available for important events. The transfer took place in July of 1910. About six years later the ship started to suffer from neglect and there were complaints. Following a period of cold weather the ship's bow was damaged and let in water. The park authorities said that they had had to maintain the ship at their own expense and appropriations from the state had been cut. In 1920 the Holland Society of New York, an organisation with a very exclusive membership of Roosevelts, Vanderbilts and other distinguished families of Dutch descent, tried to intervene in the *Halve Maen*'s behalf. The park authorities again complained about the cost of upkeep and suggested that the Holland Society should donate 2,300 dollars to raise the ship from the water and place it on a concrete base. The Holland Society declined. Other attempts to obtain funds from railroad companies and – again – the New York State Legislature were unsuccessful.

In 1924 the mayor of Cohoes, New York, asked and was granted permission to adopt the ship and display it in his town. According to some experts, during his ex-

plorations in 1609 Hudson had sailed as far north as Cohoes, a little north of present-day Albany. The ship was now the sole responsibility of the town of Cohoes. The town installed it on dry land in East Side Park but did not actively maintain it. Eyewitnesses speak of the wood rotting away. On the evening of September 9 1933 vandals set fire to the ship. That was the second time a journey of a ship named the *Halve Maen* ended in Cohoes. Fortunately, in the late 1980s Andrew Hendricks, a dentist from North Carolina with Dutch roots, decided that a second replica should be constructed. May it survive at least another one hundred years.

Lucas Ligtenberg

www.henryhudson400.com

In Love with the Neighbours Opposite
Lisa Jardine's Enthusiasm for the Seventeenth-Century Dutch Republic

Lisa Jardine's *Going Dutch* can confidently be described as a hymn of praise to the Netherlands. The only discordant note is on page 232, where she quotes the seventeenth-century English poet Andrew Marvell who described Holland as a miserable piece of land created by the stubborn Dutch. It was, he wrote, no more than the *'off-scouring of British sand'* ... *'this indigested vomit of the Sea'*.

That England, or *'perfidious Albion'* as we Dutch called it, harboured strong anti-Dutch sentiments was well known. In 1623 the Dutch had killed a number of Englishmen rather unpleasantly in Ambon and this 'Amboyna massacre' was to sour relations between the two nations for decades. In the seventeenth century England and Holland fought three wars that included some extremely bloody sea battles. The thick-skulled Dutchmen even had the insolence to sail up the Medway in 1667 and destroy part of the English fleet at Chatham. The Surveyor of the Navy complained at the time that it seemed as if *'the Devil shits Dutchmen'*. In the eighteenth century things were not much better. The

Dutchman with his *'boorish manners'* figured consistently in political cartoons as an idle pipe-smoking peasant or fisherman. Or as a bloated, over-fed frog.

But now all of a sudden there is Lisa Jardine, who has rediscovered our lowland country and, as *Going Dutch* bears witness, has fallen unconditionally in love with it. Lisa Jardine is an English professor of history at the University of London. She is the author of numerous books, including one on the architect Christopher Wren and another about the scientist and architect Robert Hooke. She is a public figure who sits on adjudicating panels, writes reviews in the press, gives talks on the radio, appears on TV and is a member of several historical councils and committees. In 2008 she was a visiting research fellow at the Netherlands Institute of Advanced Studies in The Hague.

Going Dutch has been written with great enthusiasm. The author loves her subject. Her main theme is the cultural interaction between the Netherlands and England in the seventeenth century, *'the ongoing to-and-fro exchange of ideas, influence and taste'*. She focuses particularly on the connections between the English royal House of Stuart and the Dutch Stadholders, especially William III, and her book opens dramatically with his invasion of England in 1688, the so-called 'Glorious Revolution'.

Stadholder William III (1650-1702) was the son of Mary Stuart, daughter of the English King Charles I. He was also married to a Stuart, another Mary, the daughter of Charles II's brother James. So he had close ties with the English royal house. After the eighteen-year Republican interlude Charles II was restored to the English throne in 1660, and when he died in 1685 he was succeeded by his brother James. The problem for most Englishmen – as Anglicans – and also for the Dutch was that James was a Roman Catholic. Were he to adopt an anti-Protestant policy in alliance with France it could be very dangerous for the Netherlands.

However, for a couple of years there did not seem to be much cause for concern because his Queen either had miscarriages or her children died young. If James were to die his daughter Mary, the wife of William III of Orange, would succeed him on the throne. But on 10 June 1688 the birth of a baby son appeared to guaran-

tee a Catholic succession in England. The Protestant world was in uproar.

Jardine now describes how a well-oiled machine was set in motion. Spurred on by leading British Protestants, William III assembled a fleet and an army of invasion, and in November, in great secrecy, 500 ships with ten thousand sailors and hundreds of horses set sail from Hellevoetsluis. The soldiers, horses, cannon, munitions and provisions landed in Torbay on the south coast of England and, although delayed by torrential rain, finally made their way to London. James took to his heels and went into exile in France. In the following year William and Mary were proclaimed King and Queen of England, and until his death in 1702 William remained the successful leader of Protestant Europe against the constant expansionism of Louis XIV.

Lisa Jardine is surprised at how easily this Dutch military invasion was papered over and forgotten. She concludes that it was because of the careful preparation and the refined propaganda of William III. The underlying power politics and the military action were cleverly legitimised. A political manifesto had been drawn up beforehand to justify the whole operation: England was being threatened, the laws were being trampled on and the invasion was in fact a liberation. Ten thousand copies of this manifesto were printed in the greatest secrecy and distributed immediately after the invasion. Triumphant propaganda pamphlets also helped to seal its success.

After this political introduction, Jardine guides us into the field of culture, which is what the book is really about. We read about important painters such as Van Dyck, Jan Lievens, Honthorst and Peter Lely who all crossed the Channel to make their living in England. The Commonwealth period between 1642 and 1660 when England was ruled by Oliver Cromwell and later by his son receives a great deal of attention. Many leading royalists fled to the Netherlands, including the heir apparent himself, later Charles II, and many of the nobility, with or without their art collections. There they absorbed Dutch culture and exploited it in England after the Restoration.

A second period of intensive cultural exchange be-

William III, King of England
(1650-1702). Frontispiece from
*Life and Times of William the Third
and History of Orangeism* (1890).

gan after William became King, when hundreds of courtiers and practising artists followed him to England. Jardine discusses the artists' commissions, gardens that were laid out, houses that were built in the classic Dutch style and art collections that were brought over from the Netherlands.

One of the later chapters is devoted to the natural sciences. Among the Dutchmen who were members or correspondents of the Royal Society, founded in 1660, were Anthony van Leeuwenhoek, Jan Swammerdam and Christian Huygens. Jardine considers that Huygens' reputation has been somewhat exaggerated by historians. In the development of the pendulum clock and the pocket watch more credit should be given to her hero, Robert Hooke.

The book closes with a somewhat unrelated chapter on the Dutch settlement of New Amsterdam, which was conquered by the English in 1664 and has been

called New York ever since. Optimistic, but equally out of tune, is the Conclusion in which Jardine continues the theme of collaboration up to the present day with the merger of Hoogovens and British Steel in 1999.

Jardine writes in her Introduction that her book deals with the cultural interaction between the Netherlands and England. But in practice she confines herself to court circles, to the elite. That allows the Huygens family to play a central role: Constantine the Elder who was Secretary to the Stadholders Frederick Henry and William II, Constantine the Younger, Secretary to William III, and his brother Christian the brilliant physicist. Among the Dutch it is commonly accepted that Constantine Huygens the Elder was a genius, but for English readers he needs an introduction and Jardine uses every opportunity to provide that. He was an expert in the fields of painting, garden design, architecture and music and advised the stadholders on all these subjects. He had come to know England through his diplomatic missions and, as Jardine repeatedly tells us, spoke English fluently. He also translated John Donne into Dutch.

Going Dutch has the feel of an edited set of introductory lectures aimed at the general reader on cultural links between England and the Netherlands. For those with some knowledge of the seventeenth century it contains little that is new. Jardine relies on printed and in particular English language sources and even they are fairly modest in scope: '*I have barely scratched the surface of my subject.*'

That subject is fascinating, but it has much, much more to offer. Anglo-Dutch exchanges existed much earlier, and were not restricted to aristocratic circles. Many important Dutchmen do not receive a mention. Where is Hendrick Vroom of Haarlem, who was commissioned to design the tapestries commemorating the defeat of the Spanish armada? Where are the two world-famous marine painters William van de Velde, father and son, who moved to England in 1672 and became painters to the court? English students went *en masse* to study in Leiden. Why is there no mention of John Locke who lived in the Netherlands for five years? And where is Bernard Mandeville, the Rotterdam physician and philosopher, who went to live in England?

The only reason that I can think of for these omissions is that the original starting point was the role of the Huygens family. Jardine seems to have excluded anyone without a Huygens connection.

The book is therefore not exhaustive. On the other hand, it is a sincere and welcome declaration of love of the Netherlands, and for English readers it is an attractively written eye-opener.

Roelof van Gelder
Translated by Chris Emery

Lisa Jardine, *Going Dutch. How England Plundered Holland's Glory.* New York: HarperCollins, 2008, 406 pp.
This article courtesy of the author and NRC Handelsblad

Birth of a Nation
Belgium and the Treaty of London

On April 19 1839 the European Great Powers signed the 24 Articles of the Treaty of London and by doing so legally dissolved the 'United Kingdom of the Netherlands'. From then on Belgium and the Netherlands would go their separate ways. It was a painful break that had been building up over many years, and its effects would reverberate for many decades to come.

It started under the Emperor Napoleon. After his abdication the victors planned to dismantle his bellicose Empire and create a defensive ring around France. The creation of the 'United Kingdom of the Netherlands' was part of that plan. The amalgamation of the old Seventeen Provinces of the Netherlands and the Prince-Bishopric of Liège was to be total, '*un amalgame le plus complet*'. After Napoleon's return and the battle of Waterloo, attitudes towards France hardened and the Congress of Vienna strengthened the new kingdom by adding to it the Duchy of Bouillon, Chimay, Philippeville and Mariembourg. The Duchy of Luxembourg was promoted to a Grand Duchy and entrusted to King William I. From then on he could style himself 'King of the Netherlands and Grand Duke of Luxembourg' (November, 1815). The Congress also created a German Confederation consisting of 34 states, including the

Grand Duchy of Luxembourg, and 4 Imperial Cities. The Kingdom of Prussia received Eupen, Malmedy and Sankt Vith in compensation.

The survival of the United Kingdom of the Netherlands was soon threatened by political, economic, linguistic and religious differences. Following violent disturbances in Brussels in September 1830 the position of King William I was fatally undermined. On 4 October a Provisional Government declared Belgian independence, and on 3 November a 'National Congress' was elected. A conference of the Great Powers that met in London during November attempted to impose a cease-fire, but met with little success. The National Congress drew up a constitution that retained the monarchy but disqualified the House of Orange-Nassau for all time (24 November). The process of dissolution seemed unstoppable: although Russia, Prussia and Austria voted for heavy-handed intervention, France was hoping to fish in troubled waters while England decided to wait on events. In the event, military intervention proved impossible. On 20 January 1831 the powers presented a draft treaty, the first part of which guaranteed Belgian neutrality in perpetuity. It further proposed the following division of territory: the Netherlands should keep its 1780 boundaries while Belgium should have the remainder, except for the Grand Duchy of Luxembourg which remained the personal possession of King William. The fate of Limburg remained the thorniest issue. Despite its title of Duchy the province had virtually no connection with the ancient Duchy of Limburg. Furthermore, it was a patchwork governed by a range of different authorities. Venlo, for instance, and 53 so-called 'Generality' villages had not been part of the United Provinces in 1790 but were added to the United Kingdom of the Netherlands in 1796. Moreover, Maastricht had been governed jointly by the Netherlands and the Prince-Bishop of Liège; and all the rights of the Prince-Bishops had passed to Belgium. The second issue was the National Debt: Belgium was to take over 16/31 of this, leaving 15/31 to the Netherlands. This arrangement was unjust because it took no account of the origin of the debt, and the Netherlands was responsible for the larger part of it. Back in the early days of the union such a division

had already caused a great deal of bad blood. King William accepted the proposals, but the National Congress rejected them because the revolution had been actively supported by the whole of Luxembourg, by Limburg including Sittard and Venlo and even by Zeeland-Flanders.

Meanwhile, the National Congress had produced a constitution but as yet no King. In the end, Prince Leopold of Saxe-Coburg declared himself willing to accept the crown on condition that the National Congress accepted the proposals of the Great Powers. In response, the Belgian representatives proposed a number of modifications. This new draft treaty of XVIII Articles contained little that referred explicitly to the division of territory but it had a good deal to say about the National Debt. But the Powers accepted it on 26 June, and after heated debate the National Congress followed suit on 3 July 1831. Whereupon Prince Leopold accepted the crown.

King William rejected the treaty and invaded Belgium with an army which had no difficulty in defeating its much weaker opposition. Brussels was only saved from occupation by the last-minute appearance of a French army sent to its aid. Belgium's defeat showed that, far from functioning as a dam against French expansion, it was in fact dependent on the French army, and only the Dutch army could be relied on. Consequently, all the outstanding issues were resolved in the Netherlands' favour: William I kept German-speaking Luxembourg as an independent Grand Duchy with a seat in the German Confederation and acquired half of Limburg, also as a duchy with a seat in the German Confederation. He was also granted Zeeland-Flanders, with control of both banks of the Western Scheldt, although the Netherlands had to guarantee free access to Antwerp by water and to allow the construction of an 'iron Rhine', a railway linking the port of Antwerp with the German Ruhr across Dutch territory. (When the Netherlands recently opposed a Belgian demand to reopen the railway after years of non-use, on 24 May 2005 the Permanent Court of Arbitration found in Belgium's favour on the basis of this treaty.)

Internationally, Belgium was awarded neutral status, to be guaranteed by the United Kingdom. It also

Signatures (a.o. British Prime
Minister Lord Palmerston)
on the 1839 Treaty of London.

had a decisive effect on the course of the First World War. When the German army marched across the Belgian frontier on 4 August 1914, in breach of Germany's agreement, the United Kingdom felt obliged to involve itself in the war. In 1919 the question of the treaty was again broached. During the peace negotiations in Paris, some groups demanded not only the abolition of the neutral status but also and especially the return of Zeeland-Flanders, Dutch Limburg and German Luxembourg. Their demands fell on deaf ears. The Belgian representatives were only able to persuade their European neighbours to lift their neutrality and to restore Eupen, Malmedy and Sankt Vith to Belgium. And so yet another piece of the Congress of Vienna's work was undone.

Romain Van Eenoo
Translated by Chris Emery

A Calvinist Country?

retained Belgian Limburg and French-speaking Luxembourg. These resolutions were formally set down in London on 14 October 1831 in the 'Treaty of 24 Articles'.

In spite of the row that blew up when the treaty was made public, Belgian signed on 15 November 1831. But King William I remained intransigent. As a result Belgium retained de facto possession of Limburg and Luxembourg for years; but conflict between supporters and opponents of the treaty steadily increased, with the Dutch King's refusal to withdraw his forces from Belgian territory provoking military action against their presence.

It was not until 14 March 1838 that political, economic and personal pressures finally led King William to inform the London Conference that he would accept the Treaty. But this was now met by a Belgian refusal. Never before had such emotionally-charged speeches been heard in the parliament. The European Powers were unmoved, however, and on 19 March 1839 a final vote was held; the result was 58 for and 42 against.

The curtain had come down, but it was some time before passions subsided. Belgium's neutral status

Look at any Dutch newspaper and you get the distinct impression that the Netherlands is a Calvinist country – or used to be, at any rate. Dutch vices like frugality and moderation are attributed to the country's supposedly Calvinist nature. For many people Calvinism is inextricably bound up with Dutch history and culture, and the commemoration of Calvin's five hundredth birthday in 2009 may well confirm that impression. When she said *'There's a little bit of Calvin in all of us'*, the maker of the glossy personality magazine *Calvijn* (*'about the state of Dutch Calvinism today'*) articulated the feeling that Calvin has left deep footprints running through the Dutch landscape.

If the Netherlands has gained the reputation of being a Calvinist country, it's perfectly understandable. In the sixteenth and seventeenth centuries, the still young Republic presented itself to its neighbours as a Reformed country. After the French period, and after Belgium had separated itself from the Netherlands, Dutch historians (most of them Protestant) began looking for a new national identity. They found it in the struggle for independence from Spain in the

sixteenth and seventeenth centuries. Valiant Calvinists, so they said, under the command of William of Orange – the Father of the Country, the new David – had freed themselves from the Spanish yoke. The idea that Calvinism laid the groundwork for Dutch identity was forcefully propagated by the principal founder of neo-Calvinism: Abraham Kuyper. According to Kuyper, the Netherlands had Calvinism to thank for its freedom. In his view, moreover, Calvinism was the best line of defence against tyranny and against the social disruption of the French Revolution.

The historical reality was different. It wasn't Calvinism that was the most significant religious feature of the Low Countries following the Reformation, but religious diversity. During the Reformation period, a variety of new schools of Christian thought took root in the Low Countries. Of all these movements, Calvinism – more properly Reformed Protestantism – ultimately became the most important. The Reformed Church became the church of privilege. The other churches – the Lutherans and the Anabaptists – were tolerated. But as all these new Protestant denominations gained a foothold in the young Republic, the Catholic Church simply carried on as usual. Although it found itself in an unenviable position, certainly when compared with the Reformed Church, it succeeded in remaining a large and vigorous faith community.

The various church groups influenced each other. And this religious diversity gave rise to an ecclesiastical market. The different churches competed against each other in order to enlist members. The Reformed Church, thanks to its privileged position, clearly had it much easier than the other churches. As the competitive battle went on, the churches marked out their boundaries, adopted powerful features from each other and aroused particular virtues in each other. It is my belief that this competitive struggle had a greater influence both on the churches and on the Dutch religious landscape than the mere presence of Calvinism. So before anything else I'd like to take a look at this competition between the churches.

In the competition that flared up during the Reformation, the various churches tried to outdo each other when it came to virtue, attempted to restrict cross-border traffic and did their very best to arm their flocks with knowledge of the truth of their own faith. In their lively polemics, each of the churches claimed that its believers led exemplary lives. The religious leaders were absolutely convinced that a church's attractive power could be either increased or reduced by its believers' lifestyle. For this reason, pastors enjoined their flocks to live moderate and sober lives and to live together peacefully within the church community.

To prevent their believers from developing sympathetic leanings for a rival church, the church leaders attempted to curb cross-border traffic. Visiting another denomination was 'not done', and all denominations condemned mixed marriages. The church leaders were kept busy marking out well-defined borders so their own group would remain clearly delineated.

The different churches 'armed' their faithful by keeping them well informed. For instance, the Catholic Church in the Republic put a lot of emphasis on knowing the Bible, so their followers would not find themselves at a loss for words when conversing with their Reformed neighbours. Reformed believers were taught Reformed doctrine during catechetical sermons on Sunday afternoons and were instructed in the competition's errors and failings. Finally, prospective ministers and priests were taught to debate from both the Catholic and the Reformed side. It was important for them to know the arguments for and against their own church and to learn how to use them.

In short, because of the Republic's religious market, the various churches placed great emphasis on acquiring knowledge, guarding their borders and making sure their parishioners led respectable lives. The one thing they were all agreed on was the value of frugality, knowledge and denominational purity within the family. The competitive battle they were fighting caused them to strengthen these qualities among themselves. This inter-faith competition reinforced the churches' profiles, kindled a desire for frugality and moderation and stimulated appreciation of an intellectual knowledge of the faith.

Although many of the Dutch traits that are now regarded as typically Calvinist seem to me more like a pattern of commonly held norms and values, I would

still (with the requisite reservations) like to mention two other elements that have contributed to forming the Dutch culture.

Calvinism was able to take root in the Netherlands because of its view of government. Calvinists expected a great deal from their government, but they did not grant it unlimited authority. This put the Calvinists in a moderate position. Anabaptists in general took a negative view of the government, and because of this they were never able to formulate a positive idea of what they expected from government, nor to take an active part in it. Lutherans were by definition obedient to the government and thereby ruled themselves out: they could not organise themselves under a Catholic authority. Calvinists taught that in principle the government was God's handmaid, so they did all they could to convert it. If the government turned against

them, however, and trampled justice underfoot, a citizen had the right to rise up in revolt. This enabled Calvinists to be good citizens as well as rebels, if need be. During the Second World War this tense relationship with government authority was the seed that gave rise to discussions on whether the German authority was lawful or not; and once that question had been answered with a 'no', it led to the exceptionally high proportion of Calvinists in the Resistance.

What went for the Calvinist attitude to the government also went for the Calvinist attitude to the world in general. There, too, the relationship was tense. Calvinism gave daily life an even stronger religious colour than the Catholic tradition had done. One pursued one's vocation not in a monastery but in an ordinary job. According to Calvinist theory, a carpenter was no less 'called' than a clergyman. This imparted new value to everyday life. Yet the Calvinist regard for everyday life was not unreservedly positive. For the world was sinful. It had been corrupted by the Fall. So while the world was the place where the believer had to live his life, it was also a place full of danger. The ideal believer, therefore, was 'in the world but not of it'. This tense relationship had the potential to be an engine of Calvinist idealism. After all, the Calvinist was called to act in and for this corrupted world. The sinful world had to become the Kingdom of Christ. This conviction turned some believers into campaigners for world improvement, particularly in the 1970s and '80s.

To summarise: Calvinism was an important feature in the Dutch landscape, but the same was true of other Christian persuasions. On a number of points, such as the tense relationship towards the government and an activist desire to improve the world, we may perhaps speak of a Calvinist influence. More important than Calvinism in the shaping of Dutch culture, however, was the country's religious diversity.

Mirjam van Veen
Translated by Nancy Forest-Flier

www.calvijn2009.nl

Language

Sojourner Truth was once Isabella Van Wagenen
Dutch Culture and Language among African-Americans

Sojourner Truth, the United States' best-known African-American woman of the nineteenth century, grew up speaking Dutch. She was born into slavery as Isabella Bomefree in 1797 in Ulster County, which lies north or upstate along the Hudson River from New York City. Her family was owned by well-to-do land-owners, the Hardenberghs. In her autobiography she speaks about her mother ('*mau-mau Bett*'), whose only language was Dutch. In the community where she lived, Dutch was spoken both by the owners and the slaves. Also in her autobiography, Sojourner Truth re-lates how she was sold to English-speakers when she was nine years old. She didn't understand a word of English and was severely punished for not doing what was expected of her. The narrative of Sojourner Truth is one example of how widespread the Dutch language and culture were among African-Americans during the seventeenth, eighteenth and nineteenth centuries.

It is well known that New York City and the Hudson Valley retained much of their Dutch character long af-ter New Netherland was taken over by the English in 1664. What is not well known is that the thousands of slaves who lived among the Dutch and their descendants adopted the culture and language of their owners.

The writings of Timothy Dwight (1752-1817), a Con-necticut preacher who ultimately became president of Yale, tell us something of what the Hudson Valley looked like when he passed through the area in the last quarter of the eighteenth century and recorded some observations: '*The women commonly walk with-out shoes, and the number of Negroes is large. The latter and the whites speak Dutch generally, so that the trave-ler imagines himself in the middle of a Dutch colony.*'

What is certain is that during the seventeenth and eighteenth centuries and into the nineteenth tens of thousands of slaves had to cope with Dutch owners, their culture and their language. In 1749 one-third of the population of Kings County, the present New York

City boroughs of Brooklyn and Queens, was of African origin and almost all of them were slaves. In Bergen County, New Jersey, directly across the Hudson River from New York City, the ratio of African-Americans was one in five. Kings County and Bergen County both had populations that were predominantly of Dutch

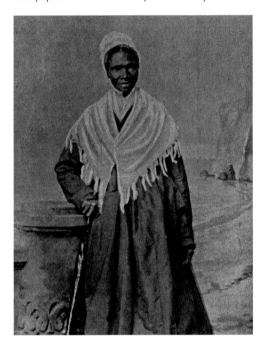

Sojourner Truth (1797-1883).

descent. Graham Russell Hodges, researcher and au-thor of numerous publications on slavery, estimates that in around 1750 there were about ten thousand slaves living within a fifty-mile radius of New York City.

Hodges collected advertisements for runaway slaves from the area around New York City, including New Jersey. In the description owners usually list their characteristics, one of which is the languages they speak. A number of them spoke Dutch, Low Dutch or Negro Dutch. 58 out of 662 ads mention the slave's ability to speak Dutch, less than ten percent. On the other hand, at least one Dutch-speaking slave ran away more than once, and on the second occasion the

owner didn't bother to mention that he spoke Dutch. In some areas that might not have been anything very special.

Much has been written about the so-called Pinkster festivities among African-Americans. Originally Pinkster was introduced as the Dutch version of Whitsun, the religious celebration seven weeks after Easter. It is said that many slaves would have been familiar with the religious holiday from Africa, where missionaries had been teaching Roman Catholicism. Converting African people according to the Catholic tradition usually meant accepting all their current traditional beliefs as long as they were not incompatible with Christianity. Some Africans may have had a festival similar to Pinkster and the two may have merged together. In the seventeenth and eighteenth centuries there weren't many Roman Catholics in the Hudson Valley.

Pinkster became a genuine festival for blacks from the beginning of the eighteenth century. The week-long celebration brought together African-American and white people. Pinkster included elements of the European Shrove Tuesday/Mardi Gras celebrations, part of which were role reversals, but also of African festivities. During the eighteenth century there was a slave in the Hudson Valley who during Pinkster became King Charley and danced the 'Toto'. In the early nineteenth century Pinkster was banned, not only because it became too raucous, but also because of a growing fear that at gatherings like these conspiracies for revolts were formed.

James Fenimore Cooper gave an account of a Pinkster celebration in New York City in his novel *Satanstoe*. The novel was written in 1845, but the author returns to a period a hundred years earlier. He describes how everybody in the city is leaving to go to The Park, where the Pinksterground is. The Park he refers to is the area that now lies just north of City Hall, which wasn't built until 1807. Cooper is very detailed in his descriptions. He claims that almost all the African-Americans had been born in America. He tells us that 90% of all the area's African-Americans are present and there are African songs. The festival is also a destination for girls aged fifteen to twenty; these are chaperoned by older women, 'who belonged to the race that kept the festival'. Cooper mentions as typically Dutch that young children are partnered with a slave of the same age and in this way form a combination which can last a lifetime. This particular custom was adopted by the English.

The Dutch Reformed Church in America was established shortly after the founding of New Amsterdam in 1625. The first slaves were imported in the same year or in 1626. The slaves enjoyed some autonomy under the Dutch, and in 1641 two black couples married in the Church. When some slaves petitioned for freedom in 1644 they were successful, but had to pay a kind of annual tax or they would lose their freedom again. Their children remained the property of the West Indian Company. In 1649 some citizens protested at the children of free Christian mothers being enslaved and the WIC quickly made some concessions so that only now and then would they be called upon to work for the Company. Under Dutch rule between 1641 and 1664 twenty-six marriages of African-Americans took place in the Dutch Reformed Church. The reverend ministers wanted to stop baptising African-American children because 'the parents wanted nothing else than to deliver their children from bodily slavery, without striving for Christian virtues.' It became increasingly difficult for African-Americans to convert or become members of the Dutch Reformed Church or any other church. It was only towards the end of the eighteenth century, as abolitionist ideas became more popular, that the churches changed their attitude.

The itinerant preacher John Jea testified to having had a dream one night around 1790 in which an angel appeared before him with a Holy Bible. The angel is quoted as saying: 'Thou hast desired to read and understand this book and to speak the language of it both in English and in Dutch; I will therefore teach thee, and now read.' And when he woke up, Jea, until then illiterate, was able to read. Jea had been born in Nigeria in 1756 and came to America as a slave when he was two and a half. His family was sold to the Terhunes, a New York Dutch family in Flatbush (today part of Brooklyn). He was interested in religion, but converted to Christianity without asking his master's permission. Terhune

Literature

wanted to have the baptism annulled, but could not. Jea wanted to read the Bible, but his master would not allow him to learn to read and write. Then, six weeks later, he had this dream. Word of the miracle spread through New York and the authorities gave him his freedom.

Before taking the name Sojourner Truth the slave Isabella Bomefree chose to call herself Van Wagenen after the Van Wagenen family, who had hired her from the man who claimed to be her owner. Many slaves ended up taking the names of their owners, so it is not uncommon to come across African-Americans named Schermerhorn or Schenck or Sutphen. And it was not only slaves who took Dutch names. Free African-Americans who lived in a Dutch society adopted Dutch names. In the Ramapo Mountains area on the border of New York State and New Jersey there are people with names like De Freeze and Van der Dunk. They claim to be of native American descent and they could well be, but it is likely that they also descend from the first free seventeenth-century African-Americans who lived on Manhattan Island. Imported as slaves, they petitioned and gained their freedom and owned land. When the English took over in 1664 and New Amsterdam became New York they moved uptown, but around 1680 they left for a quieter area across the Hudson. During the eighteenth century their situation did not improve, with restrictions on slaves increasing and life becoming more difficult for all non-whites along the way. The free African-Americans moved into mountainous, more isolated areas, such as the Ramapo Mountains. Less than one hundred years ago the descendants of these people were still speaking Low Dutch, the term which is always used for the Dutch language that survived in the United States.

Lucas Ligtenberg

Awater in the UK
Martinus Nijhoff's First English volume

Two gentlemen in a restaurant in Nijmegen. During dinner one of them says with a sigh what a shame it is to write poetry in a language that reaches so few people as Dutch does. This means that his readership remains somewhat limited, and that weighs on his heart. Eventually the other man promises to go home and not rest until he has translated one of his friend's major works into English. According to his own account, that is how poet and translator Daan van der Vat (better known as Daan Zonderland) embarked on the first English translation of Martinus Nijhoff's 'Awater' in 1939. Van der Vat completed a first version in three days, and then spent the next ten years honing the translation. During this time face-to-face contact was hampered by, among other things, the German occupation and Van der Vat's emigration to London, but nonetheless poet and translator discussed the progress and finer points of the translation from time to time by letter.

The long poem 'Awater', which appeared in 1934 as part of the volume *New Poems* (Nieuwe gedichten), is indisputably one of Nijhoff's most important works, which immediately makes it also one of the most important works in twentieth-century Dutch poetry. The modern and startling atmosphere, the stylistic refinement, the network of allusions and references, the concrete meanings and their various possible interpretations: whole books have been written about these features in the Netherlands, literary reputations built on them, readers bewitched by them and poets inspired by them to this very day. Of course this does not relate to 'Awater' alone: it relates to Nijhoff's poetry and his views on poetry in general. It is precisely for this reason that Nijhoff's lament at the limited reach of Dutch is still so understandable. Apparently the British literary heavyweight T.S.Eliot, whom Nijhoff admired, said after reading 'Awater' that if he only had written it in English rather than Dutch Nijhoff would have been world-famous. And another Nobel Prize winner, Joseph Brodsky, referred to 'Awater' as *'one of the grandest works of poetry in this century'*, and added: *'It's a com-*

pletely different thing. This is the future of poetry, I think, or it at least paves the way for a very interesting future.'

Meanwhile, Nijhoff's work has been translated into about fifteen languages, and in some countries – such as Slovenia, Germany and Russia – not just in a general anthology or periodical: what came on the market was a fully-fledged anthology. But still: our greatest twentieth-century poet is not yet really world-famous. And when in recent years contemporary Dutch language poets have been able to enjoy increasing attention and appreciation abroad, it would be good if the world beyond our borders could also be given a fuller picture of the work of their most important fore-runners, such as Martinus Nijhoff. As regards 'Awater' in England, Van der Vat's first step, the initial translation initiative, was followed by a second: in 1949 he finally published his translation in the London periodical *Adem*. A good ten years later a second translator, this time a native English speaker, ventured to tackle Nijhoff's masterpiece: the Netherlands-based American James S Holmes. (A salient detail: in 1956 this same Holmes had been the first non-Dutch citizen to receive the prestigious Martinus Nijhoff Prize for literary translations.) The new translation, published in 1961 in the periodical *Delta*, was highly praised and seemed so to impress everyone that for a long time not a single other translator attempted to surpass him. It has taken until the twenty-first century for the Australian author and translator David Colmer to take up the challenge – at the request of the Foundation for the Production and Translation of Dutch Literature. His approach is not only fresh and contemporary, it is also ambitious. His aim is to achieve something that both previous translators had failed to do: not only to be semantically and metrically (at least reasonably) faithful, but also to reflect the rich assonances of the original verse in a better way in the translation. In this way Colmer possibly come a bit closer still to what is the ideal for many translators of poetry: to create a translation that is as much a poem in its own right in the target language as the original poem is in the source language.

In the course of 2009 the English public will be able to compare the existing 'Awater' translations for itself, when all three are included in a special publication from Anvil Press Poetry. Fifteen years ago, under the title *Against the Forgetting,* this London poetry publisher published poems by another great twentieth-century Dutch figure: Hans Faverey (translated by Francis R. Jones). In this projected publication, *Martinus Nijhoff: Awater,* the three translations will follow each other in chronological order: from 1949 to 1961 to 2009, preceded by the Dutch original and an introduction by the Dutch Nijhoff expert Wiljan van den Akker. The letters written by Nijhoff to Van der Vat between April 1939 and June 1949 are also included in the collection, as is a short 'Note by the Translator' by Holmes and a fuller account by Colmer entitled 'Retranslating Awater'. The whole volume concludes with an English translation of Nijhoff's famous 'Enschede lecture' given to the Enschede People's University in 1935, a year after the completion of 'Awater'. In this lecture he explains how 'Awater' came about, and sets the poem and his poetic genius against the background of his times. The title of the lecture alone, 'Poetry in a Period of Crisis' indicates that Nijhoff's poetry, and also his thinking *about* poetry, have still lost little of their topicality.

Exactly sixty years after 'Awater' could first be read in England in a periodical, with the Anvil publication Martinus Nijhoff will finally get what he has always deserved: his first UK volume. Hopefully, and probably, it will not be another sixty years before somebody takes the next step and publishes a more comprehensive Nijhoff anthology in English.

Thomas Möhlmann
Translated by Sheila M. Dale

www.anvilpresspoetry.com – www.nlpvf.nl

The Father of Angels
A Novel by Stefan Brijs

A fascination with the unusual was already apparent in earlier work by the Flemish writer Stefan Brijs (1969-). In his second novel, *Eagle* (Arend, 2000) all attention is focused on a sluggish overweight young man trying to rise above and fly beyond the vale of tears in which he finds himself. In this book, which follows his debut as a novelist with *Degeneration* (De verwording) in 1997, Brijs manages to evoke his character's tragic attempts with considerable compassion and empathy. His lengthy novel, *The Angel Maker* (De engelenmaker), published in late 2005, at first appears to be about genetic experiments, a hot topic in many a committee of clerics and politicians but also a regular cause of academic squabbling. Research results published by a South Korean professor a couple of years ago, for instance, proved to have been rather economical with the truth. So there are obvious dangers lying in wait for any novelist wishing to illuminate such a complicated issue. His or her story would soon be eclipsed by the theoretical detail. But Stefan Brijs has handled the topic differently, and magnificently, in his masterful novel. Of course the book is about scientific experiment and cloning, but it is mainly a play of voices, a dialogue between truth and illusion, between suspicion and reality, a dialogue not so much between characters as by the villagers, neighbours and (so-called) witnesses. Brijs uses this interplay to build up the tension page by page, releasing its horrifying climax on the reader only at the very end of the novel.

In Part I a doctor called Victor Hoppe moves to Wolfheim, a village in Belgian Limburg close to the borders with the Netherlands and Germany, and settles there with his three sons Gabriel, Rafael en Michael. The locals are quick to remark that the boys are far from being archangels. Their father is a repulsive-looking introverted man with untidy rust-brown hair, dead white skin and a repaired harelip. At first he hides himself away in his practice, but in time begins to see the villagers. They come to him not only with their complaints and sicknesses but mainly to satisfy their curiosity: what do his children really look like and,

more particularly, where is their mother? Hoppe manages to break the ice by bringing the three boys with him to the local café. There the villagers see three lads with huge heads, each with a harelip like their father's and skin white to the point of being transparent. And the mother? Does she live somewhere else; is she dead? 'No', Hoppe tells them smoothly, 'they never had one'. Their fear and anxiety is transformed into admiration for this mysterious doctor, who with the help of a retired schoolmistress devotes himself to bringing up his sons in what the villagers consider an exemplary way. But the schoolmistress, Charlotte Maenhout, soon discovers that things are very far from what they seem. The children are constantly subjected to medical experiments, they are not allowed out of the house, their fates are sealed. They are all mortally ill and are going to die. Having discovered the terrible truth, she devotes herself with all her heart to looking after the children. At the same time she tries to draw Hoppe out. But she says and claims things that trigger something in him he has no control over. Brijs writes that the evil had entered into him, and evil has to be fought against. Then, before Hoppe's very eyes, Charlotte Maenhout falls backwards down the stairs.

In Part II, Brijs switches the perspective to Victor Hoppe himself. Hoppe's mother believed that her malformed son was a *'child of the devil'*. He was put up for adoption and grew up in miserable circumstances in an orphanage run by nuns. Most of the nuns thought he was mad and dangerous, but a novice discovered he had a brilliant mind and was in fact very talented. He was allowed to continue his education at a Catholic boarding school, where the strict rules and schedules only helped him to progress. He becomes fascinated by Christ's Way of the Cross, by the Son of God who died, mocked and ridiculed, on the cross. From that moment on, Victor Hoppe decides *'he'll put one over on God'*. He finishes his studies, becoming an embryologist, and is awarded a doctorate at Aachen where he writes a

highly-praised dissertation on cell cycles. He becomes renowned in Bonn as a fertility specialist, producing strains of mice from exclusively male or female parents. He continues single-mindedly with his research, but some of his colleagues accuse him of fraud. His experiments cannot be replicated and Hoppe refuses to give any explanation. He leaves the university and without informing his immediate colleagues moves to Wolfheim. These are the facts, but the novelist explicitly states that it is only half the truth and that another, much enlarged, story is about to be revealed.

This story is told in all its intensity in Part III. Dr Victor Hoppe has cloned himself, and the woman he needed for the purpose has discovered the awful truth through one of Hoppe's former colleagues. They make their way to Wolfheim separately; the former colleague has minimal contact with Hoppe but still notices how passionate and obsessive he is about his work. The 'mother' craftily manages to work her way into the household and takes over from the deceased schoolmistress. The villagers see this woman as a dangerous intruder, someone who will put the doctor and his children in danger. In fact she tries to save the lives of the doomed children, who nevertheless die one by one. Hoppe had stopped feeding them, thus leaving them in God's hands: 'it was up to God to decide when He would take their lives. It was God's own decision to drag it out and not to take all three of them in one fell swoop. The evil came from Him. From Him alone. What could he do about it?'

Hoppe continues with his work; in some future attempt the cloning must be successful. No one could stop him now. He nails himself to the cross, the same cross he remembered from his youth, a cross that now marks the finishing point of a procession by the villagers. 'The body fell from the cross (...). Everything goes black before Father Kaisergruber's eyes (...) other people collapsing at the same moment.'

The Angel Maker owes its success to Brijs' handling of the topic. By zooming in on the various characters in the course of the three sections of the novel, he gradually reveals more and more detail, thus strengthening an already fascinating story-line. The novel not only deliberately switches perspective, it also shifts from one topic to another. What does a group or a partial initiate think of someone who is going off the rails? Is our sympathy for someone determined by irrational things or by facts? Brijs is a master at playing with rumour and half truth. And this only heightens the importance of those passages in which he does no such thing. The young malformed Victor Hoppe is taken by his mother to be the devil's child. This is why he is rejected and grows up without love. Later on, his genius is neither guided nor curbed, with the result that Hoppe's alienated single-mindedness only gains in strength, finally degenerating into total religious delusion. The father of his self-'constructed' angels nails himself to the cross like a modern-day Christ. This ending is already announced halfway through The Angel Maker during an incident at school. Because of the stream of references to the road to Calvary, Victor Hoppe's life can certainly be seen as a procession from one Station of the Cross to the next, something which, because of the many interruptions and changes of perspective, only becomes apparent at the very end.

Stefan Brijs' Angel Maker is a highly accomplished novel with many qualities. He offers us more than just a page turner, which of course the book also is: to quote the reviewer of the English translation in SFX Magazine, the novel 'has superglue-soaked covers; you can't put it down... compulsive reading... This is a great big clunking fist of a book. Prepare to be knocked speechless.' The author has managed to build a highly topical social issue into his own imaginative world, a world dominated by the quest for identity, a world in which the dividing lines between good and evil are mainly a matter of points of view and perspective, all unfolding, as the reviewer in The Independent states, in this 'tall tale of angelic sons and lofty ideals'

Daan Cartens
Translated by Peter Flynn

The Angel Maker, the UK edition of Flemish writer Stefan Brijs' novel De Engelenmaker, translated by Hester Velmans, was published by Weidenfeld & Nicolson in July 2008, and became available from Penguin USA at the end of 2008.

(see also www.stefanbrijs.be)

Wayward Authenticity
Paul Van Nevel, Musician and Expert
in the Art of Living

Something is 'authentic' when it is genuine, unadulterated and truthful, from an historical point of view just like the original – if not the original itself. However, the stamp of 'authenticity' can also mean that something is original in a creative sense, with a distinct personal identity. In an area where creativity and historicity rub up against each other, as in early music, authenticity always contains this ambiguity. Since the 1970s the attempt to achieve an 'authentic way of performing' has prompted musicians to make choices on the basis of historical sources about music. And yet this practice does not detract from the other meaning of authenticity: the performer's personal input is still often as salutary as it is inevitable. And more than anyone the Flemish conductor and musician Paul Van Nevel finds himself caught between these two extremes. His career, which now spans almost forty years, is an exciting tight-rope dance between the faithful and the wayward, watched by many and regularly greeted with cries of astonishment and admiration.

Coming from a musical family in Belgian Limburg, Van Nevel (1946-) studied at the Maastricht Conservatory. Later he was a part-time assistant at the renowned Schola Cantorum Basiliensis, the Swiss academy for early music. It was there that he founded the Huelgas Ensemble that was to become his laboratory, life's work and pride and joy. Over the years it has been internationally acclaimed and showered with praise on countless occasion. It has made over fifty recordings on the Sony and Harmonia Mundi labels. Van Nevel is also active as a guest conductor with, among others, the Nederlands Kamerkoor and Ghent's Collegium Vocale.

On his return from Basle Van Nevel was given a scholarship by the Belgian government to undertake research in Spanish libraries and archives. This would be the beginning of a real journey of exploration through dusty manuscripts and printed texts all over Europe, the first steps in the rediscovery of countless gems from the rich repertoire of Renaissance polyph-

ony. Van Nevel cherishes this cultural heritage and enjoys getting people to take unknown masters and their works to their hearts. For example, he devoted an entire CD to the likes of Matthaeus Pipilare, Jean Richafort or Jacobus de Kerle, names once familiar only to musicians, while Johannes Ciconia and Nicolas Gombert were the subject of publications aimed at a broad public.

Skilled in deciphering the old Renaissance notation, initially Van Nevel accesses the music through the surviving record of the notes. Direct contact with the 'old notes' is a first step towards authenticity, in the sense that the textual starting point of the music's performers is created from the original material. But Van Nevel's search of the archives goes beyond contact with the actual musical sources. He also knows the treatises on musical theory in which all sorts of aspects of polyphony were discussed. These manuscripts attest to the multiplicity of disciplines in which a Renaissance musician was proficient. Trained from childhood in cathedral schools, in addition to mastering their voices and musical notation singers would also know several languages and be familiar with theological and philosophical ideas, verse forms and the rules of rhetoric. When he auditions would-be singers Van Nevel too looks for skills other than the purely musical, such as the recitation of Latin or Old French texts. Such an approach provides him with a group of committed and involved performers.

Contrary to what must have been the historical practice, Van Nevel also uses female voices. In the Middle Ages and the Renaissance much of polyphonic music, particularly church music, was an exclusively male affair. The high registers were covered by choirboys or even by the falsetto voices of male altos and sopranos. We have to remember here that in those days voices broke later and that (because of the 'lack' of vocal training as it has existed since the nineteenth century) the adult male voice remained more flexible than today.

Although he is an accomplished musicologist and a talented musician, there is more to Van Nevel than the seemingly happy combination of performing musician and academic researcher in the field of music. His ap-

proach is exceptional in that to a considerable extent it brings the logic of a forgotten way of thinking to bear on present-day practice. That way of thinking is one of far-reaching associations and omnipresent symbolism. Scientific break-throughs, political and social upheavals and a waning sense of religiosity and spirituality separate the twenty-first century individual from the human world of ideas in the Middle Ages and the Renaissance.

In that world art too could thrive as well as alchemy. As though in search of the magic fifth element, Van Nevel travelled to the Water Museum in Lisbon to record *La Quinta essentia*. Against the intriguing backdrop of basins, pipe systems and reservoirs, he began to search for a perfect mixture of three figures from the sixteenth century. To the familiar names of Orlandus Lassus and Giovanni Pierluigi da Palestrina he added a secret ingredient: the little-known Englishman Thomas Ashwell. These choices are not so much historically motivated, but the recording can still be called authentic, because like no other it breathes the atmosphere of an almost ethereal associative thought process in a way quite without parallel. And indeed, the musical result is equally heavenly.

A particular source of inspiration for Van Nevel is the landscape he comes across in what is now the borderland between Belgium and France, the region where many of his beloved polyphonists were raised. Influenced by the landscape philosophy of Ton Lemaire, he sees the threads of the multi-voiced tapestry of sounds reflected in the slopes of the fields. The most important element is a horizontal concept of polyphonic music: each voice follows an independent course that weaves it way through the trajectories of the other (individual) voices). It is not the vertical harmonies that are fundamental, but the linear unfolding of each separate part.

Anyone who has ever been to a Huelgas Ensemble concert, will certainly not have been disturbed by attempts to popularise the performance and attract the largest possible audience. On the contrary, the singers arrange themselves in a circle with their backs rather rudely turned towards the audience. The circular arrangement is the one that is musically the most effec-

The Huelgas Ensemble.

tive: it provides optimal contact between the singers, something that is necessary for anyone seeking to achieve Van Nevel's perfection of rhythm and intonation. Yet the closed aspect of the circle also epitomises that his concerts are aimed primarily not at the audience, but at the music itself. Above all else Van Nevel wants to let quality be heard, not to offer pleasure. Such an attitude seems out of keeping with a cultural policy of democratisation and participation. Nevertheless, in Huelgas' case neither the sales figures for recordings nor the takings from the evening performances need suffer because of it. Listening to polyphonic music is not mere relaxation; it is a mental exercise.

Some of Van Nevel's projects make surprising cross-connections, too, with room for real cross-over, such as his co-operation with the saxophone quartet Bl!ndman. Moreover, the outstanding live recording *Tears of Lisbon* alternates early Portuguese music with fado, provided by two top-notch *fadistas*. Indeed, Van Nevel spoke explicitly of his passion for the melancholy of fado in the book *A Lisbon Addict for Thirty Years* (Dertig jaar verslaafd aan Lissabon, 2006). And finally, another memorable piece is the musical ode to the

cigar that Van Nevel – himself a notorious cigar-smoker – once composed using nineteenth-century texts and appropriate music. In a hall in the Palais des Beaux Arts (BOZAR) in Brussels, transformed for the occasion into a smoking parlour, Van Nevel may well have made one of his most wayward statements.

He loathes cigarettes, but is quite happy to let himself be photographed with a plump Havana. For Paul Van Nevel the difference lies in the tempo: the rushed, selfish satisfaction of nicotine addiction versus the timeless appreciation of a cigar. For him, slowness is what constitutes the art of living. In our own day, listening to polyphonic music is the task it is because the music is not of the moment alone but extremely enduring. The subtleties of the complex mass of voices reveal themselves little by little, if only a listener is able and willing to concentrate – something he must have been far more ready to do in an age without recordings, when, in other words, every performance was unique and could never be repeated. The ensemble takes its name from the Monasterio de las Huelgas, close to one of the country residences of the kings of Castile; maybe it is no accident that – 'huelga' means not only 'cessation' but also 'tranquillity'.

According to his own account, after his first visit to his beloved Lisbon a young musician discovered in himself 'a Romantic who until then had been carefully concealed under a layer of Renaissance varnish'. In his artistic creations this Romantic spirit is never very far away: searching for unexplored beauty, averse to conventions, acting from individual passions... However, the close contact with the music itself and an enduring search for context and meaning means that the authenticity of the enthusiasm does not get in the way of the authenticity of the cultural heritage. Far from it; the Renaissance varnish shines through all the more clearly.

Simon Van Damme
Translated by Sheila M. Dale

www.huelgasensemble.be

Learning to Live with Uncertainty
A Portrait of Abram de Swaan

A photograph from 1968 shows the then twenty-six-year-old Abram de Swaan interviewing the Cuban leader Fidel Castro. The bearded hero of many left-wing students at the time is holding forth vehemently, clenched fist raised, while De Swaan listens attentively and looks at him sidelong. In the interview that he later published in the social-democrat newspaper *Het Vrije Volk*, De Swaan dutifully recorded the *líder máximo's* determined statements: '*Within ten years Cuba will have made such advances in cattle-breeding that we will be exporting Cuban cows to the Netherlands.*'

Although De Swaan definitely saw himself as left-wing back then, he did not, unlike many of his generation, harbour an unquestioning admiration for the Cuban leader or for any other revolutionary heroes. Neither did he view Marxism, so much in vogue at the time, as a closed doctrine that was able to offer a definitive answer to every question or problem. Marx had asked good questions and formulated valuable insights, but the same could be said of so many philosophers and scientists. De Swaan's attitude in that 1968 photograph could be described as 'boundlessly inquisitive', and that same expression – in Dutch: *Grenzeloos nieuwsgierig* – was chosen as an appropriate title for the festschrift published in 2007 to mark De Swaan's departure from the University of Amsterdam. De Swaan, who in 2008 won the P.C. Hooft Prize, the highest literary award in the Netherlands, for his essays, has never allowed his curiosity to be shackled by any one doctrine, political tendency, research method, or even by a single academic discipline.

De Swaan, born in 1942, got off to a flying start in the world of intellectual debate. He grew up in a left-wing, Jewish family, in a house where intellectuals and artists were frequent visitors and where as a child he participated in discussions about democracy, capitalism and Stalinism. '*In our house, people never talked about day-to-day niggles. Our discussions were always about the situation in the world,*' he once said in an interview. His father Meik de Swaan ran a successful jute-sack business, and was also director of *De Vrije Katheder*,

a magazine with its origins in the Artists in Resistance movement. Communists and non-communists worked together on the magazine from 1945 until 1950, when the communist party did away with it. De Swaan's mother, Henny de Swaan-Roos, was later one of the driving forces behind the radical feminist Dolle Mina group.

In 1959, De Swaan went to the University of Amsterdam to study political science, which for a while he combined with mathematics. Three years later he chose sociology as a subsidiary subject and went on to become one of the most important sociologists in the Netherlands. He also created a reputation for himself in many other areas. In 1964, he joined the editorial team of the renowned student magazine *Propria Cures*. He was charged with '*contemptuous blasphemy*' for a piece he wrote in October 1964 and was the last person to be condemned for this offence in the Netherlands. The charge was based on such comments as '*a carpenter's son who rose through active self-study*' and '*the rabble-rouser, faith-healer and nutritional expert J. "Christ" of Nazareth*'. That he had meant to poke fun not at Jesus, but at the hysterical and infantile style of writing in publications such as *Time* and the *Haagse Post* was something the judge considered irrelevant.

De Swaan expressed his matter-of-fact, gently ironic, sociological view of the world around him through various outlets, including a lengthy article about the Beatles first concert in the Netherlands which was published in the weekly magazine *De Groene Amsterdammer* in 1964. While many older people saw the hysterical scenes as evidence of a serious 'youth problem', he viewed it as a relatively innocuous phenomenon. Soon after that, he started writing for the prestigious magazine *De Gids*, founded in 1837, and served as its editor from 1969 to 1991. In 1966, he graduated cum laude with a thesis entitled *Possibilities and Problems of a Politicological Application of Game Theory*. He then went to the United States for two years, where he worked on his doctorate at Yale and Berkeley. He continued to write articles for newspapers and recorded opinion pieces for the progressive broadcaster VPRO, which were published in 1967 as a book with the title *America in Instalments: A Breathless Report from the USA (Amerika in termijnen: een ademloos verslag uit de USA)*. On his way home he stopped off in Cuba, where he interviewed Castro, and when he got back to the Netherlands he worked as a journalist and made TV documentaries on subjects which included art, pop music, factory workers and the sociologist Norbert Elias.

In 1970, De Swaan published a controversial article in which he declared that political science in the Netherlands had failed because the academic discipline kept itself too remote from relevant social issues. This resulted in a rift with his supervisor Hans Daudt. Three years later he finally gained his doctorate with the strongly mathematical *Coalition Theories and Cabinet Formations: A study of formal theories of coalition formation applied to nine European parliaments after 1918*. In the same year he accepted a position in the sociology department at the University of Amsterdam, becoming professor of sociology in 1977.

Anyone who supposes that De Swaan with political science, sociology and journalism had explored enough professions is underestimating his insatiable curiosity. By that point, he had also qualified as a psychoanalytical therapist and from 1973 to 1984 he had a small psychotherapy practice alongside his university post. In the early 1970s, he worked with other researchers on psychological aspects of treatment at a cancer hospital. The findings of this study, which included a plea for improved psychological support for cancer patients, did not go down well with the hospital management, who forbade the report's publication.

This research at the cancer hospital, together with other projects, including a sociological study of the psychotherapeutic profession, formed part of De Swaan's preliminary studies for a much larger task that he had set himself: a historical and sociological account of the rise of the welfare state. The result of this undertaking was *In Care of the State. Health Care, Education and Welfare in Europe and the USA in the Modern Era* (Oxford University Press, 1988), in which he analysed the development of the welfare state over a period of no fewer than five centuries.

Although De Swaan is seen as a proponent of historical sociology and as strongly influenced by the work

of Norbert Elias, who is a well-respected figure particularly amongst the members of Amsterdam's sociology department, his approach has always been much broader. In addition to comparative historical research between different countries, he also uses models based on 'rational choice' theory. *In Care of the State* combines Eliasian analyses with game-theory models. Within sociology, these two traditions, historical or figurational sociology and rational choice theory, are generally seen as incompatible, so sociologists almost always opt for one or other of the two approaches. De Swaan spoke about this in an interview in 2002: *'I believe that this distinction is out of date, and that you can make very good use of a flexible form of rational choice theory, in which economic models are applied to other spheres, within a historical, comparative account. The soft, supple flesh of the comparative historical argument can be carried on the skeleton of sharp analyses made possible by rational choice theory. This allows you to formulate much sharper questions and hypotheses.'*

In the chapter on education in *In Care of the State*, De Swaan describes how in some countries the advent of primary education involved a linguistic conflict. While the church generally defended local dialects, the state wanted education to be delivered in the national language. To analyse this development, De Swaan devised a centre-periphery model of languages which he summarised in a formula. As he was fascinated by the economic and political significance of languages but could find little about the subject in the work of historians and linguists, he decided to focus on this area of research. By entering this field as an outsider, his native inquisitiveness enabled him to ask questions that had never been asked before. For instance, what sort of economic good does a language actually constitute? Or: what differences in economic value exist between different languages? In 2002, he published a book on the subject: *The World Language System: A Political Sociology and Political Economy of Language* (Polity Press).

His book about the world language system fits in very well with his great interest in globalisation and cosmopolitanism, as expressed in his collection of essays *The Cosmopolitan's Song* (Het lied van de kosmopoliet, 1987) and elsewhere. The behaviour of nation states, which have on the whole played a positive role in the creation of the welfare state in the Western world, can also have very negative consequences, as is clearly demonstrated by the subject that has chiefly occupied De Swaan in recent years: genocide and other forms of mass violence. He collected a number of essays on this theme in *Beacons in No Man's Land* (Bakens in niemandsland, 2007), in which he employed his typically sober and lucid style to write about subjects including the genocide in Rwanda, the extremely violent role played by the state in the twentieth century and the problems in the Middle East. In his writing, he shows a keen eye for all kinds of group processes and assumes positions that sometimes conflict with prevailing opinions. For example, he views Islamic radicalism as in part a struggle for liberation against authoritarian puppet regimes in the Arab world that are feathering their own nests with support from the United States.

Although De Swaan has never settled exclusively for one single academic method or ideology, he is not a postmodern relativist who views the collapse of the 'grand narratives' as an unmitigated blessing. This collapse has, after all, led many people to become insecure. In his final essay in *Beacons in No Man's Land*, 'The National Bad Mood' ('Het nationale slechte humeur'), he describes how, in confusing and gloomy times, this uncertainty can easily turn into despair. As to whether anything can be done about this, De Swaan gives no clear-cut answer because, to a great extent, it is a question of the individual's philosophy of life. And since many people no longer have a clearly defined ideology, De Swaan gives some advice that is typical of the matter-of-fact, gently ironic and intensely curious way in which he looks at the world: *'Try to get by with some emotion, common sense, a cheerful outlook and the help of the sensible people around you. That sense of certainty is never going to return. So learn to live with uncertainty, that gentle, nagging pain of freedom.'*

Rob Hartmans
Translated by Laura Watkinson

www.deswaan.com

Robbert Dijkgraaf:
a Mathematical Physicist Throws
the Windows Wide Open

Robbert Dijkgraaf (1960-), who took over as President of the Royal Netherlands Academy of Arts and Sciences (Koninklijke Nederlandse Akademie voor Wetenschappen, KNAW) on 19 May 2008, is a man of many talents. A brilliant mathematical physicist, he is a passionate champion of his own field of study and a talented populariser who has also made a name for himself as an artist. The youngest president in the history of the KNAW, Dijkgraaf is the ideal person to promote science in the Netherlands, with his great enthusiasm and strong sense of social responsibility.

While he was still at grammar school Dijkgraaf wrote computer programmes to calculate the orbit of a planet around a black hole. As a sixteen-year-old, he discovered the journal *Scientific American* and became fascinated by physics. He went on to study the subject at Utrecht, but lost interest because of a lack of intellectual challenge. After an interlude studying painting at the Gerrit Rietveld Academy in Amsterdam, however, Dijkgraaf returned to physics. In Utrecht he became a pupil of Nobel Prize winner Gerard 't Hooft. His doctoral thesis was on string theory, a cutting-edge branch of theoretical physics that currently attracts a great deal of interest and posits minuscule oscillating lines as the basis of nature. String theorists often come under fire because the theory operates with extra dimensions, not just the four dimensions of time and space that we are familiar with, and the energy required makes it practically impossible to prove the theory through experiment.

After a stimulating period as a postdoctoral fellow at Princeton, in 1992 Dijkgraaf was offered a professorship in Amsterdam. His colleagues at the Institute for Advanced Study, the research centre where Einstein had spent his later years, advised him against the move, arguing that Amsterdam had little to offer in the field of string theory and that you constantly had to submit proposals, whereas Princeton pampered its fellows. However, Dijkgraaf still chose to return to the Netherlands, partly because of his sentimental ties to the country and also out of a sense of responsibility. Amsterdam now has an internationally renowned string-theory research group that is a match for the best in the world. For Dijkgraaf the fascination of string theory, the most extreme form of theoretical physics, lies in the way it asks the very biggest questions about nature and thereby creates a new mathematics.

Dijkgraaf feels that the most important qualities for a successful scientist are focus and daring. Strangely, the best ideas often seem to come when you're relaxing. You might suddenly find yourself taking a silly joke

Robbert Dijkgraaf with pupils of the
Panta Rhei school in Coevorden
on the occasion of their meteorology
project.

about your research very seriously. You also have to be able to immerse yourself completely in your work. Dijkgraaf is at his best after ten in the evening, when his three children have settled for the night. Ideas never come to him when he's at his desk. However, Dijkgraaf describes the development of string theory as a very painful process, like digging a tunnel with no guarantee that you'll ever reach daylight. It's like creating a work of art: only when it's finished can you relax.

Dijkgraaf was appointed a 'university professor' in Amsterdam in 2005. This professorial rank carries more privileges than an ordinary professorship: a good deal of freedom, additional research funds and in many cases exemption from administrative work and

teaching duties. This means that Dijkgraaf is spared the fuss of paperwork and meetings and can dedicate himself to research. He also has an ambassadorial role, which he carries out with great enthusiasm. He writes a column for the Science and Education supplement of the daily *NRC Handelsblad*; is the chairman of the Commissie Bètacanon, a group that aims to promote essential basic scientific knowledge among the Dutch population; a member of the innovation platform headed by the Dutch Prime Minister Jan Peter Balkenende; editor of the *Amsterdamse Boekengids* (Amsterdam Book Guide); and he is also involved in secondary education.

In 2003 when Dijkgraaf won the Spinoza Prize, the highest scientific award in the Netherlands, he used the one and a half million euros not only to support groundbreaking string-theory research, but also to set up proefjes.nl, a virtual laboratory for ideas and experiments. This website is a fun way for children of eight and older to explore physics and chemistry. The children's television programme *Villa Achterwerk* has also adopted the initiative with great success.

Robbert Dijkgraaf is unique in his ability to convince the general public of the importance of science. Likeable and enthusiastic, with boyish enthusiasm and great verve, he has a talent for winning people over. In 2005 he appeared as a guest on the popular Dutch television slot *Zomergasten*, in which famous people put together an evening of entertainment consisting of their favourite shows and television moments. He delighted viewers with his original insights and his brilliant selection of films, including the funeral of Nobel Prize winner H.A. Lorentz in 1928. Dijkgraaf appears as an expert on *Hoe?Zo!*, a popular TV science programme, writes opinion pieces that can be both pointed and polite, and even managed to captivate pop fans at the Lowlands festival in Biddinghuizen.

In his acceptance speech as the new president of the KNAW, Dijkgraaf stressed the point that science in the Netherlands owes its strong position today to investments made in the past. However, current levels of research in the Netherlands, at universities and in industry, are among the lowest in Europe – and the rate of decline shows no sign of slackening. The KNAW has

its back to the wall, says Dijkgraaf. In order to put a halt to this attrition, he would like the KNAW to help bring together as many different parties as possible, with the aim of creating a common agenda. What is needed is a breath of fresh air, and Robbert Dijkgraaf, with his charm and energy, is the ideal person to throw the windows wide open.

Dirk van Delft
Translated by Laura Watkinson

www.knaw.nl – www.proefjes.nl

The Idiosyncratic Philosophy of Herman De Dijn

At the end of 2008 Herman De Dijn (1943-) was awarded the title of Professor Emeritus at the Katholieke Universiteit Leuven. In recent decades De Dijn has undoubtedly been one of the most prominent voices in the philosophical landscape of the Low Countries. He first made his name as an eminent authority on the work of Spinoza and Hume, about whom he published in specialised international periodicals. After publishing *Rationality and its Limits* (De rationaliteit en haar grenzen) with Arnold Burms in 1986 he began to write cultural-philosophical essays, adopted positions in all manner of social and cultural-philosophical debates and wrote contributions for newspapers and magazines in which he did not hesitate to adopt controversial and challenging points of view.

De Dijn's methodological approach may have evolved, but that is certainly not true of the intrinsic position that he espouses. That there is no yawning gap between the scholar De Dijn and the cultural philosopher is most obvious in his book, *Modernité et Tradition. Essais sur l'entre-deux*, the product of the lectures he gave at the Université Catholique de Louvain (Louvain-la-Neuve) during the 2001 academic year. This is the key book for anyone wanting to gain an insight into the evolution of De Dijn's thinking, because its explicit theme is the link between his studies of Spinoza and Hume on the one hand, and on the other his cultural-philosophical view-

points on subjects such as the tension between modern and postmodern and the relationship between religion and ethics or between religion and science. Far more than just a Spinoza-and-Hume scholar, De Dijn is a 'real' philosopher who, using the heritage of these thinkers and others, has developed his own philosophy with which he responds to the challenges of the age.

How to live in a culture in which the traditional frameworks of meaning have largely disappeared? For Herman De Dijn it is this question that constitutes the challenge of our time. His answer is clear: we must endeavour to endure the tension between tradition and modernity, because we know that there is an irrevocable division between the abstract world of the scientist and the real world of everyday life. The theme of all of his books from 1986 on is the gulf between scientific knowledge and real life, starting from the proposition that science cannot answer man's most fundamental questions. If we can provide answers, we will only find them in the way people live and converse in a human culture.

So what is the essence of this position? It is about no less than safeguarding and nurturing key human values and attitudes, which need protecting from the ever-increasing tendency towards objectification. Values and attitudes of trust, hope, humility, vulnerability, freedom and responsibility typify man not as a biological being, but as an interactive player who is part of a social and symbolic environment. After all it is these basic attitudes, which cannot be substantiated by rationality, that make man what he is in relationship to others and the world, and which we should continue to nurture.

This philosophical position is also typical of Herman De Dijn as a policymaker. Two examples: as editor-in-chief of the leading philosophical periodical in the Low Countries, *Tijdschrift voor Filosofie*, he has always, contrary to the spirit of the times, defended the continued use of Dutch as a philosophical language. His reason for doing so was clear: every philosopher expresses him/herself in the most nuanced way in his/her mother tongue, and philosophy depends on nuance. That is a courageous, consistent position that has not been adopted by the majority of philosophers in the Low Countries.

A logical extension of this is that, as Vice-Chancellor of the Katholieke Universiteit Leuven, De Dijn has always had reservations about the dominant 'bibliometric' model whereby academic output is assessed on the basis of the model used in the sciences. These reservations are part of a broader defence of the university as a place that needs to accommodate not only specialised research, but also the search for wisdom.

The defence of Dutch as a philosophical mother tongue and of the university as an institution where 'thinking' takes place ties in with De Dijn's defence of the religious position and of the ethical worth of each individual. In the end these are all examples of what is a constant in De Dijn's oeuvre: the defence of 'embodied meaning'. There can be no respect for human rights if that respect does not have its roots in respect for the vulnerability of each actual individual; there can be no openness for the religious, if all sensitivity to the symbolic power of signs disappears. Any talk of ideals is impotent if those ideals are not rooted in recognition of the particularity that is peculiar to concrete reality.

Herman De Dijn's philosophy has never been a purely intellectual game. With him, as with every important philosopher, it has always been a matter of commitment, in the service of which philosophy was used. So for many people De Dijn has been a thorn in their flesh. But then, in philosophical circles that is actually the greatest compliment.

Guido Vanheeswijck
Translated by Lindsey Edwards

Society

Herman Van Rompuy Succeeds Yves Leterme

Since the 30th December 2008 a new Prime Minister has been running Belgium: the Flemish Christian Democrat Herman Van Rompuy (1947-). The man has a long experience of the wheels of the State. He entered politics at the age of 28, and was Deputy Prime Minister and Minister for the Budget from 1993 to 1999. Before being called upon by the King to head the cabinet, he was comfortably installed as President of the Chamber of Deputies, a perch he was reluctant to leave. *'I'm not a candidate'* was his response to the post of Head of Government and the responsibilities that go with it.

It must be said that his task is exceptionally hard. For some observers of political life it constitutes a veritable challenge. It comes down to this: the Prime Minister has to guide the country through an economic crisis which looks set to be the most serious since that of 1929. He already had to deal with one of the manifestations of this crisis: the consequences of the break-up of the banking and insurance group Fortis. On top of which, regional elections are due in June 2009 and could revive the tensions between the communities. Finally, and this is not the least of the government's problems, it will have to impose a compromise between the members of its own federal government and the representatives of the federated entities on a constitutional reform; while this has been accepted in principle by practically everyone in Belgium, there has been little agreement as to its extent. Cornerstone or stumbling-block of this highly sensitive community matter: the splitting of the electoral district of Brussels-Halle-Vilvoorde, the only one in the country which is still bilingual.

Herman Van Rompuy presides over a slightly recast government, reuniting five parties: Christian Democrats of the CD&V and liberals of the Open VLD on the Flemish side, liberals of the MR, Democratic Humanists of the CDH and Socialists of the PS on the French-speaking side. Three political families divided by intercommunity antagonisms, and parties which are often at daggers drawn with each other.

For all his image as a well-groomed Fleming, a

Yves Leterme and Herman Van Rompuy.

great lover of French literature, Herman Van Rompuy has nonetheless immediately established himself as the head of this difficult team. An intellectual whose interlocutors appreciate his ability to listen, he is praised for his synthesising mind which enables him rapidly to formulate the web of agreements to be negotiated. Add to that a reputation as a moderate, a federalist, and take into account his experience in financial matters. Isn't he exactly the right man for the job?

Paradoxically, the only people not to have joined this broad consensus on the new premier right away are certain members of his own party, who according to the press dislike his affiliation to the right wing of CD&V, or who see him as having betrayed the fallen star of the Flemish Christian Democrats, the outgoing Prime Minister Yves Leterme, with whom he maintains *'polite relations'*.

While there was always scepticism regarding Mr Leterme's ability to push through a balanced constitutional reform, in the end it was 'Fortisgate' that brought him down. Seldom if ever has a Belgian political individual accumulated so many superlatives: a candidate with 800,000 preferential votes in the parliamentary elections of June 2007, he only took on the premiership after more than nine months of painful efforts to form a government, the longest in Belgian history, throughout which Guy Verhofstadt of the Open VLD held the office of Prime Minister for Current Affairs, and for a scant three months that of Interim Prime Minister, a formula hitherto unknown in Belgium.

Without doubt, the sheer scale of his electoral promises and the rigidity with which he sought to impose them on everyone in the early days, weighed on Yves Leterme, as did the pressures of the Flemish Nationalist party N-VA with which he formed a political coalition until the autumn of 2008. The decline in the general economic situation certainly did not help him, and the rescue of Fortis was a particularly delicate and sensitive matter for the many Belgians with savings.

As the regional elections of June 2009 draw near, observers are wary of tipping Herman Van Rompuy to win; but when asked by the press political scientist Pierre Vercauteren of the University of Mons gave it as his opinion that '*he possesses three qualities necessary for government action to succeed: leadership, creativity and the ability to compromise*'. And already it has only taken him two days to form his government.

15 March 2009
Gerald de Hemptinne
Translated by Sheila M. Dale

The Fortis Saga

On 6 August 2007 the Belgian-Dutch banking and insurance group Fortis held an extraordinary shareholders' meeting in which enthusiastically and by more than 95% of the votes the bid was approved that Fortis had made – together with the British Royal Bank of Scotland and the Spanish Banco Santander – for the Dutch ABN AMRO Bank. The bid was for 71 billion euro, the Fortis part being 24 billion euro for which it would acquire the Dutch branch of the worldwide operating ABN AMRO Bank. That day Fortis shares closed at 28.05 euro at the Brussels and Amsterdam stock exchanges.

On 1 December 2008 Fortis held another extraordinary shareholders' meeting in the Netherlands and the next day in Belgium. This time the board had to account to the furious shareholders for the catastrophic dismantling of the group which had taken place in the space of a few weeks as a direct consequence of Fortis having paid far too much for ABN AMRO. In early October 2008 Fortis had been forced to offload all its banking activities as well as its Belgian and Dutch insurance activities, with only the international insurance business outside these two countries plus a portfolio of American toxic assets remaining in the holding company. On 1 December 2008 Fortis shares quoted 0.69 euro on the stock exchanges. More than 97% of the shareholder value had evaporated.

In 2007 everything still seemed to be going well. In October of that year Fortis paid the €24 billion, having succeeded in increasing its capital by €13.4 billion by means of a rights issue. The share price was then around €23. Several billion euros had also been raised through other channels to finance the acquisition, and in November the Chinese insurance group Ping An acquired a stake of more than 4% in Fortis' equity. In all its public statements Fortis expressed the fullest confidence in its financial health. At the shareholders' meeting on 29 April 2008, Chief Financial Officer Gilbert Mittler explained that, '*barring unforeseen circumstances*', the intention was to distribute an interim dividend in September, as in 2007.

But then, on 26 June 2008, Fortis announced a number of measures designed to '*accelerate the implementation of the solvency plan*', including a share issue of €1.5 billion and the cancellation of the September interim dividend. These announcements shook confidence in Fortis shares, heralding the demise of a concern which had been created in 1990 by a merger of Belgian and Dutch insurance companies. Through its acquisition in the 1990s of the Belgian banks ASLK and Generale Bank and of MeesPierson Bank in the Netherlands Fortis had grown into a major banking and insurance concern. But institutional investors who had subscribed in October 2007 when the share price stood at €23 were no longer willing to do so now at €12.50. The share price slumped to 10 euros. By now, Fortis was worth just €22 billion, less than it had paid for ABN AMRO.

Not less than 15% of Fortis shares are held by Belgian private investors, for many of whom this represents a large proportion of their assets since they have very few investments elsewhere. The cancellation of the interim dividend hit them very hard and

landed some of them in personal difficulties. On 11 July, CEO Jean-Paul Votron was forced to step down.

As the international credit crisis spread further in August and September 2008, triggering the failure of the major US bank Lehman Brothers, share prices fell worldwide. Fortis shares were no exception: on 25 September 2008 the share price fell to €6.55. On that day the Belgian regulator, the Banking, Finance and Insurance Commission, advised Maurice Lippens, chairman of the Fortis board, to seek support from a strong partner. Despite this, next day Fortis issued a press release stating that its liquidity was adequate, that only a limited number of clients were pulling out of the business and that the solvency position was solid. On the following day the shares closed down more than 20%, at €5.18. Major institutional clients and banks from Asia and Russia withdrew their money *en masse*. The result was an acute lack of liquidity and a serious threat of bankruptcy.

During the weekend of 27 and 28 September the governments of Belgium, the Netherlands and Luxembourg decided to take over. Each of them took a 49% stake in the Fortis businesses in their own country. Belgium put up €4.7 billion, the Netherlands 4 billion (which in the end was not paid) and Luxembourg 2.5 billion: a total of €11.2 billion. The Dutch contribution excluded ABN AMRO. The expectation was that this would restore confidence in Fortis. Maurice Lippens was forced to resign.

But confidence was not restored. Fortis was no longer able to raise money on the wholesale market to finance its own operations. The following weekend, the Fortis board was completely excluded from events and it was the Belgian and Dutch governments who decided what was going to happen. The Fortis group was broken up. All the Dutch components, this time including ABN AMRO, were nationalised by the Dutch government at a cost of €16.8 billion (instead of the unpaid 4 billion for a 49% stake): 12.8 million for the banking activities and 4 billion for the insurance business. During this process, Dutch Finance Minister Wouter Bos managed to call down the wrath of the Belgian public on his head by declaring publicly, and with some arrogance, that by taking this step he had rescued the

healthy Dutch part of the Fortis operation and at the same time provided Belgium with the means to solve Fortis' problems in Belgium. ABN AMRO was to be amalgamated with Fortis Bank Netherlands and would in due course be re-privatised.

The Belgian state nationalised the other half of the Belgian Fortis for a further €4.7 billion. The Belgian government then reached an agreement with the French bank BNP Paribas: the latter would acquire a 75% stake in Fortis' Belgian banking operations, with the state retaining 25%; the Belgian state would also receive an 11% stake in BNP Paribas. As part of the agreement BNP Paribas also managed to negotiate the right to buy the insurance operation Fortis Assurance Belgium in its entirety for 5.73 billion in cash, despite the fact that it was a financially healthy business and of absolutely no significance for Fortis' continued existence. However, Fortis had no option but to accept.

The final word has yet to be written on the outcome of those decisions, however. For example, at the behest of the Dutch Association of Investors the Dutch Enterprise Chamber (*Ondernemingskamer*), the special judicial body that deals with cases of this kind, has instigated an investigation into the policy pursued by Fortis in 2007 and 2008, albeit without declaring its decisions invalid. And in mid-December 2008 the Court of Appeal in Brussels ruled in a case brought by a group of Belgian shareholders that the sale of Fortis to BNP Paribas must first be submitted to a shareholders' meeting in Belgium. The Belgian government then lodged an appeal against this ruling, a procedure which is likely to take months and prolong the uncertainty.

But in the meantime the Fortis affair had already led to the fall of the Leterme government in Belgium, which had supposedly become too involved in the legal processes concerning Fortis and so infringed the principle of the division of powers.

Following the decision of the Court of Appeal, implementation of the agreement with BNP Paribas had to be suspended until it had been approved by a shareholders' meeting to be held on 11 February 2009. Meanwhile, at the end of January the Belgian state conciliated shareholders by reaching an agreement with the board of Fortis and BNP Paribas under which Fortis would retain 90% of Fortis Assurance Belgium. BNP Paribas would acquire 10% for €550 million instead of the whole company for €5.7 billion. In this way Fortis would remain a major Belgian insurance company with subsidiaries in a number of countries. Belgium will also take over €3 billion of toxic assets from the Fortis holding company. But that holding company has now been stripped of all its banking business.

But by the narrowest of majorities (50.3%) the highly emotional shareholders' meeting on 11 February rejected this agreement, thus facing Fortis with a new period of uncertainty. But on March 7 the Belgian government, Fortis Holding and BNP Paribas reached a new agreement. Fortis Bank would be 75% owned by BNP Paribas and 25 % by the Belgian government. Fortis Holding will sell 25% of Fortis Assurance Belgique to Fortis Bank. This agreement was to be subject to the approval of the shareholders at a shareholders' meeting to be held on 8 and 9 April.

15 March 2009
Christiaan Berendsen
Translated by Julian Ross

Belgian Society and Politics

Since the general election of June 2007 Belgium has been plunged into a deep political crisis. At times the opposition between the country's Dutch and French language communities has been so harsh that various international newspapers have wondered whether the country could survive this political deadlock. In August 2008 the *New York Times* even had as a title: 'Belgium teeters at the edge'.

Unfortunately, little up-to-date information on Belgian politics is available in English. Self-evidently, *The Low Countries* is a source of information, but the scope of this yearbook is much broader than just hard politics. It is very useful, therefore, that since 2007 the monthly publication *Samenleving en Politiek* (Society and Politics) has published an annual review of Belgian politics in English. The review consists partly of especially commissioned articles, partly of a selection of articles published earlier in the monthly review. Consequently, these annual reviews can be very useful to the discerning reader who wants to know more about the intricacies of Belgian politics.

Let there be no misunderstanding, however. Despite the title of this annual review (*Belgian Society and Politics*), the focus is firmly on politics and political issues. Social developments are only highlighted if they have become a political issue (e.g. the politics of diversity, the Belgian social security system, etc.). Secondly, it should be noted that the review is published by the Gerrit Kreveld Foundation, which is an independent think-tank affiliated to the Flemish Socialist party. This explains why the review devotes a number of articles to an analysis of the Socialists' extremely low score in 2007 and the prospects for social democracy during and after the European elections of June 2009. These texts are written both by academics and by leading members of the Socialist party itself. Despite the fact that these articles contain very interesting ideas and analyses, in the end the reader is left with a fundamental question. In the 2007 election the Flemish Socialist party obtained 16.2 per cent of the vote, by far the worst result of any Socialist party in Western Europe. Even in Switzerland – not the most leftist country one could think of – the Socialists score better than that. It would be extremely interesting to discover the precise reason for this negative marginal position of the Flemish Socialist party.

The 2008-2009 volume of the annual review includes a cluster of five articles on the issue of Brussels. The city of Brussels is indeed the main complicating factor in the ongoing discussion on Belgian constitu-

tional reform. While the rest of the country is either French- or Dutch-speaking, the Brussels agglomeration (roughly one million inhabitants, out of ten million for Belgium as a whole) is officially bilingual. But Brussels is of crucial importance to the entire country: economically and culturally but also as regards infrastructure and its international status as a capital. Without Brussels it would be relatively easy for the Dutch and French regions to go their own way, but both communities would stand to lose if they could no longer profit from the economic and political powerhouse that is Brussels. It is often remarked that, just as some couples stay together 'because of the children', the two communities in Belgium stay together 'because of Brussels'. In the entire discussion on the future of Belgium, however, little attention is being paid to the consequences for Brussels itself. Over the past two decades, both the Flemish and the Walloon regions have invested heavily in the economic and social fabric of their region. Brussels has been rather left behind, since the city, or city-region, has only limited autonomy. The potential of Brussels is huge, given the presence of the European Union, NATO, and the numerous international organisations and multinational corporations. But the ongoing quarrels about the future of Belgium leave the city as a kind of orphan, since neither of the two large communities is inclined to invest in it. As one of the authors in this annual review remarks: there are probably few countries in the world that fail so completely to make the best of the available economic potential.

These annual reviews are essential reading for anyone who wishes to follow the discussion on the future of Belgium and that of Socialism in Western Europe. Just a graphical note: the editors now seem in some doubt whether they want this annual review to be a proper book, or just a special issue of a monthly journal. The aesthetic effect of this in-between option is a bit poor.

Marc Hooghe

www.stichtinggerritkreveld.be

'Pauper Paradise': the Dutch Re-education Laboratory

Journalist Suzanna Jansen's *Pauper Paradise* (Het pauperparadijs) is a clever and moving description of the attempts to re-educate and integrate *'the dregs of humanity'* in the Netherlands in the period from 1823 to 1973. Her family history leads us through the utopian projects that were intended to combat pauperism in the nineteenth century.

The author begins by showing us what the ideal (closely associated with the ideal of the enlightenment) of the perfectible human being could achieve in a liberal society. She then provides an evocative insight into the functioning of the principles of charity, social democracy and the welfare state. It emerges clearly that in the last two centuries it has become steadily easier for individuals to break the chains of poverty. But even though *'not to be made destitute'* has become a right, this tale of penury and impotence is still an important reflection on society. For the stigma of the 'underclass' seems once more to be lying in wait. Just think for a moment of what can happen to people with Turkish or Moroccan-sounding names, or of the term 'alien' with all its connotations.

When checking the information on an obituary card for her great grandmother, Suzanna Jansen chanced on the unusual fact that her family originates from Veenhuizen. Until the 1980s this settlement for convicts and beggars was the property of the Ministry of Justice. It was also known as 'the Dutch Siberia' because it was so far from civilisation, out there in the wilds of Drenthe.

Just as natives and slaves could perform useful tasks on the plantations of the Dutch Indies provided they were properly organised, when Johannes van den Bosch founded the Benevolent Society (Maatschappij van Weldadigheid) in 1818 he thought that by so doing he could tackle the problem of poverty in the Netherlands. Discipline and fresh air away from alehouses and brothels would make new people of the urban paupers. By a united effort poor families, vagrants and orphans were 'despatched' to the Society's open and enclosed settlements. In total some 70,000 people

'Vagrants' Day' in
Veenhuizen, 2008.

would spend, if not their whole lives, at least the greater part of them, in one of these large institutions. Despite the considerable investment – modern weaving and spinning machinery was installed – the ideals of a self-supporting population and the eradication of poverty proved unattainable. On the contrary, the people who were 'despatched' remained poor and the fact that they came from the 'settlements' was perceived as a stigma. Moreover, the character of Veenhuizen changed in 1843, when all those found guilty of vagrancy anywhere in the Netherlands were sent there. For three whole generations Jansen's forebears returned there time and again.

From Jansen's chequered family history, in which poverty and alcohol abuse are interwoven with utopianism and emancipation, the reader gains a good picture of the social history of the Netherlands, in which state intervention has grown ever greater. She manages not only to re-create touching life stories from data in the archives, but also seamlessly to interweave them with the broader events of the time. By recounting her emotions during her research and when visiting Veenhuizen, that nowadays accommodates a prison museum and five penal establishments, she conveys to the reader the depth of her commitment. She discovers that the first of her ancestors to live in Veenhuizen was not 'someone who had gone off the rails' at all, but a soldier honourably discharged from Napoleon's army, who like many other veterans had been taken on as a guard. Although his family lived apart from the paupers, and although he was paid a modest amount and had a vegetable patch, none the less his position in the pauper settlement meant that for three generations his descendants were inextricably linked to the detested Veenhuizen, and for five generations to poverty.

The Netherlands Central Statistical Bureau has calculated that of the current 16 million inhabitants of the Netherlands one million must have had ancestors in the pauper settlements. The Drenthe Archive had long been planning to digitise the personal details in the archives of the Benevolent Society's open and enclosed settlements. When *Pauper Paradise* was almost completed, they decided to speed up the digitising to enable a combined publicity effort with Suzanna Jansen. As a result, in May 2008 an 'Ancestors Day' was organised, when prominent Dutch citizens such as Ruud Lubbers, the former prime minister, were presented with personal data on those of their ancestors with a settlement past. And as it turned out, the general public was indeed interested in this recent history: since then there have been twenty impressions of *Pauper Paradise* and over 80 thousand copies have been sold. And among other things there has been a noticeable rise in the number of people visiting the prison museum and the Drenthe Archive.

The utopian projects have not succeeded in eradicating poverty, but during the years that followed the Second World War initiatives were put in place to humanise the penal establishments in the Drenthe settlements. Eventually re-education was more closely tailored to the individual and to rehabilitation, while not excluding the group system. It is to be hoped that Jansen's most instructive history of what she herself refers to as 'the Dutch re-education laboratory' may also arouse interest abroad.

Dorien Kouijzer
Translated by Sheila M. Dale

www.suzannajansen.nl

Visual Arts

Mark Manders:
Artist under the Table

'Under a table you have the possibility to test your own absence. The realization that life is taking its course, even without you, is an intense human experience; it shows the finiteness of personality.'

The above is the opening sentence of 'The Absence of Mark Manders', a text from 1994 on Mark Manders' website. *The Absence of Mark Manders* was also the title selected for an exhibition which has been on the road since 2007 (after Hanover in Germany, Bergen in Norway and Ghent in Belgium, it will be in Zürich in Switzerland until June 14, 2009) and its accompanying publication. Book and exhibition contain many parts of the *Gesamtkunstwerk* that Mark Manders (b. Volkel, 1968) has been creating since 1986: *Self-Portrait as a Building*. A Total Plan that has been growing steadily. But the work will never be displayed in its entirety or in its intended ultimate form. In the preface to the book, that shows its progress until now, Manders apologises for this inconvenience. Although many parts can be considered complete, they have, in his eyes, not been exhibited in the right place, or been photographed under the right conditions, and above all, not been linked to each other. Out of necessity – in order to have the money to continue working – 'fragments' have been sold over the years and it would be impossible to buy them all back. So how should we look at his work? *'... please note that all of the works ... in fact belong together in a single building with a gray concrete floor and white walls, in spaces with varying heights and lit from above – some of them from the side – by natural light. You cannot look out of this building – the windows have either been covered with fake newspapers or they face other parts of the building.'* It will never be really cozy in the building where this artist's body of ideas has to live.

In 1986, at the age of eighteen, Manders took the writing utensils he had at hand and drew up a floor plan of an imaginary building: *Inhabited for a Survey, (First Floor Plan from Self-Portrait as a Building)*. This was to be a decisive point for his life as an artist. He had actually wanted to become a writer, to create one book – with no beginning and no end – at which he would have to work continually, but he feels more at home using visual means to describe things. The floor plan is the visual equivalent of the plot of a novel. The pens and felt tips neither write nor draw, but with their material bodies represent a system in the process of formation. For Manders, the real and the imagined world are too complex to be captures in words (alone). As he puts it: *'The world itself is more complex than the world of language that has been embedded in the world.'*

With his creations Mark Manders constructs a universe of his own within the world in which he finds himself. In doing so he makes use of images *and* language. The execution he leaves to an imaginary artist who operates under the name of 'Mark Manders' (more about that later).

Visual art and the poetic word greatly enhance each other. The titles Manders gives his work are never purely random. The epigrams strengthen, explain and/ or underpin the visual work. Language is one of the building blocks that Manders uses, in the same way as a painter sometimes mixes sand with his paint. He takes this a very long way. If necessary he uses newspapers he has created himself, which are distributed in tiny or large editions depending on the occasion. Together with a partner Manders even runs his own publishing house: Roma Publications. Whether the name contains a reference to the gypsy-like existence of Manders' self-portrait is open to question, though for someone with an associative mind it seems more likely than not.

Conversely, the linguistic can be found in the visual work. Manders takes 'visual language' fairly literally and often regards his combinations as sentences. And just as sentences are made up of words, he will connect objects with, and even join them to, each other. Clamping a sugar cube, for example, between an upper-arm bone made of epoxy and a coffee cup: *A Place where My Thoughts Are Frozen Together* (2001). Or creating a *Still Life with Interconnected Holes* (2006). Sometimes he helps the imagining of a bond by adding a rope or a cord: *Room with Broken Sentence (Cup / – / Cup / Fragment of Forgetting / Cup / Transmitter / Cup /*

Mark Manders, *Inhabited for a Survey (First Floor Plan from Self-Portrait as a Building)*. 1986. Writing materials, erasers, painting tools, scissors, 8 x 267 x 90 cm. The Art Institute of Chicago (gift promised by Donna and Howard Stone).

Mark Manders, *Livingroom Scene*. 2008. Various materials, 330 x 350 x 300 cm. Courtesy of Zeno x Gallery, Antwerp / Photo by Dirk Pauwels, SMAK.

– (– / Receiver) / Cup / – (Chair / Chair / Matchbox / –) Cup / Boomerang / Cup / – / Cup / – / – (Bottle / –) / – (Bottle / -) / Chair / – / – / Marble / Bottle / Cup) (1993-1998) or chains a post-fox (the animal is carrying a letter in his mouth to transmit thoughts) to a wardrobe with an up-side-down table on top: *Parallel Occurrence* (2001/2002). Each of his installations is a meticulously worked out sequence of associations that is so personal, so private that without an explanation – and luckily MM provides one from time to time – they would be completely incomprehensible to an outsider.

These works are not completely static. Manders regularly reviews the setting and composition of the fragments. In that lies a parallel with what people regularly do in their own homes: they move the furniture around and replace parts of their interior. Since Manders' world is in fact a virtual representation of an imaginary construction, he can keep on building in a way very few people can, transcending borders and space. For that reason he constantly has to adjust his floor plan so he can accommodate and display the stream of household goods coming in.

However personal his work may be – and one would not readily attribute any work of his to any other artist – there is always a certain absence of individuality. His human figures are a hotchpotch of idealised forms from classical traditions. In this he shows a certain preference for the effect of unbaked clay: little or no structure, no wrinkles. The same applies to his choice

of impersonal objects. Ornaments are ballast. A cupboard must be nothing more than a storage system. The only 'frivolity' on a bench devised by Manders is a gigantic clothes peg. But that does also have a practical reason: it can hold a newspaper.

The *artist* Mark Manders is something between a character in a novel, who gives a non-autobiographical commentary from a first-person perspective, and the avatar who in *Second Life* inhabits the virtual world of the internet. The Mark Manders of flesh and blood has consciously created an imaginary artist. He says: '*To me, the artist Mark Manders is a fictitious person. He is a character living in a world that has been logically devised and constructed and consists of thoughts that were halted or solidified when they were at their strongest. He is someone who disappears into his actions. He lives in a building that he leaves continually, an uninhabited house in fact.*'

The archetypical artist is absent in Mark Manders' spaces – and when he's not lying under the table, he's looking down from above at the dioramas that are his own creations. Mark Manders keeps his distance.

Frank van der Ploeg
Translated by Pleuke Boyce

Stephan Berg *et al.*, *The Absence of Mark Manders*. Ostfildern: Hatje Cantz Verlag, 2007.
www.markmanders.org / www.romapublications.org

Crazy for Art
The Dr Guislain Museum of Psychiatry

Until a few weeks ago, in an out-of-the-way museum in the northern part of Ghent, screens projected the more disturbing fragments from films by Alfred Hitchcock and David Lynch, dioramas showed theatre scenes dominated by mad scientists and crazy kings, and paintings depicted little people manipulated by strings attached to giant hands.

Last year the same space was home to the Roca Collection, an array of wax heads and torsos depicting horrifying diseases and jars containing Siamese twins floating in formaldehyde. And before that was an exhibition devoted to whether people who were sick in the body were really sick in the head – and vice versa.

Has this museum gone mad? Well, yes, in a matter of speaking. The Dr Guislain Museum in northern Ghent is Belgium's only museum of psychiatry, and its rotating exhibitions – like its permanent collections – all attempt to uncover what it calls 'the heart of madness'. That's an appropriate image to a museum that sometimes graphically, sometimes poignantly, and always honestly explores the intersections between science and art, between medicine and the soul.

In late 2007 the Dr Guislain museum re-opened after a complete renovation which updated the presentation of its two permanent collections – the history of psychiatry and outsider art. 'It is not an easy history,' says Patrick Allegaert, the museum's curator. 'There are some practices in psychiatry where, even just 20 years later, doctors will say "what have you done?" One's instinctive reaction is to cover it up.' But when the museum opened 22 years ago, 'it was very important for us to go in the opposite direction,' says Allegaert, 'to document the history in order to help us to talk about psychiatry and "otherness" now.'

Named after the man who designed Belgium's first psychiatric institution, the museum is housed in that very building. Joseph Guislain was born into a family of architects at the end of the eighteenth century and was one of the first students of medicine at Ghent's university. He was Belgium's first psychiatrist, though at the time that word didn't exist. Instead, the mentally ill were referred to in French as aliénés and Guislain was an aliéniste.

Guislain was appalled at the conditions in establishments that housed the mentally ill – from hospices to prisons to orphanages. Kept in locked rooms and frequently bound to chairs and beds, there was no attempt to separate such people from other kinds of prisoners or chronically sick patients. Guislain was the first person in Belgium – and one of the first in Europe – who claimed that the mentally ill should be treated as patients who could be cured or whose situation could improve.

He distinguished between different types of illness, between chronic conditions like autism and treatable conditions such as depression. In 1850, Guislain helped pen the country's earliest official laws on the treatment of the insane – guidelines that were so far ahead of their time that they were used until 1991.

The 'Father of Belgian psychiatry' then set out to build the perfect facility for these people. He first travelled to Switzerland and Italy to study architecture, accommodation and nursing in several institutions. In 1857, the Hospice pour hommes aliénés opened in an area that was then outside Ghent – because Guislain rightly believed that the stress of the city had a detrimental effect on the mentally disturbed. He also separated children from adults and people with different kinds of disorders from each other.

Guislain's asylum employed a Roman Byzantine style with plenty of gardens and properly equipped wards for specific conditions. He was the first director of what became a model institution which attracted international attention from medical and care communities. Guislain had, literally and figuratively, freed the mentally ill from their chains.

The ordinary visitor is generally unaware of certain aspects of the building that were crucial. For instance, the city of Ghent insisted that the windows of the institution have bars to keep the patients from getting out unattended. Guislain refused, saying that bars were not therapeutic. In the end, a compromise created windows of beauty and function: decorative iron stanchions from top to bottom appear to be a simple choice of design.

Dr Guislain Museum,
Ghent.

Guislain is also famous for refusing to classify mental disorders as completely physical or completely psychological: instead, he said, they are a combination of the two. He insisted that mental illness was a result of complex processes, incorporating the German emphasis on somatic causes of mental illness with the more philosophical approach of the French. *'It's typically Belgian to do that, too,'* smiles Allegaert. *'Be a little bit French and a little bit German.'*

A new mental institution now stands next to the old one, and the patients are encouraged to visit the museum next door that reflects Guislain's original approach. The history of psychiatry is the purely physical section: tools of the trade, photographs and explanations of past methods of curing various kinds of conditions. The other section is metaphysical: artwork by mental patients, prisoners or others who live a marginalised existence – essentially on the fringes or outskirts of society – an internationally recognised genre known as 'outsider art'.

In the historical section, your tour begins with a journey through the Roman and Greek schools of thought, led by the widely accepted theory of 'humours' – that the body and mind was kept in balance through four substances (black bile, yellow bile, phlegm and blood) and every form of physical and mental illness was caused by having too much or too little of one or other of them.

Evil spirits, too, were often thought to play a part in causing delirium, a belief that lasted into late medieval times when trepanning (boring into the skull to release the spirit) was a common practice. The museum contains excavated skulls and trepanning instruments, as well as exhibits on witchcraft, exorcism and the fascinating history of home health care, which has its origins in the area that is now the Flemish city of Geel.

You can also see reproductions of a patient's room and of a nineteenth-century pharmacy, as well as models of devices used, including by Guislain, for water shock therapy and body rotation. Photographs from the children's section of the asylum are moving and illustrate the importance both professional photographers and mental health workers placed on a photographic record.

Meanwhile, the Dr Guislain Museum's art collection includes works by some of Europe's best-known outsider artists, including an excellent selection of work by Willem van Genk, who built extensive networks out of cardboard, bus tickets, sweet wrappers, wire and other materials people throw away. His models of railway stations are particularly fascinating – ordering and controlling everything by means of lines and wire, the Dutch artist, who died in 2005, made himself the orchestrator of his own worlds, which took the place of a real world that offered him nothing but confusion.

Many outsider artists in fact turned to drawing, painting or constructing special imaginary worlds to similarly control their environments. In this way, art becomes both therapeutic for the patient and an invaluable glimpse into the worlds of the mentally ill for the rest of us. Because, as Allegaert reminds us: *'It isn't possible to reduce psychiatry to only the physical and chemical processes. It's also human, it's also social.'*

Lisa Bradshaw

www.museumdrguislain.be

A Hundred Years of Dutch Design

Overviews of the culture of design are mostly written from an artistic or stylistic perspective, rarely from an economic, sociological or political-philosophical angle. In her book *Dutch Design: A History*, however, Mienke Simon-Thomas has opted for the latter approach; the products and designers are relegated to second place. This means that the focus is first and foremost on information on design education, designers' associations and the role of the state as the instigator of initiatives and provider of subsidies within the system.

The book is built around five topics, which taken together portray the ideological context in which designers worked. The overview begins with 'New Art, Old Craft, 1875-1915', a period in which traditional design confronted increasing industrialisation. The author discusses the development of applied industrial art in the nineteenth century and also examines the role of Victor de Stuers, the first Dutch civil servant with a responsibility for 'art'. A Museum of Applied Industrial Art was established in Haarlem, and in 1871 the first technical school was opened in Amsterdam. There is a detailed study of the phenomenon of 'geometric design', which combined the stylised reproduction of natural forms with geometry. Examples of this style include the work of K.P.C. De Bazel, Lion Cachet and H.P. Berlage. By virtue of his creations for "t Binnenhuis' and his writings Berlage became a central figure in the modernisation of Dutch design. The Netherlands was also represented at the 1900 World Exhibition in Paris. Karel Sluyterman designed a presentation in Art Nouveau style (also called 'Congo style' by people in the Netherlands), that referred to the successful exhibition in Tervuren in 1897.

The second theme, 'Design as Art, 1915-40', examines the concept of design as 'art' and the rapprochement with industry. The example of the 'Deutsche Werkbund', founded in 1907, stimulated co-operative working throughout Europe. For Jan Eisenloeffel it was impossible to combine industry and art. Piet Zwart took the opposing view. For Zwart design was not a question of art or taste, but an expression of the designer's attitude to life. The ideas championed by the Bauhaus determined the new role of the designer. Simon-Thomas also discusses the yearbooks of the Society for Craft and Applied Industrial Art (Vereniging voor Ambachts- en Nijverheidskunst or VANK, founded in 1904) published between 1919 and 1932, which give a good idea not only of the products, but also of the debate.

'Good Design, 1925-65', the third topic to be covered, is about the need to improve the world through creating a good design. The author uses the expression 'moralistic modernism', a style of design that can be defined by three concepts: efficiency, honesty and simplicity. The younger generation of architects in particular, members of De8 (Amsterdam) and Opbouw (Rotterdam), were arguing for a functional architecture in which moral aspects took precedence over those of style. Looking after a modern kitchen was seen as liberating for women. The new applied graphics in advertising, combined with modern typography, were also supposed to contribute to a better world. The work of Piet Zwart, Paul Schuitema and Gerard Kiljan was not only about the products; advertising was also regarded as a new form of art.

Post-war idealism reached its fullest expression in the foundation of the Good Living Foundation (Stichting Goed Wonen) in 1946 and the National Institute for Industrial Design (IIV) in 1950. After the German capitulation the Contracted Artists federation (Gebonden Kunstenaars federatie, GKf) was established by Willem Sandberg and Mart Stam. The concept of 'contracted artist' replaced the old term 'industrial artist' or 'technical artist'. People, not things, were central to the concept of Good Living. There was pressure to contribute to a better style of living in general, in which attractive and well-designed products could play their part. Products that were functional, reliable and affordable qualified for a 'Good Living hallmark'.

In addition to the designers the book also looks at the role of firms such as Philips, Mosa, the glass manufacturer Leerdam, Ahrend, 't Spectrum etc. The importance of 'taste education' through retail outlets is discussed at length. The 1953 *Our House-Our Home* (Ons Huis-Ons Thuis) exhibition in the Bijenkorf in Amsterdam was organised by Aldo van Eyck, Martin

Visser and Benno Premsela. Even greater was the impact of Metz & Co, who played a pioneering role: the majority of foreign design creations were first shown in the Netherlands by Metz.

Chapter 4, 'Design as Profession, 1945-80', examines the shift towards mass production and how designers and companies reacted to this. Industrial activity in the Netherlands doubled between 1948 and 1962. Firms took on professionally-trained industrial designers rather than draughtsmen because design was becoming an important element in the development of a product. In 1953 a group of designers was given a government subsidy to travel around America and acquaint themselves with recent developments in industrial design, with immediate consequences for design education in the Netherlands.

Manufacturers such as Tomado, which had captured the Dutch interior with its metal bookshelf, and Pastou are cited as examples of this period. Vision comes from the individual, as in the case of the designer Kho Liang Ie who in 1959 advised the firm of Artifor to work with the Frenchman Pierre Paulin. This collaboration earned the firm a European name it retains to this day. More and more emphasis was placed on the importance of graphic design, on logos and other graphic products. Bureaus such as Tel Design, Total Design, Design Studio Premsela Vonk and Studio Dumbar became the trendsetters. Total design projects like the new airport at Schiphol became calling cards for the Netherlands. And with progressive designs for banknotes and postage stamps the government too contributed to the Netherlands' image as a land of designers.

The concluding chapter, 'Design for Debate, 1970s to the Present', begins with Gijs Bakker's umbrella lamp (1983). The boundaries between art, fashion and design are beginning to blur. The dogma of the strictly functional is losing ground, a product also has to make a statement. For the 1970s Simon-Thomas cites Simon Mari Pruys' fundamental contribution to the design debate: his *Things Shape People* (Dingen vormen mensen), published in 1972, is 'the first socio-cultural inventory of the theme of design education in the Netherlands'. Government begins to put the emphasis on the debate, not so much on the creation of products.

Lingerie by Marlies Dekkers (from a survey exhibition at Rotterdam Kunsthal, 2008).

There has been a massive upsurge in public interest in design, design takes over everything. In 1978 Ikea entered the Dutch market and Hema launched the phrase 'good, cheap and well designed'. The author goes at length into the debate in the graphic sector, discussing figures like Crouwel, Van Toorn, Beeke, Brattinga and others. The 1980s saw the emergence of a new phenomenon: designers who also manufactured their own designs. Following the founding of Droog Design (Dry Design) by Renny Ramkers and Gijs Bakker in 1994, the international media hailed the Netherlands as 'the' country for design. This set-up gave figures like Bey, Hutten, Wanders and Jongerius a chance to make a name for themselves. Droog Design creations found a home in the restaurant of MoMa in New York, an initiative subsidised by the government as 'propaganda for avant-garde Dutch design'.

But Droog Design does not stand alone. Think for instance of Marlies Dekkers' lingerie, Viktor & Rolf's fashion, and the typefaces of Gerard Unger.

The success of Dutch design is the fruit from a reorientation in design education. The starting point is 'conceptual design', in which the Design Academy in Eindhoven is the pioneering institution. In addition the government is providing a considerable subsidy for design, to be distributed through various channels. And 2002 saw the establishment of Premsela, a new design institute for design and fashion.

Marc Dubois
Translated by Sheila M. Dale

Mienke Simon-Thomas, *Dutch Design. A History*. London: Reaktion Books, 2008.

Contributors

Christiaan Berendsen
Former Chief Editor *Het Financieel Dagblad*
chrberendsen@hotmail.com

Derek Blyth
Chief Editor *Flanders Today* and *The Bulletin*
derekblyth@gmail.com

Maria Bouverne-De Bie
Professor at the Dept. of Social Welfare
Studies (Ghent University)
maria.debie@ugent.be

Lisa Bradshaw
Deputy Editor *Flanders Today*
lisa.bradshaw@ackroyd.be

Daan Cartens
Staff member of the Letterkundig
Museum (The Hague)
daan.cartens@nlmd.nl

Dieter De Clercq
Architect engineer/Architect-partner
(ABSCIS Architecten)
dieter.de.clercq@telenet.be

Mark Cloostermans
Literary critic
mark.cloostermans@skynet.be

Chinazo Cunningham
Associate Professor of Medicine
(Montefiore Medical Center New York)
ccunning@montefiore.org

Simon Van Damme
Fellow of the Research Foundation-Flanders,
Musicology Research Unit (Catholic University
of Leuven)
simon.vandamme@arts.kuleuven.be

Anneleen Decoux
Literary critic/Teacher
anneleendecoux@hotmail.com

Dirk van Delft
Director Museum Boerhaave/Professor
in the History of Science (Leiden University)
delft@strw.leidenuniv.nl

Luc Devoldere
Chief Editor Ons Erfdeel vzw
luc.devoldere@onserfdeel.be

Jeroen Dewulf
Queen Beatrix Professor in Dutch Studies
(University of California, Berkeley)
jdewulf@berkeley.edu

Bart Dirks
Journalist *de Volkskrant*
b.dirks@volkskrant.nl

Peter A. Douglas
Librarian (New York State Library, Albany, NY)
pdouglas@mail.nysed.gov

Marc Dubois
Architect/ Professor at the Dept. of Architecture
(St Lucas Ghent & Brussels)
marc.dubois@pandora.be

Romain Van Eenoo
Emeritus Professor of Modern History (Ghent
University)
romainvaneenoo@yahoo.com

Roelof van Gelder
Historian/Editor book section *NRC Handelsblad*
rgelder@xs4all.nl

Ton Gloudemans
Writer (upworks.nl)
ton.gloudemans@upworks.nl

Jenny Graham
Lecturer in Art History (University of Plymouth)
jennifer.graham@plymouth.ac.uk

Ger Groot
Writer/Lecturer in Philosophy
(Erasmus University, Rotterdam)
ger.groot@skynet.be

Rob Hartmans
Historian/Journalist
rhhistor@xs4all.nl

Gerald de Hemptinne
Journalist
gdehemptinne@hotmail.com

Rudy Hodel
Art critic/Collaborator Fries Museum
(Leeuwarden)
r.hodel@friesmuseum.nl

Marc Hooghe
Professor of Political Science
(Catholic University of Leuven)
marc.hooghe@soc.kuleuven.be

Luc Huyse
Emeritus Professor of Sociology and Sociology
of Law (Catholic University of Leuven)
luc.huyse@law.kuleuven.be

Hans Ibelings
Architecture critic
ibelings@cuci.nl

Dorien Kouijzer
Staff member Institut Néerlandais (Paris)
conf@institutneerlandais.com

Pieter Leroy
Professor of Political Sciences of
the Environment (Nijmegen University).
p.leroy@fm.ru.nl

Annemie Leysen
Children's literature critic
annemie.leysen@chello.be

Lucas Ligtenberg
Writer/ Member of the editorial staff
PropertyNL.com
lucasligt@yahoo.com

Joke Linders
Children's literature critic
joke.linders@tiscali.nl

Erik Martens
Film critic/Chief editor DVD production
(Royal Belgian Film Archive)
erik.martens@cinematek.be

Filip Matthijs
Editorial secretary *The Low Countries*
tlc@onserfdeel.be

Lut Missinne
Professor of Modern Dutch Literature
(Westfälische Wilhelmsuniversität, Munster)
lut.missinne@uni-muenster.de

Thomas Möhlmann
Poet/Editor/Staff member Foundation for
the Production and Translation of Dutch Literature
(Amsterdam)
t.moehlemann@nlpvf.nl

Tom Naegels
Writer
tom@tomnaegels.be

Cyrille Offermans
Writer/Literary critic
cyrilleoffermans@home.nl

Frank van der Ploeg
Art historian
info@artaz.nl

Anne-Marie Poels
Editor <*H*>*ART*/MuHKA (Antwerp)
ampoels@mac.com

Jellichje Reijnders
Dramaturgist/curator/critic
jellichje.reijnders@zonnet.nl

Marieke van Rooy
Architectural historian/Ph.D. candidate
architectural history and theory (Technical
University Eindhoven)
mvrooy@zonnet.nl

Wijbrand Schaap
Theatre journalist/Board member Dutch
Association of Theatre Critics
wijbrand.schaap@xs4all.nl

Nancy Sohler
Adjunct Assistant Professor of Epidemiology
(Mailman School of Public Health, New York)
nls9@columbia.edu

David Stroband
Art historian
davidstroband1@versatel.nl

Johan Thielemans
Critic
jvthielemans@telenet.be

Wilco Tuinebreijer
Psychiatrist/Medical Director GGD (Amsterdam)
wtuinebreijer@ggd.amsterdam.nl

Guido Vanheeswijck
Professor of Philosophy (University of Antwerp/
Catholic University of Leuven)
guy.vanheeswijck@ua.ac.be

Mirjam van Veen
Church historian (VU University Amsterdam)
mgk.van_veen@th.vu.nl

Mieke van der Wal
Art historian
wal.heij@online.nl

Emile Wennekes
Professor of Musicology/Head of School Media
and Culture Studies (Utrecht University)
e.wennekes@uu.nl

Karin Wolfs
Editor-Researcher *Filmfestival Journaals*/
VPRO television
mail@karinwolfs.nl

Gregory Ball
Pleuke Boyce
*James Brockway**
Sheila M. Dale
Lindsay Edwards
Chris Emery
Peter Flynn
Nancy Forest-Flier
Donald Gardner
Tanis Guest
John Irons
Yvette Mead
Elizabeth Mollison-Meijer
Julian Ross
Paul Vincent
Laura Watkinson

ADVISORS ON ENGLISH USAGE

Tanis Guest (UK)
Lindsay Edwards (Belgium)

Colophon

Association

This seventeenth yearbook is published by the Flemish-Netherlands Association 'Ons Erfdeel vzw', with the support of the Dutch Ministry of Education, Culture and Science (The Hague), the Flemish Ministry of Culture (Brussels) and the Provinces of West and East Flanders. The Association 'Ons Erfdeel vzw' also publishes the Dutch-language periodical *Ons Erfdeel* and the French-language periodical *Septentrion*.
Arts, lettres et culture de Flandre et des Pays-Bas, the bilingual yearbook *De Franse Nederlanden – Les Pays-Bas Français* and a series of books in several languages covering various aspects of the culture of the Low Countries.

The Board of Directors of 'Ons Erfdeel vzw'

President:
Herman Balthazar

Managing Director:
Luc Devoldere

Directors:
Greetje van den Bergh
Marcel Cockaerts
Jan Desmyter
Bert De Graeve
Mark Leysen
Cecile Maeyaert-Cambien
Frits van Oostrom
Adriaan van der Staay
Ludo Verhoeven

Honorary President:
Philip Houben

Address of the Editorial Board and the Administration

'Ons Erfdeel vzw', Murissonstraat 260,
8930 Rekkem, Flanders, Belgium
T +32 56 41 12 01, F +32 56 41 47 07
www.onserfdeel.be, www.onserfdeel.nl
thelowcountries.blogspot.com
VAT BE 0410.723.635

Bernard Viaene *Head of Administration*
Adinda Houttekier *Administrative Secretary*

Aims

With *The Low Countries*, a yearbook founded by Jozef Deleu (Chief Editor from 1993 until 2002), the editors and publisher aim to present to the world the culture and society of the Dutch-speaking area which embraces both the Netherlands and also Flanders, the northern part of Belgium.

The articles in this yearbook survey the living, contemporary culture of the Low Countries as well as their cultural heritage. In its words and pictures *The Low Countries* provides information about literature and the arts, but also about broad social and historical developments in Flanders and the Netherlands.

The culture of Flanders and the Netherlands is not an isolated phenomenon; its development over the centuries has been one of continuous interaction with the outside world. In consequence the yearbook also pays due attention to the centuries-old continuing cultural interplay between the Low Countries and the world beyond their borders.

By drawing attention to the diversity, vitality and international dimension of the culture of Flanders and the Netherlands, *The Low Countries* hopes to contribute to a lively dialogue between differing cultures.

ISSN 0779-5815
ISBN 978-90-79705-00-9
Statutory deposit no. D/2009/3006/1
NUR 612

Copyright © 2009 'Ons Erfdeel vzw'
Printed by Die Keure, Bruges, Flanders, Belgium
Design by Luc De Meyer (Die Keure)

Prices for the yearbook 2009, no. 17

Belgium € 37, The Netherlands € 39, Europe € 39, United Kingdom £ 35, USA $ 60

Other Countries: the equivalent of € 45
All prices inclusive of shipping costs
Payment by cheque: + € 22.39 bank costs

As well as the yearbook
The Low Countries,
the Flemish Netherlands
Association 'Ons Erfdeel vzw'
publishes a number of books
covering various aspects of
the culture of Flanders and
the Netherlands.

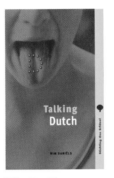

Wim Daniëls
Talking Dutch.
Illustrated; 80 pp.

J.A. Kossmann-Putto &
E.H. Kossmann
*The Low Countries.
History of the Northern
and Southern Netherlands.*
Illustrated; 64 pp.

Isabella Lanz &
Katie Verstockt,
*Contemporary Dance
in the Low Countries.*
Illustrated; 128 pp.

Mark Delaere &
Emile Wennekes,
*Contemporary Music in
the Low Countries.*
Illustrated; 128 pp.

*Standing Tall in Babel.
Languages in Europe.*
Sixteen European writers
about their mother tongues.
Hardcover; 144 pp.

Between 1993 and 2008
the first sixteen issues
of the yearbook *The Low
Countries* were published.

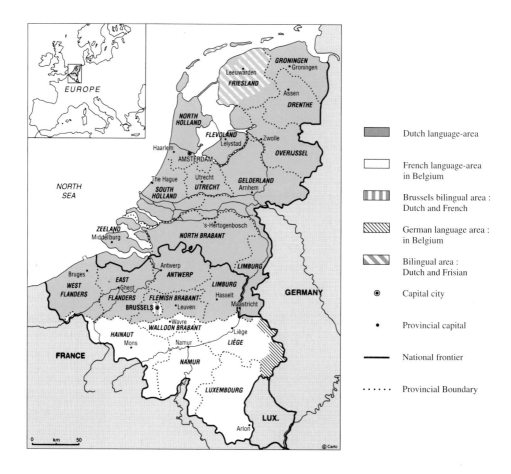

EUROPE

NORTH
SEA

GRONINGEN
• Groningen
Leeuwarden
FRIESLAND
• Assen
DRENTHE

NORTH
HOLLAND
FLEVOLAND
Lelystad
• Zwolle
Haarlem
AMSTERDAM
OVERIJSSEL

The Hague
Utrecht
GELDERLAND
SOUTH
HOLLAND
UTRECHT
Arnhem

ZEELAND
Middelburg
's-Hertogenbosch
NORTH BRABANT

Antwerp
LIMBURG
Bruges
EAST
ANTWERP
WEST
Ghent
LIMBURG
GERMANY
FLANDERS
FLANDERS
FLEMISH BRABANT
Hasselt
BRUSSELS
• Leuven
Maastricht

• Wavre
WALLOON BRABANT
HAINAUT
• Liège
Mons
Namur
LIÈGE

FRANCE
NAMUR

LUXEMBOURG

LUX.

Arlon

0 km 50

© Carto

Dutch language-area

French language-area
in Belgium

Brussels bilingual area :
Dutch and French

German language area :
in Belgium

Bilingual area :
Dutch and Frisian

◉ Capital city

• Provincial capital

——— National frontier

· · · · · · Provincial Boundary